Accession no. 36028082

WITHDRAWN

VISUAL QUICKSTART GUIDE

PHOTOSHOP ELEMENTS 4

FOR WINDOWS

Craig Hoeschen

Visual QuickStart Guide

Photoshop Elements 4 for Windows

Craig Hoeschen

Peachpit Press

1249 Eighth Street Berkeley, CA 94710 510/524-2178 800/283-9444 510/524-2221 (fax)

Find us on the Web at www.peachpit.com To report errors, please send a note to errata@peachpit.com

Peachpit Press is a division of Pearson Education Copyright © 2006 by Craig Hoeschen

Editor: Suzie Nasol Production Editor: Becky Winter Copyeditor: Anne Marie Walker Proofreader: Evan Pricco Compositor: Maureen Forys, Happensta

Compositor: Maureen Forys, Happenstance Type-O-Rama

Indexer: Julie Bess Cover design: Peachpit Press

Notice of Rights

No part of this book may be reproduced or transmitted in any form by any means, electronic, mechanical, photocopying, recording, or otherwise, without the prior written permission of the publisher. For information on getting permission for reprints and excerpts, contact permissions@peachpit.com.

Notice of Liability

The information in this book is distributed on an "As Is" basis, without warranty. While every precaution has been taken in the preparation of the book, neither the author nor Peachpit Press, shall have any liability to any person or entity with respect to any loss or damage caused or alleged to be caused directly or indirectly by the instructions contained in this book or by the computer software and hardware products described in it.

Trademarks

Visual QuickStart Guide is a registered trademark of Peachpit Press, a division of Pearson Education.

Adobe is a registered trademark, and Photoshop Elements is a trademark of Adobe Systems, Inc.

Many of the designations used by manufacturers and sellers to distinguish their products are claimed as trademarks. Where those designations appear in this book, and Peachpit was aware of the trademark claim, the designations appear as requested by the owner of the trademark. All other product names and services identified throughout the book are used in an editorial fashion only and for the benefit of such companies with no intention of infringement of the trademark. No such use, or the use of any trade name, is intended to convey endorsement or other affiliation with this book.

ISBN 0-321-42335-6

987654321

Printed and bound in the United States of America

Dedication

For Bob and Jack

Acknowledgements

Special thanks to my editor, Suzie Nasol for her tireless work and thoughtful guidance throughout the course of this project. Special thanks also to everyone who contributed to the final production and composition of these pages, especially: Becky Winter, Production Editor; Maureen Forys, Compositor; Evan Pricco, Proofreader; and Julie Bess, Indexer. Thank you again to Chris Dahl and Paul Carew for their images, insights, and friendship. And, as always, thank you to Karen for her patience, encouragement, and support.

TABLE OF CONTENTS

	Introduction	ix
Chapter 1	The Basics Understanding the Work Area Opening and Closing Files Saving Files Selecting Tools Using the Options and Shortcuts Bars. Working with Palettes Using the Zoom Tool Moving Around in an Image Selecting Activities from the How To Palette Using the Help System	
Chapter 2	Creating and Managing Images Understanding Resolution and Image Size Creating a New Image Importing Images from Cameras and Scanners. Changing Image Size and Resolution Getting Information About Your Image Opening and Arranging Multiple Views Using Rulers Setting Up the Grid	. 26 . 29 . 31 . 38 . 43 . 46
Chapter 3	Changing and Adjusting Colors About Computers and Color Models Working with Color Modes Changing Color Modes About Tonal Correction. Adjusting Levels Automatically Adjusting Levels Manually Lighting Your Image Correcting for Color Cast Replacing Color	. 54 . 55 . 58 . 70 . 72 . 74 . 76

Chapter 4	Making Selections	87
	About the Selection Tools	88
	Using the Marquee Tools	91
	Selecting Areas Using the Lasso Tools	
	Making Selections by Color	
	Using the Selection Brush Tool	
	Adjusting Selections	
	Softening the Edges of a Selection	
	Modifying Selection Borders	
Chapter 5	Working with Layers	115
chapter 5	Understanding Layers	_
	Using the Layers Palette	
	Layer Basics	
	Changing the Layer Order	
	Managing Layers	
	Merging Layers	
	Converting and Duplicating Layers	
	Copying Layers Between Images	
	Transforming Layers	
	About Opacity and Blending Modes	
	Creating Masking Effects with Layer Groups.	
	Applying Effects with Layer Styles	
	The Style Settings Dialog Box	147
	Making Color and Tonal Changes with	1.40
	Adjustment Layers	
	Using the Undo History Palette	152
Chapter 6	Fixing and Retouching Photos	155
	Cropping an Image	
	Straightening a Scanned Image	
	Straightening a Crooked Photo	
	Repairing Flaws and Imperfections	
	Applying Patterns	
	Correcting Red Eye	
	Sharpening Image Detail	173
	Enhancing Image Detail	176
	Blending Image Elements with the	
	Smudge Tool	178
	Using the Tonal Adjustment Tools	179
	Removing Color	183
	Adding a Color Tint to an Image	185

Chapter 7	Filters and Effects	189
	Using the Filters and Effects Palettes	190
	Applying Filters and Effects	193
	Filter Gallery	197
	Effects Gallery	204
	Simulating Action with the Blur Filters	207
	Distorting Images	212
	Creating Lights and Shadows	216
	Using Textures	222
	Creating Your Own Filters	226
Chapter 8	Painting and Drawing	229
chapter o	About Bitmap Images and Vector Graphics.	
	Filling Areas with Color	
	Filling Areas with a Gradient	
	Creating and Saving Custom Gradients	
	Adding a Stroke to a Selection or Layer	
	Using the Brush Tool	
	Creating and Saving Custom Brushes	
	Creating Special Painting Effects	
	Erasing with Customizable Brush Shapes	
	Erasing Backgrounds and Other Large Areas	
	Removing a Foreground Image from Its	
	Background	261
	Understanding Shapes	264
	Drawing Basic Shapes	265
	Transforming Shapes	268
	Creating Custom Shapes	272
	Using the Cookie Cutter Tool	278
Chapter 9	Working with Type	281
J	Creating and Editing Text	
	Changing the Look of Your Type	
	Working with Vertical Text	
	Anti-aliasing Type	
	Warping Text	
	Warping Text Style Gallery	
	Creating Text Effects Using Type Masks	297
	Applying Layer Styles to Type	
	Text Layer Style Gallery	
Chapter 10	Preparing Images for the Web	303
	Understanding Image Requirements	J = J
	for the Web	304
	About the Save for Web Dialog Box	305
	Optimizing an Image for the Web	306

	Adjusting Optimization Settings	
	Making a Web Image Transparent	
	Previewing an Image	
	Sending Images by Email	322
Chapter 11	Saving and Printing Images	329
	Understanding File Formats	
	Setting Preferences for Saving Files Formatting and Saving Multiple Images	336
	Automatically	339
	Creating a Contact Sheet	
	Creating a Photographer's Picture Package	
	Setting Up Your Computer for Printing	348
	Preparing an Image for Printing	
	Setting Additional Printing Options	
	Printing an Image	355
Chapter 12	Creative Techniques	357
	Creating Panoramas	
	Making Your Own Slide Show	
	About Web Photo Galleries	
	Creating Animated GIFs	
	Compositing Images	388
Chapter 13	The Photo Organizer	397
	Understanding the Photo Organizer	
	Work Area	
	Working in the Photo Browser	400
	Your Photos	404
	Creating Tags	
	Using Tags to Sort and Identify Photos	
	Using Categories to Organize Tagged Photos	421
	Using Collections to Arrange and Group Photos	427
	Using Stacks to Organize Similar Photos	
	Using Catalogs to Store Your Photos	
	Finding Photos	
Appendix A:	Editor Keyboard Shortcuts	443
Appendix B:	Organizer Keyboard Shortcuts	449
	Index	451

INTRODUCTION

Welcome to Photoshop Elements, Adobe's powerful, easy-to-use, image-editing program. Photoshop Elements gives hobbyists, as well as professional photographers and artists, many of the same tools and features found in Adobe Photoshop (long the industry standard), but packaged in a more accessible, intuitive workspace. Photoshop Elements' friendly user interface, combined with its bargain-basement price, has made it an instant hit with the new wave of amateur digital photographers lured by the recent proliferation of sophisticated, low-cost digital cameras and scanners.

Photoshop Elements 4 provides new tools and workspace enhancements that not only help stretch the bounds of your creativity, but also help to make your quick photo corrections and creative retouching even simpler and more fun than before.

In the next few pages, I'll cover some of Photoshop Elements' key features (both old and new) and share a few thoughts to help you get the most from this book. Then you can be on your way to mastering Photoshop Elements' simple, fun, and sophisticated image-editing tools.

Introducing Photoshop Elements

Photoshop Elements makes it easy to retouch your digital photos; apply special effects, filters, and styles; prepare images for the Web; even create wide-screen panoramas from a series of individual photos. And Photoshop Elements provides several features geared specifically to the beginning user. Of particular note are a comprehensive Help system featuring a glossary of common, digital image-editing terms; and a unique, engaging palette that helps guide you step by step through a variety of fun and useful tasks: from basic photo retouching to creating special digital effects.

The **Glossary**, accessible from within Photoshop Elements' Help, provides easy-to-understand definitions of nearly 200 terms. Although this glossary is specifically written for use with Photoshop Elements, it also serves as a good general digital photography and image-editing resource. Alongside the software-specific topics like *brush type* and *canvas size*, you'll find excellent working definitions of concepts diverse as *bit depth*, *PostScript*, and *RGB color*.

The **How To palette** features collections of *activities* designed to take you through tasks from basic photo retouching to creating special digital effects. At the same time, these activities are designed as a reference, so that over time you'll learn how to perform these tasks on your own. The How To palette provides a great way to quickly learn sophisticated image-editing techniques while completing your own projects.

What's new in version 4

If you've worked with Photoshop Elements in the past, you should feel right at home in version 4.0. Although you'll notice some subtle changes as you scan the interface, most of the tools, palettes and menus remain in easy to locate areas of the desktop. The toolbox, options bar, palette bin, and photo bin still figure prominently, as does the powerful Organizer with its Photo Browser and Creation work environments. New tools and features have been woven throughout both the Edit and Organizer workspaces. Following are just a few of the highlights.

The Magic Selection Brush and Magic Extractor

Two new tools have been added to Photoshop Element's toolbox for version 4. The Magic Selection Brush operates on the same principle as the Magic Wand, selecting areas based on color and tonal values. But rather than simply clicking an area as with the Magic Wand, the Magic Selection Brush (as its name implies) allows you to paint through an area that you would like to select. This technique not only offers you feedback in the form of colored brushstrokes, but also allows you to more easily select a variety of tones and colors simultaneously.

The Magic Extractor, which you access from the Image menu, works in much the same way as the Magic Selection brush, but specializes in separating foreground images from their backgrounds. The Magic Extractor (a unique work environment unto itself) features the added benefit of its own toolbox of specialty tools you can use to fine-tune and enhance your selections.

The Straighten tool

The simple, little Straighten tool is one of my favorite new features. You use it to align photos based on a horizontal plane, and it couldn't be easier. Start with a photo that's askew, and then just drag the Straighten tool from one side to the other, and presto! Your crooked landscape is crooked no more.

The improved Slide Show Editor

The Slide Show Editor within the Organizer workspace has been given a complete makeover. Starting with a more streamlined approach to importing and organizing your slides, the new Slide Show Editor also makes it much easier to add transitions and effects. But that's really just the beginning. Now you can also add text, clip art, and even narration. And when it comes time to save and export a slide show, Photoshop Elements can create either a PDF or a movie file, and save it in different formats suitable for email, for burning to disc, and even for viewing on TV.

Personalizing Photoshop Elements

Because no two users work quite the same way, Photoshop Elements gives you the freedom to customize its tools and palettes to suit your own personal work habits, expertise, and aesthetic. You can create favorite sets of brush types, swatch libraries, and patterned fills, and you can set preferences for save options, transparency, ruler units, and grid color. Slightly more advanced options help you to set the ways the program manages memory, and the ways it works with your monitor and printer to display and print color. Additionally, since it supports Adobe's plug-in file format, Photoshop Elements can be a constantly changing and evolving tool, as you add new plug-ins for everything from custom filter effects to digital camera image browsers.

Setting preferences

Preferences are settings that let you control and modify the way that Photoshop Elements looks, works, and behaves. The Preferences dialog box is divided into a series of windows, each one focusing on a specific aspect of the application: general display properties, file saving options, cursor display and behavior, transparency settings, rulers and units of measurement, grid appearance and behavior, cache levels for managing memory, and display settings for the file browser (Figure i.1). You can change preferences at any time by choosing Preferences from the Edit menu or by navigating through the dialog box using the drop-down menu (Figure i.2).

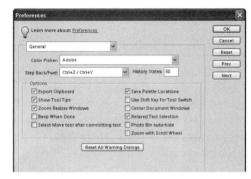

Figure i.1 You can customize Photoshop Elements' tools, palettes, and settings within its series of specialized Preferences dialog boxes.

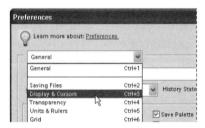

Figure i.2 Move from one Preference dialog box to the next by choosing different options from the drop-down menu.

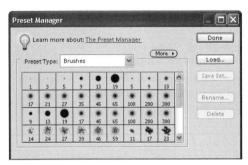

Figure i.3 The Preset Manager allows you to load custom brushes, color swatches, gradients, and patterns.

About presets

Presets are collections of brush styles, swatch colors, gradient fills, and patterns organized into sets, or *libraries* (**Figure i.3**). At any time during your work session, you can load different preset libraries using either the Preset Manager, or the palette menus on the options bar or Swatches palette.

About plug-ins

Photoshop Elements makes great use of Adobe's extendable plug-ins format. Plug-in modules are little software programs that add functionality to the main application. For instance, the different filters and effects that you access from Photoshop Elements' Filter menu are all plug-in modules. Plug-ins are stored inside a Plug-ins folder, where additional plug-ins can be added at any time.

Plug-ins are worth special mention because you aren't limited to just those included with Photoshop Elements. In cooperation with Adobe, developers of both software and hardware have created compatible plug-ins that install and run seamlessly with Photoshop . Elements. If you've recently purchased a digital camera or scanner, its browser or scanning software may very well include plug-ins to help the devices communicate with Photoshop Elements.

Downloading Plug-ins

To download additional plug-ins from Adobe, first make sure your computer is connected to the Internet. In Photoshop Elements, choose Help > Photoshop Elements Online to view an updated collection of plug-ins and other downloads available for purchase.

How to Use This Book

This Visual QuickStart Guide, like others in the series, is a task-based reference. Each chapter focuses on a specific area of the application and presents it in a series of concise, illustrated steps. I encourage you to follow along using your own images. I believe the best way to learn is by doing, and this Visual QuickStart Guide is the perfect vehicle for that style of learning.

This book is meant to be a reference work. and although it's not expected that you'll read through it in sequence from front to back, I've made an attempt to order the chapters in a logical fashion. The first couple of chapters take you on a tour of the work area and provide a foundation for the basics of image editing and creation. From there you explore color, selections, layers, effects, painting, and typography, and then learn a variety of techniques for saving and printing images, including special formatting options for distributing images over the Web. I've also included a chapter with a collection of advanced techniques and projects, organized as short tutorials that I hope will provide further creative inspiration as you work with your own images. This book is suitable for the beginner just starting in digital photography and image creation, as well as hobbyists, photo enthusiasts, intermediate-level photographers, illustrators, and designers.

Keyboard shortcuts

Many of the commands that you access from Photoshop Elements' menu bar have a keyboard equivalent (or shortcut) that appears beside each command name in the menu. Keyboard shortcuts are great time-savers and prevent you from having to constantly refocus your energy and attention as you jump from image window to menu bar and back again. When this book introduces a command, the keyboard shortcut is also listed. For example, the keyboard shortcut for the Copy command is displayed as (Ctrl+C). You'll find a complete list of Photoshop Elements' keyboard shortcuts in the appendices.

1

THE BASICS

Before you start working in Photoshop Elements, take a look around the work area to familiarize yourself with the program's tools and menus. When you first launch Photoshop Elements, you immediately see the Welcome screen, which allows you to quickly open and create new files or download images from a digital camera or scanner. The work area includes the document window, where you'll view your images, along with many of the tools, menus, and palettes you'll use as you get better acquainted with the program.

This chapter presents a quick tour of the palettes and menus you'll use when you first create or open a new file in Photoshop Elements. You'll learn more about how to use these tools in subsequent chapters of this book.

Understanding the Work Area

The Photoshop Elements work area is designed to make the tools easy to find and use. Just as with a well-organized workbench, the menus, palettes, and tools are intuitively arranged in a way that makes them easy to find where and when you need them.

The Welcome screen

When you first start Photoshop Elements, the Welcome screen automatically appears on your desktop (Figure 1.1). Think of the Welcome screen as a handy launching pad for creating projects from scratch, opening photos to edit and enhance, or acquiring images from a digital camera or scanner. The Welcome screen includes additional buttons to help you navigate to the Quick Fix dialog box, as well as to a couple of other environments: Photo Creations and the Photoshop Elements Organizer (Figure 1.2). Additionally, the Welcome screen includes a Tutorial button, which along with your Internet connection, gives you access to helpful tips and tutorials straight from the Adobe Photoshop Elements Web site.

✓ Tip

■ The Welcome screen features a small pop-up menu in the lower-left corner that you can use to control how Photoshop Elements will launch (**Figure 1.3**). From the pop-up menu, select Welcome Screen (the default), Editor, or Organizer. The next time you start Photoshop Elements, it will automatically open in the environment you selected.

Figure 1.1 The Photoshop Elements Welcome screen provides a simple and fast way to open, create, and import files.

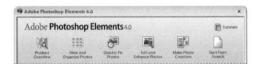

Figure 1.2 The Welcome screen features links to the Quick Fix dialog box, as well as the Organizer and Photo Creations environments.

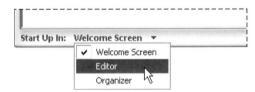

Figure 1.3 A pop-up menu on the Welcome screen allows you to control how Photoshop Elements opens.

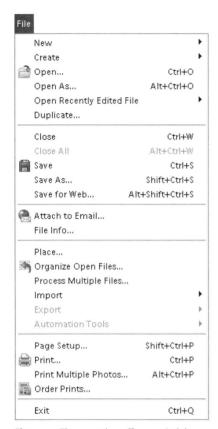

Figure 1.4 The menu bar offers myriad dropdown menus, with commands you choose to help perform tasks.

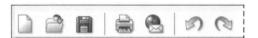

Figure 1.5 The shortcuts bar gives you easy access to some of Photoshop Elements' most common tasks, such as creating, browsing, and printing files.

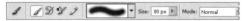

Figure 1.6 The options bar changes its display depending on the tool you select in the toolbox.

Menus, tools, and palettes

The Photoshop Elements work area may look familiar if you've used other Adobe products. Adobe has worked hard to maintain a consistent interface across its software product lines—so if you've ever used Adobe Photoshop, you'll be pleased to know that you don't have to learn your way around a whole new program. Photoshop Elements retains much of the look and feel of its bigger, more powerful cousin.

The **menu bar** offers drop-down menus for performing common tasks, editing images, and organizing your work area. Each menu is organized by topic. For example, the File menu offers commands for opening, importing, saving, and batch processing your images (**Figure 1.4**).

The **shortcuts bar** (**Figure 1.5**) displays buttons for performing routine Photoshop Elements commands, such as creating, browsing, and printing files. You can perform these same tasks by navigating through the menus, but the shortcuts bar offers easier access to many of the most common file management tasks.

The **options bar**, located right below the shortcuts bar, provides unique settings and options for each tool in the toolbox. For instance, when you're using the Marquee selection tool, you can choose to add to or subtract from the current selection; and when you're using a Brush tool, you can adjust settings like brush size and opacity (**Figure 1.6**).

The **toolbox** may be the single most important component of the work area. It contains most of the tools you'll use for selecting, moving, cropping, retouching, and enhancing your images. The tools are arranged in the general order you'll be using them, with the most commonly used selection tools near the top, down to the painting, drawing,

and color correction tools toward the bottom. The toolbar is docked on the left edge of the work area where the tools are displayed in a single, long column. If you prefer, the toolbar can be pulled a short distance from the left edge, where it will display the tools in Adobe's more common, two-column format (**Figure 1.7**).

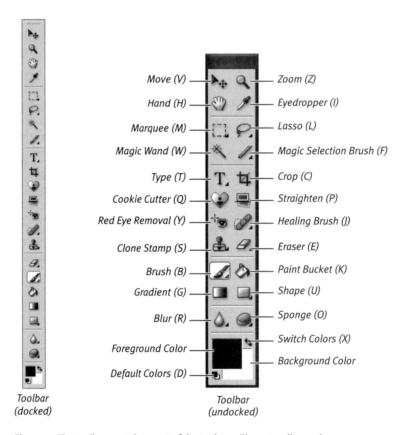

Figure 1.7 The toolbox contains most of the tools you'll use to edit your images.

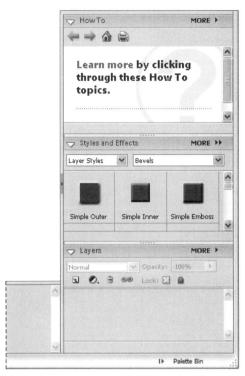

Figure 1.8 Palettes can be used from within the palette bin (as shown) or moved to your work area.

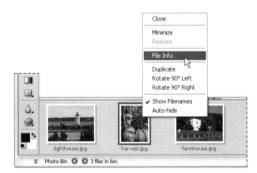

Figure 1.9 The photo bin is a holding area where you can store and retrieve all of your open images.

The **Palette Bin**, located on the right side of the desktop, contains the How To, Styles and Effects, and Layers palettes (**Figure 1.8**). Any of the other five palettes can also be stored in the palette bin, though by default they appear in the main work area when you open them from the Window menu.

You can work with palettes from within the palette bin or you can drag them to the main work area. Palettes can also be grouped together or docked to one another, depending on your individual working and organizational style.

The **photo bin**, located at the bottom of the desktop, serves as a convenient holding area for all of your open images. In addition to providing a visual reference for any open image files, you can even perform a couple of basic editing functions. Click to select any photo thumbnail in the photo bin, and right-click to display a pop-up menu. From the thumbnail menu you can get file information, hide or close the file, and even rotate it in 90-degree increments (**Figure 1.9**).

Opening and Closing Files

Before you can do any image editing in Photoshop Elements, you need to find and open your photo files. You can open files using either the Open command on the File menu, or the Open file shortcut on the shortcuts bar. Both of these Open options will display the Open dialog box. The Open dialog box includes features for limiting your search to specific file formats and displaying an image preview.

Photoshop Elements also offers a third option for opening your files. The Photo Browser is the core component of Photoshop Elements Organizer environment. It's a powerful and helpful tool and is covered in depth in Chapter 13, "The Windows Photo Organizer."

To open a file from the Open dialog box:

- **1.** To find and open a file, *do one of the following*:
 - ▲ From the File menu, choose Open (**Figure 1.10**), or press Ctrl+O.
 - ▲ On the shortcuts bar, click the Open icon (**Figure 1.11**).

The Open dialog box appears (**Figure 1.12**).

- Browse to the folder that contains your images (Figure 1.13).
- **3.** To open the file you want, *do one of the following*:
 - ▲ Double-click the filename.
 - ▲ Select the filename and click the Open button.

The image will open in its own document window.

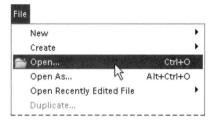

Figure 1.10 Choose File > Open to open an image file.

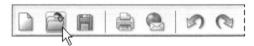

Figure 1.11 You can also open a file by clicking the Open icon on the shortcuts bar.

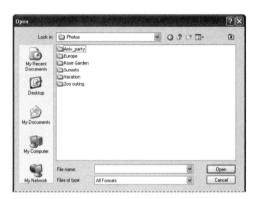

Figure 1.12 The Open dialog box lets you browse for specific file types.

Figure 1.13 Browse to navigate to any folder or file.

Figure 1.14 Click the close button in the upper-right corner of the title bar.

Figure 1.15 From the File menu, choose Close.

To close a file:

Do one of the following:

- Click the close button on the title bar for the active window (Figure 1.14).
- ◆ From the File menu, choose Close (**Figure 1.15**), or press Ctrl+W.
- ◆ To close all open files at once, from the File menu, choose Close All, or press Alt+Ctrl+W.

✓ Tip

■ If your document contains unsaved changes, Photoshop Elements asks you if you'd like to save those changes. Read on for more information on saving files.

Saving Files

As you work on an image, it's good practice to periodically save the file to your hard drive. When you save a file, you can choose from a number of file formats. (For detailed information on the file formats you can choose, see Chapter 11, "Saving and Printing Images.")

If you're interested in posting your photos to the Web, you can choose the Save for Web option. Saving your images for the Web involves its own set of unique operations; these are covered in detail in Chapter 10, "Preparing Images for the Web."

To save a file:

 From the File menu, choose Save, or press Ctrl+S.

To save a file in a new format or to a specific location:

- From the File menu, choose Save As, or press Shift+Ctrl+S.
 The Save As dialog box appears (Figure 1.16).
- **2.** Choose a destination for the file by browsing to a location using the Save In drop-down menu.
- **3.** In the File name text box, type a name for the file.
- **4.** From the Format drop-down menu, choose a format from the list of options (**Figure 1.17**).

Photoshop Elements automatically chooses a format based on the image file's original format. (For instance, most photos you import from your digital camera will be formatted as JPEGs and will default to the JPEG format when you choose Save As.)

Figure 1.16 The Save As dialog box.

Figure 1.17 If the default format is not what you need, you can choose a different file format.

- If you're not sure which format to use, choose either the native Photoshop format (PSD), which is the best all-purpose format, or the JPEG format, which works especially well with digital photos. When saving an image as a JPEG file, choose the highest quality setting possible.
- 5. If you want to be sure not to alter your original file, select the As a Copy option. Choosing As a Copy creates and saves a duplicate file, which becomes the working file open on your desktop. This selection protects your original file from changes as you edit the duplicate file.
- **6.** To include color profile information, make sure the Color box is selected. You can assign a color profile to an image to control how colors are reproduced on specific printers or displayed on computer monitors. At this point, you don't need to be concerned with setting color profiles. For more information on managing color in your images, see Chapter 3, "Changing and Adjusting Colors."
- **7.** When you've finished entering your settings, click Save.

✓ Tips

■ Saving using the As a Copy option is a good idea if you're experimenting with various changes and want to ensure that you keep your original version intact. It's also handy if you want to save an image in more than one file format, which is useful if you want to save a high-quality copy for printing and keep a smaller-sized file for emailing to friends.

■ Photoshop Elements allows you to customize your Save settings. From the Edit menu, choose Preferences > Saving Files. In the Saving Files dialog box you can control how file extensions are displayed, choose whether to include image previews with your saved files—image previews are small thumbnail images that appear in the Open dialog box when you select a file—and determine in which circumstances you would like to be prompted with the Save As dialog box.

Selecting Tools

The toolbox contains all of the tools you need for creating and editing images. You can use them to make selections, paint, draw, and easily perform sophisticated photo-retouch operations. To view information about a tool, rest the pointer over it until a tool tip appears showing the name and keyboard shortcut (if any) for that tool (**Figure 1.18**).

To use a tool, you must first select it from the toolbox. Some tools have additional tools hidden beneath them, as indicated by a small triangle at the lower right of the tool icon (**Figure 1.19**).

To select a tool from the toolbox:

Click the tool icon in the toolbox.
 When you move your pointer into the document window, the pointer changes appearance to reflect the tool you have selected (Figure 1.20).

To select a hidden tool:

- On any tool that displays a small triangle, either click and hold down the mouse button, or right-click the tool icon.
 A menu of the hidden tools appears (Figure 1.21).
- **2.** Click to select the tool you want to use.

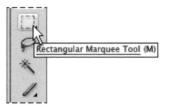

Figure 1.18 Hover the pointer over any tool icon to see a tip that displays the tool's name and keyboard shortcut.

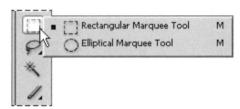

Figure 1.19 A small triangle next to a tool icon indicates additional tools. Right-click to see a menu of these hidden tools.

Figure 1.20 When the Rectangular Marquee tool is selected, the pointer changes to crosshairs as it moves over the document window.

Figure 1.21 Click and hold down the mouse button to view hidden tools.

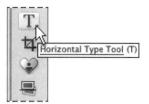

Figure 1.22 Tool tips display the keyboard shortcut for each tool.

✓ Tips

- Once you've familiarized yourself with the toolbox, it's even easier to use keyboard shortcuts to access tools. Shortcuts are displayed in tool tips, on the printed Quick Reference card included in the product box, and in the online help. For example, if you look at the tool tip for the Type tool, you'll see the letter T in parentheses (Figure 1.22). That's the keyboard shortcut for the Type tool. If you press T on your keyboard, even when another tool is selected, the Type tool becomes the active tool. (Note that when you press a letter to select a tool with a hidden tool group, Photoshop Elements selects the tool from the group that was used most recently.)
- To cycle through hidden tools, repeatedly press the tool's shortcut key. Each tool option will be displayed in turn.

Using the Options and Shortcuts Bars

Think of the options bar as a natural extension of the toolbox. After you select a tool, you can adjust its settings from the options bar. The buttons on the options bar change depending on the tool selected. If you're using the Brush tool, for example, you can use the options bar to select a brush size and opacity setting. The options bar also displays all of the hidden tools for any given tool, and allows you to select those hidden tools without having to return to the toolbox.

The shortcuts bar gives you easy access to some of the most frequently used menu commands. Instead of navigating through the File menu to open, save, or print your image, you can accomplish the same tasks with a single click on the shortcuts bar. Two of the handiest shortcuts are the arrows that allow you to step backward (undo) or forward (redo), to cancel or restore each change you make to an image file.

To use the options bar:

- **1.** From the toolbox, select a tool.
- View the options bar to see the available options for that tool (Figure 1.23).
 Click through the tools to see the options for each tool.

To use the shortcuts bar:

 On the shortcuts bar, click the icon for the desired command (Figure 1.24).
 The command is launched, just as if you'd chosen it from the menu bar.

✓ Tip

■ The shortcuts bar also includes icons to launch the Organizer and Creation workspace environments (**Figure 1.25**).

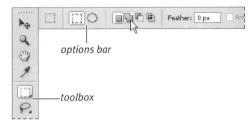

Figure 1.23 Use the options bar to customize the tool you've selected.

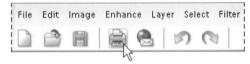

Figure 1.24 The shortcuts bar provides easier access to common commands than does the menu bar.

Figure 1.25 The shortcuts bar includes links to the Organizer and Creation workspaces.

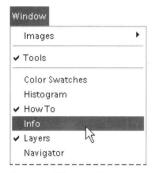

Figure 1.26 You can show or hide any palette from the Window menu.

Figure 1.27 To close a palette, you can click the close icon on the title bar.

Figure 1.28 To move a palette from the bin, just drag the tab to place the palette anywhere on your desktop.

Working with Palettes

Although Photoshop Elements opens with just three palettes displayed in its palette bin, a total of eight palettes are available from the Window menu. Each palette can be used entirely on its own or can be combined with other palettes to help to organize and streamline your workflow. All of the palettes feature handy drop-down menus that allow you to perform additional tasks or customize palette options.

To display a palette:

 From the Window menu, choose any palette to display it in your work area (Figure 1.26).

To close a palette:

Do one of the following:

- If the palette is open in your work area (outside the palette bin), click the close box on the palette title bar (Figure 1.27).
 If the palette is inside the palette bin, you need to first move it into the work area, and then click its close box.
- From the Window menu, choose any open palette; open palettes are indicated by a check mark.

To move a palette out of the palette bin:

- **1.** Click the tab of the palette that you want to move from the palette bin.
- Drag the tab until the palette is in the desired location in your work area (Figure 1.28).

The palette is now a floating palette on the desktop.

To return a palette to the palette bin:

Do one of the following:

- Click the palette tab, and drag the palette back into the palette bin.
- From any palette's More menu, choose Place in Palette Bin when Closed, and then click the palette's close box (Figure 1.29).

✓ Tips

- When Place in Palette Bin when Closed is selected for a particular palette, it will always return to the palette bin when closed. If you don't want a palette to return to the palette bin, choose the Place in Palette Bin option again to deselect it.
- The How To, Styles and Effects, and Layers palettes all have the Place in Palette Bin option selected by default.

To group palettes:

- **1.** Make sure you can see the tabs of all of the palettes you want to group. At least one of the palettes (the target palette) must be outside the palette bin.
- 2. Drag a palette tab into the window of the target palette (Figure 1.30).
 A thick line appears around the window of the target palette to let you know that the palettes have been grouped.
 To ungroup a palette, simply select the palette's tab and drag it out of the palette group.

✓ Tip

■ If, from the Window menu, you choose to close a single palette residing in a palette group, the entire palette group will close.

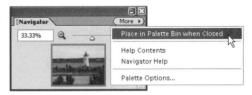

Figure 1.29 You can choose to have any palette automatically return to the palette bin by selecting the command on its More menu.

Figure 1.30 Drag a palette tab into another open palette to form a palette group.

Figure 1.31 Docking one palette below another helps avoid clutter on your desktop.

Figure 1.32 When a palette is inside the bin (left), the More button looks a little different than when the same palette is located outside the bin (right).

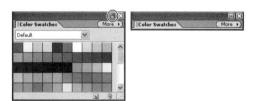

Figure 1.33 Click the minimize/maximize box to collapse a palette group.

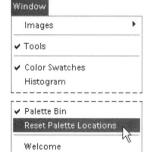

Figure 1.34
You can always
reset the palettes to
restore them to their
default locations.

To dock palettes:

• Drag any palette's tab to the bottom of any palette outside the palette bin. You must drag the palette by its tab (not its title bar) to successfully dock it to another palette. A double line appears at the bottom of the target palette to let you know that the palettes have been docked (Figure 1.31).

To undock a palette, select one palette's tab and drag it away from the other palette.

To use palette menus:

 Click the More button in the upper-right corner of any palette.
 The More button will look a little differ-

The More button will look a little different, depending on whether a palette is located inside or outside the palette bin (**Figure 1.32**).

✓ Tip

■ To collapse a stand-alone palette or a palette group, click the minimize/maximize box, or double-click the palette tab or title bar (**Figure 1.33**).

To return palettes to their default positions:

 From the Window menu, choose Reset Palette Locations (Figure 1.34).

Using the Zoom Tool

You can magnify and reduce your view by using the Zoom tool, which you can access either from the toolbox or by using keyboard shortcuts. Since you'll often want to zoom in and out while using another tool, you'll find the shortcuts quite helpful, so you should become familiar with them. The current level of magnification is shown in the document status bar and, when the Zoom tool is selected, in the options bar above the document window. In the options bar you can adjust the magnification either with the Zoom slider or by entering a value in the Zoom text box (**Figure 1.35**).

To zoom in:

 In the toolbox select the Zoom tool (Figure 1.36), or press Z on the keyboard.

The pointer changes to a magnifying glass when you move it into the document window.

- 2. Be sure that a plus sign appears in the center of the magnifying glass. If you see a minus sign, click the Zoom In button on the options bar (**Figure 1.37**).
- **3.** Click the area of the image that you want to magnify.

With a starting magnification of 100 percent, each click with the Zoom In tool increases the magnification in 100 percent increments up to 800 percent. From there, the magnification levels jump to 1200 percent, and then finally to 1600 percent.

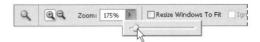

Figure 1.35 When the Zoom tool is selected, you can adjust the magnification level from a slider on the options bar.

Figure 1.36
The Zoom tool.

Figure 1.37 To zoom in on an image, check that the Zoom In button is selected on the options bar.

Figure 1.38 To zoom out on an image, check that the Zoom Out button is selected on the options bar.

Figure 1.39 Drag with the Zoom tool to zoom in on a specific area of an image.

To zoom out:

- **1.** In the toolbox, select the Zoom tool, or press Z on the keyboard.
- 2. Click the Zoom Out button on the options bar, then click in the area of the image that you want to zoom out from (**Figure 1.38**).

With a starting magnification of 100 percent, each click with the Zoom Out tool reduces the magnification as follows: 66.7 percent; 50 percent; 33.3 percent; 25 percent; 16.7 percent; and so on, down to 0.167 percent.

✓ Tip

■ You can also change the magnification level of an image from the zoom-percentage text box in the lower-left corner of the document window. Double-click in the text box to select the zoom value, and then type in the new value.

To zoom in on a specific area:

- 1. In the toolbox, select the Zoom tool; if necessary, click the Zoom In button on the options bar to display the Zoom tool with a plus sign.
- 2. Drag over the area of the image that you want to zoom in on.
 - A selection marquee appears around the selected area. When you release the mouse button, the selected area is magnified and centered in the image window (**Figure 1.39**).
- 3. To move the view to a different area of the image, hold down the spacebar until the hand pointer appears. Then drag to reveal the area that you want to see. For more information on navigating through the document window, see "Moving Around in an Image" later in this chapter.

To display an image at 100 percent:

To display an image at 100 percent (also referred to as displaying actual pixels), do one of the following:

- In the toolbox, double-click the Zoom tool.
- In the toolbox, select either the Zoom or Hand tool, and then click Actual Pixels on the options bar (Figure 1.40).
- From the View menu, choose Actual Pixels, or press Alt+Ctrl+0 (Figure 1.41).
- Enter 100 in the Zoom text box in the options bar, and then press Enter.
- Enter 100 in the status bar at the bottom of the document window, and then press Enter (Figure 1.42).

✓ Tips

- With any other tool selected in the toolbar, you can toggle to the Zoom tool.
 Hold down Ctrl+spacebar to zoom in or Alt+ spacebar to zoom out.
- To change the magnification of the entire image, press Ctrl++ (Control and the plus sign) to zoom in or Ctrl+- (Control and the minus sign) to zoom out.
- Toggle the Zoom tool between zoom in and zoom out by holding down the Alt key before you click.
- You can automatically resize the document window to fit the image (as much as possible) when zooming in or out.

 With the Zoom tool selected, click the Resize Windows to Fit check box on the options bar. To maintain a constant window size, deselect the Resize Windows to Fit option.

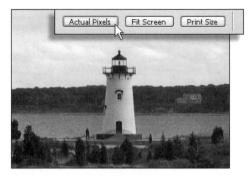

Figure 1.40 Clicking the Actual Pixels button on the options bar returns the image view to 100 percent.

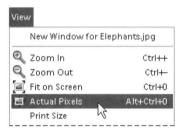

Figure 1.41 You can also choose Actual Pixels from the View menu.

Figure 1.42 You can type a specific view percentage in the status bar at the bottom of the document window.

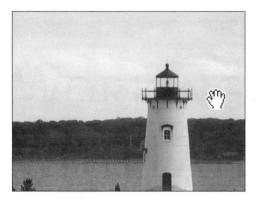

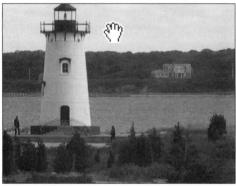

Figure 1.43 Drag with the Hand tool to view a different area of the same image.

Figure 1.44 Click the arrows or drag the scroll bars to move around an image.

Moving Around in an Image

When working in Photoshop Elements, you'll often want to move your image around to make a different area visible in the document window. This can happen when you're zoomed in on one part of an image or when an image is just too large to be completely visible within the document window. Luckily, Photoshop Elements offers you multiple features for adjusting the viewing area. Two of the most common are the Hand tool and the Navigator palette. (For more information on how to manage views, see Chapter 2, "Creating and Managing Images.")

To view a different area of an image:

Do one of the following:

- From the toolbox, select the Hand tool and drag to move the image around in the document window (Figure 1.43).
- Use the scroll arrows at the bottom and right side of the document window to scroll to the left or right and up or down.
 You can also drag the scroll bars to adjust the view (Figure 1.44).

Tip

 With any other tool selected in the toolbar, you can press the spacebar to give you temporary access to the Hand tool.

To change the view using the Navigator palette:

- **1.** Choose Window > Navigator to open the Navigator palette.
- Drag the view box in the image thumbnail (Figure 1.45).
 The view in the document window changes accordingly.

✓ Tip

■ You can drag the slider bar at the bottom of the Navigator palette to adjust the level of magnification in the document window.

Figure 1.45 As you move the view box on the Navigator palette, the image view in the document window changes to match.

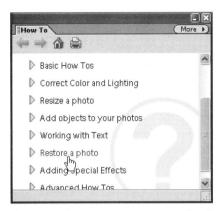

Figure 1.46 Choose a category to open a list of How To activities.

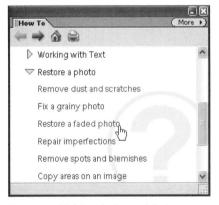

Figure 1.47 Click to select an activity to open its step-by-step instructions.

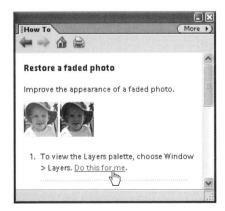

Figure 1.48 *Do this for me* actions complete certain steps for you.

Selecting Activities from the How To Palette

The How To palette provides step-by-step instructions (activities) for many commonly performed Photoshop Elements tasks, such as adding a drop shadow to text or removing red-eye from a photograph. Most activities also feature a *Do this for me* action with certain steps. When you click *Do this for me*, Photoshop Elements will perform that step for you.

To use the How To palette:

- **1.** From the How To palette menu, choose a category (**Figure 1.46**).
- **2.** Select an activity from the category list that appears (**Figure 1.47**).
- **3.** Follow the step-by-step instructions. If a step includes a *Do this for me* action, click it, and Photoshop Elements will complete that step for you (**Figure 1.48**).

Using the Help System

Photoshop Elements includes a comprehensive help system containing the complete text of the *Photoshop Elements User Guide*, keyboard shortcuts, and links to the same tasks available in the How To palette. Although the help system uses a Web browser for viewing, you don't need a live Internet connection to use the help system. All of the help files are automatically installed on your hard drive during the Photoshop Elements installation process.

Photoshop Elements also includes a search field located on the shortcuts bar. If you have a question, type it into the text field, and Photoshop Elements will search through both the Help contents and How To tasks to find all of the appropriate links in the help system. There's even a glossary that includes an extensive list of terms you're likely to run across while working on your images.

To use the help system:

 From the Help menu, choose Photoshop Elements Help (Figure 1.49), or press F1.
 The Photoshop Elements help system opens in your browser (Figure 1.50).

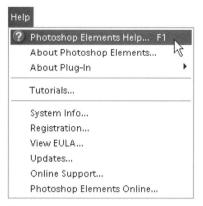

Figure 1.49 The Help menu includes links to the help system, a glossary, and tutorials.

Figure 1.50 If you need assistance with a task in Photoshop Elements or want more information about a feature, use the built-in help system.

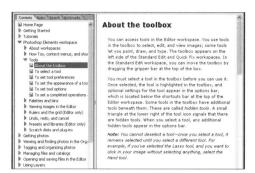

Figure 1.51 From the Contents tab, navigate to a topic you want help on.

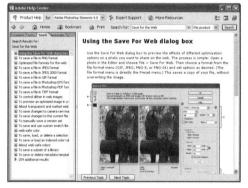

Figure 1.52 You can search for a specific topic using the text box at the top of the Help window.

Figure 1.53 You can also type a topic in the Search field located on the shortcuts bar.

- **2.** To find information, *do one of the following*:
 - ▲ On the Contents tab, click the arrow next to either the How To or Help Topics heads to view a list of tasks or topic heads. Click the arrow next to any topic head, and then click a topic in the list to view it in the main Help area (**Figure 1.51**).
 - ▲ On the Index tab, click the arrow next to any letter to view an alphabetized list of help topics, and then click a topic to view it in the main help area.
 - ▲ In the text box at the top of the Help window, enter a topic and click the Search button. A list of search results appears in the topic column on the left side of the Help window, and a selected topic appears in the main Help area (**Figure 1.52**).

To search for help using the shortcuts bar:

- **1.** Type a topic in the Search field on the shortcuts bar, then click the Search button (**Figure 1.53**).
 - Photoshop Elements finds all topics that include the word or words you entered.
- **2.** A list of search results appears in the topic column on the left side of the Help window, and a selected topic appears in the main Help area.

CREATING AND MANAGING IMAGES

One of the first tasks you'll do in Photoshop Elements is set up your image. This involves creating a new file (or importing a photo or image from a digital camera, camcorder, or scanner), setting its dimensions and size, and arranging it on your desktop in a way that works best for you. Photoshop Elements might seem a little overwhelming at first, presenting you with so many settings choices as you begin working on an image. But a basic understanding of the principles of resolution and print size will prove helpful in the long run.

This chapter shows you how to get your images into Photoshop Elements, and offers some basic guidelines on adjusting image size and resolution, depending on whether you want to print, email, or post to the Web. You'll also learn the different methods for viewing additional information about your images.

Understanding Resolution and Image Size

Resolution and image size are frequently used and often misunderstood terms.

Resolution simply refers to the number of physical *pixels*, or picture elements—tiny, square, building blocks—that are packed into a digital image.

Image size refers to both the print size and resolution of an image. Depending on whether you want to print a photograph, post it on a Web page, or email it to a friend, you'll need to adjust its image size and resolution accordingly.

This section explains the important relationship between image resolution and image size, and how to control these options to get the results you want.

Pixel basics

Everything you do in Photoshop Elements involves controlling and changing pixels. Pixels make up your entire image and are typically not visible as individual elements until you zoom in on your picture (**Figure 2.1**). In fact, Photoshop Elements may even have derived its name at least in part from these small but powerful image structures.

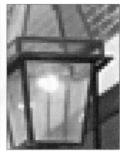

Figure 2.1 Pixels become more visible as you increase the magnification of your image.

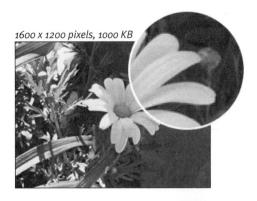

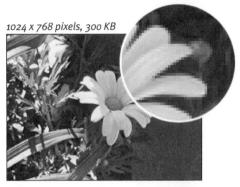

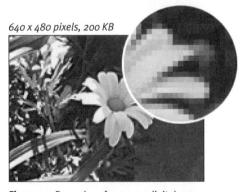

Figure 2.2 Examples of common digital camera resolutions and associated file sizes, all viewed at 100% (also referred to as actual pixels). Higher-resolution images, like the photo on top, provide a sharp, clear picture that's excellent for printing. Lower-resolution images, like the middle and bottom photos, lack sufficient pixel information for printing purposes, but work fine for posting on the Web or emailing to friends.

As you work in Photoshop Elements, you'll find that you need to adjust the size of your images for different projects. If you want to email a photo to a friend, you'll need a small file size for easy delivery—so you'll want to create a low-resolution image, which means it contains a smaller number of pixels. If you're planning to print high-quality images on your ink-jet printer, you'll want to maintain as high a resolution as your printer can handle (meaning a greater density of pixels) to ensure a crisp, clear print.

Images are often described using pixels as the unit of measure. For example, a common setting for many digital cameras is 1600×1200 pixels (the x is pronounced "by," just as in "3 x 5 photo"). Multiplying 1600 times 1200 gives you the total number of pixels in the image, which in this case is 1.92 million pixels.

Digital cameras often include preset resolution modes. These settings determine both the physical dimensions and file size of the image (**Figure 2.2**).

Displaying and printing images

Any discussion of resolution and output can be confusing, so you need to keep a few basic details in mind. Image resolution is described in *pixels* per inch, or *ppi*. When you print your file, the printer resolution setting is usually described in *dots* per inch, or *dpi*.

The ideal amount of detail and level of resolution depend on how you intend to use an image. If you're going to display your photos on the Web, keep in mind that large files take forever to download and view, so you'll want to choose a lower resolution like 72 ppi (72 ppi is the most common image resolution for monitor displays).

Three factors affect the way that an image is displayed on a computer monitor: the number of pixels in the image, the screen resolution, and the screen size (Figure 2.3). The size of each pixel is determined by the resolution and size of the monitor. For example, a 17-inch monitor set to a resolution of 1024 x 768 pixels would have 82 pixels per inch (Figure 2.4). The same monitor set to a resolution of 800 x 600 would have fewer pixels per inch, so each pixel takes up more screen space (Figure 2.5). If you change your monitor resolution to a lower resolution setting, the images and icons appear larger on your screen. It takes fewer pixels to fill the monitor, so the size of each pixel appears larger.

Print resolution is usually described by the number of dots per inch a printer is capable of printing. If you want to print a high-quality flyer or photo, you may want to use an image resolution as high as 300 pixels per inch, so that a maximum amount of image information is sent to the printer. Fortunately, a wide range of image resolutions are available that work well for different types of situations, and Photoshop Elements includes some automatic functions (such as the Save for Web command) that take the guesswork out of the process.

20-inch monitor at 1280 x 1024 resolution

Figure 2.3 The display of an onscreen image is based on the resolution of the image, the size of the monitor, and the monitor resolution.

Figure 2.4 A monitor set to 1024 x 768 is a much more common setting, and allows program menus to be seen more easily.

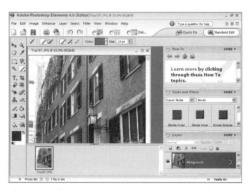

Figure 2.5 The same monitor set to 800 x 600 displays fewer pixels per inch, so less of the image appears on your screen.

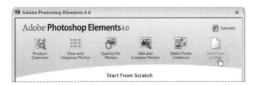

Figure 2.6 Click Start From Scratch on the Welcome screen to create a new image.

Figure 2.7 The New File icon on the shortcuts bar offers another quick way to get started with a new file.

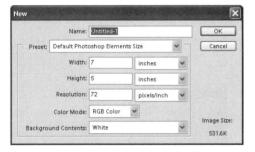

Figure 2.8 The New file dialog box lets you name your new image and set its dimensions, resolution, and color mode.

Creating a New Image

You have many alternatives for creating a new file. Whichever way you choose, you end up using the New Image dialog box to set up the basic dimensions, image resolution, and color mode. Creating a new file is like starting with a blank canvas. You can create your own work of art using Photoshop Elements' many painting and drawing tools, or you can assemble a collage of multiple images. But for now, we'll stick with the basics.

To create a new image:

- **1.** To create a new image, click Start From Scratch on the Welcome screen (**Figure 2.6**), or *do one of the following*:
 - ▲ From the File menu, select New > Blank File, or press Ctrl+N.
 - ▲ On the shortcuts bar, click the New File icon (**Figure 2.7**).

The New file dialog box appears, presenting you with options for changing size, resolution, and file type.

- 2. In the New file dialog box, enter a file name; then enter dimensions for the width and height (**Figure 2.8**).

 The default size is 7 x 5 inches, which works fine as a starting point. You can always change it later.
- 3. Set the resolution and color mode.

 By default, Photoshop Elements automatically chooses a preset resolution and color mode for you. If you want more information on color modes, see Chapter 3, "Changing and Adjusting Colors."

continues on next page

4. From the Background Contents drop-down menu, choose an option for the background layer of the image.

White is the default background option and creates a pure white background layer for the image. This option is just fine for most purposes.

Background Color fills the background with the current background color, making this setting useful if you're creating a Web graphic and want it to match the background color of your Web page.

Transparent makes the first layer transparent and results in an image with no background at all—a good choice if you're creating an image for the Web and want it to appear transparent on the page. For more information on Layers, see Chapter 5, "Working with Layers."

✓ Tip

■ Don't be intimidated by the sheer number of size, resolution, and transparency settings available when you first create a new image. All of these settings will be covered in more detail as you progress through the book. If you're brand new to Photoshop Elements, creating a new image can be as simple as pressing Ctrl+N and accepting the default settings.

Compact Storage Cards

Almost all digital cameras ship with some sort of *compact storage card*—it's a thin, plastic card that stores your camera's digital data. The most common variety is the CompactFlash card; other compact storage cards include SmartMedia, Secure Digital Card (SD), and the MultiMedia Card (MMC). Sony uses its own proprietary storage format called a Memory Stick.

As you snap photos, your digital camera's compact storage card acts as a holding space for all your images. When you delete (or transfer and then delete) images from your camera, that memory space is freed up on your storage card, giving you more room for additional photos.

Most digital cameras include a cable that connects your camera to your computer for easy photo transferring. An alternate way to get photos into your computer is via a *storage card reader*, which you connect via a USB cable. Once you've installed the card reader software on your computer, just insert your compact storage card into the card reader to import your photos from your camera to your computer with a minimum of fuss.

Importing Images from Cameras and Scanners

Digital cameras have revolutionized photography and are one of the main forces driving the need for products like Photoshop Elements. Over the past several years, prices have dropped and quality (as measured by higher resolution) has risen dramatically. Typically, these cameras come with their own software to help you browse and manage photos. You can download photos from the camera to your hard drive and then open them in Photoshop Elements, or you can access your camera from within Photoshop Elements and then download your images.

Photoshop Elements even lets you capture frames from digital videos, using the Frame From Video command. To capture video frames, you'll need to make sure your video is in a format that can be recognized. Supported Windows formats include .avi, .mpg, and .mpeg, and Macintosh formats include QuickTime and .mpeg.

Similar to digital cameras, scanners offer another way to get images into Photoshop Elements. They're ideal for getting family photos and other paper documents into the computer. As long as you can fit the image or object onto your flatbed scanner, you can scan almost anything: letters, buttons, fabric, leaves, or a page of clip art. You can also scan an image from within Elements, as long as your scanner's appropriate plug-in is located inside the Import/Export folder. This folder is inside the Plug-ins folder, which is located within the Photoshop Elements application folder on your hard drive.

To import images from a digital camera:

- Connect your digital camera to your computer using the instructions provided by the camera manufacturer.
 If the Adobe Photo Downloader launches automatically, skip to step 3. If you don't see the Adobe Downloader window, continue to step 2.
- 2. From the shortcuts bar, click the Photo Browser button to launch the Photoshop Elements Organizer (Figure 2.9).
 For more information on the Organizer see Chapter 13, "The Windows Photo Organizer."
- 3. From the Organizer shortcuts bar, click the Get Photos button. Then from the drop-down menu, choose From Camera or Card Reader (Figure 2.10).

 The Get Photos from Camera or Card Reader window (also called the Adobe Photo Downloader) will open.
- 4. From the Get Photos from drop-down menu, choose your camera (Figure 2.11). The Photo Downloader window is automatically populated with every image on your camera.
- Click the Browse button to assign a location where you would like your photos to be downloaded.
- 6. In the Browse For Folder window, click OK to accept the default location, or click Make New Folder to save to a different location (Figure 2.12).
 Then. click OK to return to the Photo

Downloader window.

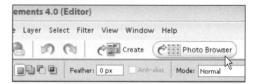

Figure 2.9 The Photo Browser button on the shortcuts bar launches the Photoshop Elements Organizer.

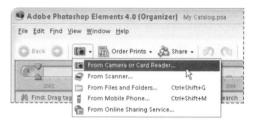

Figure 2.10 Choose From Camera or Card Reader if you want to download photos from your digital camera.

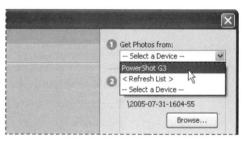

Figure 2.11 Your digital camera will appear in the Get Photos from menu list.

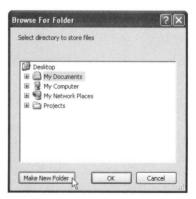

Figure 2.12 Use the Browse For Folder window to select the location where you would like to save your photos.

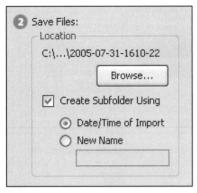

Figure 2.13 You can create and name a folder to store subsets of your photos directly in the Save Files area of the Photo Downloader window.

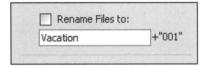

Figure 2.14 Photoshop Elements can automatically rename and number all of the images you download. In this example, the files will be named Vacationoo1, Vacationoo2, and so on.

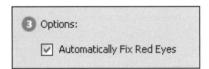

Figure 2.15 You can automatically fix red eye problems in your photos as they're downloaded from your camera.

- **7.** Leave the Create Subfolder Using check box selected, and select one of two options:
 - ▲ Date/Time of Import will automatically create a folder named with the current date and time.
 - ▲ New Name will create a folder with a name that you enter (**Figure 2.13**).

If you deselect the Create Subfolder Using check box, your photos will still be placed in the location (folder) you chose in step 5, they just won't be grouped together into their own subfolder.

- **8.** Click the Rename Files to check box, if you want your photos to be saved with more descriptive names than what your camera assigns (**Figure 2.14**).
 - For example, your camera's default naming scheme is probably something like "IMG_1031.JPG." With the Rename Files to option selected, you can name and number a set of photos "Vacation," for instance. Then your photos will automatically be saved and named "Vacation001.jpg," "Vacation002.jpg," and so on.
- Select the Automatically Fix Red Eyes check box to fix red eye problems in your photos as they're downloaded (Figure 2.15).

continues on next page

- Click to deselect the check box under any photos that you don't want to download.
 - By default, the Photo Downloader assumes that you want to download every image in your camera.
- **11.** Click the Get Photos button to download the selected images to your computer (**Figure 2.16**).

Once your images have been downloaded, a dialog box will appear asking if you'd like to delete the images from your camera. Click Yes or No. The dialog box closes and you proceed to the Organizer window.

Your downloaded photos will first appear in their own Organizer window. Click the Back to All Photos button to return to the main Organizer window (**Figure 2.17**).

✓ Tips

- If your camera software is not visible from the File > Import menu, check to make sure that your digital camera's plug-in is located in the Photoshop Elements Plug-ins folder.
- When shooting pictures with your digital camera, it's best to use the highest resolution possible. That way, you start out with a high-quality original file. You can always reduce the image resolution or file size later, if necessary, in Photoshop Elements.
- If you want to first deselect all of the photos in the Photo Downloader and then select only a few, press Ctrl+A to select all of the photos, then click in the check box of any single photo. All of the photos will be deselected at once. You can follow the same procedure to *select* all of the photos at once.

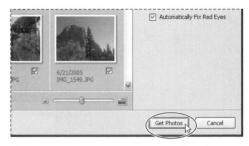

Figure 2.16 Once you've set location and naming options for your images, click Get Photos to download selected images from your camera.

Figure 2.17 When you download photos from your camera, they appear in their own Organizer window.

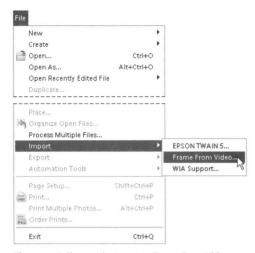

Figure 2.18 Choose the Import > Frame From Video command to convert movie footage into Photoshop Elements image files.

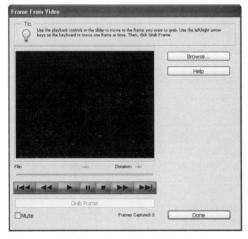

Figure 2.19 The Frame From Video dialog box lets you browse for and play movie files.

To capture frames from video footage:

 From the File menu, choose Import > Frame From Video (Figure 2.18).
 The Frame From Video dialog box appears (Figure 2.19).

continues on next page

- Click the Browse button to locate the file you want, and then click Open to see the video footage (Figure 2.20).
 The video clip appears in the Frame From Video dialog box (Figure 2.21).
- 3. To view your footage, click the Play button. When you see the frame you want, click the Grab Frame button.

 To grab the frame you want, you can also use the Pause button to stop the video at the desired frame. Another useful option is to simply move the slider to the correct frame in the video.
- 4. Grab as many video frames as you want, one by one, then click Done.
 As you click the Grab Frame button, you will see the images appear as Photoshop Elements files in your work area (Figure 2.22).
- **5.** Once you've captured the frames, you can save and edit them just like any other images.

✓ Tip

■ You'll likely have a greater variety of exposure problems with video frames than with the still shots you take with a digital camera. You can easily fix contrast and tonal problems with a few of Photoshop Elements' correction tools, which you'll explore more in Chapter 3 and in Chapter 6, "Fixing and Retouching Photos."

Figure 2.20 You can open any supported movie file format. Supported Windows formats include .avi, .mpg, and .mpeg.

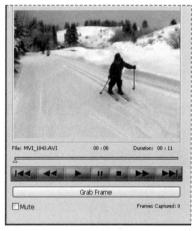

Figure 2.21 After you open a movie file, it appears in the Frame From Video dialog box, where you can play, pause, and grab movie frames.

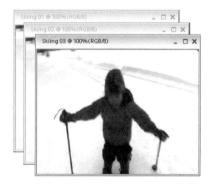

Figure 2.22 Captured frames automatically appear as Photoshop Elements images in your work area.

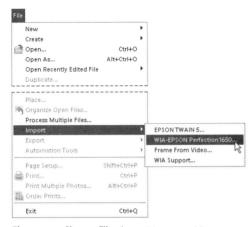

Figure 2.23 Choose File > Import to connect to your scanner.

Figure 2.24 Most scanning software allows you to choose a specific area of an image to crop to (left), so that your scan is already cropped when you open it in Photoshop Elements (right).

To scan an image into Photoshop Elements:

- Connect the scanner to your computer using the instructions provided by the scanner manufacturer.
- 2. From the File menu, choose Import.
- **3.** Select your scanner software from the menu list (**Figure 2.23**), and then follow your scanner's directions to complete the scan.
- **4.** Import and open the digital images within Photoshop Elements.

✓ Tips

- If you're planning to use only part of an image, you'll save a lot of time by using your scanning software to crop your image *before* importing it into Photoshop Elements (**Figure 2.24**).
- You can also access your scanner from the Get Photos button in the Photo Organizer.

Changing Image Size and Resolution

Pixel dimensions, image dimensions, and resolution are all adjusted using the Image Size dialog box. You will often capture one image and then use it for different purposes, so it's important to understand how these adjustments affect your image file.

For the Web and other onscreen viewing, it's common to adjust the pixel dimensions, or number of pixels, to control the resolution and/or file size of the image. This is known as resampling. The Resample Image check box is probably the most important feature to understand. When this box is checked, the pixel dimensions change—that is, the pixels will increase or decrease in number as the image is resampled (Figure 2.25). When the box is not checked, the pixel dimensions are locked in, and no resampling can occur. You can change the document size (the size the image will print), but the number of pixels in the image and the size that the image displays onscreen will stay the same.

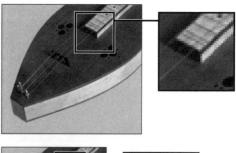

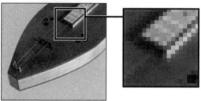

Figure 2.25 This image was duplicated (top) then reduced 70% (bottom). Notice in the zoom views that the reduced image isn't as detailed as the original. That's because, even though both have the same number of pixels per inch, the reduced image contains fewer pixels overall.

Recommended Resolutions

There are no absolute rules for the best resolution to use when scanning your images for the Web or for printing. The best approach is to try a couple of settings, using the following guidelines, and see what works well for your specific situation. Here are some typical situations and recommended resolution ranges:

- For onscreen viewing of Web images, 72 ppi is a standard and safe resolution.
- For color images printed on color ink-jet printers, a range of up to 150 ppi is often ideal. The
 exact resolution will depend on your printer and the type of paper on which you are printing.
- For color or high-resolution black and white images printed on photo printers, you'll want a resolution between 150 and 300 ppi.

If you want to create higher-quality professional projects, such as magazine or print design work, be aware that Photoshop Elements is not capable of producing CMYK files (the color-separated files used for high-end printing). If you need an image-editing program that can handle these kinds of jobs, you should consider buying the full version of Adobe Photoshop.

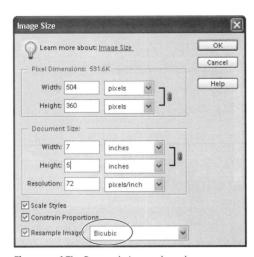

Figure 2.26 The Resample Image drop-down menu includes three primary options for specifying how the resampling occurs.

Figure 2.27 You can resample an image using one of three calculation methods: Bicubic (left), Bilinear (center), or Nearest Neighbor (right). Bicubic does the best job at retaining detail and anti-aliasing, whereas Nearest Neighbor creates images with a rougher quality.

To resize an image for onscreen viewing:

- From the Image menu, choose Resize > Image Size to open the Image Size dialog box.
- 2. Make sure the Resample Image box is checked (**Figure 2.26**), and choose an option from the Resample Image dropdown menu.

When you resample an image, its pixels are transformed using a process known as an *interpolation*. Interpolation is a computer calculation used to estimate unknown values based on existing known values—in this case, pixel color values. So, when you resample an image in Photoshop Elements, its existing pixels are changed using one of three primary interpolation methods (**Figure 2.27**):

Bicubic is the default option and generally produces the best results and smoothest gradations.

Bilinear produces medium-quality results. **Nearest-Neighbor** is the fastest method, but may produce jagged effects.

Two additional Bicubic options are also available: Bicubic Smoother and Bicubic Sharper. Bicubic Smoother can be used when you're increasing the size of an image, or *upsampling*. Typically, I strongly advise against using upsampling, because there is usually a noticeable loss of image quality and sharpness. But I've found that I can get acceptable results with the Bicubic Smoother interpolation, as long as I don't resize much above 120 percent. **Bicubic Sharper** can be used when you're reducing the size of an image, or downsampling. Its purpose is to help to retain sharpness and detail; although my success with this option has been mixed.

continues on next page

- To maintain the current width-to-height ratio, make sure Constrain Proportions is checked.
- 4. Enter new values in the Pixel Dimensions fields. You can enter values in pixels or as a percentage (Figure 2.28).

 If you choose percent, you can enter a percentage amount in either the Height or Width box to automatically scale the image to that percentage. The new file size for the image is displayed at the top of the dialog box (along with the old file size in parentheses).
- **5.** Click OK to complete the change. The image is resized larger or smaller, depending on the pixel dimensions or percentage you entered (**Figure 2.29**).

Figure 2.28 Pixel dimensions can be entered as pixels or as a percentage.

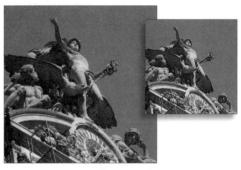

Figure 2.29 If you want to reduce an image's file size and display size, you can resize it by reducing its pixel dimensions, making it smaller for posting on the Web or emailing to friends.

Downsampling vs. Upsampling

In Photoshop Elements, changing the resolution and/or size of an image by adjusting the number of its pixels is known as *resampling*.

Downsampling, which is the term for decreasing resolution by *removing* pixels from your photo, is one of the easiest and most common ways to make your files smaller. If you take an 8 x 10 photograph of your grandmother and shrink it to a 4 x 5 image by reducing its pixel count, you've just downsampled it. Photoshop Elements "throws away" unneeded pixels intelligently, with little visible impact on the quality of your image.

But *upsampling*, which is the term for increasing resolution by *adding* new pixels to your photo, should be avoided whenever possible. If you take a 4 x 5 photograph and try to enlarge it to 8 x 10, Photoshop Elements has to add pixels to your photograph. Since it has to manufacture those pixels out of thin air, they tend to add a ghosted, fuzzy appearance to any hard edge—the overall effect is that your image can look out of focus.

Because downsampling rarely detracts from the quality of your images, you should capture all your original files at the highest resolution possible, whether you're scanning an image or snapping a digital photo.

✓ Tip

■ When you change an image's size by changing its pixel dimensions, you also change its print size (you'll see the change in the width and height dimensions in the Document Size fields of the Image Size dialog box). Although these images are acceptable for onscreen viewing or as quick test prints, you may be disappointed with their printed quality. That's because you discard image information by resampling, and so lose some sharpness and detail. If you're resizing an image mainly for print purposes, see the following topic, "To resize an image for print."

To resize an image for print:

- **1.** From the Image menu, choose Resize > Image Size.
- **2.** To maintain the current width-to-height ratio, check that the Constrain Proportions option is selected.
- 3. Uncheck the Resample Image box.
- **4.** Choose a unit of measure (or a percentage) and then enter new values for the width or height in the Document Size portion of the dialog box (Figure 2.30). In the Document Size portion of the dialog box, the resolution value will change accordingly. For instance, if you enter width and height values of half the original image size, the resolution value will double, and the image will print clearer and sharper. That's because you're compressing the same number of pixels into a smaller space. So, when scaled at 50 percent, an image 4 inches wide with a resolution of 150 pixels per inch (ppi) will print at 2 inches wide and at a resolution of 300 ppi.
- 5. Click OK to complete the change.

 The image's print size will be changed, but since it still contains the same number of pixels, it will appear to be unchanged on your screen. You can, however, view a preview of the final print size onscreen.
- **6.** From the View menu, choose Print Size. The image will be resized on your screen to approximate its final, printed size (**Figure 2.31**).
- 7. From the View menu, choose Actual Pixels, or press Alt+Ctrl+0 to return the display size on your screen to 100 percent.

Figure 2.30 Enter new width and height values to change an image's print size.

Figure 2.31 An image can be viewed at an approximation of its final print size, even when its resolution differs from the computer's display.

✓ Tip

If resizing gets really confusing and you want to return the dialog box to its original settings, press Alt to change the Cancel button to a Reset button. Then click Reset.

Figure 2.32 To view the Info palette, choose Window > Info.

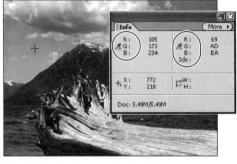

Figure 2.33 Any two sets of color information (RGB, HSB, Web Color, or Grayscale) can be viewed at one time.

Figure 2.34 Color mode displays can be changed at any time from pop-up lists in the Info palette.

Getting Information About Your Image

The Info palette displays measurement and color information as you move a tool over an image in the image window. In combination with the Eyedropper tool, you can use it to view the RGB (red/green/blue), Grayscale, and HSB (hue/saturation/brightness) values of your image. The Info palette is a handy tool if you want to sample and then enter specific color values in the Color Picker (covered in detail in Chapter 3). When an area is selected, this palette shows the position, angle of rotation, and scale, allowing you to control the precise placement and movement of selections.

In addition, you can customize the status bar at the bottom of the Info palette to display different file and image information.

To use the Info palette:

- From the Window menu, choose Info to open the Info palette (Figure 2.32).
 If you like, you can drag the Info palette into the Palette Bin.
- 2. Select the desired tool and then move the pointer over the image. Depending on the tool you are using, the following types of information appear:
 - ▲ The numeric values for the color beneath the pointer. You can view any two sets of color modes at the same time (**Figure 2.33**). Information for different color modes can be displayed at any time by clicking either of the eyedropper cursor buttons in the Info palette (**Figure 2.34**).

continues on next page

- ▲ The x and y coordinates of the pointer, and the starting x and y coordinates of a selection or layer, along with the change in distance as you move the pointer over your image (**Figure 2.35**).
- ▲ The width and height of a selection or shape and the values relating to transformations, such as the percentage of scale, angle of rotation, and skew (which distorts a selection along the horizontal or vertical axis) (Figure 2.36).

✓ Tip

■ It can be quicker to change units of measure using the Info palette rather than by using the Preferences menu. Simply click the XY cursor icon (it looks like a plus sign) at the lower left of the palette to choose from a list of measurement options.

Figure 2.35 The x and y coordinates of the pointer are shown in the Info palette.

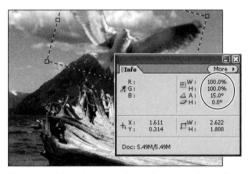

Figure 2.36 Any change in the scale or transformation of a selection or layer is visible in the Info palette.

Figure 2.37 Access Palette Options from the Info palette's More menu.

Figure 2.38 You can control what type of information will be displayed for color modes and for units of measurement.

Figure 2.39 The Info palette can display the status for up to seven different types of information, all at the same time.

To display different Info palette options:

- 1. Click the More button on the Info palette to open the palette menu, and then choose Palette Options (Figure 2.37).
- 2. Use the drop-down menus in the top three areas of the dialog box to change the color and unit options you would like the palette to display (Figure 2.38).
- **3.** In the Status Information area of the dialog box, click the check box next to the options that you would like the palette to display (**Figure 2.39**).

Here are descriptions of some of the most useful options:

Document Sizes displays information relating to the file's size. The first number represents the approximate size of the file if flattened (all layers combined into one) and saved. The second number represents the current file size, with layers.

Document Profile displays the color mode of the image.

Document Dimensions displays the width and height of the image.

Scratch Sizes displays the amount of memory needed to process the image. The first number represents the memory currently used to display all open images. The second number represents the total, available RAM. If you think you're running into memory problems and need to add RAM, viewing this information will help you evaluate the problem.

GETTING INFORMATION ABOUT YOUR IMAGE

Opening and Arranging Multiple Views

The image window is where your image appears in Photoshop Elements. You can open multiple windows with different images, or, if you prefer, you can open multiple views of the same image. This is a handy way to work on a detailed area of your image while viewing the full-sized version of the image at the same time. It's especially useful when you're doing touch-up work, such as correcting red eye or erasing a blemish in a photo.

To open multiple views of an image:

- **1.** From the View menu, choose New Window for *name of current file* (**Figure 2.40**).
- **2.** Drag the title bar to move the additional window(s) as necessary to view them simultaneously.

You can set different levels of magnification for each window to see both details and the big picture at the same time (**Figure 2.41**).

Figure 2.40 You can open multiple windows of the same image from the View menu.

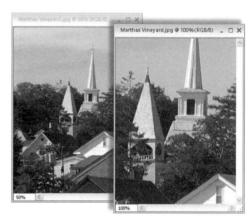

Figure 2.41 Multiple image views let you work on a detailed area while at the same time allowing you to see how the changes affect the overall image.

Figure 2.42 Cascading windows overlap from the upper left to the lower right. They allow you to keep multiple windows open at once, without cluttering the work space.

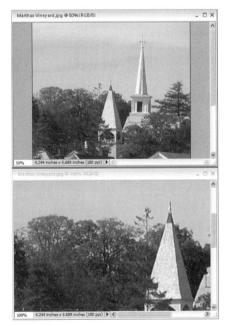

Figure 2.43 Tiled windows are arranged in a stack, from top to bottom.

To arrange multiple views:

Do one of the following:

- To create cascading, overlapping windows from the upper left to the lower right of your screen, from the Window menu, choose Images > Cascade (Figure 2.42).
- ◆ To display windows stacked, from the Window menu, choose Images > Tile (Figure 2.43).

To close multiple view windows:

Do one of the following:

- ◆ To close a single window, click the close button on that window's title bar.
- To close all document windows, from the File menu, choose Close All or press Alt+Ctrl+W.

✓ Tip

■ To quickly switch from one open window to another, press Ctrl+Tab.

Using Rulers

Customizable rulers, along the top and left sides of the document window, can help you scale and position Photoshop Elements graphics and selections. The rulers are helpful if you are combining photos with text (for a greeting card, for example) and want to be precise in placing and aligning the various elements. Interactive tick marks in both rulers provide constant feedback, displaying the position of any tool or pointer as you move it through the window. You can also change the ruler origin, also known as the zero point, to measure different parts of your image.

To show or hide the rulers:

 From the View menu, choose Rulers to turn the rulers on and off, or press Shift+Ctrl+R (Figure 2.44).

Ruler units number down and to the right, starting from the zero point, where the two rulers intersect. To measure from a given spot in an image, you can move the zero point to anywhere within the document window.

To change the zero point:

- **1.** Place the pointer over the zero point crosshairs in the upper-left corner of the document window (**Figure 2.45**).
- Drag the zero point to a new position in the document window.
 As you drag, a set of crosshairs appears, indicating the new position of the zero point (Figure 2.46).
- **3.** Release the mouse button to set the new zero point.

✓ Tip

■ To reset the zero point to its original location, double-click the zero point crosshairs in the upper-left corner of the document window.

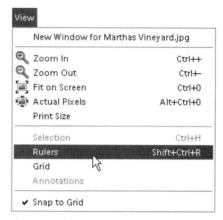

Figure 2.44 Choose Rulers from the View menu to toggle the rulers on and off.

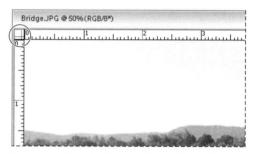

Figure 2.45 The rulers' zero point establishes the origin of the rulers.

Figure 2.46 Drag the zero point to a new location anywhere in the document window.

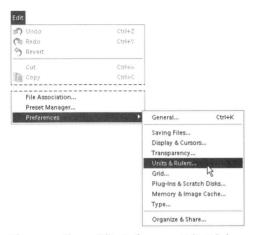

Figure 2.47 Choose Edit > Preferences > Units & Rulers to open the Units & Rulers dialog box.

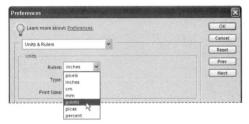

Figure 2.48 Rulers can be displayed in any of seven measurement systems.

To change the units of measure:

- **1.** Open the Units & Rulers dialog box. To do so, *do one of the following:*
 - ▲ Double-click a ruler in the document window.
 - ▲ From the Edit menu, choose Preferences > Units & Rulers (Figure 2.47).
- 2. From the Rulers drop-down menu, choose a unit of measure (Figure 2.48). The default setting is Inches. You can choose Pixels, to view the actual pixel dimensions in your image, in addition to other unit options.
- 3. Click OK.

✓ Tip

■ You can quickly change the rulers' units of measure without having to open the Preferences dialog box. Right-click on either ruler. A pop-up menu appears, from which you can choose a new measurement unit.

Setting Up the Grid

The nonprinting, customizable grid appears as an overlay across the entire document window. As with the rulers, it can be used for scaling and positioning, but it can be especially helpful for maintaining symmetry in your layout and design, or for occasions when you'd like objects to snap to specific points in the window.

To show or hide the grid:

◆ From the View menu, choose Grid to turn the grid on and off (**Figure 2.49**).

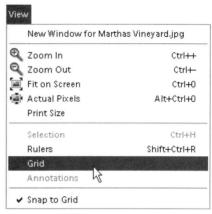

Figure 2.49 Choose View > Grid to display the document grid.

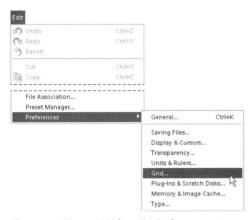

Figure 2.50 Choose Grid from the Preferences menu to open the Grid Preferences dialog box.

Figure 2.51 Choose a grid color from the list of preset colors or create a custom color.

Figure 2.52 Examples of grid line styles.

Figure 2.53 This figure shows a document grid with major grid lines set every inch, subdivided by four minor grid lines.

To change the grid settings:

- **1.** From the Edit menu, choose Preferences > Grid to open the Grid Preferences dialog box (**Figure 2.50**).
- 2. From the Color drop-down menu, choose a preset grid color, or choose Custom (Figure 2.51).
 - Choosing Custom displays the Color Picker, where you can select a custom grid color.
- **3.** From the Style drop-down menu, choose a line style for the major grid lines (**Figure 2.52**).
- **4.** In the Gridline every drop-down menu, choose a unit of measure; then enter a number in the accompanying field to define the spacing of the major grid lines.
- **5.** In the Subdivisions field, enter a number to define the frequency of minor grid lines (**Figure 2.53**).
- 6. Click OK.

CHANGING AND ADJUSTING COLORS

3

Almost any photograph can benefit from some simple color or lighting corrections. For example, you might find that a vivid sunset you photographed ends up looking rather dull and ordinary, or that a portrait taken outdoors is too dark to make out any details. Luckily, with Photoshop Elements, you're never stuck with a roll of inferior images. Photoshop Elements provides a powerful set of color correction tools, with both manual and automatic adjustments, so that you can fine-tune your images as much as you want.

In this chapter, I'll review Photoshop Elements' color-correction tools and discuss which tools you may want to use, and when you'll most likely want to use them. I'll also show you how to make sure colors display and print accurately (also known as *color management*) and how to correct colors and tonal values in your images. Along the way, I'll shed some light on why what may at first appear to be the most obvious color-enhancement options are not always the best choices for improving the color in an image.

About Computers and Color Models

No matter how your images got into the computer, whether from a scanner, a digital camera, or copied from a stock art CD-ROM, the version of the image stored in the computer can only *approximate* the colors of the original scene. A computer, at its core, is only capable of dealing with numbers, so it somehow has to come up with numerical equivalents of the colors perceived by our eyes.

Computers use number systems, called *color models* to display and reproduce color. One of the most common is the RGB color model. In this model, the color of each pixel is described as combinations of different amounts of the colors red, green, and blue. These colors were chosen because the cells in our eyes that respond to color (called cones) come in three types; some are sensitive to red, some to green, and some to blue. Therefore, the RGB model tries to characterize colors in a way that's similar to the way the human eye perceives them.

It's important to remember that color models, at best, can only *approximate* the colors in your image. No color model is as sensitive as the human eye.

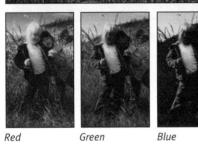

Figure 3.1 An RGB image is made up of three separate color channels: Red, Green, and Blue.

Working with Color Modes

As you work in Photoshop Elements, you'll find that you may want to save your image in a different color *mode*. A color mode specifies which color model will display and print your images. Photoshop Elements includes four color modes—RGB, Grayscale, Bitmap, and Indexed.

Most of the time you'll work in the RGB mode, because it's the standard, default mode in Photoshop Elements (as well as the most versatile), but you can convert to other color modes whenever necessary. For example, you may want to convert an RGB image to grayscale to reduce its file size, if you know the image will only be printed in black and white. And a grayscale image can be converted to a bitmap to create a more graphic, stylized look, and then be colored or altered. Indexed color is used when you want to prepare images for viewing on the Web. It reduces the millions of colors possible in RGB mode to just 256 colors optimized for Web viewing.

RGB mode

As mentioned earlier, RGB stands for red, green, and blue, which are the three color channels your eye perceives (**Figure 3.1**). Not coincidentally, these are also the three color phosphors used in your computer monitor to display color. The combination of these three channels, viewed simultaneously, brings the full color in your image to life. It's important to understand this concept, because many of your color selection and correction options allow you to adjust these colors independently. (See the color plate section of this book for a full-color example of RGB mode.)

Grayscale mode

A grayscale image is not black and white, but is actually made up of 256 unique shades of gray. If you're creating an image that will be printed in black and white, there are many advantages to converting it to grayscale. First, the conversion reduces the image to just one color channel, so the resulting image file size is about one third of the RGB version. In addition, it increases the speed of image editing and printing within Photoshop Elements. Second, when you work on the image in Grayscale mode on your monitor, it's easier to predict what the final black-and-white image will look like when printed.

Bitmap mode

An image converted to Bitmap mode really *is* a black-and-white image, because during the conversion, each little pixel is rendered as black or white. The result is an image with a very graphic look that can be effective on its own, or modified even further with the painting and drawing tools (**Figure 3.2**). The Bitmap mode is also a good choice if you're preparing an image for printing to a low-resolution, black-and-white printer.

Figure 3.2 You can convert any grayscale image to a bitmapped image.

Figure 3.3 Indexed images are made up of 256 colors, as represented in this Color Table.

Indexed mode

The indexed color version of an image is limited to a maximum of 256 colors, and is used when you're preparing images strictly for viewing on computer monitors. Limiting the number of colors reduces the file size, allowing quick loading and display of images on Web pages. When you convert an image from RGB to Indexed mode, Photoshop Elements creates an image Color Table, which is designed to represent the color palette of the image as accurately as possible. When the image contains colors not included in the Color Table, Photoshop Elements chooses the closest available color (**Figure 3.3**).

✓ Tip

■ Ever wonder about the origin of those "millions of colors" described in all that marketing literature? Each of the red, green, and blue color channels contains 256 different color possibilities. When you multiply 256 x 256 x 256, the result is over 16 million colors.

Changing Color Modes

Before converting your file to a different color mode, it's a good idea to save a "master" version of your photo first. That way, no matter what changes you make to your image, you always have the original, unaltered version.

The HSB Color Model

The RGB model isn't the only way to translate and interpret color. For some purposes, it's useful to describe color in terms of the HSB model. H represents the color's overall *hue* (or how you'd characterize it in the color spectrum—for example, is that flower blossom "purple" or "teal"). S stands for *saturation*, the purity of the color, and B stands for *brightness*, or how light or dark the color is. Although you can't convert an image to HSB mode, you can make color selections

and changes using either RGB or HSB from within the *Color Picker* (**Figure 3.4**) and with many of the color-adjustment tools covered later in this chapter. Say, for example, you want to color something bluish-green. How do you describe that in terms of red, green, and blue? If you're working in the HSB model, it's relatively easy. In the toolbox, click the foreground or background color selection box to access the Color Picker. Using the Color Picker, just click the H button, find the basic color on the Hue slider, and then choose the specific shade from the large square on the left, which shows all the variations of saturation and brightness within that hue.

Figure 3.4 The Color Picker includes access to the hue, saturation, and brightness (HSB) of your image.

Figure 3.5 Choose Image > Mode > Grayscale to convert an RGB image to grayscale. A grayscale image is only about $\frac{1}{3}$ the size of an RGB image.

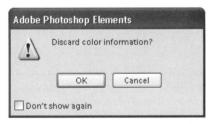

Figure 3.6 To convert from RGB to grayscale, you will discard the color information. Before you convert an image to grayscale, you may want to save a separate version to preserve the colors in the original image file.

To convert an image to grayscale:

 From the Image menu, select Mode > Grayscale (Figure 3.5).
 A message appears asking "Discard color information?"

2. Click OK (Figure 3.6).

The conversion discards all color information, resulting in an image with up to 256 shades of gray. (See the color plate section of this book for a full-color example.)

✓ Tip

■ It's usually a good idea to save the RGB version of your image before converting to grayscale. But if you forget and want to revert to the RGB mode to regain all that lost color information, just choose Edit > Undo Grayscale or press Ctrl+Z.

To convert an image to bitmap:

- **1.** From the Image menu, select Mode > Bitmap (**Figure 3.7**).
- Click OK in the message box that appears, to first convert the image to grayscale (Figure 3.8).
 The Bitmap dialog box appears (Figure 3.9).
- **3.** If desired, enter a value for the output resolution.

The default value is the current resolution of the image, which is usually fine for most purposes, and need not be changed during this conversion.

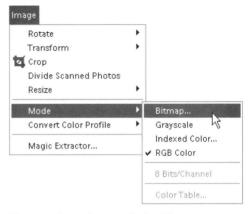

Figure 3.7 Choose Image > Mode > Bitmap to convert an image to Bitmap (black and white) mode.

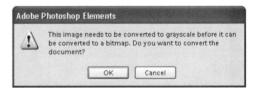

Figure 3.8 Before converting to Bitmap mode, your image is converted to grayscale.

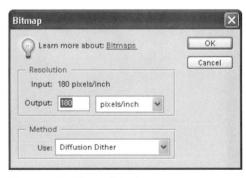

Figure 3.9 The Bitmap dialog box.

Figure 3.10 50% Threshold results in a high-contrast image.

Figure 3.11 Pattern Dither creates geometric patterns based on areas of gray.

- **4.** From the Use drop-down menu, choose from one of the following three conversion methods to complete the bitmap conversion:
 - ▲ 50% Threshold converts pixels above medium gray to white and below medium gray to black, resulting in a high-contrast image (**Figure 3.10**).
 - ▲ Pattern Dither converts areas of gray into geometric patterns (**Figure 3.11**).
 - ▲ Diffusion Dither results in a grainy, graphic look (**Figure 3.12**).
- **5.** Click OK to convert the image to Bitmap mode.

Figure 3.12 Diffusion Dither results in a grainy, posterized look.

To convert an image to indexed color:

- From the Image menu, select Mode > Indexed Color (Figure 3.13).
 The Indexed Color dialog box appears.
- 2. Choose Palette, Dither, and other options displayed in the dialog box (Figure 3.14). Palette options allow you to choose the best color palette, taking into account where the image will ultimately be viewed. See the sidebar "Indexed Color Palette Options" for a summary of the different Palette options.

The **Forced** option lets you lock in specific colors so that they are not changed in the conversion process. You can choose to lock in **Black and White**, which is particularly useful if you have a large area of white or black in the background, as well as **Primaries** (white, red, green, blue, cyan, magenta, yellow, and black). Choosing the **Forced Web** option protects all 216 "Web-safe" colors in the palette from being altered.

3. Click OK to confirm your choices.

✓ Tip

■ If all you want to do is convert your images for posting on the Web, you don't have to mess around with the Indexed Color dialog box. Instead, try using Photoshop Elements' Save for Web command, which takes a lot of guesswork out of the process. See Chapter 11, "Saving and Printing Images," for more information.

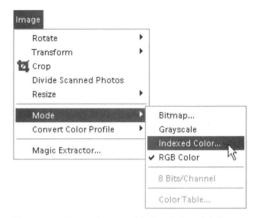

Figure 3.13 Choose Image > Mode > Indexed Color to convert an RGB image to indexed color.

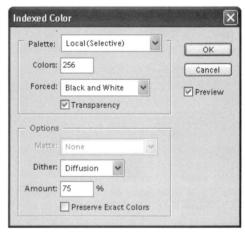

Figure 3.14 The Indexed Color dialog box includes options for choosing colors, palettes, and dithering. This figure shows the dialog box on a Macintosh.

Indexed Color Palette Options

Exact Choosing this option means that Photoshop Elements uses the exact same colors in your image to construct the color table. But this option appears only if your image contains fewer than 256 colors (such as an image in Grayscale mode).

System (Mac OS or **Windows)** Choose one of these options if you know that a majority of your users will be viewing your images on a specific computer system. (Macintosh and Windows monitors display the same colors slightly differently.) This is also a useful option if you just want to see how your image will look when viewed on a computer system different from your own.

Web When you choose the Web palette, your image is limited to the 216 colors recognized by most Web browsers. Your image's colors will stay consistent, no matter whether it's viewed using Internet Explorer, Netscape Communicator, AOL, or any other Web browsers.

Uniform The Uniform color palette relies on its own even (uniform) sampling of 216 colors to make up its color palette. Unlike other color palettes, it doesn't look to your original image to try to approximate those colors.

Adaptive (Local and Master) This palette creates a color table based on the most frequently occurring colors in your image. For example, if your image contains mostly red and orange colors, the adaptive color palette will be composed of mostly reds and oranges. Use the Local setting if you're working on a single image. You'll rarely have to use the Master setting unless you're working on multiple open images that all share the same color palette.

Perceptual (Local and Master) This palette relies on color to which the human eye has the most sensitivity. Just as with the Adaptive palette, use the Local setting when working on a single image; use the Master setting when working on multiple open images that all share the same color palette.

Selective (Local and Master) Places selective emphasis on Web-safe colors, which results in images with the best color integrity. This is the best choice for most images, and you'll find that this palette often appears as the default choice on the Palette drop-down menu. As with the Adaptive and Perceptual palettes, use the Local setting when working on a single image; use the Master setting when working on multiple open images that all share the same color palette.

Custom Use this choice if you want to create your own custom color palette.

Managing color

You've learned some color basics, but before going any further, you may want to take a couple of steps to ensure that the color you see on your monitor will be reasonably accurate when you decide to print or send images to the Web. Fortunately, color management in Photoshop Elements is very simple and doesn't require any labor-intensive chores on your part.

You should first make sure that the colors you see on the monitor are reasonably accurate, and represent what others will see on their monitors. Calibrating your monitor is a particularly good idea if you have an older monitor or have inherited it from a friend or relative (you don't know what they might have done to the monitor settings). If you have a newer monitor, it probably came with an accurate calibration from the factory. In that case, as you go through the following steps, you may find that no changes are needed.

If you prefer, you can also choose color settings optimized for either Web graphics or color printing.

About Color Profiles

The choices that you make in the Color Settings dialog box affect only the *display* of an image onscreen and won't affect how an image is printed. The Always Optimize for Printing option, for instance, will simulate the AdobeRGB color spectrum on your monitor, but will not assign the AdobeRGB color profile to an image. A color profile is information embedded in an image and stored in the background until it's required (usually by a printer). The color profile helps to interpret the RGB color information in an image and convert it to a color language that a printer can understand, and so reproduce the most accurate color possible. You can assign a color profile to an image at anytime regardless of the option that you've set in the Color Settings dialog box. With an image open, simply choose Convert Color Mode from the Image menu. From the Convert Color Profile submenu, you can Remove an unwanted profile (sRGB, for example) and apply the profile more suitable for printing: AdobeRGB.

Figure 3.15 The Adobe Gamma control panel is located with the other control panel options.

To calibrate your monitor with Adobe Gamma:

 Start Adobe Gamma, which you'll find in the Control Panel options window (Figure 3.15).

The Adobe Gamma start screen appears. If you've calibrated your monitor before, you may be launched to the Gamma control panel directly. If so, go to step 3.

continues on next page

The History of Web-Safe Color

If you're familiar with the creation of graphics or images specifically for the Web, you may already know about Web-safe or browser-safe colors. For those of you new to this buzzword, Web-safe colors are the 216 colors that can be accurately displayed on all color computer monitors regardless of age or platform. Here's the background.

Back in the pioneer days of the Web—in the mid-1990s—a lot of computer systems still used 256-color cards (also known as 8-bit color). This meant that the monitors on these systems could display only 256 colors at any given time. You (or your kids) may even still have a few CD-ROM games designed around this limitation; you'll know them because they ask you to change the display to 256 colors—in other words, to use the Web-safe palette.

But even though the palette consists of 256 colors, only 216 of those colors are considered Web safe. That's because Windows and Macintosh computers share only 216 colors, each reserving the remaining colors for system use. Thus, you're left with 216 colors that are guaranteed to appear with absolute accuracy regardless of platform. Surprisingly, even using just these 216 colors, your images can come out looking pretty good.

Today, even the most basic PCs come out of the box with the capability of displaying thousands—or, more often, millions—of colors, and there are very few 8-bit systems still in use. However, because Windows and Macintosh computers still display some colors a little bit differently, using the Web-safe palette is the only way to ensure that your colors look exactly the same on *both* systems.

Bottom line? If you're not concerned about folks running older computer systems, or with the slight color differences in PC and Macintosh systems, use all of the colors your system came with. But if you want to make sure that absolutely *all* viewers can see your images in the exact colors you intended, stick to the Web-safe color palette.

- 2. From the Adobe Gamma start screen (Figure 3.16), do one of the following:
 - ▲ Click Step by Step (Wizard) to adjust your color settings using the onscreen instructions.
 - ▲ Choose Control Panel, click Next, and follow steps 3, 4, and 5.

Figure 3.16 The Adobe Gamma utility is used to calibrate your monitor for Windows XP. It includes a Step by Step mode that guides you through the monitor calibration process.

Figure 3.17 Setting up Adobe Gamma ensures that the color images on your screen are represented accurately. In this dialog box, unchecking View Single Gamma Only lets you adjust the red, green, and blue values on your monitor.

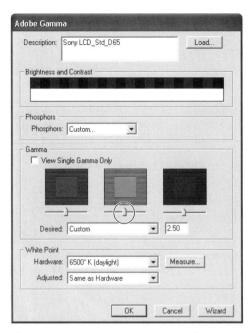

Figure 3.18 To make adjustments to the red, green, and blue values, move the color slider back and forth until the inside and outside boxes match as closely as possible. Usually, the colors will match closest around the midpoint of the sliders' range.

- 3. When you come to the gamma settings screen, uncheck the View Single Gamma Only check box (Figure 3.17).

 Three color boxes appear, representing the red, green, and blue colors displayed by your monitor (Figure 3.18).
- **4.** Using the sliders, match the inner colors to the outer colors in the boxes.
- 5. Click OK, then in the Save As dialog box, click Save to save your changes.
 The monitor profile is saved in the profiles folder.

✓ Tips

- It's very possible that your monitor settings will be correct. In that case, choose Cancel to exit the Adobe Gamma dialog box.
- The default White Point settings in the lower portion of the dialog box are usually fine for most monitors and environments. But light sources and even the color of surrounding walls can affect how color is displayed on your monitor. If there is a marked difference between the image on your display and your printed output, you may want to experiment with different White Point settings.
- To ensure accurate calibration of your monitor, make sure that it's been on for at least 30 minutes. The colors may display slightly differently until the monitor is completely "warmed up."

Color Management Is an Imperfect Science

As you start selecting and adjusting colors in Photoshop Elements, it's important to understand that the term *color management* can be a little misleading.

Color management operates under the assumption that we're creating artwork at our calibrated monitors under specific, controlled lighting conditions, and that our desktop printers work at peak performance at all times. In other words, it assumes controlled, uncompromised perfection.

At the time of this writing, the late afternoon sun is casting some lovely warm reflections off the blinds of the window and onto the wall directly behind my computer monitor, and is competing for attention with the glow from the 40-watt, soft-white bulb in my desk lamp. Therein lies the problem: the vast majority of Photoshop Elements users are working in similarly imperfect conditions.

In addition to trying to make a perfect science out of a host of imperfect variables, color management all but ignores one of the most imperfect sciences of all: our very human, very subjective perception. I may print out an image I find perfectly acceptable, whereas you may look at the same image and decide to push the color one way or another to try to create a different mood or atmosphere. That's what makes everything we create so different. That's what makes it art. And that's (at least in part) what makes color management an imperfect science. So, as you read through this chapter, keep in mind that your images will never look *precisely* the same when viewed by different users on different monitors.

And that's perfectly all right.

Figure 3.19 Choose Edit > Color Settings to bring up the Color Settings dialog box.

Figure 3.20 Choose a color management option best suited to the final output of your image.

To choose color settings:

- From the Edit menu, choose Color Settings (Figure 3.19).
 The Color Settings dialog box appears with three color management options plus the option to choose No Color Management (Figure 3.20).
 - ▲ Always Optimize Colors for Computer Screens displays images based on the sRGB color profile and is the default setting. It's a good all around solution, particularly if you are creating images to be viewed primarily onscreen.
 - ▲ Always Optimize for Printing displays color based on the AdobeRGB profile. Although the image you see onscreen may display with only subtle color differences (as compared to sRGB), you will generally get truer, more accurate color when you send the image to print.
 - ▲ **Allow Me to Choose** will default to sRGB, but if the image contains no color profile, you'll have the option of choosing AdobeRGB.

About Tonal Correction

Tonal correction tends to be one of the least understood (and therefore most intimidating) features of Photoshop Elements. Mention *levels* and *histograms* and *white points* to even some seasoned graphics professionals, and you'll see their eyes begin to glaze over. That's a shame, because there's really no magic involved. Once understood, tonal correction can be one of the simplest and most instantly gratifying steps you can take to improving an image.

In plain terms (and whether you're working with a grayscale or color image), correcting tonal range simply comes down to adjusting brightness and contrast. Photoshop Elements offers several ways to make automatic brightness and contrast adjustments (see "Adjusting Levels Automatically" later in this chapter). But the most precise and intuitive method is by using the Levels dialog box; the heart of the Levels dialog box is the histogram.

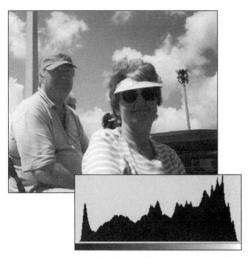

Figure 3.21 A photo displaying full tonal range and its accompanying histogram. Note how the histogram extends all the way to the left and right, indicating that pure blacks are present in the darkest shadow areas and pure whites are present in the lightest highlight areas. The fairly uniform peaks and valleys throughout the middle portion of the histogram also indicates that there is sufficient pixel data present in the midtones.

Figure 3.22 Here's the same image, this time with insufficient contrast. Note how the histogram doesn't extend all the way to the left and right. This is an indication that both the darkest and lightest areas of the image are shades of gray rather than pure blacks and whites. The shortage of high-contrast pixel data makes the image appear washed out.

Understanding histograms

The **histogram** is a graphic representation of the tonal range of an image. The lengths of the bars represent the number of pixels at each brightness level: from the darkest, on the left, to the lightest, on the right. If the bars on both sides extend all the way to the left and right edges of the histogram box, the darkest pixels in the image are black, the lightest pixels are white, and the image is said to have a *full tonal range* (Figure 3.21). If, as in many images, the bars stop short of the edges, the darkest and lightest pixels are some shade of gray, and the image may lack contrast (Figure 3.22). In extreme circumstances, the bars may be weighted heavily to the left or right, with the tonal range favoring either the shadows or highlights. Whatever the tonal range, the brightness and contrast of an image can be adjusted using sliders located beneath the histogram in the Levels dialog box (see "Adjusting Levels Manually" later in this chapter).

Adjusting Levels Automatically

Photoshop Elements gives you the option of applying a quick fix to image levels and contrast with the Auto Levels and Auto Contrast commands. Although I recommend working with the histogram in the Levels dialog box, the auto commands can be a good jumpingoff point before launching into more controlled, manual image correction. The auto commands tend to be most successful when applied to photographs that contain an average tonal range; one where most of the image detail is concentrated in the midtones. Midtones are those tonal values that fall about halfway between the darkest and lightest values. Midtone areas tend to contain more image information—more visible detail, that is—than extremely dark or light areas. Photographs with predominant midtones whether in gravscale or in color—are usually the best candidates for auto correction. Severely overexposed or underexposed images may be beyond help. If the camera or scanner didn't capture the detail in the first place, it's not there to be corrected.

To apply Auto Levels to an image:

- From the Enhance menu, choose Auto Levels, or press Shift+Ctrl+L.
 Photoshop Elements instantly adjusts the image's tonal range (Figure 3.23).
- 2. If you're not happy with the result, select Edit > Undo Auto Levels, or press Ctrl+Z.

Figure 3.23 The photo on the top lacks sufficient tonal range, particularly in the highlight and lighter midtone areas. The photo on the bottom, corrected with the Auto Levels command, reveals more detail in both the shadow and highlight areas because the pixels have been distributed across the full tonal range.

Enhance	
Auto Smart Fix	Alt+Ctrl+M
Auto Levels	Shift+Ctrl+L
Auto Contrast	Alt+Shift+Ctrl+L
Auto Color Correction	Shift+Ctrl+B
👁 Auto Red Eye Fix	Ctrl+R
Adjust Smart Fix	Shift+Ctrl+M
Adjust Lighting	•
Adjust Color	•

Figure 3.24 Choose Enhance > Auto Contrast to apply an instant contrast fix to your image.

Figure 3.25 The photo on the top lacks sufficient contrast, so detail is lost in both the shadow and highlight areas. The photo on the bottom, corrected with Auto Contrast and containing both strong blacks and whites, reveals detail not present in the original.

To apply Auto Contrast to an image:

- From the Enhance menu, choose Auto Contrast (Figure 3.24), or press Alt+ Shift+Ctrl+L.
 Photoshop Elements instantly adjusts the
- **2.** To undo, choose Edit > Undo Auto Contrast, or press Ctrl+Z.

image's contrast (Figure 3.25).

✓ Tip

As mentioned earlier, the auto commands work best in specific circumstances (as when the image's tonal range favors the midtones) and so should be used sparingly. The Auto Levels command, in particular, can yield some surprising and unexpected color shifts. In some instances it seems to overcompensate by swapping out one undesirable color cast for another, whereas in others it may ignore the color altogether and throw the contrast way out of whack. Give these auto commands a try, but be prepared to commit that Undo keyboard shortcut to memory.

Adjusting Levels Manually

The Levels dialog box can do more to improve the overall tonal quality of your image than any other workspace in Photoshop Elements. Many images, whether scanned or imported from a digital camera, don't contain the full tonal range, and as a result lack sufficient contrast. That lack of contrast translates into loss of detail, usually most noticeably in the shadow and highlight areas. Using the histogram and sliders in the Levels dialog box, you darken the darkest pixels and lighten the lightest ones to improve contrast, then adjust the brightness levels in the midtones.

To adjust the tonal range:

- From the Enhance menu, choose Adjust Lighting > Levels, or press Ctrl+L to open the Levels dialog box (Figure 3.26).
- **2.** With the Preview box selected, drag the slider on the left until it rests directly below the left edge of the histogram graph (**Figure 3.27**).

The image darkens as the darkest pixels in the image move closer to black.

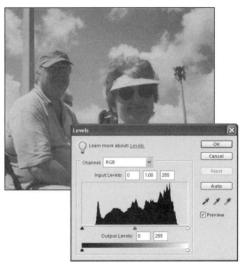

Figure 3.26 The Levels dialog box.

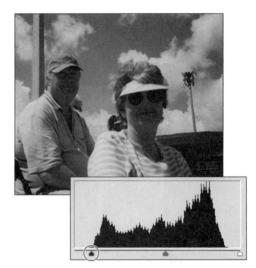

Figure 3.27 Moving the left slider underneath the left edge of the histogram spreads the darker pixels more evenly into the dark areas of the midtones and shifts the darkest pixels to black.

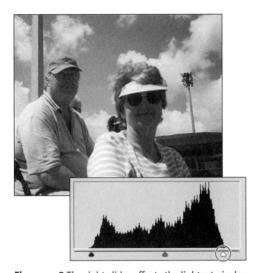

Figure 3.28 The right slider affects the lightest pixels in the image. Moving the right slider underneath the right edge of the histogram spreads the lighter pixels more evenly into the light areas of the midtones and shifts the lightest pixels to white, resulting in more detail in the highlight areas.

- **3.** Drag the slider on the right until it rests directly below the right edge of the graph (**Figure 3.28**).
 - The image lightens as the lightest pixels in the image move closer to white.
- **4.** Drag the middle slider to the left or right to adjust the brightness level of the pixels that fall in the midtones.
- $\textbf{5.} \ \, \text{Click OK to close the Levels dialog box}.$

✓ Tip

■ You may have noticed a topic conspicuous by its absence: the Brightness/
Contrast command. That's because I never use it. Unlike Levels, which affects pixels in specific tonal ranges, Brightness/
Contrast indiscriminately lightens or darkens pixels across the entire tonal range, typically creating more problems (such as contrast that's either too weak or too severe) than it solves.

Lighting Your Image

Overexposed background images and underexposed foreground subjects are a common problem for most amateur photographers. Photoshop Elements provides an elegant tool to help salvage your otherwise perfect compositions. Much like the Levels command, it operates on pixels in specific tonal ranges (either highlights or shadows) while leaving the other tonal ranges alone. A Lighten Shadows slider helps to add detail to areas in shadow, whereas a Darken Highlights slider can add detail to washed-out areas in the background.

To improve foreground detail:

- From the Enhance menu, choose Adjust Lighting > Shadows/Highlights.
 The Shadows/Highlights dialog box appears (Figure 3.29).
- **2.** In the Shadows/Highlights dialog box, *do one or all of the following:*
 - ▲ Drag the Lighten Shadows slider to the right to lessen the effect of the shadows, or to the left to introduce shadow back into the image.
 - ▲ Drag the Darken Highlights slider to the right until you're satisfied with the detail in the foreground or other brightly lit areas.
 - ▲ Drag the Midtone Contrast slider to the right to increase the contrast, or to the left to decrease the contrast.
- **3.** Click OK to close the Shadows/Highlights dialog box and apply the changes (**Figure 3.30**).

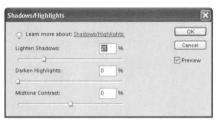

Figure 3.29 The Shadows/Highlights dialog box.

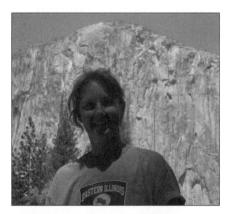

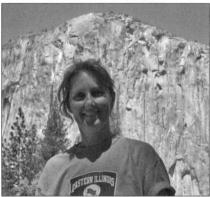

Figure 3.30 The top photo is very underexposed in the foreground, so detail in the woman's face is hidden in shadow. In the bottom photo, making adjustments with the Lighten Shadows and the Midtone Contrast sliders selectively brightens and enhances detail in both her face and shirt.

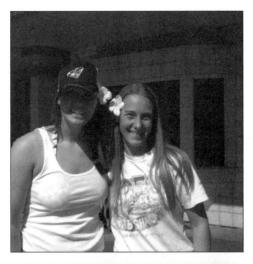

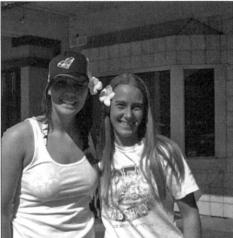

Figure 3.31 The top photo suffers from underexposure problems throughout both the foreground and the background. In the bottom photo, making adjustments with all three Shadows/Highlights sliders restores the lost detail in the women's faces and in the background storefronts.

✓ Tips

- I've found that in many (if not most) images imported from a digital camera, the Shadows/Highlights dialog box defaults work surprisingly well on their own, requiring just minor slider adjustments.
- In any case, use the Midtone Contrast slider sparingly. A little goes a long way, and adjustments of more than plus or minus 10% can quickly wash out or flatten an image's details.

To improve background detail:

- **1.** From the Enhance menu, choose Adjust Lighting > Shadows/Highlights.
- 2. In the Shadows/Highlights dialog box, drag the sliders as described in the preceding procedure until you're satisfied with the contrast and detail in the background or in other brightly lit areas.
- **3.** Click OK to apply the change (**Figure 3.31**).

✓ Tip

Because in the majority of circumstances the Lighten Shadows slider most improves foreground images, whereas the Darken Highlights slider most improves backgrounds, I chose to break the Shadows/ Highlights dialog box into two discrete topics. By no means do I want to imply that one setting or the other should be restricted to improving either only the foreground or only the background. Both the Lighten Shadows and Darken Highlights sliders can be used effectively across an entire image.

Image Correction One-Stop Shopping

Adobe's **Quick Fix** window groups a cross-section of some of the more commonly used commands and functions into one convenient, interactive workspace (**Figure 3.32**). You open the Quick Fix window by clicking the Quick Fix button in the shortcuts bar. You'll see that the Quick Fix window is really its own, self-contained editing environment, with a main image window, a palette well, photo bin, and a small toolset for cropping, zooming, and red-eye cor-

rection. From the View drop-down menu, you can choose from a number of before and after image viewing options. From the palette well, you make image adjustments with a group of simple, specialized palettes. Palette sliders help you to correct common problems like lighting, color, and sharpness. In addition, the palettes feature Auto buttons that work just like the Auto commands in the Enhance menu. Each time you make an adjustment or correction, a button on each palette allows you to either accept or cancel the operation. And a handy Reset button above the After image allows you to cancel all the changes you've made, and start over from scratch.

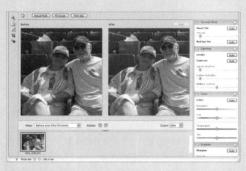

Figure 3.32 The Quick Fix dialog box offers a space to perform many common image correction functions. The Tip area in the center of the window provides helpful explanations of each adjustment you select and apply.

Figure 3.33 Choose Auto Color Correction from the Enhance menu to automatically remove color cast from your image.

Correcting for Color Cast

Color cast refers to a general shift of color to one extreme or another: an image can be said to have a yellow or red cast, for instance. Although sometimes introduced into images intentionally (to create a certain mood or effect), color casts are usually unhappy accidents. They can result from any number of circumstances, from a scanner in need of calibrating to tired chemicals in a film developer's lab. Even light from a fluorescent bulb can create unwanted color shifts in photographs.

Thankfully, Photoshop Elements gives you several ways to deal with color cast: a wonderful little automatic menu command, a dialog box that allows you to manually color-correct your image by adding and subtracting color values in small increments, and a feature new in Version 4.0 that can dramatically improve skin tones.

To remove color cast with the Auto Color Correction command:

 From the Enhance menu, choose Auto Color Correction, or press Shift+Ctrl+B (Figure 3.33).

That's it. Photoshop Elements does some elegant, behind-the-scenes magic, examining the image's color channels and histogram and performing a little math, and *voilà*—no more color cast. (See the color plate section of this book for a full-color example of removing color cast.)

✓ Tip

■ I use this little feature all the time before applying any other image correction. I'm constantly amazed at how well this simple menu command works, and usually give it a try even if I don't perceive a color cast. It almost always offers some degree of improvement to the color.

To adjust color in an image based on skin tones:

- 1. From the Enhance menu choose Adjust Color > Adjust Color for Skin Tone to open the Adjust Color for Skin Tone dialog box (**Figure 3.34**).
- 2. Check that the Preview check box is selected, and then move the cursor onto the photo until it becomes an eyedropper. Click with the eyedropper on any part of a person's skin (Figure 3.35). Photoshop Elements will adjust the color in the entire image, but will pay special attention to the skin tones.
- **3.** If you're not satisfied with the results, you can click on a different area of skin, or use the sliders to fine-tune the color (**Figure 3.36**).
- **4.** Click OK to close the dialog box and set the color changes.

Figure 3.34 The Adjust Color for Skin Tone dialog box.

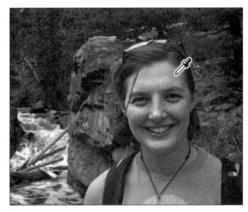

Figure 3.35 The eyedropper samples skin tones in a photo and then makes a best-guess color correction.

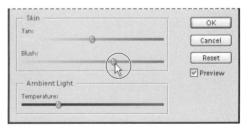

Figure 3.36 Use dialog box sliders to make manual skin tone corrections.

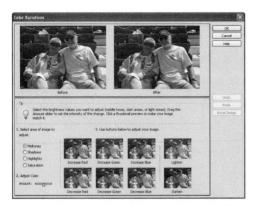

Figure 3.37 The core of the Color Variations dialog box is the lower, thumbnail button area. Each time you click a thumbnail you apply a slight color shift to your image. The thumbnails can be clicked any number of times and in any combination.

To remove color cast with the Color Variations dialog box:

- **1.** From the Enhance menu, choose Adjust Color > Color Variations.
- 2. Determine the color cast of your image. Because Elements doesn't offer any help in determining color cast, you're pretty much on your own here. Look for clues to color cast in objects or areas you are familiar with and can make good, educated guesses on. Ask yourself if that bright blue sky is looking a little yellow, or if those leafy greens have a little pink tinge to them, then work from there.
- 3. In the lower portion of the dialog box, click the thumbnail with the description that most describes what you need to do (Increase Red, Decrease Blue, and so on) while referring to the After view in the top half of the dialog box (Figure 3.37).
- **4.** Continue to click any combination of thumbnails, as many times as necessary, until the After view looks satisfactory.
- Click OK to close the Color Variations dialog box and view your corrected image.

✓ Tips

- To a large degree, using the Color Variations dialog box is a matter of trial and error, and to a lesser degree a rather subjective process. And as much as I'd like to be able to provide some little hints or formulas, experience and experimentation are the real keys to success with this dialog box.
- If you find yourself completely lost, or just want to start over, click the Before thumbnail in the upper-left corner, or the Reset Image button along the right side to reset the entire dialog box.

Replacing Color

The Replace Color command does just what you would expect it to do, and does it very well indeed. In a nutshell, it allows you to select a specific color, either across an entire image or in an isolated area of an image, and then change not only the color but its saturation and lightness values as well. Eyedropper tools let you add and subtract colors to be replaced, whereas a slider control softens the transition between the colors you choose and those around them. I've seen this used to great effect on projects as varied as experimenting with different color schemes before painting a house's trim to changing the color of a favorite uncle's tie so that it no longer clashes with his suit. (See the color plate section of this book for a full-color example.)

To replace color across an entire image:

- From the Enhance menu, choose Adjust Color > Replace Color.
- 2. In the Replace Color dialog box, click the Selection radio button under the image preview box (Figure 3.38).
 When the Replace Color dialog box is open, your pointer will automatically change to an eyedropper tool when you move it over your image.

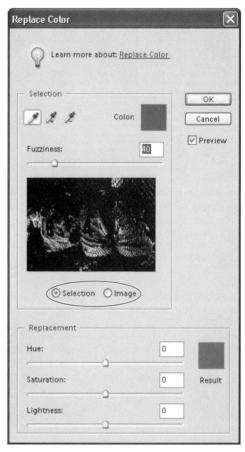

Figure 3.38 Options under the image preview box let you choose whether to view your color selections or the just the image.

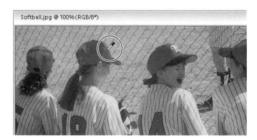

Figure 3.39 Click the actual image in the image window to make a color selection.

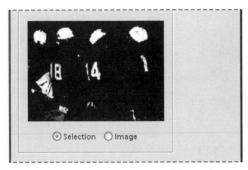

Figure 3.40 The image preview area of the Replace Color dialog box shows selected colors as white or shades of grav.

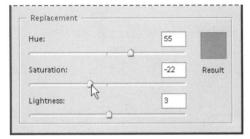

Figure 3.41 Drag the Hue, Saturation, and Lightness sliders until you capture the right color effect. You may have to experiment a little until you get it just right.

- **3.** With the eyedropper tool, click in the image to select the color you want to change (**Figure 3.39**).
 - The color selection appears as a white area in the image preview of the Replace Color dialog box (**Figure 3.40**).
- **4.** To expand the selection and include similar colors, drag the Fuzziness slider to the right. To contract the selection and exclude similar colors, drag the Fuzziness slider to the left.
 - You may want to expand or contract your selection beyond the limits of the Fuzziness slider. If parts of a selection fall too heavily in shadow or highlight, or have very reflective surfaces, you may need to make additional color selections or deletions.
- **5.** To add a color to the selection, Shift+click the eyedropper tool in another area of the image. To subtract a color from the selection, press Alt+click.
 - The dialog box contains separate add and subtract eyedropper tools, but the keyboard shortcuts provide a much more efficient way to modify your color selections.
- **6.** With the Preview check box selected, drag the Hue, Saturation, and Lightness sliders (**Figure 3.41**) until you achieve the desired color effect.
 - These sliders operate just like the ones in the Hue/Saturation dialog box. The Hue slider controls the actual color change; the Saturation slider controls the intensity of the color, from muted to pure; and the Lightness slider controls the color's brightness value, adding either black or white.
- **7.** Click OK to close the Replace Color dialog box and view your corrected image.

To replace color in a specific area of an image:

- 1. In the image window, make a selection around the specific area or object you want to apply the color change to (Figure 3.42) (see Chapter 4, "Making Selections").
- 2. From the Enhance menu, choose Adjust Color > Replace Color.
- **3.** In the Replace Color dialog box, click the Image button under the image preview box.
 - A detail view of your selection appears in the image preview box.
 - When the Replace Color dialog box is open, your pointer will automatically change to an eyedropper tool when you move it over your image in either the image window or the image area of the dialog box.
- **4.** With the eyedropper tool, click in the image preview box of the Replace Color dialog box to select the color you want to change (**Figure 3.43**).

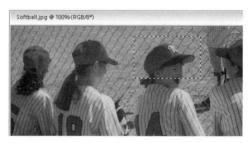

Figure 3.42 Any selections you make are reflected in the Replace Color dialog box.

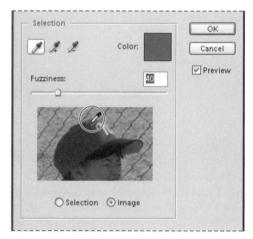

Figure 3.43 Click the image within the Replace Color dialog box to make a color selection.

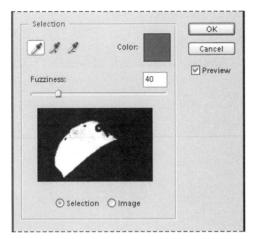

Figure 3.44 When the Selection radio button is clicked, the image in the preview box changes to show the selected colors as white or shades of gray.

- Click the Selection radio button to toggle to the Selection view.The color selection appears as a white
 - The color selection appears as a white area in the image preview (**Figure 3.44**).
- **6.** To add or subtract a color from the selection, click the Image button to toggle back to that view, then use the keyboard shortcuts, as described in the previous procedure, to adjust the selection.
- **7.** Use the Fuzziness slider to further finetune your selection.
- **8.** With the Preview check box selected, drag the Hue, Saturation, and Lightness sliders until you achieve the desired color effect.
- **9.** Click OK to close the Replace Color dialog box and apply your changes.

✓ Tip

■ If you prefer, you can always choose to make your color selection in the actual image in the image window, just as we did in the previous procedure. But if the selections you're making are small, relative to the total size of your image, it's often easier to work within the confines of the Replace Color dialog box.

Making Selections

Photoshop Elements offers many sophisticated options for enhancing and retouching your image. Those options include colors, filters, resizing tools, vignettes, and all sorts of special effects. But before you can start tinkering, you need to learn how to make selections. Once you select a specific area of an image, you can change its color, copy and paste it into another image, or change its size and rotation.

You can also use selections to create a protective mask for specific portions of an image. It's easy to select one area of an image, apply a change to the entire image, and keep the selected area untouched.

In this chapter, you learn about all of Photoshop Elements' selection tools and when to choose one tool over another. You also learn how to use these tools in tandem to make the quickest and most accurate selections, depending on your specific needs.

About the Selection Tools

Often, you'll want to make changes and adjustments to just a portion of an image. For example, you may want to eliminate a distracting element in your photo, change the color of a specific item in a photograph, or adjust the brightness of the background. Photoshop Elements gives you a wide variety of selection tools from which to choose.

The selection tools are all grouped together near the top of the toolbar (**Figure 4.1**). You make rectangular and elliptical selections using the **marquee** tools. When you select a marquee tool, the selection area is indicated by a row of moving dots, like the sign outside a movie theater; hence the name *marquee* tools (**Figure 4.2**).

You select free-form, or irregular, areas using the **lasso** tools (**Figure 4.3**). These include the regular Lasso tool; the Polygonal lasso, which is great for selecting areas that include straight sections; and the Magnetic lasso, which can select the edge of an area based on its color or tonal values.

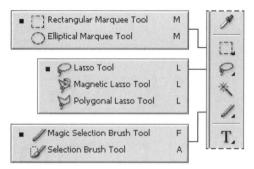

Figure 4.1 The selection tools appear under three icons on the toolbar.

Figure 4.2 A selection border is represented by a row of moving dots, called a marquee.

Figure 4.3
Each of the three lasso tools works best in a particular situation.

Figure 4.4 The Magic Wand lets you select areas based on their color.

Figure 4.5 The Magic Wand also lets you set the tolerance, or range of colors selected.

Figure 4.6 Here, the white background was selected with the Magic Wand, and then the selection was inverted to capture the clown.

The **Magic Wand** lets you select areas with the same (or similar) color or tonal value. This is probably the most difficult tool to master, but with a little practice it allows you to make selections that would be difficult to make with any of the marquee or lasso tools (**Figure 4.4**). For example, if your photo displays a field of yellow poppies, you can select all of them at once, rather than having to select each individual flower.

The selection tools work well on their own, but many times the area you want to edit will include all sorts of angles and edges. In these situations, you can use the tools in combination to expand and change the selection area.

You can also expand or contract a selection area using the same tool with different settings. For example, the Magic Wand allows you to alter the range of your selection by adjusting the tolerance using the options bar (**Figure 4.5**).

When your photo includes an object surrounded by a large background area, it's often easier to select the background and then invert the selection to select the object. Once the selection is made, you can copy and paste it into another composition or make any other changes (**Figure 4.6**).

continues on next page

You can adjust your selection area by adding to or subtracting from the selection. You'll often find it easier to use one tool to make your initial selection and then edit the selection area using another selection tool (**Figure 4.7**).

The Selection Brush allows you to make selections by simply dragging across any area or object in an image. Like the lasso tools, it works especially well for selecting irregular areas. Unlike the other selection tools, you actually "paint on" the selection using any of the brush shapes available in Photoshop Elements' vast collection of brush sets (**Figure 4.8**). This method of selection affords you great control and flexibility.

The Magic Selection Brush is new to Photoshop Elements 4.0, and works in much the same way as the Magic Wand tool—selecting areas based on similar color and tonal values. What distinguishes the Magic Selection Brush from the other selection tools is the method you use to make the selections. By painting on a series of scribbles and dots, Photoshop Elements then creates a selection area based on the color or tonal values below the painted marks (**Figure 4.9**).

Figure 4.7 Here, the Elliptical Marquee tool was used to select the clown's head, and then the Lasso tool was used to select the clown's mouth.

Figure 4.8 The Selection Brush can be used in either Selection or Mask mode.

Figure 4.9 When you "paint" through an area with the Magic Selection Brush, any pixels similar in color or tonal value to those you brush over will be selected.

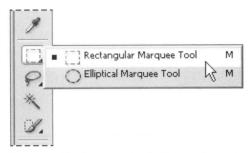

Figure 4.10 Simple geometric selections can be made with the Rectangular or Elliptical Marquee Tool.

Figure 4.11 The default setting on the options bar creates a new selection.

Figure 4.12 After selecting one of the marquee tools, just click and drag to make a selection.

Using the Marquee Tools

The Rectangular and Elliptical Marquee tools are the easiest and most straightforward selection tools to use. With these tools, you can select rectangular or oval (elliptical) areas. You can also select a perfectly square or circular area. You will often want to move a selection area (or marquee) to align it perfectly, and Photoshop Elements offers a couple of quick and simple ways to make these kinds of adjustments.

To make a rectangular or elliptical selection:

1. From the toolbar, choose either the Rectangular Marquee tool (M) or Elliptical Marquee tool (M again) (Figure 4.10).

The default setting on the options bar creates a new selection (**Figure 4.11**). See "Adjusting Selections" later in this chapter for more information on other options when creating selections.

2. Click and drag to choose the selection area (**Figure 4.12**).

continues on next page

✓ Tips

- You can create a perfect circle or square selection using the marquee tools by holding down the Shift key (**Figure 4.13**).
- You can draw the marquee from the center outward by holding down the Alt key (**Figure 4.14**).
- To toggle between marquee tools, press the M key. In fact, this works for any tool with hidden tools—simply press the keyboard shortcut key repeatedly to toggle through all of the choices.
- To select all pixels on a layer, press Ctrl+A. This creates a selection around your entire image window, and is useful when you want to make universal color corrections or special effects to your image.

Figure 4.13 To select a perfect square or circle, hold down the Shift key while dragging.

Figure 4.14 To draw a selection from the center outward, hold down the Alt key.

Figure 4.15
To move the selection area, position the pointer within the selection boundary.

Figure 4.16
Drag the selection border to a new location.

Figure 4.17 To move the marquee during a selection, just press the spacebar while holding down the mouse button and adjust the border's location.

To reposition a selection border:

- 1. Once you've made a selection, with the New selection icon active, position the pointer anywhere inside the selection area. The pointer becomes an arrow with a small selection icon next to it (Figure 4.15). Note that if the Add to, Subtract from, or Intersect with icons are active, the pointer indicates that choice and the selection can't be moved.
- Click and drag to reposition the selection area.
 The pointer arrow changes to solid black as you move the selection (Figure 4.16).

✓ Tip

■ You can use the arrow keys on your keyboard to move a selection in 1-pixel increments. Holding down the Shift key changes the movement to 10-pixel increments.

To reposition a selection border while making a selection:

- **1.** Click and drag to create the selection area.
- **2.** While keeping the mouse button pressed, press the spacebar.
- **3.** Move the selection area to the desired location and release the spacebar and mouse button (**Figure 4.17**).

Selecting Areas Using the Lasso Tools

Use the lasso tools to select areas with irregular shapes. The standard Lasso tool lets you draw or trace around an object or area in a freehand manner, much as you would draw with a pencil. This method takes patience, but with practice you can make very accurate selections with it.

The Polygonal Lasso tool is useful for selecting areas that include straight edges—and you can toggle between the freehand and straight-edge mode when your object includes both irregular and straight edges.

With the Magnetic Lasso tool, you trace around an area, and the tool automatically "snaps" the selection border to the edge of an area based on differences in color and tonal values in adjoining pixels. For this reason, the tool usually works best on high-contrast images. Experiment with the settings on the options bar to get the best results

To select with the Lasso tool:

- **1.** From the toolbar, choose the Lasso tool (L).
- Keeping the mouse button pressed down, drag all the way around an object or area in your image (Figure 4.18).
 When you release the mouse button, the

open ends of the selection automatically join together (**Figure 4.19**).

✓ Tip

Normally, if you lift the mouse button during a selection, the selection area will automatically close. To prevent this, hold down the Alt key while you make your selection.

Figure 4.18 Select any area by tracing around it with the Lasso tool.

Figure 4.19 When you release the mouse button, the ends of the selection automatically join together.

Figure 4.20 The Polygonal Lasso tool creates a border made of straight-line segments.

Figure 4.21 For selection with both freehand and straight lines, press Alt to switch between the regular Lasso and Polygonal Lasso tools.

To select with the Polygonal Lasso tool:

- **1.** From the toolbar, choose the Polygonal Lasso tool (L).
- **2.** Click points along the edge of the object to create straight-line segments for your selection (**Figure 4.20**).
- 3. Click back at the original starting point to join the open ends of the selection. You can also Ctrl+click or double-click anywhere on the image to close up the selection.

✓ Tips

- Be warned; the Polygonal Lasso tool can sometimes slip out of your control, creating line segments where you don't want them to appear. If you make a mistake or change your mind about a line selection, you can erase line-segment selections as long as you haven't closed the selection. Just press the Backspace or Delete key, and one by one the segments will be removed, starting with the most recent one.
- To use both the regular Lasso and Polygonal Lasso tools together, hold down the Alt key when using either tool to toggle between the two modes (Figure 4.21).

To select using the Magnetic Lasso tool:

- **1.** From the toolbar, choose the Magnetic Lasso tool (L).
- **2.** Click on or very close to the edge of the area you want to trace to establish the first fastening point (**Figure 4.22**).
- **3.** Move the pointer along the edge you want to trace.
 - The Magnetic Lasso tool traces along the selection border to the best of its ability and places additional fastening points along the way (**Figure 4.23**).
- **4.** If the selection line jumps to the edge of the wrong object, place the pointer over the correct edge and click the mouse button to establish an accurate fastening point (**Figure 4.24**).
- **5.** To close the selection line, click the starting point, or *do one of the following:*
 - ▲ Ctrl+click.
 - Double-click anywhere on the image.
 - ▲ Press Enter.

✓ Tip

■ Press Alt+click to use the Polygonal Lasso tool while the Magnetic Lasso tool is selected. Alt+drag to use the Lasso tool.

Figure 4.22
To start a selection border with the Magnetic Lasso tool, click the edge of the area you want to trace to create the first fastening point.

Figure 4.23
As you trace with the Magnetic
Lasso tool, it places additional fastening points along the edge of the selection.

Figure 4.24 Sometimes the Magnetic Lasso tool jumps to another edge (left). To correct the path, just click the correct edge to bring the border back to the right location (right).

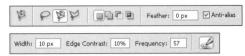

Figure 4.25 Look at the options bar while the Magnetic Lasso tool is selected; you'll find options that are unique to this tool.

Width: 3 pixels Width: 10 pixels

Figure 4.26 The Width option lets you set the width of the edge that the tool looks for to determine the selection edge.

Frequency: 1

Figure 4.27 The Frequency option lets you determine how closely the fastening points are spaced.

To set Magnetic Lasso tool options:

- 1. Select the Magnetic Lasso tool.
- **2.** Set any of the options visible on the options bar (Figure 4.25).
 - ▲ Width sets the size of the area that the tool scans as it traces the selection
 - You can set this option to a value from 1 to 40 pixels. Wide widths work well for high-contrast images, and narrow widths work well for images with subtle contrast and small shapes that are close to each other (Figure 4.26).
 - ▲ Edge Contrast establishes the amount of contrast required between shapes for an edge to be recognized and traced.
 - This option is indicated by the percentage of contrast (from 1 to 100 percent). Try higher numbers for high-contrast images, and lower numbers for flatter, low-contrast images (just as with the Width option).
 - ▲ Frequency specifies how close the fastening points are to each other. For Frequency, enter a number from 1 to 100. In general, you will need to use higher frequency values when the edge is very ragged or irregular (Figure 4.27).
 - ▲ If you are using a stylus tablet, you can select Stylus Pressure to increase the stylus pressure and so decrease the edge width. That's right: With the box checked, pressing harder on the stylus will yield a smaller, more precise edge.

Making Selections by Color

The Magic Wand and Magic Selection Brush tools allow you to make selections based on a selected color or tonal value. These tools can seem truly magical—or wildly unpredictable—at first. When you select an area of an image with either tool, it selects all of the pixels within a color or tonal range close to the pixel you've initially selected.

The Magic Wand tool provides options for setting tolerance (the number of color or tonal values included in the selection), anti-aliasing (smoothing), contiguousness (whether the pixels need to be connected to that first selected pixel), and whether to include all layers in the selection.

The Grow and Similar commands, found in the Select menu, can be used with the Magic Wand to expand the selection area. The Grow command expands the range of adjacent pixels, and the Similar command expands the selection based on the pixel colors.

Although the Magic Selection Brush doesn't offer the options available with the Magic Wand, it will often make an accurate selection based solely on the areas you mark with the brush.

To use the Magic Wand:

- **1.** From the toolbar, choose the Magic Wand (W) (**Figure 4.28**).
- 2. On the options bar, choose whether to create a new selection, add to or subtract from an existing selection, or select an area where two selections intersect (Figure 4.29).

The default setting on the options bar creates a new selection.

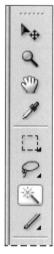

Figure 4.28
The Magic Wand icon is located just below the Lasso tool on the toolbar.

Figure 4.29 The Magic Wand options bar.

Tolerance: 5

Tolerance: 50

Figure 4.30 The Tolerance setting determines how wide a range of colors is included in the selection.

Contiguous on

Contiguous off

Figure 4.31 Choose Contiguous if you want the selection to include only adjacent pixels. Uncheck the box if you want to select all colors throughout the image.

- **3.** Select the tolerance (a range of pixels from 0 to 255) to establish how wide a tonal range you want to include in your selection.
 - The default tolerance level is 32 pixels. To pick colors or tonal values very close to the selected pixel, choose lower numbers. Entering higher numbers results in a wider selection of colors (**Figure 4.30**).
- **4.** If you want your selection to have a smooth edge, select Anti-alias.
- **5.** If you want only pixels adjacent to the original pixel to be included in the selection, select Contiguous (**Figure 4.31**).
- **6.** If you want the selection to include pixels on all the layers, select Sample All Layers.
- Click a color or tone in the image. Based on your settings, a group or range of pixels will be selected.

✓ Tip

■ When you make your original selection with the Magic Wand, it takes a color "sample" from your image. You can adjust the sample size with the Eyedropper tool. The Eyedropper options bar lets you sample 1 pixel, or the average of a 3-by-3-pixel area (9 pixels total), or a 5-by-5-pixel area (25 pixels total). Whichever option is active determines how the Magic Wand establishes the sample color.

To expand the selection area:

- **1.** From the toolbar, choose the Magic Wand tool.
- 2. Click a color or tonal value in the image.
- 3. From the Select menu, choose Grow to expand the selection of adjacent pixels. Each time you select Grow, the selection is expanded by the tolerance amount displayed on the Magic Wand options bar (Figure 4.32).

✓ Tip

■ You can also access the Grow command by right-clicking after you have made a selection with the Magic Wand. A pop-up menu appears in the image window, which includes the Grow and Similar commands plus a number of other useful selection options (**Figure 4.33**).

To include similar colors:

- 1. From the toolbar, choose the Magic Wand.
- **2.** Click a color or tonal value in the image.
- 3. From the Select menu, choose Similar to expand the selection of nonadjacent pixels. The selection is expanded by the tolerance amount set on the Magic Wand options bar (Figure 4.34).

Figure 4.32 In this example, the tolerance is set to 50 pixels, with Contiguous unchecked for the first two Grow commands. To fine-tune the selection, the Contiguous box is checked, and the tolerance is reduced to 20 pixels.

Figure 4.33 After making a selection with the Magic Wand tool, right-click to access selection options.

Figure 4.34 Choose Select > Similar to add pixels to your selection.

Figure 4.35The Magic Selection Brush tool.

Figure 4.36 Buttons in the options bar supply different functions for the Magic Selection Brush.

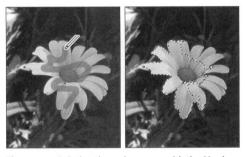

Figure 4.37 Painting through an area with the Magic Selection Brush creates a new selection.

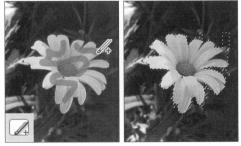

Figure 4.38 To add to a selection, paint in additional brushstrokes.

To use the Magic Selection Brush:

- **1.** From the toolbar, choose the Magic Selection Brush (F) (**Figure 4.35**).
- **2.** On the options bar, check that New Selection is chosen (**Figure 4.36**).
- **3.** Again in the options bar, choose a brush size. The default brush size is 13 pixels.
- **4.** In the image window, click, or click and drag in the area where you want to make your selection.
 - When you release the mouse button, the selection area will appear (**Figure 4.37**).
- 5. To add to the selection, choose the Indicate Foreground button in the options bar, and then click (or click and drag) in an area outside the current selection (Figure 4.38).

The Indicate Foreground button is selected automatically once you've made your first selection.

6. To subtract from a selection, choose the Indicate Background button, and then click (or drag) inside the selection area (**Figure 4.39**).

Figure 4.39 Use the Indicate Background button in the options bar to delete a portion of a selection.

Using the Selection Brush Tool

The Selection Brush tool lets you brush over areas to make a selection. The brush options are very similar to the normal Brush tool, allowing you to choose from a wide range of brush styles and sizes. So once you become familiar with one of these brush tools, you should feel pretty comfortable with the others.

The Selection Brush works a bit differently than the other selection tools. When you're in Selection mode you simply click and drag through an area of your image to create a free-form, brushed selection. And unlike the other selection tools, the Selection Brush includes a Mask mode, which allows you to create a "protected" or unselected area. To make it easier to work with masked areas, you can control the opacity and color of the mask overlay. The two modes can also be used together with great results. You will often find it easier to make your initial selection, and then change to Mask mode to make final adjustments to your selection.

To make a selection with the Selection Brush:

- **1.** From the toolbar, choose the Selection Brush (A) (**Figure 4.40**).
- 2. From the Mode menu on the options bar, choose Selection (**Figure 4.41**).
- **3.** Choose a brush style (**Figure 4.42**) and then enter values for the brush size and hardness.

You can either enter specific values for the size and hardness, or drag the sliders (**Figure 4.43**) until you get the size and hardness you want.

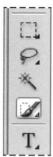

Figure 4.40 | The Selection Brush tool is located on the toolbar.

Figure 4.41 To make a selection, choose the Selection mode option.

Figure 4.42 You can choose from a wide variety of prebuilt brushes.

Figure 4.43 The brush size can be set from the options bar.

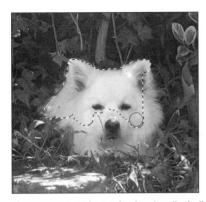

Figure 4.44 To make a selection, just "paint" over your image with the Selection Brush.

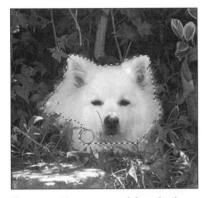

Figure 4.45 You can expand the selection by brushing around and through the original selection.

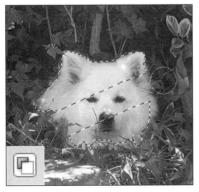

Figure 4.46 Use the Subtract from selection button in the options bar to remove areas of your selection.

- **4.** Drag the brush tool over your image to make a selection (**Figure 4.44**).
- 5. To expand your selection, brush on the edge of the selected area (Figure 4.45). To make a selection in another portion of your image, click and drag away from the original selection.
- **6.** To subtract from your selection, choose the Subtract from selection button in the options bar, and then click and drag through any portion of the selection (**Figure 4.46**).

✓ Tip

■ Remember that the Selection Brush tool works with any brush you can select from the Brushes palette. You can make some interesting selections and masks by choosing a brush shape from one of the specialty brushes sets.

To make a mask with the Selection Brush:

- **1.** From the toolbar, choose the Selection Brush.
- **2.** From the Mode menu on the options bar, choose Mask (**Figure 4.47**).
- **3.** Choose a brush style and then enter values for the brush size and hardness.
- **4.** Set the overlay opacity with the slider, or enter a percentage in the text box (**Figure 4.48**).
- **5.** Set the overlay color by clicking the Overlay Color box in the options bar, and then choose a color from the Color Picker (**Figure 4.49**).

The default color is red, so if your selection area is also red it may be hard to see. Just choose a color that works best for each image.

Figure 4.47 To make a mask, first select the Mask mode option.

Figure 4.48 The opacity of your mask overlay can be set with the slider or entered into the text box.

Figure 4.49 The mask overlay color can be changed from the default (red) to any color using the Color Picker.

Figure 4.50 When you paint with the Mask option on, the area becomes filled with the mask overlay.

Figure 4.51 In Mask mode, you paint a mask through any areas that you *do not* want to be selected.

6. Drag the brush tool over your image to make a mask (**Figure 4.50**).

As soon as you select another tool, the mask overlay area changes to a selection border. The area is protected from any changes you apply to the image (**Figure 4.51**). If you want to modify the mask, select the Brush Selection tool again. The mask will automatically appear over the image, and you can continue to paint in additional masked areas.

✓ Tip

■ The mask overlay is a very handy tool for inspecting your selections and can be used with any selection tool. Whenever you have an active selection, just click the Selection Brush tool and select the Mask option to see the masked area. When you're done viewing it in Mask mode, choose Selection from the dropdown menu.

To adjust a selection using a mask:

- From the toolbar, choose the Selection Brush, and make sure you're in Selection mode.
- **2.** Choose a brush style and enter values for the brush size and hardness.
- **3.** Drag the brush over a selection area to establish a quick, rough selection (**Figure 4.52**).
- **4.** Change to Mask mode to see the mask overlay (**Figure 4.53**).
- **5.** Fine-tune the edge of your mask, adjusting the brush size and hardness as necessary (**Figure 4.54**).
- **6.** To remove areas of the mask, press the Alt key while using the Selection Brush in Mask mode.
- When you're satisfied with the mask, choose the Selection mode on the options bar.

✓ Tip

■ You can use also use the Add to selection and Subtract from selection buttons in the options bar to modify your selection mask. To remove areas of your mask, choose the **Add to** selection button. To add areas to your mask, choose the **Subtract from** selection button.

Figure 4.52 You can use a large brush size to quickly rough out your original selection.

Figure 4.53 When you change to Mask mode, the selection area becomes a mask.

Figure 4.54 In Mask mode, it's easy to see where the edge of your selection needs to be adjusted.

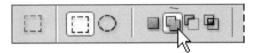

Figure 4.55 To add to the current selection, either click the Add to Selection icon on the options bar, or hold down the Shift key while making another selection.

Figure 4.56 In this example, two selections are combined to form a single selection.

Adjusting Selections

You can probably tell by now that creating selections usually involves a little fine-tuning to get things just right. For example, imagine you're using the Magnetic Lasso tool to trace the outline of a face, but then realize you didn't include the ear in your selection. Rather than start all over again from scratch, you can simply add to or subtract from your selection until you've included every part of the image you want. Photoshop Elements even lets you select the intersection (or overlapping area) of two independent selections. This feature offers a creative solution for constructing interesting selection areas that would be difficult to create with a single selection tool.

To add to a selection:

- **1.** Make a selection in your image with any of the selection tools.
- **2.** With the selection still active, *do one of the following*:
 - ▲ If desired, select a different selection tool, then click the Add to Selection icon (**Figure 4.55**) on the options bar. If the Add to Selection icon is already highlighted, skip to step 3.
 - Hold down the Shift key, and, if desired, select a different selection tool.
 A plus sign appears, indicating that you are adding to the current selection.
- 3. Make a new selection in your image. If you want to add to your existing selection, make sure your new selection overlaps the original. If you want to create an additional selection, make sure you click outside of your original selection.

 The new selection area is added to your first selection (Figure 4.56).

To subtract from a selection:

- **1.** Make a selection with any of the selection tools.
- **2.** With the selection still active, *do one of the following*:
 - ▲ Select the Subtract from Selection icon on the options bar and, if desired, choose any of the selection tools (**Figure 4.57**).
 - ▲ Hold down the Alt key.

A minus sign appears, indicating that you are subtracting from the current selection.

3. Drag the pointer through the area you want to subtract.

The area you defined is removed from the selection (**Figure 4.58**).

To select the intersection of two selections:

- **1.** Make a selection with any of the Marquee or Lasso selection tools.
- **2.** With the selection still active, *do one of the following*:
 - ▲ Select the Intersect with Selection icon on the options bar and create a new selection that overlaps the current selection (**Figure 4.59**).
 - ▲ Hold down Alt+Shift and create a new selection that overlaps the current selection. An X appears, indicating that you are selecting an area of intersection.
- **3.** A new selection area is formed based on the intersection of the two selections (**Figure 4.60**).

Figure 4.57 To subtract from the current selection, either click the Subtract from Selection icon on the options bar, or hold down the Alt key while selecting the area you want to subtract.

Figure 4.58 In this example, a pie-shaped cutout is left where the rectangle selection has been subtracted.

Figure 4.59 To create an intersection of two selections, click the Intersect with Selection button on the options bar.

Figure 4.60 In this example, only the area of intersection remains.

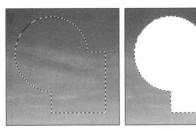

Figure 4.61 When you delete a selection, the selected area disappears, and your current background color shows through.

To deselect the current selection:

 From the Select menu, choose Deselect, or press Ctrl+D.

✓ Tip

■ You can *deselect* an entire selection at any time by pressing the Esc key.

To reselect the last selection:

 Choose Select > Reselect, or press Shift+Ctrl+D.

To delete a selection:

Do one of the following:

- From the menu bar, choose Edit > Cut, or press Ctrl+X.
- ◆ Press Backspace/Delete.

 When you delete a selection, the portion of the image within your selection disappears entirely, leaving a hole in your image (**Figure 4.61**). If you accidentally delete a selection, click the Undo icon on the shortcuts bar or press Ctrl+Z.

To hide a selection border:

 From the View menu, uncheck Selection, or press Ctrl+H.

Sometimes, after you've made a selection, you will want to temporarily turn off the selection marquee to edit the image without the selection border obscuring your view. Be sure to press the same keyboard shortcut to display the selection once more—otherwise, you might lose track of where your selection is.

Softening the Edges of a Selection

When working with selections, you will often want to smooth or soften the edges of your selection before copying and pasting it into another image or layer. Anti-aliasing smoothes out the jagged edges of a selection by creating a gradual color transition along the edge (**Figure 4.62**). You will generally want to leave the Anti-aliased option on to leave nice smooth edges on your selections. This is especially true if you are creating a composite (combination) image by copying and pasting selections from a number of photos.

Feathering blurs the edges of a selection. You set the amount of blurring on the options bar in the Feather box. Unlike anti-aliasing, which affects just the very edge of a selection, feathering creates a more dramatic, soft transition or halo effect around an image. Depending on the image selection, you may want to experiment with different feathering settings, because some detail is usually lost around the edges of a feathered selection.

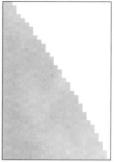

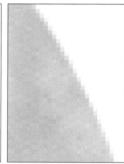

Figure 4.62 Anti-aliasing automatically smoothes a selection edge by adding pixels that blend the color transition.

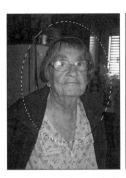

Figure 4.63 Select Anti-aliased on the options bar before you make a selection to create a smooth edge, even on curved shapes.

Figure 4.64 To get the vignette effect shown here, use the Elliptical Marquee tool to create a border. Choose Select > Feather, and enter a radius of around 10 pixels, then choose Select > Inverse to select the background. With white selected as the background color in the toolbox, press Ctrl+Backspace to complete the effect.

To smooth jagged edges with anti-aliasing:

- 1. From the toolbar, choose any selection tool other than the Rectangular Marquee tool. The Rectangular Marquee tool's edges are composed of straight right angles, so no anti-aliasing is necessary. A rectangle selection's edge can still be softened with the Feather option.
- **2.** Select Anti-alias on the options bar. You must have anti-aliasing active before making your selection.
- **3.** Make a selection using the desired tool.
- Cut or copy and then paste the selection into a new file.
 The resulting selection edge is automatically smoothed, with no jaggies (Figure 4.63).

To feather the edge of a selection:

- **1.** From the toolbar, choose from any of the Marquee or Lasso tools.
- 2. On the options bar, enter a value for the feather radius (from 1 to 250 pixels).
- **3.** Make a selection.

 The resulting edge appears blurred, based on the number you entered for the Feather option (**Figure 4.64**).

✓ Tips

- Unlike with anti-aliasing, you can apply feathering after you make a selection.
 With your selection active, from the Select menu choose Feather (Alt+Ctrl+D), then enter a feather radius.
- You can also apply feathering effects to your image by applying the Vignette effect, available in the Effects palette. For more detail, see "To apply effects" in Chapter 7, "Filters and Effects."

Modifying Selection Borders

You can make subtle—or not so subtle—changes to a selection border with four options found on the Select > Modify menu (Figure 4.65). The Border command lets you change the width of the selection border. The Smooth command smoothes out a jagged or irregular selection edge. To increase the size of a selection, use the Expand command. To reduce the size of a selection, use the Contract command.

To change the width of the border:

- **1.** Make a selection in your image with any of the selection tools.
- From the Select menu, choose Modify > Border.
- **3.** Enter a value for the border width. The selection border changes based on the number you enter (**Figure 4.66**).

To smooth the edge of a selection:

- From the Select menu, choose Modify > Smooth.
- **2.** Enter a value for the radius of the smoothing effect.

The radius values range from 1 to 100 and define how far away from the current edge the selection will move to create a new, smoother edge.

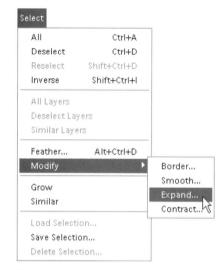

Figure 4.65 Choose Select > Modify to use the Border, Smooth, Expand, and Contract tools.

Figure 4.66 The Border command lets you control the width of a selection border. In this example, I applied a white fill to a 10-pixel border (left) and a 30-pixel border (right).

Figure 4.67 You can expand or contract the size of a selection border from the Modify menu.

To expand or contract the selection area:

- **1.** From the Select menu, choose Modify; then choose Expand or Contract.
- 2. Enter a value for the number of pixels you would like the selection to either grow (expand) or shrink (contract) (Figure 4.67).

WORKING WITH LAYERS

Photoshop Elements allows you to work on individual image layers. You can create and name new layers, then reorder, group, and even merge selected layers together.

In this chapter, you'll learn how layers are created, and then explore a number of methods and techniques to help you take advantage of one of Photoshop Elements' most powerful and creative features. The chapter concludes with a comprehensive look at the Undo History palette. This helpful palette tracks and displays a record of every action you make (from selections, to layer creation, to retouching), and then lets you easily undo any action and return to different states in the history of your image creation.

Understanding Layers

When you first import or scan an image into Photoshop Elements, it consists of just one default layer. In many cases, you'll find that you want to make just a few simple changes to your photo and will have no need for multiple layers. But when you begin working with some of the more involved and complex image manipulation and retouch tools, you'll find that layers can make things a whole lot easier.

Layers act like clear, transparent sheets stacked one on top of another, and yet, when vou view a final image, they appear as one unified picture (Figure 5.1). As you copy and paste selections, you may notice that these operations automatically create new layers in your image. You can edit only one layer at a time, which allows you to select and modify specific parts of your photo without affecting the information on other layers. This is the real beauty of layers: the ability to work on and experiment with one part of your image while leaving the rest of it completely untouched. One exception to this is the adjustment layer, which lets you make color and tonal corrections to individual or multiple layers without changing the actual pixels.

Layers appear in your image in the same order as they appear in the Layers palette. The top layer of your image is the first layer listed on the Layers palette, and the background layer is positioned at the bottom of the list (**Figure 5.2**).

Figure 5.1
Layers act like clear acetate sheets, where transparent areas let you see through to the layers below.

Figure 5.2 By default, an image with layers consists of a background layer, with additional layers named Layer 1, Layer 2, and so on. But you can change the default names to more descriptive names at any time.

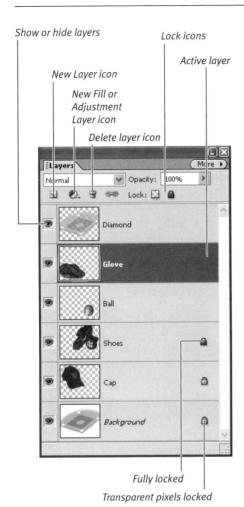

Figure 5.3 The Layers palette shows stacked layers exactly as they're arranged in your image, with the active layer on top. This palette gives you complete control over the stacking order of your layers, whether they're visible or hidden.

Using the Layers Palette

When you launch Photoshop Elements for the first time, the Layers palette automatically appears in the lower-right corner of your screen in the palette bin. You can use the Layers palette from within the palette bin, or drag it out into the work area.

From within the Layers palette, you can select which layer to make the active layer, display and hide layers, and lock layers to protect them from unintentional changes (**Figure 5.3**). You can also change layer names, set the opacity (transparency) of individual layers, and apply blending modes.

The palette menu offers quick access to many of the same commands found on the Layer menu, plus options for changing the appearance of the palette thumbnails.

To view the Layers palette:

Do one of the following:

- ◆ Choose Window > Layers.
- Click the arrow on the Layers palette tab in the palette bin.
- Choose Window > Reset Palette
 Locations to return all of the palettes to
 their default locations, including Layers,
 which appears in the lower right.

To view the Layers palette menu:

 Click the More button in the top-right corner of the Layers palette (Figure 5.4).
 Once the Layers palette menu is open, you can select a command from the menu.

✓ Tip

■ To change the appearance of the layer thumbnail views, choose Palette Options from the Layers palette menu and click the size you want (**Figure 5.5**). The smaller the icon, the more layers you're able to view at one time on the palette. So if you find yourself working on images with a lot of layers, the smallest thumbnails may work best.

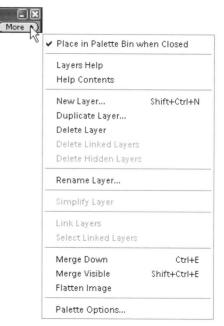

Figure 5.4 Click the More button to display the Layers palette menu.

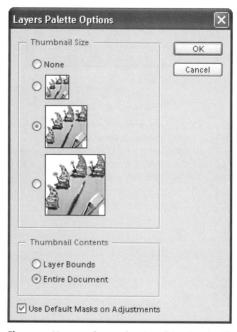

Figure 5.5 You can choose the size of the thumbnail views from the Layers Palette Options menu.

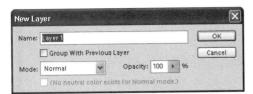

Figure 5.6 Default layer names are Layer 1 for the first layer you create, Layer 2, Layer 3, and so on. You can enter a new name when creating a layer, or you can rename it later.

Figure 5.7 Click the New Layer icon to quickly create a new. blank layer.

✓ Tips

- You can also quickly create a new layer by clicking the New Layer icon near the top of the Layers palette (**Figure 5.7**). The new layer appears as the top layer in the palette with the default blending and opacity modes applied. To rename the new layer, double-click its name in the Layers palette and enter a new name.
- To work more easily on your image, you can choose to show or hide any of its layers from the Layers palette menu.

Layer Basics

To begin working with layers, you need to master just a few fundamental tasks. You can start by creating and naming a new layer, and then adding an image (or portion of an image) to it.

Once you've constructed an image file of multiple layers, you need to select the individual layer before you can work on that layer's image. Keep in mind that any changes you make will affect only the selected, or *active* layer, and that only one layer can be active at a time.

To create a new layer:

- From the Layer menu or from the Layers palette menu, select New > Layer, or press Shift+Ctrl+N.
- **2.** In the New Layer dialog box, choose from the following options:
 - ▲ Rename the layer with a more meaningful and intuitive name related to its contents. The default names are Layer 1, Layer 2, Layer 3, and so on (Figure 5.6).
 - ▲ Choose a blending mode for the layer.

 The default blending mode is Normal, meaning that no change will be applied to the layer. You can experiment with other blending modes directly from the Layers palette.
 - ▲ Choose the level of opacity for the layer. Opacity can also be adjusted at any time from the Layers palette.
 - ▲ Group the new layer with the Previous (or lower) layer.
 - The Group feature in the Layers palette produces an effect like masking where the lower layer in the group acts as a window for the upper layer's image to show through. For a detailed description of layer grouping, see "Creating Masking Effects with Layer Groups" later in this chapter.

To select a layer:

Do one of the following:

- On the Layers palette, click the Layer thumbnail or name to make that layer active (Figure 5.8).
 - If you've just imported an image from a digital camera or scanner, by default it will have only one layer—the background layer, which is selected by default.
- Select the Move tool and click directly on a layer image in the image window
 A border with selection handles will appear around the layer image to indicate that it's selected (Figure 5.9).

✓ Tip

■ When you try to select or make changes to an area in your image, you sometimes may keep getting weird and unexpected results. For example, your selection can't be copied, or you apply a filter but nothing happens. More often than not, this is because you don't have the correct layer selected. Just refer to the Layers palette to see if this is the case. Remember that the active layer is always highlighted in the Layers palette.

To show or hide a layer:

 On the Layers palette, click the eye icon to hide the layer (the eye disappears).
 Click again and the eye reappears, making the layer visible again in the image window (Figure 5.10).

✓ Tips

- You can quickly show or hide multiple layers by simply dragging through the eye column.
- To quickly display just one layer, Alt-click the eye icon for the desired layer. All of the other layers will become hidden. Alt-click again to show all of the layers.

Figure 5.8 Click the layer name or thumbnail to make it the active (editable) layer.

Figure 5.9 When you click a layer image in the image window, a bounding box appears to show you that it is the selected, active layer.

Figure 5.10 Click the eye icon to hide a layer; click again to make the layer visible.

Figure 5.11 Choose Layer > Delete Layer from the Layer menu (or Layers palette menu) to delete a selected layer.

Figure 5.12 Clicking the trash icon also removes the selected layer.

To delete a layer:

- 1. Select a layer on the Layers palette.
- **2.** Do one of the following:
 - ▲ From the Layer menu or from the Layers palette menu, choose Delete Layer (**Figure 5.11**).
 - Click the Trash icon on the Layers palette (Figure 5.12) and then click Yes.
 - ▲ Drag the layer to the Trash icon on the Layers palette.

Background Layers

When you import a photo from a digital camera or scanner, the photo appears on the *back-ground* (or base) layer in Photoshop Elements. In fact when you open an image file from just about any source, it's very likely that it has been flattened and contains just a background layer. This layer cannot be reordered (that is, its relative position or level cannot be moved), and it cannot be given a blending mode, or assigned a different opacity.

When you create a new image and choose Transparent for its background, the bottom layer is called *Layer 1*. This layer can be reordered, and you can change its blending mode or opacity just as with any other layer.

A simple *background* layer can never be transparent, but that's okay if you're not concerned with changing opacity or applying blending modes. However, if you want to take advantage of the benefits that transparency offers, start by creating an image with transparent background contents, or convert an existing *background* layer to a regular layer.

Changing the Layer Order

The layer stacking order determines which layers are on top of others, and plays a big role in determining how your image looks. As you build a composition, you may find that you want to change the layer order, either to help you work more easily on a particular layer, or to get a particular result or effect. The actual, visible overlapping of elements is determined by the layer order, so you may find that you need to reorder layers frequently when you work on complex images.

There are two main ways to change the stacking order of your layers. The most common and versatile approach is to drag the layer wherever you want in the layer stack within the Layers palette. The second way is to select the Layer > Arrange menu and then choose commands such as Bring to Front and Send to Back—a method similar to what you use to arrange objects in a drawing program.

To change the layer order by dragging:

- **1.** On the Layers palette, select the layer you want to move.
- Drag the layer up or down in the Layers palette (Figure 5.13).
 You will see a thick double line between the layers, indicating the new layer position.
- **3.** Release the mouse button when the layer is in the desired location.

Figure 5.13 Drag a layer either up or down on the Layers palette to change its stacking order.

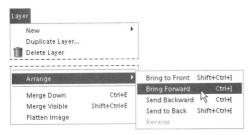

Figure 5.14 You can also change a layer's position using the options on the Layer > Arrange menu.

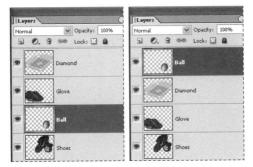

Figure 5.15 The Bring to Front command moves the layer to the top of the palette and to the top level in your image.

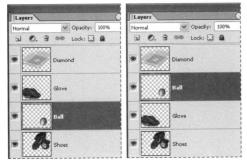

Figure 5.16 The Bring Forward command moves the layer up just one level.

To change the layer order by arranging:

- **1.** Select the layer you want to move on the Layers palette.
- 2. From the Layer menu, choose Arrange, and then select one of the following options from the submenu; or use the keyboard shortcuts noted for each (Figure 5.14).
 - ▲ Bring to Front (Shift+Ctrl+]) moves the layer to the top of the Layers palette and the image (**Figure 5.15**).
 - ▲ Bring Forward (Ctrl+]) moves the layer up by one step in the stacking order (**Figure 5.16**).
 - Send Backward (Ctrl+[) moves the layer down by one step in the stacking order.
 - ▲ Send to Back (Shift+Ctrl+[) makes the layer the bottom layer on the Layers palette.

You can also Shift-click to select two layers in the Layers palette, and select Reverse to swap their order in the layer stack.

✓ Tip

■ If your image contains a background layer and you choose the Send to Back command, you'll find that the background layer stubbornly remains at the bottom of your Layers palette. By default, background layers are locked in place and can't be moved. To get around this, just double-click and rename the background layer to convert it to a functional layer. Then you can move it wherever you like.

Managing Layers

Photoshop Elements includes many of the same layer management tools found in Adobe Photoshop. As you add layers to an image, Elements assigns them a default numerical name (Layer 1, Layer 2, and so on). As your image becomes more complex, you'll usually find that renaming your layers takes a lot of guesswork out of managing your workflow. If you're adding a sky layer to your vacation photo, it's much easier to find a cloud image on a layer called *clouds* than it is to remember that the clouds are on Layer 14, for example.

You can also link layers together, so that any changes, such as moving and resizing, happen to two or more layers together.

And you can protect layers from unwanted changes by locking them. All layers can be fully locked, so that no pixels can be changed, or you can lock just the transparent pixels, so that any painting or other editing happens only where there are already opaque (nontransparent) pixels present. This partial locking is useful if you've set up your image with areas that you know you want to preserve as transparent (like for a graphic you want to incorporate into a Web page). And locking an image protects it in other ways, too: you can move a locked layer's stacking position on the Layers palette, but the layer can't be deleted.

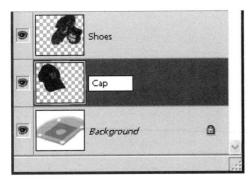

Figure 5.17 To rename a layer, just double-click its name on the Layers palette.

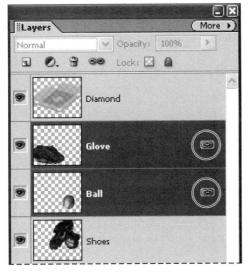

Figure 5.18 Link icons indicate which layers are linked together.

To rename a layer:

- 1. Double-click the layer's name on the Layers palette to display the text cursor and make the name editable (**Figure 5.17**).
- 2. Enter a new name for the layer and press the Enter key.

The new name now appears on the Layers palette.

✓ Tip

■ If you prefer, you can also use the Rename Layer command available on both the Layer menu and the Layers palette menu.

To link layers:

- **1.** Ctrl-click to select the layers in the Layers palette that you want to link together.
- Click the Link icon near the top of the Layers palette (Figure 5.18).
 The link icon will appear in each linked layer, to the right of the layer name.

To lock all pixels on a layer:

- **1.** Select the layer on the Layers palette.
- 2. Click the Lock All icon near the top of the Layers palette (**Figure 5.19**).

 The Lock All icon appears to the right of the layer name on the Layers palette (**Figure 5.20**).

To lock transparent pixels on a layer:

- **1.** Select the layer on the Layers palette.
- Click the Lock Transparent Pixels icon near the top of the Layers palette (Figure 5.21).

The Lock Transparent Pixels icon appears to the right of the layer name on the Layers palette (**Figure 5.22**).

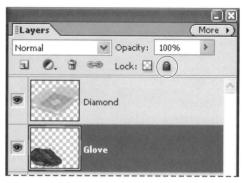

Figure 5.19 Select a layer and click the Lock All icon to prevent changes to any pixels.

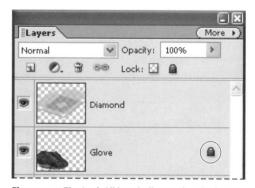

Figure 5.20 The Lock All icon indicates that the layer's pixels are completely locked.

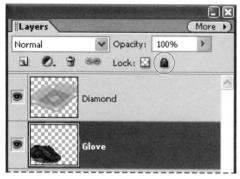

Figure 5.21 Select a layer and click the Lock Transparent Pixels icon to prevent changes to any transparent pixels in your image.

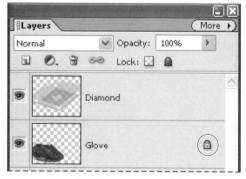

Figure 5.22 The Lock Transparent Pixels icon indicates that the transparent pixels are locked.

Figure 5.23 This photo collage (above left) was originally composed of three separate folk instrument layers, plus two background layers (lower left). To simplify the file, the three instrument layers were merged into a single layer (lower right). The finished collage will look the same, but because it's composed of fewer layers, its file size will be significantly smaller.

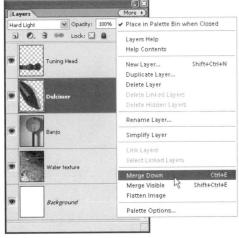

Figure 5.24 Combine a single layer with the layer below it by using the Merge Down command.

Merging Layers

Once you begin to create projects of even moderate complexity, the number of layers in your project can add up fairly quickly. Although Photoshop Elements lets you create an almost unlimited number of layers, there are a couple of reasons why you may want to consolidate some or all of them into a single layer (**Figure 5.23**). For one thing, it's just good housekeeping. It doesn't take long before the Layers palette begins to fill up, and you find yourself constantly scrolling up and down in search of a particular object or text layer. And every layer you add drains a little more from your system's memory. Continue to add layers, and depending on available memory, you may notice a decrease in your computer's performance.

Photoshop Elements offers three approaches to merging image layers. You can merge just two at a time, merge multiple layers, or flatten your image into a single background layer.

To merge one layer with another:

- 1. On the Layers palette, identify the two layers you want to merge, and then select the topmost of the two layers.

 Photoshop Elements will only merge two layers when one is stacked directly above the other. If you want to merge two layers that are separated by one layer or more, you'll need to rearrange their order in the Layers palette before they can be merged.
- 2. From the More menu on the Layers palette, choose Merge Down (**Figure 5.24**), or press Ctrl+E.

The two layers are merged into one layer.

To merge multiple layers:

- 1. On the Layers palette, identify the layers you want to merge, checking that the Visibility (eye) icon is on for just the layers you want to merge.
- From the More menu on the Layers palette, choose Merge Visible (Figure 5.25), or press Shift+Ctrl+E.
 - All of the visible layers are merged into one layer.

✓ Tip

You can create a new layer and then place a merged *copy* of all of the visible layers on that layer by holding down the Alt key while choosing Merge Visible from the Layers palette's More menu. The visible layers themselves aren't merged and so remain separate and intact (Figure 5.26). This technique offers you a way to capture a merged snapshot of your current file without actually merging the physical layers. It can be a handy tool for brainstorming and comparing different versions of the same layered file. For instance, take a snapshot of a layered file, change the opacity and blending modes of several layers, and then take another snapshot. You can then compare the two snapshots to see what effect the different settings have on the entire file.

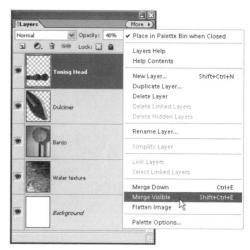

Figure 5.25 Combine any number of layers using the Merge Visible command.

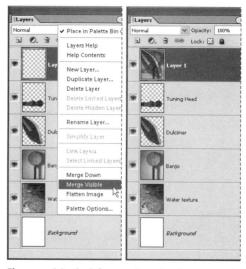

Figure 5.26 On the left, a new layer has been created at the top of the Layers palette. If you hold down the Alt key while selecting Merge Visible from the palette menu, all visible layers are merged and copied to the new layer, as shown on the right.

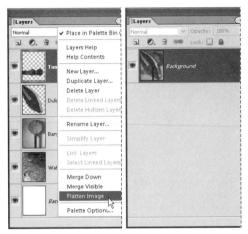

Figure 5.27 Combine all of the layers in a project into a single layer by using the Flatten Image command.

To flatten an image:

- **1.** In the Layers palette, click the More button to open the palette menu.
- **2.** From the palette menu, select Flatten Image.
- **3.** If any layers are invisible, a warning box appears asking if you want to discard the hidden layers. If so, click OK.

 The entire layered file is flattened into one layer (**Figure 5.27**).

✓ Tip

■ If there's any chance you may eventually want to make revisions to your layered image, always create a duplicate file before flattening so that the layers are safely preserved in your original. Once you've flattened, saved, and closed a file, there's no way to recover those flattened layers.

Converting and Duplicating Layers

You now know that you can create a new layer using the Layer > New command; in addition, Photoshop Elements creates layers in all sorts of sneaky ways. For example, whenever you copy and paste a selection into an image, it's automatically added to your image on a brand-new layer.

When you start editing an image, you'll often find it convenient to create a selection and convert it to a layer to keep it isolated and editable within your photo. It's also quite easy to duplicate a layer, which is useful when you want to copy an existing layer as is, or use it as a starting point and then make additional changes.

The background layer is unique and by default can't be moved, but sometimes you will need to move it, change its opacity, or apply a blending mode. To do any of those things, you'll need to convert it to a regular layer. And sometimes you'll want to convert an existing layer to the background. Although these conversions are not necessary for most simple photo projects, they are quite common when you combine or make composite images.

To convert a selection to a layer:

- **1.** Make a selection using any of the selection tools (**Figure 5.28**).
- **2.** From the Layer menu, choose New; then choose one of the following commands:
 - ▲ To copy the selection, choose Layer via Copy (Ctrl+J) (**Figure 5.29**). The selection is copied to a new layer, leaving the original selection unchanged (**Figure 5.30**).

Figure 5.28 Any selected area can be converted to its own layer.

Figure 5.29 Choose Layer > New > Layer via Copy to copy the selection to a new layer.

Figure 5.30 Copying a selection to a new layer leaves the original selection unchanged.

Figure 5.31 The Layer via Cut command cuts the selection to a new layer.

▲ To cut the selection, choose Layer via Cut (Shift+Ctrl+J).

The selection is cut to a new layer, leaving a gaping hole in the original layer, with the current background color showing through (**Figure 5.31**).

Removing a Halo from an Image Layer

Often when you create a new image layer from a selection, you'll find that you've inadvertently selected pixels that you didn't want to be included. This is a particularly common problem when you're trying to remove an image from its background using the Magic Wand or Magic Selection Brush tools. On close inspection you may find that what you thought was a clean selection, actually includes a *halo* of colored background pixels. New to Photoshop Elements 4.0 is a simple little function that can help to eliminate those troublesome halos.

Once you've pasted your selection into its new layer, choose Adjust Color from the Enhance menu, and then choose Defringe Layer from the Adjust Color submenu. In the Defringe dialog box, enter a the pixel width to control how much of the border of your image you want to affect—for high resolution images, I usually start with around 5. Then, just click OK to see the results in the image window (**Figure 5.32**). If you're not happy with the results, undo the operation by pressing Ctrl+Z, then repeat the steps, entering a new pixel width in the Defringe dialog box.

Figure 5.32 When zoomed in, it's apparent that the old, weathered baseball I've cut and pasted carried with it a halo of the background it was resting on (left). After applying Defringe, the colored halo has disappeared (right).

To duplicate a layer:

- **1.** Select the layer on the Layers palette.
- **2.** Duplicate the layer using *one of the following methods:*
 - ▲ If you want to create a new name for the layer, choose Layer > Duplicate Layer.
 - The Duplicate Layer dialog box appears, where you can rename the layer (**Figure 5.33**). Note that you can also get to this dialog box from the Layers palette menu.
 - ▲ If you're not concerned with renaming the layer right now, just drag the selected layer to the New Layer icon on the Layers palette (**Figure 5.34**). The new layer appears right above the original layer with a "copy" designation added to the layer name (**Figure 5.35**).

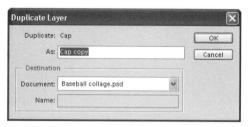

Figure 5.33 Use the Duplicate Layer dialog box to rename your new duplicate layer.

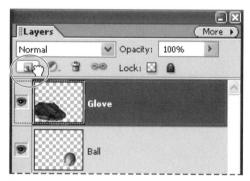

Figure 5.34 You can also duplicate a layer by dragging any existing layer to the New Layer icon on the Layers palette.

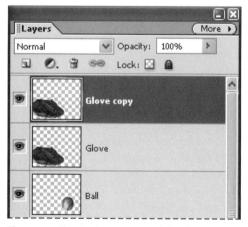

Figure 5.35 The new layer appears right above the original layer on the Layers palette.

Figure 5.36 You can convert the background to a layer and rename it during the conversion.

Figure 5.37 You can convert a layer to a background by choosing Layer > New > Background From Layer.

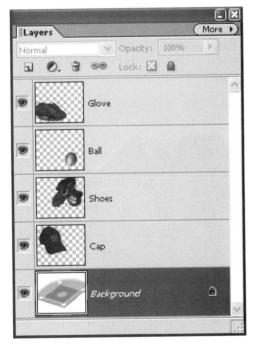

Figure 5.38 New background layers always appear at the bottom of the Layers palette.

To convert a background to a layer:

- **1.** From the Layer menu, choose New > Layer from Background.
- **2.** If desired, type a new name for the layer and click OK (**Figure 5.36**).

✓ Tip

■ You can also convert the background by double-clicking the background on the Layers palette, which brings up the same New Layer dialog box.

To convert a layer to a background:

- 1. Select a layer on the Layers palette.
- **2.** From the Layer menu, choose New > Background From Layer (**Figure 5.37**).
- **3.** The new background appears at the bottom of the Layers palette (**Figure 5.38**).

✓ Tips

- The Type and Shape tools also each automatically generate a new layer when you use them, keeping those elements isolated on their own unique layers.
- The Background From Layer command won't work if you already have an existing background layer in your Layers palette. Why? Because no image can have two background layers at the same time. To get around this, create a duplicate of the current background layer (you can rename it later). You can then safely delete the background layer, then follow steps 1–2 to convert a regular layer into a background.

Copying Layers Between Images

It's extremely easy to copy layers from one Photoshop Elements document to another. If you're used to the drag-and-drop technique, you'll be glad to know that this works really well for copying layers as well as selections. Remember that as you copy and paste selections they end up on their own layers. So, layers often contain unique objects that you can easily share between photos.

To drag and drop a layer from the Layers palette:

- 1. Open the two images you plan to use.
- **2.** In the source image, select the layer you want to copy by clicking it in the Layers palette.
- **3.** Drag the layer's name from the Layers palette into the destination image (**Figure 5.39**).

The new layer appears both in the image window and on the Layers palette of the destination image (**Figure 5.40**). When you drag a layer from one image into another, the original, source image is not changed. The layer remains intact.

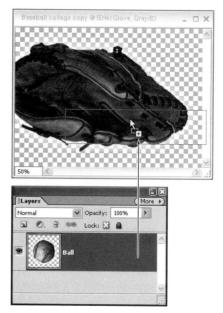

Figure 5.39 To copy a layer, just drag it from the Layers palette and drop it directly onto another image.

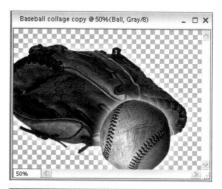

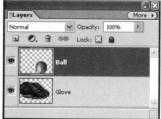

Figure 5.4o The new layer appears directly above the previously selected (active) layer in the destination image and in the Layers palette.

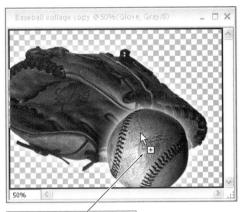

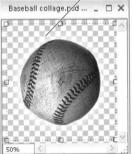

Figure 5.41 The Move tool lets you select and duplicate a layer from within the image window.

To drag and drop a layer using the Move tool:

- 1. Open the two images you plan to use.
- Select the Move tool, and then in the source image window, select the layer you want to copy by clicking it. You can also select the layer by clicking its thumbnail in the Layers palette.
- **3.** With the Move tool still selected, drag the actual image layer from the source image window to the destination image (**Figure 5.41**).

The copied layer appears on the Layers palette immediately above the previously active layer.

✓ Tip

■ In some cases, the layer in your source image may be larger than the destination image, in which case not all of the layer will be visible. Just use the Move tool to bring the desired area into view.

To copy and paste a layer between images:

- 1. In the source image, select the layer you want to copy from by clicking it either in the Layers palette or the image window.
- **2.** Choose Select > All to select all of the pixels on the layer, or press Ctrl+A.
- **3.** Choose Edit > Copy to copy the layer to the clipboard, or press Ctrl+C.
- 4. In the destination image, choose Edit > Paste, or press Ctrl+V.
 The contents of the copied layer will appear in the center of the destination

image.

Transforming Layers

You can also scale (resize), rotate, and distort layer images. They can be altered either numerically, by entering specific values on the options bar, or manually, by dragging their control handles in the image window. Constrain options, such as proportional scaling, are available for most transformations, and a set of keyboard shortcuts helps to simplify the process of adding distortion and perspective.

To scale a layer image:

- Click a layer in the Layers palette to make it active; then from the Image menu, choose Transform > Free Transform, or press Ctrl+T.
 - The options bar changes to show the scale and rotation text boxes and the reference point locator (**Figure 5.42**).
- **2.** On the options bar, click to set a reference point location.
 - The reference point determines what point your layer image will be scaled to: toward the center, toward a corner, and so on (**Figure 5.43**).
- **3.** If you want to scale your layer image proportionately, click the lock icon between the width and height text boxes.
- **4.** Enter a value in either the height or width text box.
 - The layer image is scaled accordingly.
- On the options bar, click the Commit Transform button (Figure 5.44), or press Enter.
- Click the Commit Transform button a second time (or press Enter) to deselect the layer image and hide the selection border.

Figure 5.42 Precise scale and rotation values can be entered for any shape.

Figure 5.43 These rectangles are both being reduced in size by about half. The one on the left is scaled toward its upper-left corner, and the one on the right is scaled toward its center.

Figure 5.44 The Commit Transform button scales the layer image to the size you define.

✓ Tips

- You can scale a layer image manually by selecting it with the Move tool and then dragging any one of the eight handles on the selection border. Constrain the scaling by holding down the Shift key while dragging one of the four corner handles.
- If you want to simply reposition a layer image in the image window, click anywhere inside the image with the Move tool and then drag the image to its new position.

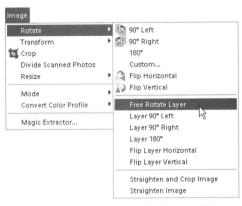

Figure 5.45 You can apply any of the layer rotation menu commands to a layer image.

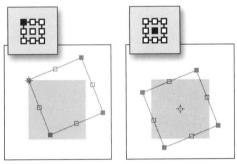

Figure 5.46 These rectangles are both being rotated about 20 degrees. The one on the left is rotated around its upper-left corner, and the one on the right is rotated around its center.

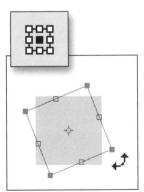

Figure 5.47 Rotate any layer image manually by dragging it around its reference point with the rotation pointer.

To rotate a layer image:

- 1. Click a layer in the Layers palette to make it active; then from the Image menu, choose Rotate > Free Rotate Layer (Figure 5.45).
 - The options bar changes to show the scale and rotation text boxes and the reference point locator.
- **2.** On the options bar, click to set a reference point location.
 - The reference point determines the point that your layer image will be rotated around (**Figure 5.46**).
- **3.** Enter a value in the rotate text box. The image will rotate accordingly.
- **4.** On the options bar, click the Commit Transform button, or press Enter/Return.
- **5.** Click the Commit Transform button a second time (or press Enter/Return) to deselect the layer image and hide the selection border.

✓ Tips

- To rotate your layer image in 90- or 180degree increments or to flip it horizontally or vertically, choose Image > Rotate; then choose from the list of five menu commands below the Free Rotate Layer command.
- You can rotate a layer image manually by selecting it with the Move tool and then moving the pointer outside of the selection border until it becomes a rotation cursor (**Figure 5.47**). Drag around the outside of the selection border to rotate the image. In addition, you can constrain the rotation to 15-degree increments by holding down the Shift key while dragging the rotation cursor.

To distort a layer image:

- 1. Click a layer in the Layers palette to make it active. From the Image menu, choose Transform; then choose Skew, Distort, or Perspective (**Figure 5.48**).
- 2. On the options bar, check that the reference point location is set to the center.

 The reference point can, of course, be set to any location, but the center seems to work best when applying any of the three distortions.
- **3.** Drag any of the layer image's control handles to distort the image.

 Dragging the control handles will yield different results depending on the distort option you choose (**Figure 5.49**).
- **4.** On the options bar, click the Commit Transform button, or press Enter/Return.
- Click the Commit Transform button a second time (or press Enter/Return) to deselect the image layer and hide the selection border.

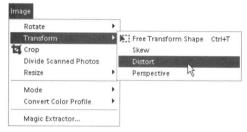

Figure 5.48 Choose one of the three specific transformation commands.

Figure 5.49 The same square layer image transformed using Skew (left), Distort (center), and Perspective (right).

Figure 5.50 Two separate layers (top) compose this simple folk instrument collage. The lower-left image displays the top layer with an opacity setting of 100 percent. The lower-right image displays the top layer with an opacity setting of 50 percent.

Figure 5.51 The image on the left contains no blending modes; the image on the right displays the top layer with the Difference blending mode applied.

About Opacity and Blending Modes

One of the most effective and simple ways to enhance your layered image is to create the illusion of combining one layer's image with another by blending their pixels. This differs from merging layers because the layers aren't physically merged, but rather appear to mix together. Photoshop Elements provides two easily accessible tools at the top of the Layers palette that can be used alone or in tandem for blending multiple layers together: the Opacity slider and the Blending Modes dropdown menu. The Opacity slider controls the degree of transparency of one layer over another. If a layer's opacity is set at 100 percent, the layer is totally opaque, and any layers beneath it are hidden. If a layer's opacity is set to 30 percent, 70 percent of any underlying layers are allowed to show through (Figure 5.50).

Blending modes are a little trickier. Whereas Opacity settings strictly control the opaqueness of one layer over another, blending modes act by mixing or blending one layer's color and tonal value with the one below it. The Difference mode, for example, combines one layer's image with a second, and treats the top layer like a sort of negative filter, inverting colors and tonal values where dark areas blend with lighter ones (**Figure 5.51**). For a complete gallery of Photoshop Elements' blending modes, see the color plates section of this book.

To set a layer's opacity:

- On the Layers palette, select the layer whose opacity you want to change (Figure 5.52).
- **2.** To change the opacity, *do one of the following*:
 - ▲ Enter a percentage in the Opacity text box, which is located at the top of the Layers palette.
 - ▲ Click the arrow to activate the Opacity slider and then drag the slider to the desired opacity (**Figure 5.53**).

✓ Tips

- You can change the opacity settings in 10 percent increments directly from the keyboard. With a layer selected on the Layers palette, press any number key to change the opacity: 1 for 10 percent, 2 for 20 percent, and so on. Also, as in Photoshop, pressing two number keys in rapid succession will work, e.g., 66 percent. If this doesn't seem to be working, make sure that you don't have a painting or editing tool selected in the toolbox. Many of the brushes and effects tools can be sized and adjusted with the number keys, and if any of those tools are selected, they take priority over the Layers palette commands.
- A background layer contains no transparency, so you can't change its opacity until you first convert it to a regular layer (see "To convert a background to a layer" earlier in this chapter).

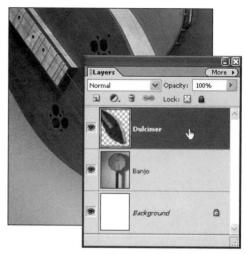

Figure 5.52 The top layer is selected on the Layers palette. Its opacity is set at 100 percent.

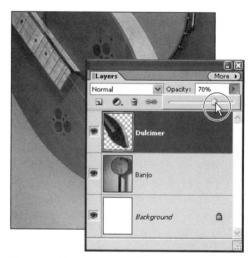

Figure 5.53 You can change a layer's opacity from 0 to 100 percent by dragging the Opacity slider.

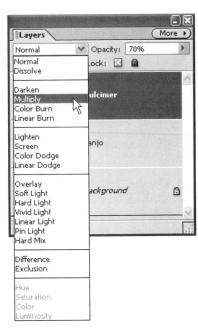

Figure 5.54 Select a blending mode from the Layers palette's Blending Mode menu.

To apply a blending mode to a layer:

- 1. On the Layers palette, select the uppermost layer to which you want to apply the blending mode.
 - Remember that blending modes work by mixing (blending) the image pixels of one layer with the layers below it, so your project will need to contain at least two layers in order for a blending mode to have any effect.
- **2.** Select the desired blending mode from the Blending Mode drop-down menu (**Figure 5.54**).

The image on the layer to which you've applied the blending mode will appear to mix with the image layers below.

✓ Tip

■ You can apply only one blending mode to a layer, but it's still possible to apply more than one blending mode to the same image. After assigning a blending mode to a layer, duplicate the layer and then choose a different blending mode for the duplicate. There are no hard-and-fast rules to follow, and the various blending modes work so differently with one another that getting what you want is largely an exercise of trial and error. But a little experimentation with different blending mode combinations (and opacities) can yield some very interesting effects that you can't achieve any other way.

Creating Masking Effects with Layer Groups

Layer groups provide a simple and quite intuitive way to create a sophisticated masking effect in Photoshop Elements. Any object placed on a layer, including photographic images and lines of editable text, can be used as the basis for masking any number of layer objects above it. Think of the lower, or base layer, as a window through which the upper layers are allowed to show through. So, for example, you could have a favorite fishing trip photo framed within the shape of a boat or fish, or a photograph of a forest placed within the word TREES (Figure 5.55). Once grouped, any layer within the group can be repositioned independently of the others, or the entire group can be linked and moved as one.

To create a layer group:

1. On the Layers palette, identify the layer that you want to use as your base layer (**Figure 5.56**).

Your layers must be arranged so that the layer (or layers) you want to group are directly above the base layer.

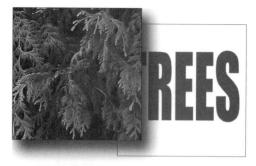

Figure 5.55 This project is composed of two layers: a photograph of cedar branches and the TREE text layer. The branches photo completely covers the text layer in the image on the left, but when grouped with the TREES layer, the branches peek through only where the text is visible.

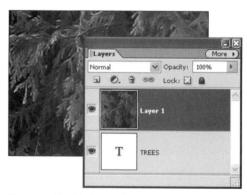

Figure 5.56 In this figure, the TREES text layer serves as the base layer. It will soon be grouped with the branches layer (Layer 1), which is selected directly above it.

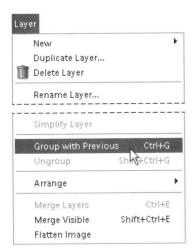

Figure 5.57 Choose Group with Previous to create a layer group.

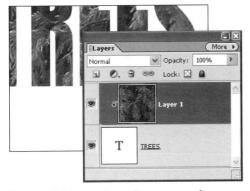

Figure 5.58 A Grouped Layer icon appears after a layer group is created.

2. Still on the Layers palette, select the layer above the base layer; then from the Layer menu choose Group with Previous (Figure 5.57), or press Ctrl+G.

The two layers are now grouped, and the upper layer is visible only in those areas where the base layer object is present.

On the Layers palette, the base layer's name is underlined, and the grouped layer's name and thumbnail are indented.

An icon, placed to the left of the thumbnail, further identifies grouped layers

(Figure 5.58). To ungroup layers:

- **1.** On the Layers palette, select the base layer.
- **2.** From the Layer menu, choose Ungroup, or press Shift+Ctrl+G.

Applying Effects with Layer Styles

With Layer styles, you can add editable effects to individual layers within an image, and you can be as conservative or as wild as your heart desires. For example, you can add a subtle drop shadow to an object, or you can go in the opposite direction and set your friend's hair ablaze with the Fire layer style. Beveled edges, glowing borders, and even custom textures can all be applied to any object or text layer. The Layer Styles palette contains a series of style sets, grouped as galleries and accessed from the palette's dropdown menu. Once you've applied a layer style, you can choose to keep it as an active element of a layer and return to and adjust it at any time; or you can choose to merge the layer object and style together to simplify the layer. For a gallery of Photoshop Layer Styles, see the color plates section of this book.

To apply a layer style:

- 1. On the Layers palette, choose the layer to which you want to apply the layer style (**Figure 5.59**).
- **2.** To open the Layer Styles palette *do one of the following*:
 - From the Window menu, choose Styles and Effects.
 - Click the arrow on the Styles and Effects palette tab in the palette bin.
- **3.** From the Category drop-down menu on the Styles and Effects palette, choose Layer Styles (**Figure 5.60**).
- 4. From the Library drop-down menu, choose a style set (Figure 5.61).
 The set you choose presents a gallery from which you can select a specific style.

Figure 5.59 You must select a layer before you can apply a layer style.

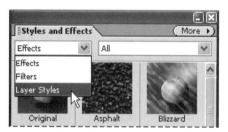

Figure 5.60 The Category drop-down menu allows you select Effects, Filters, and Layer Styles all from the same palette.

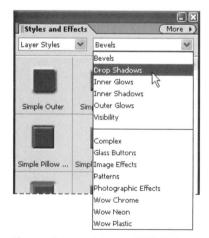

Figure 5.61 Layer styles are divided into different style sets that you can select from the Library drop-down menu.

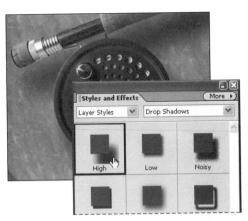

Figure 5.62 Choose a style from the palette gallery to instantly apply the style to a layer.

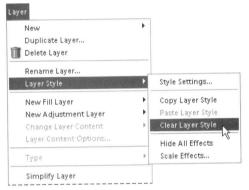

Figure 5.63 Clear all styles on a layer with the Clear Layer Style menu command.

5. In the style gallery, click the style you want to apply to your layer.
The style is instantly applied to the layer object in the image window (Figure 5.62), and a Layer Style icon appears next to the layer name on the Layers palette.

To remove a layer style:

 From the Layer menu, choose Layer Style > Clear Layer Style (Figure 5.63).
 The Clear Layer Style command will remove all styles from the layer, no matter how many have been applied.

✓ Tips

- Multiple layer styles can be assigned to a single layer; however, only one layer style from each set can be assigned at a time. In other words, you can assign a drop shadow, bevel, and outer glow style to the same layer all at once, but you can't assign two different bevel styles at the same time.
- Layer styles can only be applied to images or text on a regular, transparent layer. If you try to apply a layer style to a background, a warning box will ask if you want to first make the background a layer. Click OK and the background will be converted to a layer; your chosen layer style will automatically be applied.
- Elements will allow you to apply a layer style to a blank layer, but the layer style won't have any effect until text or an image is placed on the layer. When you place something on a layer with a previously assigned layer style, it will display with the layer style's attributes: drop shadow, beveled edge, and so on.

To edit a layer style:

- On the Layers palette, double-click the Layer Style icon to the right of the layer name (Figure 5.64).
 - The Style Settings dialog box opens.
- **2.** Make sure that the Preview box is selected; then refer to the image window while dragging the active size and distance sliders (**Figure 5.65**).

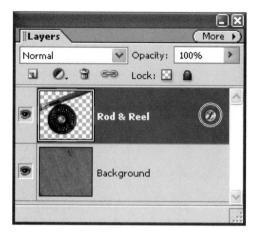

Figure 5.64 When a layer style is applied, a Layer Style icon appears to the right of the layer name.

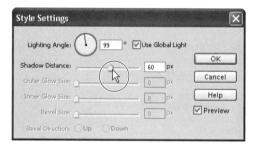

Figure 5.65 Use sliders in the Style Settings dialog box to modify the shadow, glow, and bevel styles.

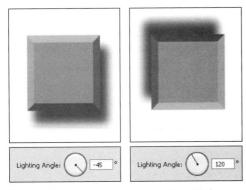

Figure 5.66 The Lighting Angle wheel sets a light source for any bevel or drop shadow styles you apply to a layer, and can be set to light any object from any angle.

The Style Settings Dialog Box

Not all of the layer styles can be adjusted. But using a series of sliders, a wheel, check boxes, and radio buttons you *can* make adjustments to drop shadows, inner and outer glows, and bevels styles. Here then is a quick tour of the Style Settings dialog box controls. (The distance and size slider values are all based on units of pixels.)

- ◆ The Shadow Distance slider quite simply controls the distance that a drop shadow is placed from an object. The larger the number, the more shadow is exposed from behind an object. If the distance is set to 0, the shadow is centered directly under the object and isn't visible.
- The Outer Glow Size slider lets you increase or decrease the amount of glow radiating out from the edges of an object.
- ◆ The Inner Glow Size slider lets you increase or decrease the amount of glow radiating in from the edges of an object.
- ◆ The Bevel Size slider controls the amount of beveled edge on your object. An inside bevel of 3 will be almost imperceptible, whereas larger values create an increasingly more pronounced bevel effect.
- ◆ The Lighting Angle wheel controls the direction of the light source when a bevel or shadow style is applied. Changing the light angle will change which beveled surfaces are in highlight and which are in shadow, and will also control where a drop shadow falls behind an object (Figure 5.66).

continues on next page

- ◆ The Use Global Light check box works only if you have bevel or shadow styles applied to more than one layer. If the check box is selected, all the layers will share the same light source; if the light source is changed on one layer (with the Lighting Angle wheel), the light source on all the layers changes at the same time. If the check box is left unselected, a light source can be set independently for each layer (**Figure 5.67**).
- The Bevel Direction radio buttons control the appearance of a bevel style. If the Up button is selected, the bevel will appear to extrude or come forward; if the Down button is selected, the bevel will appear to recede (Figure 5.68).

Once you've applied a layer style, you can return to it at any time to modify it, but you also have the option of merging the layer style with its layer by *simplifying*. In effect, simplifying is like flattening an individual layer. Simplifying a layer permanently applies a layer style to its layer and can help to reduce the complexity and file size of your project.

To simplify a layer:

- **1.** On the Layers palette, click to select the layer you want to simplify.
- 2. From the palette menu on the Layers palette, choose Simplify Layer (Figure 5.69).

The layer style is merged with the layer, and the Layer Style icon disappears from the layer on the Layers palette.

Figure 5.67 When the Global Light check box is selected, layer styles on multiple layers will all share the same light source (left). When the check box is deselected, a different light source can be set for each individual layer (right).

Figure 5.68 When the bevel direction is set to Up, the object bevel appears to come forward (left). When the bevel direction is set to Down, the object bevel appears to recede into the distance (right).

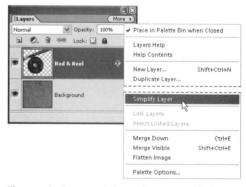

Figure 5.69 Once a style is set the way you like it, you can permanently apply it to a layer object by simplifying the layer.

Figure 5.70 Once you've selected a layer, click the Create Adjustment Layer button at the top of the Layer menu.

About Fill Layers

By now you may have noticed that the Adjustment Layer drop-down menu includes not only tonal correction options such as Levels, but a list of three layer fill options: Solid Color, Gradient, and Pattern. Follow my lead and ignore these options. They don't do anything that can't be accomplished by simply creating a new layer and applying a fill or pattern—except that they do it with more overhead, because adjustment layers require more processing power and create larger files than regular layers.

Making Color and Tonal Changes with Adjustment Layers

Adjustment layers let you make color and tonal adjustments to your image (much like the commands discussed in Chapter 3, "Changing and Adjusting Colors") without changing the actual pixels in your image. Adjustment layers work like filters, resting above the actual image layers and affecting any image layers below them. They can be especially useful when you want to experiment with different settings or compare the effects of one setting over another. Because you can apply opacity and blending mode changes to adjustment layers (just as you would to any other layer), they offer a level of creative freedom not available from their menu command counterparts. For instance, vou can create a Levels adjustment layer above an image, and then change the opacity of that adjustment layer to fine-tune the amount of tonal correction applied to the image.

To create an adjustment layer:

- 1. On the Layers palette, identify the topmost layer to which you want the adjustment layer applied, and then select that layer.
 - Remember that the adjustment layer affects all layers below it on the Layers palette, not just the one directly below it.
- 2. At the top of the Layers palette, click the Create Adjustment Layer button (Figure 5.70).

continues on next page

3. From the drop-down menu, choose from the list of adjustment layer options (**Figure 5.71**).

When you choose an adjustment layer option, its dialog box opens, and a new adjustment layer is created above the selected layer (**Figure 5.72**).

4. Use the dialog box sliders to adjust the settings, and then click OK to close the dialog box.

If you want to return to the adjustment layer dialog box later, just double-click its layer thumbnail on the Layers palette. By default, an adjustment layer affects all the layers below it in the Layers palette. But if you create a layer group, the effects of the adjustment layer will be limited to one specific layer.

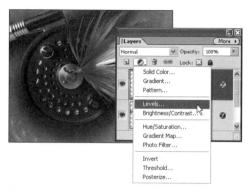

Figure 5.71 Choose an adjustment command from the drop-down menu.

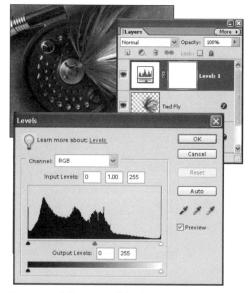

Figure 5.72 Adjustment dialog boxes appear when applicable and mirror the dialog boxes available from the main application menus.

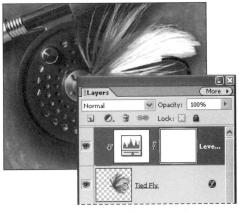

Figure 5.73 In the top image, the Levels adjustment layer is shown applied to every layer in the project. In the bottom image, the adjustment layer has been grouped with the object layer directly below it and so affects only that layer.

To apply an adjustment layer to a single layer:

- **1.** In the Layers palette, move the adjustment layer so that it's directly above the layer you want it applied to.
- 2. With the adjustment layer still selected in the Layers palette, choose Group with Previous from the Layer menu, or press Ctrl+G.

The adjustment layer and the one directly below it are grouped, and the effects of the adjustment layer are applied only to that single layer (**Figure 5.73**).

Using the Undo History Palette

The Undo History palette lets you move backward and forward through a work session, allowing you to make multiple undos to any editing changes you've made to your image. Photoshop Elements records every change and then lists it as a separate entry, or *state*, on the palette. With one click, you can navigate to any state and then choose to work forward from there, return again to the previous state, or select a different state from which to work forward.

To navigate through the Undo History palette:

- **1.** To open the Undo History palette, *do one* of the following:
 - ▲ From the Window menu, choose Undo History.
 - ▲ From the palette bin, click the arrow on the Undo History palette tab.
- **2.** To move to a different state in the Undo History palette, *do one of the following*:
 - Click the name of any state.
 - Drag the palette slider up or down to a different state (**Figure 5.74**).

✓ Tips

■ The default number of states that the Undo History palette saves is 20. After 20, the first state is cleared from the list, and the palette continues to list just the 20 most recent states. The good news is that, at any time, you can bump the number of saved states up to 100, provided that your computer has enough memory. From the Edit menu, choose Preferences > General; then in the Preferences dialog box enter a larger number in the Undo History States field.

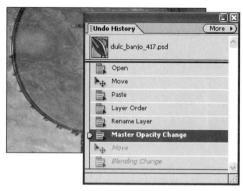

Figure 5.74 Use the palette slider to move to virtually any point in time in the creation of your project.

■ If, on the other hand, memory is at a premium (and you'd rather Photoshop Elements not clog up your precious RAM by remembering your last 20 selections, brushstrokes, and filter effects), set the number in the Undo History States field to 1. You can still undo and redo your last action as you work along, but for all practical purposes, the Undo History palette is turned off.

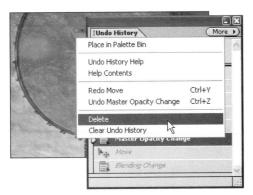

Figure 5.75 Delete any state by selecting it and choosing Delete from the palette menu.

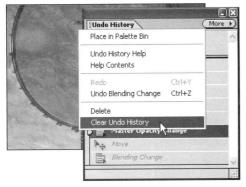

Figure 5.76 If system memory is a concern, you can periodically clear the palette of all states.

To delete a state:

 Click the name of any state; then choose Delete from the palette menu (Figure 5.75).

The selected state and all states following it are deleted.

✓ Tips

- Deletion of a state can be undone, but only if no changes are applied to the image in the interim. If you make a change to the image that creates a new state on the palette, all deleted states are permanently lost.
- Sometimes—when you're working on an especially complex piece, for instance—the Undo History palette may become filled with states that you no longer need to manage or return to, or that begin to take their toll on your system's memory. At any time, you can clear the palette's list of states without changing the image.

To clear the Undo History palette:

Do one of the following:

- From the palette menu, choose Clear Undo History (Figure 5.76).
 This action can be undone, but it doesn't reduce the amount of memory used by Photoshop Elements.
- Hold down the Alt key, then choose Clear History from the palette menu. This action cannot be undone, but it does purge the list of states from the memory buffer. This can come in handy if a message appears telling you that Photoshop Elements is low on memory.

FIXING AND RETOUCHING PHOTOS

How often have you thumbed through photo albums and found images you'd wished were better composed or lit more evenly? Or maybe you've sorted through shoeboxes from the attic, disappointed that time and age have taken their toll on those wonderful old photographs of your dad in his high school band uniform and your grandparents honeymooning at the lake. Until recently, there was no simple way to correct or repair photographs regardless of whether they were out of focus, water damaged, or poorly composed.

Happily, things have changed. Now, armed with little more than a desktop scanner and Photoshop Elements, anyone can retouch and restore old photographs. In this chapter, you learn not only how to straighten and crop a crooked scan, but how to repair a damaged photo, enhance focus and image detail, and even eliminate that troublesome red-eye effect. Although these topics are presented primarily in the context of fixing and correcting older, scanned photographs, the techniques presented here work equally well when retouching images captured with a digital camera.

Cropping an Image

The one thing that you'll want to do with nearly every image is crop it. In spite of all the wonderful advances in film and digital cameras, rarely is a picture taken with its subjects perfectly composed or its horizon line set at just the proper level. More often than not, subjects are off-center, and unwanted objects intrude into the edge of the picture frame. Take a hint from professional photographers, who almost always use cropping techniques to achieve that perfect composition. Photoshop Elements offers two simple and quick methods for cropping your images.

To crop an image using the Crop tool:

- Select the Crop tool from the toolbox (C) (Figure 6.1).
 When you move the pointer over your image, the pointer becomes the Crop tool.
- 2. In the options bar, click the Clear button to remove any entries in the Width, Height, or Resolution text boxes (Figure 6.2).
- **3.** In the image window, drag to define the area of the image you want to keep (**Figure 6.3**).

The image outside the selected area will be dimmed to indicate the portions that will be deleted.

Figure 6.1 The Crop tool.

Figure 6.2 The Clear button cancels any Crop tool settings from the options bar.

Figure 6.3 When you crop using the Crop tool, Photoshop Elements gives you visual feedback by highlighting the image that will be preserved and dimming the portions that will be deleted.

Figure 6.4 You can easily move and resize the area you choose to crop by dragging the handles around the perimeter of the cropping selection.

Figure 6.5 The Cancel and Commit current crop operation buttons appear on the lower edge of the crop selection.

Figure 6.6 The final, cropped image.

- **4.** If you want to modify your selection, move the pointer over one of the eight handles on the edges of the selection; then drag the handle to resize the selection (**Figure 6.4**).
- 5. When you're satisfied with your crop selection, double-click the pointer inside the selection, press Enter, or click the Commit current crop operation button on the lower corner of the selection (Figure 6.5).

The image is cropped to the area you selected (**Figure 6.6**).

If you're just not satisfied with your selection and want to start over, click the Cancel current crop operation button.

✓ Tip

■ You can define color and opacity options for the Crop tool shield (the dimmed area that surrounds your cropped selection) in the Display and Cursors area of the Preferences dialog box. The default color is black, and the default opacity is 75%.

The Crop Tool Size and Resolution options

It may have occurred to you that I've glossed over—okay, I've ignored—the Preset Options drop-down menu and Resolution text box in the options bar. Used together, in combination with the Crop tool, these two options can lead you down a slippery slope, introducing unexpected image quality problems—foremost among them, unwanted resolution *upsampling*, which creates a fuzzy, ghosted, and generally out-of-focus effect. For more information on upsampling, see the "Downsampling vs. Upsampling" sidebar in Chapter 2, "Creating and Managing Images."

As an example, open a 4" x 5" image with a resolution of 150 pixels per inch. Select the Crop tool, choose the 4" x 6" Preset Option from the drop-down menu, and enter 150 in the Resolution text box. Define the area that you want to crop (which by definition will be a smaller area than the original 4" x 5" image), and then crop. The area you crop from the original image, no matter the selected size, will be forced up to 4" x 6", and will introduce upsampling (**Figure 6.7**).

You can use the Preset Options drop-down menu to control the Width and Height ratios of your cropping selection; just leave the Resolution text box blank, and use the Image Size dialog box (after you crop) to set the image resolution.

Figure 6.7 Caution should be taken when using the Crop tool's size and resolution options. In this example, an image was cropped with a final size defined that was larger than the original image (top). During cropping, the image was *upsampled*, and image quality was sacrificed (bottom).

Figure 6.8
The Rectangular
Marquee tool.

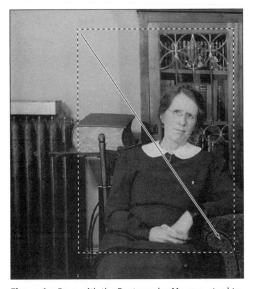

Figure 6.9 Drag with the Rectangular Marquee tool to define the part of the image you want to crop.

Figure 6.10 You can crop in one simple action by choosing Crop from the Image menu.

To crop an image using the Rectangular Marquee tool:

- **1.** Select the Rectangular Marquee tool from the toolbox, or press M (**Figure 6.8**).
- 2. In the image window, drag to define the area of the image you want to keep (Figure 6.9).
- **3.** From the Image menu, choose Crop (**Figure 6.10**).

The image is cropped to the area you selected (**Figure 6.11**).

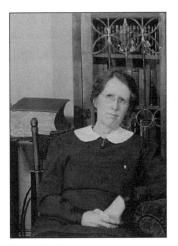

Figure 6.11 The final, cropped image.

Straightening a Scanned Image

If your experience is anything like mine, you know that it's next to impossible to scan a perfectly straight image. Some little gust of wind or seismic anomaly almost always seems to accompany the lowering of the scanner cover. The Straighten Image command works well for quick fixes, and the Crop tool offers more control for small or subtle adjustments, or in cases where you may want to change the alignment of an image for emphasis or a special effect.

To straighten a scanned image automatically:

From the Image menu, choose one of the following:

- Rotate > Straighten and Crop Image (Figure 6.12).
- Rotate > Straighten Image.

The Straighten and Crop Image command will do its best to both straighten the image and delete the extra background surrounding the image. The Straighten Image command simply straightens without cropping (**Figure 6.13**).

Both methods have their own sets of limitations. Rotate and Straighten works best if there is a space of at least 50 extra pixels or so surrounding the image. If this surrounding border is much smaller, Photoshop Elements can have a difficult time distinguishing the actual photograph from the border and may not do a clean job of cropping.

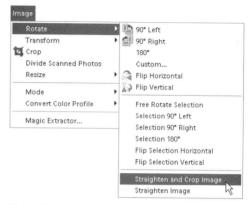

Figure 6.12 From the Image menu, you can straighten and crop an image in one step.

Figure 6.13 A scanned image (top) can be automatically straightened (center) or straightened and cropped (bottom).

Figure 6.14 After you define a preliminary cropping selection (left), you can rotate the selection so that it aligns with your image border (right).

Figure 6.15 Make final adjustments to your cropping selection (left) before Photoshop Elements automatically crops and straightens the image.

Although you'll still need to manually crop your image after using the Rotate > Straighten Image command, this method is probably a better choice, because you avoid the risk of Photoshop Elements indiscriminately cropping out areas of your image you may want to keep. For the surest control, however, straighten your images using the Crop tool as described in the next procedure.

To straighten a scanned image using the Crop tool:

- **1.** Select the Crop tool from the toolbox.
- **2.** In the image window, drag to select the area of the image you want to crop and straighten.
- **3.** Move the pointer outside the edge of the selection area until it changes to a rotation pointer (**Figure 6.14**).
- **4.** Drag outside of the selection until its edges are aligned with the image border.
- **5.** Drag the selection handles, as necessary, to fine-tune the positioning; then press Enter/Return (**Figure 6.15**).

The image is cropped and automatically straightened.

Straightening a Crooked Photo

Sometimes even your most carefully composed digital camera photos may be just a little off angle, with a not quite level horizon line or portrait subjects all tilting to one side or another. Photoshop Elements' nifty little Straighten tool makes short work out of getting your crooked digital photos back into alignment.

- **1.** Select the Straighten tool from the toolbox, or press P (**Figure 6.16**).
- 2. Using a horizon line or other subject as a point of reference, click and drag from one side of the photo to the other.

 When you release the mouse button, your image will rotate and align along the new horizontal plane you defined (Figure 6.17).
- **3.** Use either the Crop or Marquee Selection tool to remove any extra border area introduced while straightening the photo.

Figure 6.16The Straighten tool.

Figure 6.17 With the Straighten tool, you simply click and drag in a tilted photo (top) to align it perfectly (bottom).

Figure 6.18 With just a little patience and Photoshop Elements' Clone Stamp and Healing Brush tools, dust specks, water spots, and even torn edges can be easily removed from old photos.

Repairing Flaws and Imperfections

Little maladies, such as torn edges, water stains, scratches, even specks of dust left on a scanner's glass, are the bane of the photoretouch artist, and are problems all too common when you set to the task of digitizing and restoring old photographs. To the rescue come three similar but distinctly different repair and retouch tools.

The Clone Stamp tool will quickly become one of your favorite tools, not just for cleaning up and restoring photographs, but for any number of special effects and enhancements. It works on the simple principle as copying and duplicating (cloning) image pixels from one part of an image to another. Although it is ideal for repairing tears or holes in photographs, it can also be used to add or duplicate objects in a photograph. For example, you can create a hedgerow from one small bush or add clouds to a cloudless sky.

The Spot Healing Brush tool is the perfect tool for removing small imperfections like dust or tiny scratches. With just a single click, the Spot Healing brush samples (copies) pixels from around the area of a trouble spot and creates a small patch that covers up the flaw and blends in smoothly with its surrounding area.

The Healing Brush tool operates like a combination of the Clone Stamp and Spot Healing Brush tools. As with the Clone Stamp tool, it first samples pixels from one area of your image to another. Then, like the Spot Healing Brush tool, it blends those pixels seamlessly together with the area you want to repair (**Figure 6.18**).

To retouch an image with the Clone Stamp tool:

- **1.** Select the Clone Stamp tool from the toolbox, or press S (**Figure 6.19**).
- 2. On the options bar, select a brush size using the brush Size slider (Figure 6.20). The brush size you choose will vary depending on the area you have available to clone from and the area that you're trying to repair. Larger brush sizes work well for larger open areas like skies or simple, even-toned backdrops, whereas smaller brushes work well for textured surfaces or areas with a lot of detail.
- 3. Move the pointer over the area of your image that you want to clone (the pointer becomes a circle, representing the brush size you've specified), and then hold down the Alt key.

 The pointer becomes a target (Figure 6.21).
- **4.** Click once to select the area you want to sample; then release the Alt key and move the pointer to the area to which you want the clone applied (**Figure 6.22**).
- **5.** Hold down the mouse button, and drag to "paint" the cloned portion over the new area.
 - The original image is replaced with a clone of the sampled image.

Figure 6.19 The Clone Stamp tool.

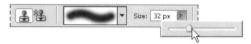

Figure 6.20 Choose any of Photoshop Elements' resizable brushes to apply your cloned repairs.

Figure 6.21 Once you've found an area of your image that you want to clone, simply hold down the Alt key and click to select it. Your pointer turns into a bull'seye target.

Figure 6.22 Drag the Clone Stamp tool over the portion of the image you want to replace (left). As you drag the Clone Stamp tool, crosshairs appear, providing a constant reference point as you paint over the image (right).

Figure 6.23 The Aligned option gives you control over where the Clone Stamp tool samples image pixels.

Figure 6.24 Using the image on the left as a source, the image in the middle was cloned with the Aligned option selected. Although the mouse button was released and depressed several times, the image was still copied *relative* to the initial sampling point. The image on the right was cloned with the Aligned option deselected. Notice that each time the mouse button was released and depressed, the clone again *started* from the initial reference point.

Figure 6.25 The Clone tool provides a controlled method for combining parts of one image with another. Here, with a little cloning from the image on the top left, this woman receives not only a newly papered wall, but a painting to hang on it as well.

To copy images from one picture to another with the Clone Stamp tool:

- **1.** Select the Clone Stamp tool from the toolbox and then select a brush size from the options bar.
- 2. Still on the options bar, check that the Aligned option is selected (**Figure 6.23**). With the Aligned option selected, the Clone Stamp tool will always copy pixels relative to the initial sampling point, even if you release the mouse button and press it again to continue. With the Aligned option deselected, each time you release the mouse button and press to resume cloning, you will copy pixels starting from the initial sampling point (**Figure 6.24**).
- **3.** Holding down the Alt key, click in the first picture to select the area you want to sample.
- **4.** Click the second picture's image window to make it active, and then drag to paint a clone of the sampled image.
- **5.** The original image in the second picture is replaced with a clone of the sampled image from the first (**Figure 6.25**).

✓ Tip

■ Before experimenting with the Clone tool, it's good practice to first create a new, blank image layer. Creating a separate layer not only protects your original image by leaving it unchanged, but it gives you more creative flexibility. You can apply different cloned areas to different layers and then compare the effect of each by turning the layer visibility settings off and on. And if you apply different cloned areas on separate layers, you can experiment further by applying different blending mode and opacity settings to each clone.

To clean up small areas with the Spot Healing Brush tool:

- **1.** Select the Spot Healing Brush tool from the toolbox, or press J (**Figure 6.26**).
- **2.** On the options bar, select a healing method from the two radio buttons (**Figure 6.27**).
 - ▲ Proximity Match samples pixels from around the edge of your brush shape to create the patch over the area you want to repair.
 - ▲ Create Texture uses the pixels directly beneath the brush shape to create a soft. mottled texture.
- 3. On the options bar, select a brush size using the brush Size slider.

 Try to size your brush to fit snugly around the flaw you're covering.
- **4.** Click and release the mouse button to apply the patch (**Figure 6.28**).

✓ Tip

Alternately, you can try to click and drag through a slightly larger area with the Spot Healing Brush tool, although I've had the best success with the one-click method described above.

Figure 6.26
The Spot Healing
Brush tool.

Figure 6.27 The Spot Healing Brush tool offers you a choice of two healing types.

Figure 6.28 With a single mouse click, each dust speck is removed.

Figure 6.29 The Healing Brush tool.

Figure 6.30 Although several healing modes are available, most times the Healing Brush tool works best with the default mode as Normal.

Figure 6.31 Once you've found an area of your image that you want to use as a patch, hold down the Alt key and click to select it. Your pointer turns into a bull'seye target.

Figure 6.32 As you drag the Healing Brush tool, crosshairs appear, providing a constant reference point as you paint over the area of the image you want to correct.

To remove flaws with the Healing Brush tool:

- **1.** In the toolbox, select the Healing Brush tool from beneath the Spot Healing Brush tool (**Figure 6.29**).
- 2. From the Mode drop-down menu on the options bar, check that Normal is selected (**Figure 6.30**).

Normal mode will blend sampled pixels with the area you're repairing to create a smooth transition with the area surrounding the repair. Replace mode does little more than duplicate the behavior of the Clone Stamp tool. For information on the other effect modes available from the drop-down menu, see "About Opacity and Blending Modes" in Chapter 5, "Working with Layers."

- 3. On the options bar, select a brush size using the brush Size slider.

 The brush size you choose will vary depending on the area you have available to sample from and the area that you're trying to repair.
- **4.** Move the pointer over the area of your image that you want to sample (the pointer becomes a circle, representing the brush size you've specified), and then hold down the Alt key.

The pointer becomes a target (**Figure 6.31**).

- Click once to select the area you want to sample; then release the Alt key and move the pointer to the area you want to repair.
- **6.** Hold down the mouse button, and drag to "paint" the sampled image over the new area (**Figure 6.32**).

The sampled image blends with the repair area to cover any flaws and imperfections.

Applying Patterns

Although some of Photoshop Elements' patterns can be a little gimmicky, others, like many of the fabric and rock textures, can be useful when you're trying to repair or retouch a damaged or aged photograph. For example, you might use one of the abstract stone patterns to camouflage a particularly damaged background in an old photo that would be difficult to salvage by any other method. Photoshop Elements provides a default set of patterns plus seven additional sets containing objects as varied as flowers, stone faces, and textured artist's surfaces. Patterns can be applied using two methods. If you have a large area of the same tonal value or color, you can use the Paint Bucket tool. On the other hand, if you have a smaller area made up of varying colors or textures, use the Pattern Stamp tool.

To apply a pattern to a selected area with the Paint Bucket tool:

- **1.** Select the Paint Bucket tool from the toolbox, or press K (**Figure 6.33**).
- **2.** On the options bar, select Pattern from the Fill drop-down menu (**Figure 6.34**).
- **3.** Still on the options bar, click to open the pattern picker (**Figure 6.35**).

Figure 6.33
The Paint Bucket tool.

Figure 6.34 Once you've selected the Paint Bucket tool, select Pattern from the options bar.

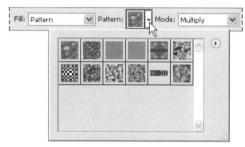

Figure 6.35 You can choose from a variety of patterns in the pattern picker on the options bar.

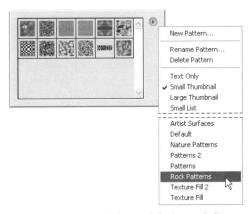

Figure 6.36 You can pick from a default sample list of patterns or load any one of seven additional pattern sets.

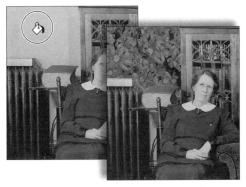

Figure 6.37 Click the Paint Bucket tool in any large area where you want to apply a pattern. Here, a floral pattern was selected to create brand-new living room wallpaper.

- **4.** Click to choose from the list of default patterns, or click the arrow button to the right of the thumbnail image to open the Pattern palette menu (**Figure 6.36**).
- 5. Select from the list of pattern sets in the bottom section of the menu.
 The pattern picker displays the new pattern library.
- **6.** Return to the image window and click in the area where you want to apply the pattern.

The pattern is painted in the image (**Figure 6.37**).

To apply a pattern with the Pattern Stamp tool:

1. In the toolbox, select the Pattern Stamp tool from beneath the Clone Stamp tool (**Figure 6.38**).

If you hold the Alt key while clicking the Clone Stamp tool in the toolbox, you can toggle between the Clone Stamp and Pattern Stamp tools. Or, if the Clone Stamp tool is already selected, you can select the Pattern Stamp tool from the options bar.

- 2. On the options bar, select a brush size using the brush Size slider (Figure 6.39). If you like, you can also make opacity and blending changes, just as you did for the Clone Stamp tool.
- **3.** Pick a pattern by following steps 3 through 5 in the previous procedure.
- **4.** Once you've chosen a pattern, return to the image window, hold down the mouse button, and then drag to paint the pattern in your image (**Figure 6.40**).

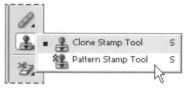

Figure 6.38 The Pattern Stamp tool is hidden underneath the Clone tool. Just right-click to access it.

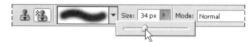

Figure 6.39 Choose a brush size appropriate for your image size and pattern.

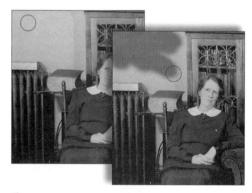

Figure 6.40 Position the pattern brush anywhere in your image to paint a pattern.

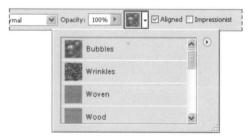

Figure 6.41 You can customize the views of the Pattern palette for easier browsing. The Large List view (shown here) combines easy-to-see thumbnails with descriptive pattern names.

Mount a Photo on an Artist's Canvas

You can create an interesting textured effect for almost any photo by using patterns from the Artist Surfaces set.

- **1.** In the Layers palette, create a new layer above your original photo layer.
- **2.** From the Pattern palette menu, choose the Artists Surfaces pattern set, and then choose from one of the artist surfaces.
- **3.** With the pattern layer selected, apply a blend mode (try Multiply) to combine the photo and pattern layers.
- **4.** If you like, adjust the pattern layer's opacity setting.

Your photo will appear to be printed on the textured artist surface (**Figure 6.42**).

Figure 6.42 Using one of the textured Artist Surfaces patterns, any photo can be made to appear printed or rendered on watercolor paper, canvas, or a variety of other fine art surfaces.

✓ Tips

- The Paint Bucket tool fills areas based on tonal value and color, so you'll have the most success filling areas composed of similar values, such as blank walls or clear, cloudless skies. You can adjust the behavior of the Paint Bucket tool by entering different values in the Tolerance text box on the options bar, but the results are a little unpredictable, and the process involves some trial and error.
- As with Photoshop Elements' Brushes palette, the Pattern palette offers several viewing options that you can access from the palette menu (Figure 6.41). In addition to the default mode of Small Thumbnail, you can view patterns as Text Only (a simple text list of the pattern names); Large Thumbnail (a larger version of the small thumbnails); Small List (tiny thumbnail views accompanied by their pattern names); or my personal favorite, Large List (similar to the Small List, but with nice, large thumbnail views). As a further aid, if Show Tool Tips (the default setting) is selected in the General Preferences dialog box, simply hover over any pattern thumbnail for a second or two to reveal a small pop-up descriptive name of that pattern.

Correcting Red Eye

If you're in an indoor or darkened space, your pupils grow larger to let in more light. The pupils can't shrink fast enough to compensate for a camera's flash, so when that light reflects off the back of the eye, it causes red eye. Many newer cameras have flashes that flicker before the picture is actually snapped, giving the subject's pupils a chance to dilate and greatly reduce the effects of red eye. But chances are that you still have some older photos lying around that you'd like to repair. The Red Eye Removal tool offers an effective way to remove red eye, simply by changing pixels from one color to another.

To remove red eye from a photograph:

- **1.** Select the Red Eye Removal tool from the toolbox, or press Y (**Figure 6.43**).
- 2. On the options bar, set the Pupil Size slider to match the proportional size of the pupil (the red part of the eye that you want to turn black) to the colored portion of the eye. Then, on the options bar, use the Darken Amount slider to control the darkness of the retouched pupil (Figure 6.44).

Although these settings are not inconsequential, the defaults of 50 percent work fine in the majority of cases I've tried.

- **3.** If necessary, zoom in on the area you want to correct, then click and drag to draw a selection over the colored portion of one eye (**Figure 6.45**).
- **4.** Release the mouse button to remove the red eye effect.

If you're not quite satisfied with the results the first time, press Ctrl+Z to undo the operation, and then repeat steps 2 through 4, revising the option bar settings or changing the size of the selection before you click and drag.

Figure 6.43
The Red Eye Removal tool.

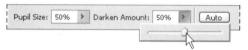

Figure 6.44 Two sliders on the options bar help you to adjust red eye removal.

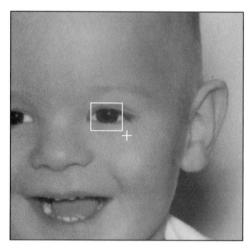

Figure 6.45 To remove red eye, simply draw a selection rectangle around the colored portion of the eye and release the mouse button.

✓ Tip

■ You may have noticed the Auto button to the right of the Darken Amount slider on the options bar. You're welcome to give it a try, although I've had mixed success with using it. The Red Eye Removal tool is really so simple to use on its own that I tend not to bother with the Auto button.

Sharpening Image Detail

Although most scanners do a pretty good job of capturing images, a little sharpness or crispness of detail seems to almost always get lost in the conversion process. If an original photo is even just slightly fuzzy, the act of converting it to pure, digital information may accentuate the detail enough to make the fuzziness even more noticeable when viewed on your computer screen. Even photos you've captured directly from a digital camera may not quite "pop" the way you'd like them to. In addition, any time you resize an image by resampling, pixels may be lost in the process, and so you also lose some degree of image detail.

Photoshop Elements offers several automatic sharpening options (Sharpen, Sharpen Edges, and Sharpen More), but all offer so little control that you may prefer not to use them. Instead, you may prefer the Unsharp Mask command, which offers plenty of control through an interactive, intuitive dialog box. The Unsharp Mask command works by finding pixels with different tonal values and then slightly increasing the contrast between those adjoining pixels, thereby creating a sharper edge. The resulting correction can help to enhance detail and bring blurred or fuzzy areas throughout an image into clearer focus.

To sharpen an image:

- From the Filter menu, choose Sharpen > Unsharp Mask to open the Unsharp Mask dialog box (Figure 6.46).
- **2.** Make sure that the Preview box is checked; then drag the sliders to adjust the image's sharpness.
 - ▲ The Amount slider sets the percentage of contrast that is applied to the pixels and so determines the degree of sharpness you apply. For high-resolution images (those above around 150 pixels per inch), set the Amount slider to between 150 and 200 percent. For lower-resolution images, use settings somewhere around 30 to 80 percent (Figure 6.47).

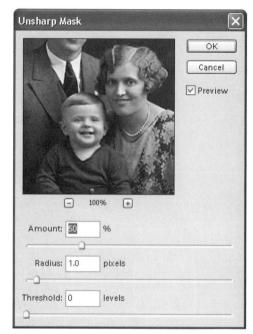

Figure 6.46 The Unsharp Mask dialog box contains sliders to adjust the degree of sharpening you apply to your image.

Figure 6.47 The Amount slider controls the percentage of sharpness applied to your image. The image on the left was corrected at 80 percent, and the one on the right was corrected at 150 percent.

Figure 6.48 The Radius slider controls the number of pixels that Photoshop Elements includes in any sharpened edge. Smaller numbers include fewer pixels, and larger numbers include more pixels. The image on the left was set to 1, and the image on the right was set to 6.

Figure 6.49 The preview area of the dialog box lets you view a specific area of your image so that you can see what affect your settings are having. Drag to move the preview to a different portion of your image.

- ▲ The Radius slider determines the number of pixels surrounding the contrasting edge pixels that will also be sharpened. Although the radius can be set all the way to 250, you should never have to enter a value higher than around 2, unless you're trying to achieve a strong, high-contrast special effect (**Figure 6.48**).
- ▲ The Threshold slider tells Photoshop Elements how different the contrasting pixels need to be before it should apply sharpening to them. A value of 0 sharpens the whole image; entering increasingly larger numbers sharpens only areas of higher contrast. For most purposes, you should leave the Threshold value set to 0.
- ▲ Use the preview area to see a detailed view of your image as you apply the changes. You can move to a different area of an image by holding down the mouse button and dragging with the hand pointer in the preview screen (**Figure 6.49**). You can also zoom in or out of an area using the minus and plus buttons below the lower corners of the window.
- **3.** When you're satisfied with the results, click OK to close the dialog box and apply the changes.

Enhancing Image Detail

The Unsharp Mask command works best on entire images or large portions of images, but a couple of tools are better suited for making sharpening and focus adjustments in smaller, more specific areas of an image. Not surprisingly, the Blur tool softens the focus in an image by reducing the detail, and the Sharpen tool helps bring areas into focus. Both tools can be further fine-tuned using controls on the options bar. You use both the Blur and Sharpen tools by dragging a resizable brush through the area that you want to affect. The brushes offer you precise control over where the blur or sharpness is applied, so the tools are ideal for subtle, special effects. For instance, you can create a sense of depth by blurring selected background areas while keeping foreground subjects in focus, or enhance the focus of a specific foreground subject so that it better stands out from others.

To blur a specific area or object:

- **1.** Select the Blur tool from the toolbox, or press R (**Figure 6.50**).
- 2. On the options bar, select a brush size using the brush Size slider.
 If you want, you can also select a blend mode and enter a Strength percentage.
 The higher the percentage, the more the affected area is blurred.
- 3. Move the brush pointer to the area of your image that you want to blur; then hold down the mouse button and drag through the area (Figure 6.51).
 As you drag, the area is blurred.

Figure 6.50 The Blur tool.

Figure 6.51 Drag the brush through the area you want to blur. You can resize the brush as you work on larger and smaller areas.

Figure 6.52 The Sharpen tool.

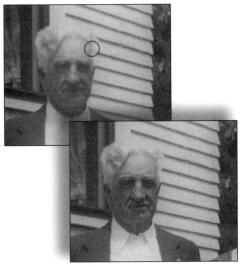

Figure 6.53 The gentleman's face in the original photo (top) is blurred and lacks definition and detail. After dragging the brush pointer through his face and collar, the sharpness and focus in those areas is greatly improved (bottom).

To sharpen a specific area or object:

- Select the Sharpen tool from the toolbox, or press R to toggle through the enhance tools to the Sharpen tool (Figure 6.52).
 If one of the enhance tools is already selected, you can also select the Sharpen tool from the options bar.
- 2. On the options bar, select a brush size. If you prefer, choose a blend mode and enter a Strength percentage. The higher the percentage, the more the affected area is sharpened.
- **3.** Move the brush pointer to the area of your image that you want to sharpen; then hold down the mouse button and drag through the area (**Figure 6.53**). As you drag, the area is sharpened.

✓ Tip

■ You can use the Blur and Sharpen tools together when you want to draw attention to a particular person or object. First, use the Blur tool to soften the focus and detail of the subjects that you want to appear to recede into the background. Then use the Sharpen tool to bring the subject of primary interest into sharp focus.

Blending Image Elements with the Smudge Tool

The Smudge tool is one of those specialty tools that's a little hard to classify. Traditionally, it's grouped with the Blur and Sharpen tools in Photoshop's toolbox and is often used for retouching tasks. The Smudge tool's closest cousin may be the Blur tool, because it can also be used to soften edges and transitions in an image. Its real strength lies in its ability to push and pull image pixels around in your picture. Drag the tool through an area, and its pixels smear and blend with the adjacent pixels as if you were pulling a brush through freshly applied paint. Use the Smudge tool in backgrounds and other areas where you may need to smooth flaws or imperfections and retaining detail isn't critical. With a little practice, you can also create some convincing painterly effects by varying the length and direction of the brushstrokes. As with the Blur and Sharpen tools, the Smudge tool's effects can be adjusted with controls on the options bar.

To use the Smudge tool:

- 1. Select the Smudge tool from the toolbox, or press R to toggle through the enhance tools to the Smudge tool (**Figure 6.54**).
- 2. On the options bar, select a brush size using the brush Size slider.
 Just as with the Blur and Sharpen tools, you can select a blend mode and enter a Strength percentage. The higher the percentage, the more the affected area is smudged.
- 3. Move the brush pointer to the area of your image that you want to smudge; then hold down the mouse button and drag through the area (Figure 6.55).
 As you drag, the area is softened and blended.

Figure 6.54 Photoshop Elements' Smudge tool.

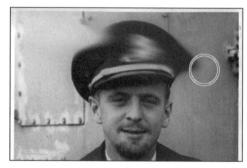

Figure 6.55 The Smudge tool can easily do more harm than good, so use it sparingly.

Tip

■ The Smudge tool tends to produce a more artificial effect than the other retouching tools, so use it with moderation. Unless your intent is to create a wet paint effect in a large portion of your image, limit use of the Smudge tool to repairing or smoothing small, unobtrusive areas. You don't want a small repair to become the focus of attention.

Using the Tonal Adjustment Tools

In traditional photography, technicians can control darkness and lightness values on specific parts of an image by masking off one area of film while exposing another. In the process, selected areas are either burned in (darkened) or dodged (lightened). Photoshop Elements' Burn and Dodge tools replicate this effect without the bother of creating masks. Instead, you simply drag an adjustable tool's brush pointer through the area you want to affect, leaving the rest of the image unchanged. If one portion of an image is dramatically overexposed or washed out, and another portion is underexposed, the Dodge and Burn tools can be used to target and correct just those specific problem areas. The Sponge tool, which works in much the same way as the Dodge and Burn tools, increases or decreases the intensity of the color. You can use the Sponge tool to bring colors back to life in badly faded, older photographs, or work in the opposite direction, pulling the color out of a newer photo and creating an antique, faded, or color-tinted effect.

To lighten a portion of an image with the Dodge tool:

- **1.** Select the Dodge tool from the toolbox, or press O to toggle through the tonal adjustment tools to the Dodge tool (**Figure 6.56**).
- 2. On the options bar, select a brush size using the brush Size slider (Figure 6.57). Choose a brush size appropriate to your image. For most images, a brush size between 20 to 40 pixels is a good place to start.

You can also select a specific tonal range to lighten (shadows, midtones, or highlights) and control the amount of lightness applied, using the Exposure setting (**Figure 6.58**).

3. Move the brush pointer to the area of your image that you want to lighten; then hold down the mouse button and drag through the area (**Figure 6.59**).

Figure 6.56 The Dodge tool.

Figure 6.57 Choose a brush size from the options bar.

Figure 6.58 Select the part of the tonal range you most want to affect with Photoshop Elements' tonal adjustment tools. With both the Dodge and Burn tools, you can choose to limit your changes to just the shadow, midtone, or highlight areas.

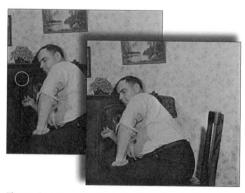

Figure 6.59 Drag the Dodge or Burn brush through any area to lighten or darken the pixels while preserving image detail. Here, I've used the Dodge tool to lighten the radio in the original picture (left), making it much easier to see (right).

Figure 6.60 The Burn tool.

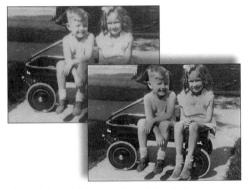

Figure 6.61 In this image, the children in the wagon were badly washed out, but the rest of the image wasn't in bad shape (left). The Burn tool was used to restore lost detail and add some much needed form and dimension by darkening the pixels in the shadow and midtone areas (right).

To darken a portion of an image with the Burn tool:

- Select the Burn tool from the toolbox, or press O to toggle through the tonal adjustment tools to the Burn tool (Figure 6.60).
- 2. In the options bar, select a brush size using the brush size slider.

 If you like, you can also select a specific tonal range to darken (shadows, midtones, or highlights) and control the amount of darkness applied with the exposure setting.
- **3.** Move the brush pointer to the area of your image that you want to darken; then hold down the mouse button and drag through the area (**Figure 6.61**).

To adjust the color saturation with the Sponge tool:

- 1. Select the Sponge tool from the toolbox, or press O to toggle through the tonal adjustment tools to the Sponge tool (Figure 6.62).
- **2.** On the options bar, select a brush size using the brush Size slider.
- **3.** From the Mode drop-down menu on the options bar, select whether you want to saturate (add) or desaturate (subtract) color (**Figure 6.63**).
 - You can also adjust the amount of color to be added or subtracted using the Flow percentage slider.
- **4.** Move the brush pointer to the area of your image where you want to change the color's intensity; then hold down the mouse button and drag through the area.

Figure 6.62 Photoshop Elements' Sponge tool.

Figure 6.63 On the options bar, you can choose whether you want the Sponge tool to add or subtract color.

Removing Color

Photoshop Elements offers two distinct ways to remove color from an image: converting to grayscale mode and using the Remove Color command. The differences may seem subtle at first, but the changes they make to your files are really quite significant.

As I mentioned in Chapter 3, "Changing and Adjusting Colors," an RGB image is constructed of three different color channels (red, green, and blue), which combine in different percentages to produce a full-color image. I also explained that a grayscale image is constructed of just one grayscale channel.

Rather than compressing the color information into one channel, the Remove Color command creates an image that appears to be in grayscale, but remains in RGB. The gray tones are actually created by combining equal parts of RGB values in each pixel. Because it's still technically an RGB image and still composed of three channels, there's no saving of file size. So why use it? Unlike converting to grayscale (which removes all color information from an image), you can use the Remove Color command to remove color from just a portion of an image. This can be used to great effect for highlighting or dimming specific areas, creating neutral fields in which to place type, or as a first step before applying a colorization or color tinting effect.

To apply the Remove Color command:

- Using any of the selection or marquee tools, select the area of your image you want to remove the color from.
 If you want to apply the Remove Color command to an entire image, it's not necessary to make a selection.
- From the Enhance menu, choose
 Adjust Color > Remove Color, or press
 Shift+Ctrl+U (Figure 6.64).
 All color is removed from your image and
 is replaced by varying levels of gray.

✓ Tip

■ You can actually control how much color to remove from an image or selection by using the Saturation slider in the Hue/Saturation dialog box. From the Enhance menu, choose Adjust Color > Adjust Hue/Saturation, or press Ctrl+U to open the dialog box. Then, move the Saturation slider to the left until you achieve the desired effect (Figure 6.65). The value 0 on the saturation scale represents normal color saturation, whereas −100 (all the way to the left) represents completely desaturated color, or grayscale.

Figure 6.64 You can remove the color from all, or just a portion, of an image by using the Remove Color command.

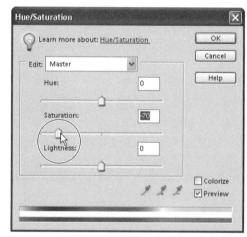

Figure 6.65 Use the Saturation slider in the Hue/ Saturation dialog box to control the amount of color you remove from an image.

Adding a Color Tint to an Image

Using a technique called colorization, you can add a single color tint to your images, simulating the look of a hand-applied color wash or the warm, antique glow of an old sepia-toned photograph. You can apply the effect to any image, even if it was originally saved as grayscale, as long as you first convert it to RGB. In addition to colorizing an entire image, you can use layers and layer modes to tint specific areas or objects. Because the shades of color you apply are determined by the image's original tonal values, photographs with good brightness and contrast levels make the best candidates for colorizing. (For information on tonal values and levels, see "About Tonal Correction" in Chapter 3.)

To colorize a large area of an image:

- 1. Using any of the selection or marquee tools, select the area of your image you want to colorize.
 - If you want to colorize an entire image, it's not necessary to make a selection.
- From the Enhance menu, choose Adjust Color > Adjust Hue/Saturation, or press Ctrl+U to open the Hue/ Saturation dialog box (Figure 6.66).
- **3.** See that the Preview check box is selected, and then click the Colorize check box (**Figure 6.67**). Clicking the Colorize check box converts all the color in the image to a single hue.
- **4.** Drag the Hue slider right or left until you arrive at the color you like (**Figure 6.68**).
- **5.** Drag the Saturation slider to adjust its values.
 - Dragging the slider to the left moves the color's saturation value closer to gray, whereas dragging it to the right moves its value closer to a pure, fully saturated color.
- 6. Drag the Lightness slider to adjust the color's brightness values.
 Dragging to the left dims the color's brightness value, shifting it closer to black, whereas dragging to the right brightens its value, shifting it closer to white.
- **7.** Click OK to close the Hue/Saturation dialog box.
 - Your image is now composed of different values of the single color hue you selected.

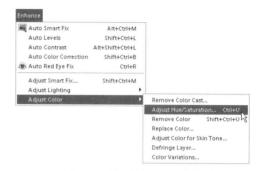

Figure 6.66 Open the Hue/Saturation dialog box to access the Colorize option.

Figure 6.67 Click the Colorize check box to add a colored tint to any image.

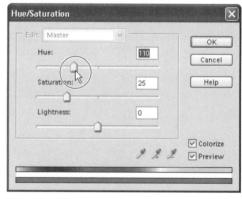

Figure 6.68 The position of the Hue slider determines the color your tinted image will be.

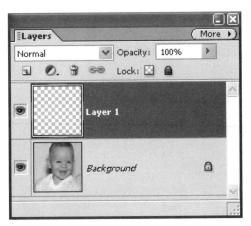

Figure 6.69 Create a new layer on which you'll apply your color tint effect.

Figure 6.70 Select a brush size that will allow you to easily paint each object in your image.

Figure 6.71 Use the Color Picker to select the colors you want to apply.

To colorize a specific area of an image:

- From the Enhance menu, choose Adjust Color > Remove Color, or press Shift+Ctrl+U.
 - Remember that although the Remove Color command removes all color from the image, it's still an RGB file, so color can be introduced back into it.
- 2. On the Layers palette, click the New Layer button to create a new layer above your gray-toned base layer (**Figure 6.69**).
- **3.** From the Blending Mode drop-down menu on the Layers palette, select Color.
- 4. Select the Brush tool from the toolbox; then on the options bar, use the brush Size slider to size your brush (Figure 6.70).

 You'll want to select a brush size that will allow you to comfortably paint within the object you've chosen to colorize.

 For more information on using the Brush tool and its options, see Chapter 8, "Painting and Drawing."
- **5.** At the bottom of the toolbox, click the Foreground color swatch to open the Color Picker, then select the color you want to use to paint onto your image (**Figure 6.71**).

Click OK to close the Color Picker.

continues on next page

- 6. Check that the new layer you created is the active layer in the Layers palette; then in the image window, paint onto the area you want to colorize (Figure 6.72).

 Because you're painting on a layer with the Color blending mode applied, all of the tonal (grayscale) levels of the base image layer will show through the color.
- 7. If you want to add a second color, repeat steps 2 through 5 to create a new layer, select a brush size, and choose a color; then paint onto the next area (on the new layer) just as you did before.

✓ Tip

■ You can apply multiple colors to the same layer and achieve the same effect as when you apply colors to different layers. I prefer to assign just one color per layer because it gives me more control. I can change the opacity level of each color separately, toggle the visibility of individual color layers on and off, try applying different colors to the same object, and even experiment with some of the other blending modes. The Overlay mode, in particular, can yield some very pleasing results.

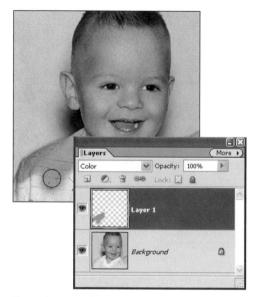

Figure 6.72 Paint directly on the new layer you created to apply a color tint above the base image layer.

FILTERS AND EFFECTS

For decades, photographers have used lens filters to improve and alter the look of their photographs. Filters are frequently used to change the intensity of color values and to lighten certain tones and darken others. In addition to using filters, photographers also rely on darkroom and printing techniques to create wonderfully creative effects.

But thanks to the advancements of digital technology, users don't have to fiddle with chemicals or additional camera equipment to enhance their photographs. The filters and effects included in Photoshop Elements go way beyond what's been possible in traditional photography. Many of these filters (such as the Sharpen filters) allow you to make subtle corrections and improvements to your photos, whereas other filters, such as Artistic, Stylize, and Sketch, can transform an image into a completely new piece of artwork. Photoshop Elements also provides effects you can add to your photos, including striking image effects (lizard skin, anyone?) as well as type effects and unique textures.

In this chapter, you explore the many ways you can use filters and effects to take your work to a whole new level. The Filter and Effects Galleries will help you visualize some of the creative ways you can apply these techniques to your own photos.

Using the Filters and Effects Palettes

Photoshop Elements includes over 100 filters and over 50 effects, offering you almost unlimited possibilities for tweaking and enhancing your images. Most filters include a dialog box where you can preview any changes and adjust the settings for either a subtle or dramatic effect. And some of the filters (such as the Liquify filter) are so comprehensive that they seem like separate little applications within Photoshop Elements.

Effects work a bit differently than filters. When you apply an effect, Photoshop Elements actually runs through a series of automatic actions in which a number of filters and layer styles are applied to your image. Effects are a bit more complex than filters. If you want to add a drop shadow, picture frame, or brushed-metal type to a photo, browse through the Effects palette to see what's available.

To view the Filters or Effects palette:

- **1.** Do one of the following:
 - ▲ From the Window menu, choose Styles and Effects.
 - ▲ Click the arrow on the Styles and Effects palette tab in the palette well.
- **2.** From the Category drop-down menu on the Styles and Effects palette, choose either Filters or Effects (**Figure 7.1**).

Figure 7.1 Filters and Effects are accessed from the Styles and Effects palette.

Figure 7.2 When you select All from the palette menu, every filter or effect in their respective library will be displayed at once.

Figure 7.3 To scan your choices more quickly, select a specific group of filters or effects.

To change the number of filters or effects displayed in the palette:

Do one of the following:

- If it's not already selected, choose All from the Library drop-down menu at the top of the palette to see all filters or effects (Figure 7.2).
- Select a set of filters or effects from the Library drop-down menu to see just the ones in that set (Figure 7.3).

Filter and Effect Plug-ins

Plug-ins provide a nifty way to extend your Photoshop Elements experience. Want to add some sophisticated 3D shadows or translucent effects to your photos? If you can't find the effect or filter you want in Photoshop Elements, chances are good that a plug-in might do the trick. Most of the plug-ins designed for Photoshop will work just as well in Photoshop Elements, since both applications use the same file format (PSD). Some plug-in packages, clearly meant for professionals and creative types, don't come cheap—they can cost a few hundred dollars. But many plug-ins are available free of charge. One of the best places to start looking for filter and effect plug-ins is at the Adobe Exchange site (www.adobestudioexchange.com), where you can download and share filters, effects, and other plug-in goodies with other Photoshop and Photoshop Elements users.

To change the palette view:

Do one of the following:

- From the palette menu, choose Thumbnail View to view the filters or effects as thumbnails (this is the default) (Figure 7.4).
- ◆ From the palette menu, choose List View to view the filters or effects as a list of identifying names (**Figure 7.5**).

 When you select a name in List View, the thumbnail for that specific filter or effect appears under the original sample image at the left side of the palette (**Figure 7.6**).

✓ Tip

You can also install and use filter plug-ins created by third-party developers. When installed, they usually appear at the bottom of the Filters palette menu.

Figure 7.5 Once you're familiar with the Filters palette, you may find it easier to work in List View since it's faster to navigate than the default Thumbnail View.

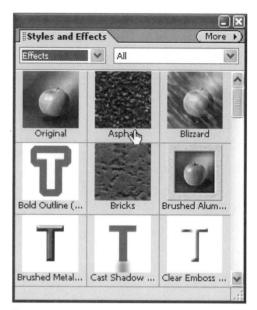

Figure 7.4 Thumbnail view is the default option for viewing filters and effects.

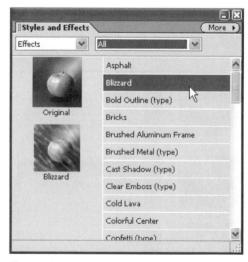

Figure 7.6 In List View, the thumbnail for the selected filter or effect appears in the first column of the palette.

Figure 7.7 Filters and effects can be applied to an entire layer or to a selection.

The Filter Dialog Boxes

Given the sheer number of filters in Photoshop Elements, there's no way to cover the specific steps for each filter in the space of this book. Fortunately, the vast majority of these filters work the same way. So once you've used a couple of them, you can figure out the rest pretty easily. Most filters use the same Filter Options dialog box with a preview window and slider bars that allow you to control the level and intensity of the filter. When using a filter for the first time, you should preview the default filter setting and apply it by clicking OK. Not what you wanted? Just press Ctrl+Z to undo your changes and start over. When you're back in the filter's dialog box, you can experiment by adjusting the sliders to preview more dramatic results in your photo.

Applying Filters and Effects

Depending on the filter or effect you choose and the size of your image, your computer can take a while to apply and display these changes. Of course, computing power increases dramatically every year, along with the typical amount of RAM installed in most new machines. Both the speed of your processor and amount of RAM contribute to faster processing of these transformations. Fortunately, almost all of the filters include a preview window, which allows you to see the result of the filter before you decide to apply it to your image.

Effects don't include a preview window, but you'll find useful examples of each effect on the Effects palette, as well as in the Effects Gallery later in this chapter. For many filters and effects, a good approach is to select a small area of your image and apply the change to see the results—that way, you don't waste a lot of time waiting for your computer to process changes to the entire image. The exceptions are effects like Frames or Photo Corners, where the effect is designed to be applied to your entire image. A few effects (such as the Cutout and Recessed frame effects) require you to make a selection before you can apply the effect.

To apply a filter:

1. To apply a filter to an entire layer, select the layer on the Layers palette to make the layer active. To apply a filter to just a portion of your image, select an area with one of the selection tools (**Figure 7.7**).

continues on next page

- **2.** Do one of the following:
 - ▲ Double-click a filter on the Filters palette (**Figure 7.8**).

 The Filter Options dialog box appears (**Figure 7.9**).
 - ▲ From the Filter menu, choose a filter from one of the filter submenus.

 If you look at the Filter menu, you'll see that filters with additional options include ellipses (...) after their names (Figure 7.10).
 - ▲ Drag any filter from the Filters palette onto your image in the image window.
- **3.** When the Filter Options dialog box opens, experiment with the available values and options until you get the look you want.

Figure 7.9 The Filter Options dialog box includes a large preview window and sliders you can use to adjust a filter's settings.

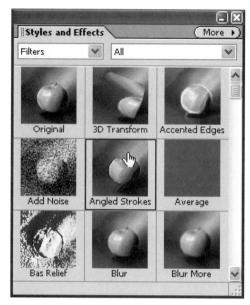

Figure 7.8 To select a filter on the Filters palette, just double-click the filter.

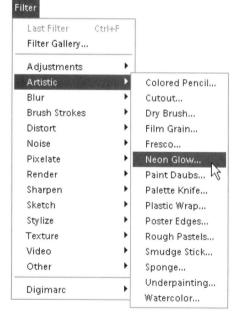

Figure 7.10 To see which filters include dialog box options, refer to the Filter menu. Filters with options include an ellipsis (...) after their names.

Figure 7.11 The Filter Options dialog box includes Zoom buttons to change the magnification of the preview image.

Figure 7.12 To move around (or pan) the preview image, just move your pointer over the preview window until the pointer changes to the Hand tool. Then click and drag to move the image.

Figure 7.13 Click OK to apply the filter to your image.

- **4.** In the dialog box preview window, you can change the view by *doing one of the following*:
 - ▲ To zoom in or out, click either the Zoom In (plus sign) or Zoom Out (minus sign) button (**Figure 7.11**).
 - ▲ To see a specific area of your image, click and drag within the preview window (**Figure 7.12**).
- Click OK to apply the filter.
 The filter is applied to your image (Figure 7.13).

If you're not happy with the result, choose Edit > Undo or select the previous state from the Undo History palette.

✓ Tips

- To view a collection of filter "recipes" you can apply to your own images, see the color plate section of this book.
- As you add filters, you'll notice that you're presented with two different types of Option dialog boxes. The Add Noise filter, for instance, opens to a dialog box specific to just that filter. But filters contained in the Artistic, Brush Strokes, Distort, Sketch, Stylize, and Texture groups open to an Option dialog box where you can not only adjust the settings for the filter you've selected, but also choose a completely different filter from a filter sets menu in the center of the dialog box. Just click any of the filter set names to open them, and then choose a new filter by clicking its thumbnail. A preview window changes to reflect the new filter you've selected.

To apply effects:

- 1. To apply an effect to an entire layer, select the layer to make it active. To apply an effect to just a portion of your image, select an area using one of the selection tools.
- 2. In the Effects palette, double-click the chosen effect (Figure 7.14).
 If you prefer, you can also drag any effect from the Effects palette directly onto your image in the image window.
 When you apply an effect, it creates one or more new layers immediately above the selected layer (Figure 7.15).

✓ Tips

- To reduce the visible impact of an effect, change the opacity of the effect layer using the slider on the Layers palette.
- Sometimes the filter and effect names, and their thumbnails, don't represent the variety of results you might get by applying them to an image. Experiment by pushing the filter and effect options to extreme limits. You'll often be surprised by the results. Print a copy of your image for future reference and to use on other photos. It's also a good idea to rename the layer with a descriptive name related to the effect you used: for instance, Blizzard 30%.
- To change the look of an effect, experiment with the various blend modes on the Layers palette.

Figure 7.14 Double-click any effect in the Effects palette to apply it to an image or selection. You can also drag an effect or filter from the palette into the image window.

Figure 7.15 When you apply an effect, it generates one or more layers above the selected layers. The number of new layers depends on the series of actions required to create the specific effect.

Filter Gallery

Artistic filters

Original image

Colored Pencil

Cutout

Dry Brush

Film Grain

Fresco

Neon Glow

Paint Daubs

Palette Knife

Plastic Wrap

Poster Edges

Rough Pastels

Smudge Stick

Sponge

Underpainting

Watercolor

Blur filters

Original image

Blur

Blur More

Gaussian Blur

Motion Blur

Radial Blur

Smart Blur (Normal)

Smart Blur (Overlay Edge)

Brush Strokes filters

Original image

Accented Edges

Angled Strokes

Crosshatch

Dark Strokes

Ink Outlines

Spatter

Spray Strokes

Sumi-e

Distort filters

Original image

Diffuse Glow

Glass

Liquify

Ocean Ripple

Pinch

Polar Coordinates

Ripple

Shear

Spherize

Twirl

Wave

ZigZag

Noise filters

Original image

Add Noise

Despeckle

Dust & Scratches

Median

Pixelate filters

Original image

Color Halftone

Crystallize

Facet

Fragment

Mezzotint

Mosaic

Pointillize

Render filters

Original image

Clouds

Difference Clouds

Lens Flare

Lighting Effects

Sharpen filters

Sharpen Edges

Sharpen More

Unsharp Mask

Sketch filters

Original image

Bas Relief

Chalk & Charcoal

Charcoal

Chrome

Conte Crayon

Graphic Pen

Halftone Pattern

Note Paper

Photocopy

Plaster

Reticulation

Sketch filters continued

Torn Edges

Water Paper

Stylize filters

Original image

Diffuse

Emboss

Extrude

Find Edges

Glowing Edges

Solarize

Tiles

Trace Contour

Wind

Texture filters

Craquelure

Grain

Mosaic Tiles

Patchwork

Stained Glass

Texturizer

Effects Gallery

Frames effects

Original image

Brushed Aluminum

Cut Out

Drop Shadow

Foreground Color

Photo Corners

Recessed Frame

Ripple Frame

Spatter Frame

Strokes Frame

Text Panel

Vignette

Waves

Wild Frame

Wood Frame

Image effects

Original image

Blizzard

Fluorescent Chalk

Lizard Skin

Neon Nights

Oil Pastel

Rubber Stamp

Soft Flat Color

Text effects

Original image

Bold Outline

Brushed Metal

Cast Shadow

Clear Emboss

Confetti

Medium Outline

Running Water

Text effects continued

Offers

effects

Sprayed Stencil

Thin Outline

Water Reflection

Wood Paneling

Texture effects

Original image

Asphalt

Bricks

Cold Lava

Gold Sprinkles

Green Slime

Marbled Glass (layer only)

Molten Lead

Psychedelic Strings

Sandpaper

Sunset (layer only)

Wood > Pine

Figure 7.16 You can apply the Motion Blur filter to an entire layer or to a selection, as we'll do in this photo.

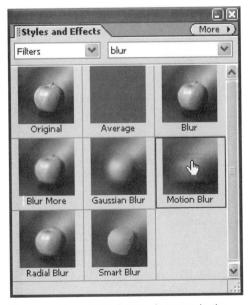

Figure 7.17 Once you've chosen a layer or selection, double-click the Motion Blur thumbnail on the Filters palette.

Simulating Action with the Blur Filters

Photoshop Elements includes a couple of blur filters that can create a sense of motion where none exists. In many cases, you'll want to select a specific area in your photo when using these filters, so that the motion or movement is applied to one object, such as a person, your dog, or a pair of shoes.

The Motion Blur filter blurs a layer or selection in a specific direction and intensity. The result can simulate the look of taking a picture of a moving object with a fixed exposure or of panning a camera across a still scene.

The Radial Blur filter can create the impression of a camera zoom or of an object moving toward or away from you. You can also create the impression of an object spinning at variable rates of speed. In either case, the Radial Blur filter lets you control the center of the effect and the amount of blurring or motion.

To add a motion blur to an image:

- Select the desired layer to make it active.
 To create a feeling of motion in just a portion of your image, select an area with one of the selection tools (Figure 7.16).
- **2.** Do one of the following:
 - ▲ Double-click the Motion Blur filter on the Filters palette (**Figure 7.17**).
 - ▲ From the Filter menu, choose Blur > Motion Blur.

continues on next page

The Motion Blur dialog box appears with options for the motion angle and distance (**Figure 7.18**).

3. Set the Angle and Distance options to get the look you want. You can refer to the preview window in the dialog box, and if the Preview option is checked, you can also see the results in the main image window.

By default, the Angle option is set to 0°, meaning that the pixels will be blurred along the horizontal axis as shown next to the Angle text box. So, the impression of motion will be right to left (or left to right) across your screen. You can change the angle by dragging the line on the Angle icon or by entering a number of degrees in the Angle text box.

The Distance option determines the number of pixels included in the linear blur, with the default set to 10 pixels (a moderate amount of blurring). When you reach the upper limits of this option (999 pixels), the objects in your photo may become barely recognizable.

4. When you are satisfied with the effect, click OK to apply it to your image (**Figure 7.19**).

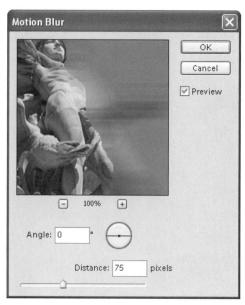

Figure 7.18 The Motion Blur dialog box includes options for the angle and distance of the effect.

Figure 7.19 Click OK to see the Motion Blur filter applied to your image. If you want to back up and try again, just choose Edit > Undo and experiment with different settings.

Figure 7.20 A circular selection, like this windmill, works particularly well with the Radial Blur filter.

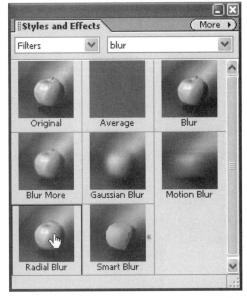

Figure 7.21 The Radial Blur filter is located next to the Motion Blur filter on the Filters palette.

To add a circular blur to an image:

- Select the desired layer to make it active.
 To create a feeling of radial motion in just
 a portion of your image, select an area
 with one of the selection tools.
 A circular (elliptical) selection works
 especially well when you want to create a
 - A circular (elliptical) selection works especially well when you want to create a circular effect (**Figure 7.20**).
- **2.** Select the Radial Blur by *doing one of the following:*
 - ▲ Double-click the Radial Blur filter on the Filters palette (**Figure 7.21**).
 - ▲ Choose Filter > Blur > Radial Blur from the main menu.

The Radial Blur dialog box appears, with options for amount of blur, blur center, blur method, and effect quality (**Figure 7.22**).

continues on next page

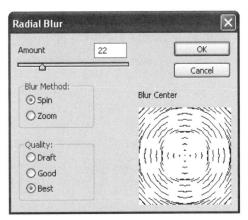

Figure 7.22 The Radial Blur dialog box includes options for the amount and method of blur. This filter does not include a preview, but the Quality options include Draft, which you can use to quickly apply and view the effects of the filter on your image.

- 3. Set the Amount and Blur Center values for the Radial Blur effect.

 The two Blur Method options are Spin and Zoom. Choose Spin to blur along circular lines (Figure 7.23) or Zoom to blur along lines radiating from the center, as if you were zooming in or out of an image (Figure 7.24).
- **4.** Select a Quality option for the filter. **Draft** quality produces a quicker rendering of the filter, but with slightly coarse results. The **Good** and **Best** options both take a bit longer to render, but provide a smoother look; there's not a big difference between the latter two options.
- **5.** When you are satisfied with the effect, click OK to apply it to your image.

✓ Tip

■ The Radial Blur filter doesn't include a preview window, so if you aren't happy with your results and want to try different settings, just click the Step Backward button (or press Ctrl+Z) to try again.

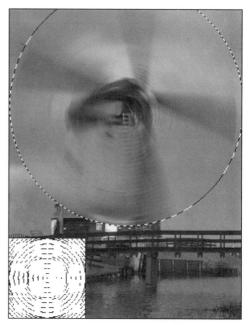

Figure 7.23 The Spin method creates the impression of an object spinning around a center point. To change the center point, drag the preview in the Blur Center window.

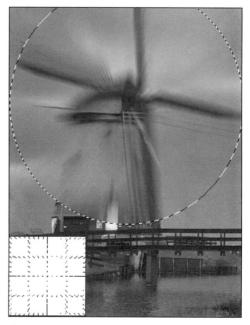

Figure 7.24 The Zoom method creates the sense of an object moving toward or away from you.

The Blur Filters

I've covered the steps for using a couple of my favorite blur filters, but the others can be just as effective. Here's a summary of how the blur filters work and when you might want to use them.

Blur softens the look of an image or selected area and is great for retouching photos where there's a harsh edge or transition. The results are similar to what you get with the Blur tool.

Blur More works like the Blur filter, but with much greater intensity—it's like using the Blur filter three times on the same image. The results are often too dramatic for minor photo retouching, but are great for blurring one particular area of an image (like the border), thereby emphasizing the untouched areas. Keep in mind that the Blur and Blur More filters don't include a dialog box or preview window. Just select a layer or area and apply the filter to see the results.

Gaussian Blur allows you a greater amount of control, and you can use this filter to make anything from minor to major adjustments to your image. For most simple photo retouching, the Blur command works well, but if you're not happy with your results and want to tweak a bit, try Gaussian Blur.

Motion Blur can be used to simulate a moving object or the panning of a camera.

Radial Blur results in either a zooming or spinning motion, depending on the option you choose.

Smart Blur lets you build customized blurs, with complete control over the blur radius (the area affected by the blur effect) and threshold (the number of pixels within a given area affected by the blur). Smart Blur is useful for softening an image or for times when you want a more subtle blur effect.

Distorting Images

The Distort filters include an amazing array of options that let you ripple, pinch, shear, and twist your images. Experiment with all of the Distort filters to get a feel for the different effects you can apply to your images. One filter in particular stands above the others in its power and flexibility: the Liquify filter.

The Liquify filter creates amazing effects by letting you warp, twirl, stretch, and twist pixels beyond the normal laws of physics. You've probably seen plenty of examples of this filter, where someone's face is wildly distorted with bulging eyes and a puckered mouth. However, you can also use the Liquify filter to create more subtle changes and achieve effects that would be impossible with any other tool.

The Liquify filter is unique in that it includes a dialog box with its own complete set of image-manipulation tools. And because the Liquify filter works within its own dialog box, you can't undo specific changes with the Edit > Undo command or Undo History palette. Fortunately, the Liquify filter offers its own Reconstruct tool to restore any area to its original (or less contorted) state. The Reconstruct tool allows you to "paint" over your image and gradually return to the original version, or stop at any state along the way. If you just want to go back and start over, clicking the Revert button is the quickest method.

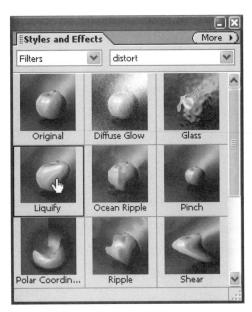

Figure 7.25 The Liquify filter appears in the Distort category in the Filters palette menu.

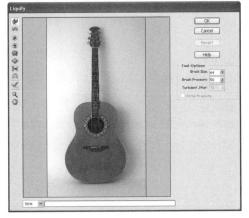

Figure 7.26 The Liquify dialog box includes its own set of distortion tools as well as options for changing the brush size and pressure.

To distort an image with the Liquify filter:

- **1.** Select an entire layer, or make a selection of the area you want to change.
- 2. From the Filter menu, choose Distort > Liquify, or double-click the Liquify filter on the Filters palette (Figure 7.25).

 If your image includes a type layer, you will be prompted to simplify the type to continue. This means that the type layer will be flattened into the rest of your image's layers. Be aware that if you click OK, the type will no longer be editable.

 The Liquify dialog box appears, with a preview of the layer or selection area. The Warp tool is selected by default, with a brush size of 64 and a pressure of 50 (Figure 7.26).

You'll probably want to change the brush size and pressure during the course of your work.

- **3.** To change the brush settings, *do one of the following*:
 - ▲ To change the brush size, drag the slider or enter a value in the option box. The brush size ranges from 1 to 600 pixels.
 - ▲ To change the brush pressure, drag the slider or enter a value in the option box. The brush pressure ranges from 1 to 100 percent.

continues on next page

4. Distort your image with any of the Liquify tools located on the left side of the Liquify dialog box (Figure 7.27) until you achieve the look you want. To use any tool, simply select it (just as you do tools on the main toolbar) and then move your pointer into the image (Figure 7.28).

To undo changes:

 In the Liquify dialog box, click the Reconstruct tool. Then, while holding down your mouse button, "brush" over your image to gradually undo each change you've made.

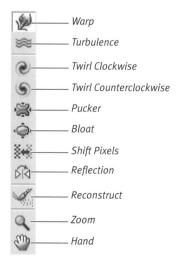

Figure 7.27 The Liquify tool set.

The Liquify Tools

Warp lets you push pixels around as you drag with the mouse.

Turbulence works similar to the Warp tool, but it incorporates some actions of the other Liquify tools to create random variations, or turbulence. You can change the amount of turbulence with the Turbulence Jitter slider in the tool options.

Twirl Clockwise and Twirl Counterclockwise rotate pixels in either direction.

Pucker moves pixels toward the center of the brush area.

Bloat moves pixels away from the brush center and toward the edges of your brush.

Shift Pixels moves pixels perpendicular to the direction of your brush stroke.

Reflection copies pixels to the brush area, allowing you to create effects similar to a reflection in water.

Reconstruct restores distorted areas to their original state. As you brush over areas with this tool, your image gradually returns to its original state, undoing each change you've made with the Liquify tools. You can stop the reconstruction at any point and continue from there.

The **Zoom** and **Hand** tools work just like the ones on the Photoshop Elements toolbar.

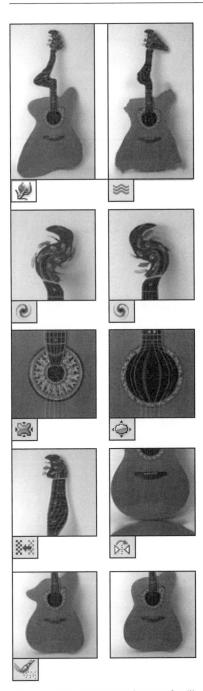

Figure 7.28 The best way to become familiar with the Liquify distortion tools is to experiment with them on a variety of images, as in this series of guitar images.

To undo all Liquify changes:

 In the Liquify dialog box, click the Revert button to return the image to its original state.

✓ Tip

Here's another way to undo Liquify changes: In the Liquify dialog box, hold down the Alt key. The Cancel button changes to Reset. Click the Reset button to undo any changes you've made with the Liquify tools. The Revert and Reset buttons work the same way, but the Reset button, true to its name, also resets the Liquify tools to their original settings.

Creating Lights and Shadows

Lights and shadows add drama to almost any photograph. There's still no better way to implement lighting effects than by planning for your lighting before you take your picture. However, there are times when you just can't control these factors, and Photoshop Elements includes some nifty filters to help you enhance the lighting after the fact.

The Lighting Effects filter lets you create a seemingly infinite number of effects through a combination of light styles, properties, and even a texture channel. It's almost like having your own lighting studio right on your desktop. The Lens Flare filter simulates the refraction of light shining inside a camera lens. This filter works really well if you've created an image with Photoshop Elements' painting and drawing tools and want to make it look like it was shot with a camera. You'll see this technique used quite a bit in computer-animated movies to give them a more realistic look. Keep in mind, however, that your image must be in RGB mode to use these lighting filters.

To add lighting effects to an image:

- 1. Select the desired layer to make it active. To confine the lighting effect to just a portion of your image, select an area using one of the selection tools.
- **2.** Select the Lighting Effects filter by *doing* one of the following:
 - ▲ Double-click the Lighting Effects filter on the Filters palette (**Figure 7.29**).
 - ▲ From the Filter menu, choose Render > Lighting Effects.

The Lighting Effects dialog box appears (**Figure 7.30**).

3. Choose a Style (Figure 7.31).

Figure 7.29 The Lighting Effects filter appears in the Render category on the Filters palette menu.

Figure 7.30 When you first open the Lighting Effects dialog box, it may seem a bit intimidating. But it only takes a little experimentation with the settings to see the range of effects possible with this filter.

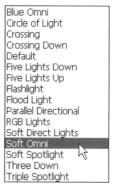

Figure 7.31
The Style drop-down menu reveals 15 unique lighting styles.

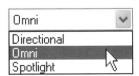

Figure 7.32 The Light Type drop-down menu.

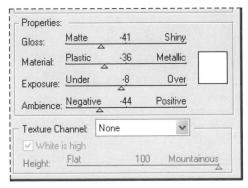

Figure 7.33 The Properties area of the Lighting Effects dialog box offers an almost infinite combination of settings that you can use to change the appearance and intensity of the lighting.

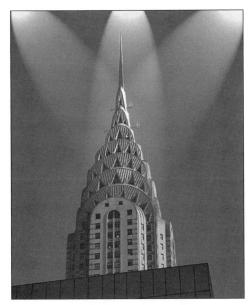

Figure 7.34 After selecting the lighting options you want, click OK to apply them to your image. This image has the Triple Spotlight filter applied.

- **4.** Choose a Light Type (**Figure 7.32**). The Light Type drop-down menu includes Directional, Omni, and Spotlight options. Each lighting style is based on one of these three light types.
- **5.** Set light properties (**Figure 7.33**).
- **6.** When you are satisfied with the effect, click OK to apply it to your image (**Figure 7.34**).

Light styles and types

The Lighting Effects dialog box offers a mind-boggling number of properties, light types, and styles, making it more than a little difficult to figure out where to start. Here's a list of some of the most useful lighting styles and types, along with some pointers on how styles work with light types and properties.

Lighting styles

Flashlight focuses a direct spotlight on the center of the image, with the rest of the image darkened. It's set at a medium intensity with a slightly yellow cast.

Floodlight has a wider focus and casts a white light on your image.

Soft Omni and **Soft Spotlight** provide gentle lightbulb and spotlight effects respectively, and work well for many different kinds of images.

Blue Omni adds a blue overhead light to your image and offers insight into how lighting styles and types work together. If you select this light type, you'll see a blue color box in the Light Type area of the dialog box. If you click on this box, the Color Picker appears (Figure 7.35), letting you change the color to anything you want. Once you've chosen a new color, click Save to apply your custom lighting style to your photo.

This is not a comprehensive list of all the lighting styles in the Lighting Effects dialog box, but an overview of the styles you'll find most useful. Most of the remaining lighting styles create more dramatic and specialized effects (for example, RGB Lights consists of red, yellow, and blue spotlights), but are worth exploring if you want to add more creative effects to your image.

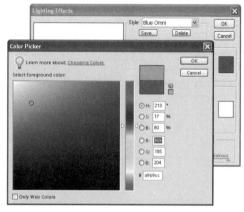

Figure 7.35 Some lighting styles, such as Blue Omni, include colored lights. You can change the color by clicking the lighting color box, which opens the Color Picker.

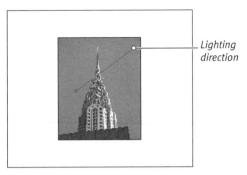

Figure 7.36 The Directional light produces a light source that shines in one direction across your photo, as indicated by the line in the image preview window.

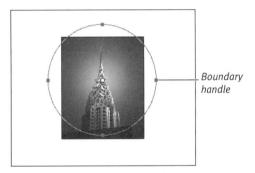

Figure 7.37 The Omni light creates the impression of a light shining directly onto your photo. To change the size of the lit area, just drag one of the boundary handles.

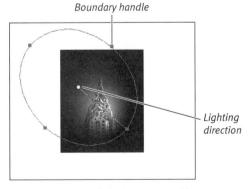

Figure 7.38 The Spotlight is represented by an elliptical boundary in the preview. Drag a handle to change the area being lit, and drag the lighting direction line to change the direction of the light source.

Light types

Directional creates an angled light that shines from one direction across your photo (**Figure 7.36**).

Omni produces a light that shines down on your image from above (**Figure 7.37**).

Spotlight creates a round spotlight in the center of your image. In preview mode, you'll see that the boundaries of the light look like an ellipse. You can change the size of the ellipse by dragging any of the handles. To change the direction of the light, just drag to move the line (**Figure 7.38**).

When you select a light style, it automatically defaults to whichever light type best supports that look—so, for example, the Floodlight style uses the Spotlight type.

Light properties

Once you've chosen a light style and type, you have complete control over four different lighting properties. To change these, just move the sliders to the left or right.

Gloss establishes how much light reflects off your image and can be set from Matte (less reflection) to Shiny (more reflection).

Material determines how much light reflects off your image. It can be set from Plastic to Metallic (and quite frankly, I find these descriptive terms less than helpful). As you move the setting toward Plastic, the color of your light grows stronger, and if you choose Metallic, the color of your image shows through more.

continues on next page

Exposure increases or decreases the light. If you click through the light types, you'll notice that most of them leave this setting at 0, or very close. This is one setting you may just want to leave as is or make only subtle changes to since it has such a pronounced impact on the light.

Ambience refers to ambient lighting, or how much you combine the particular lighting effect with the existing light in your photo. Positive values allow in more ambient light, and negative values allow less.

To add a lens flare:

- **1.** Select the desired layer to make it active. To confine the lighting effect to just a portion of your image, select an area using one of the selection tools.
- **2.** Select the Lens Flare filter by *doing one of the following*:
 - ▲ Double-click the Lens Flare filter on the Filters palette (**Figure 7.39**).
 - ▲ From the Filter menu, choose Render > Lens Flare.

The Lens Flare dialog box appears, with options for the brightness, flare center, and lens type (**Figure 7.40**).

- **3.** Set the brightness option by dragging the slider to the right to increase or to the left to decrease the brightness.
- **4.** To move the flare center, just click the image preview to move the crosshairs to another location.

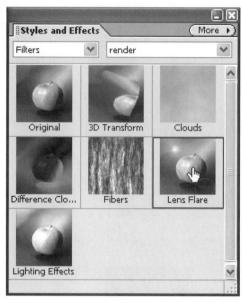

Figure 7.39 The Lens Flare filter is located just before the Lighting Effects filter on the Filters palette.

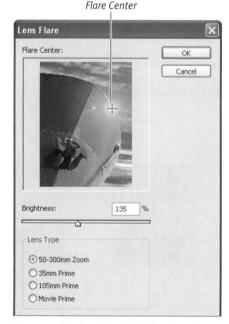

Figure 7.40 The Lens Flare dialog box is much simpler than the one used for Lighting Effects. Use this dialog box to adjust the brightness, flare center, and lens type.

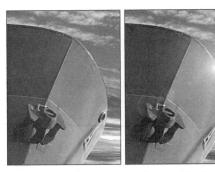

Figure 7.41 To add more atmosphere to this photo, I applied the Lens Flare filter with the default brightness of 135 percent and the 50–300mm Zoom lens option.

5. Set the Lens Type options as desired, and when you're happy with what you see, click OK to apply the filter to your image (**Figure 7.41**).

The options include settings for three common camera lenses (50–300mm Zoom, 35mm, and 105mm), plus Movie Prime, and the filter creates a look similar to the refraction or lens flare you'd get with each one (**Figure 7.42**).

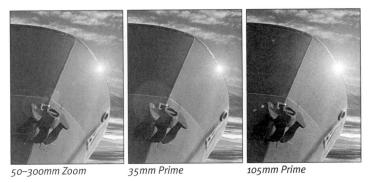

Figure 7.42 The subtle differences among the three lens options are shown here.

Using Textures

You can use Photoshop Elements' many textures to add special effects and virtual "frames" to your photos. For example, you might add the Sunset texture to a portion of your favorite beach photo, or add the Wood Frame texture to a photo before printing it. The Effects palette offers 14 textures that you can apply to either a selected area or your entire image. Keep in mind, however, that textures that include (*layer*) after their name can be applied only to an entire layer, not a selection. These include the Ink Blots, Marbled Glass, Sunset, and Wood > Pine textures.

The Filters palette includes a smaller, more subdued assortment of textures. These tend to be a little less dramatic than the ones you'll find on the Effects palette.

There's also an important distinction to keep in mind when choosing textures from these different palettes: textures from the Effects palette are applied to your image on a separate layer, whereas textures from the Filters palette are applied to the current layer.

If you can't find the texture you're looking for, you can load a few additional textures. Photoshop Elements has a supply of textures in the Textures folder in the Adobe Photoshop Elements folder.

To apply texture to an image:

- **1.** Do one of the following:
 - ▲ To apply a texture to a specific area, make a selection using one of the selection tools (**Figure 7.43**).
 - ▲ To apply a texture to the entire image, no selection is necessary.

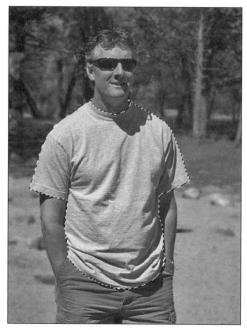

Figure 7.43 To apply a texture to just a portion of your image, make a selection using any of the selection tools. I used the Magic Selection brush to create this selection.

Figure 7.44 Double-click any texture to instantly apply it to your image.

2. With either the Effects or Filters palette lists active, select the Texture (or Textures) from the Library drop-down menu; then double-click the desired texture (**Figure 7.44**).

The texture is applied to either the selection or your entire image (**Figure 7.45**). If you've chosen a texture from the Effects palette, the texture also appears as its own unique layer on the Layers palette (**Figure 7.46**).

continues on next page

Figure 7.45 After you apply the texture, it will appear in the selected area at 100% opacity. Here, I added the Bricks texture to the t-shirt.

Figure 7.46 Textures selected from the Effects palette appear on their own layer on the Layers palette.

3. If necessary, adjust the blending mode and opacity on the Layers palette (**Figure 7.47**).

You can't adjust the blending mode or opacity of a background layer (it's locked by default), so it's a good idea to create a duplicate or adjustment layer *before* applying textures to your image.

✓ Tip

After you've selected and applied a texture to your image, you can adjust the intensity of the texture by using the opacity control slider on the Layers palette. (Make sure you haven't applied the texture to a background layer, which is locked.) Since many Photoshop Elements textures are opaque, reducing the opacity level of the texture layer lets your original image peek through, creating a wonderfully unique effect. For example, try applying the Wood-Pine texture to an image, apply a blending mode like Screen to the texture layer, and then reduce its opacity. Your image will appear to be stained onto a piece of fine-grained wood.

Figure 7.47 In this example, the Hard Light blending mode was applied to the texture layer, and then its opacity was changed to 80 percent so that the folds and shadows of the t-shirt are still visible.

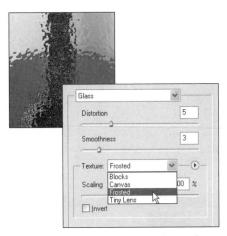

Figure 7.48 The Glass filter is one of many that includes a Texture drop-down menu.

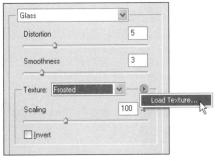

Figure 7.49 Click the arrow button to select the Load Texture option.

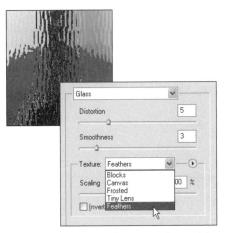

Figure 7.50 After you load a texture, the result is shown in the preview window.

To load additional textures:

- 1. With Filters selected in the Category drop-down menu, select All from the Library drop-down menu.
- 2. Double-click to choose the Conté Crayon, Glass, Rough Pastels, Texturizer, or Underpainting filter from the palette list. The Filter Options dialog box opens with a Texture drop-down menu as one of the setting options (Figure 7.48).
- **3.** Select from the list of available textures, or click the button next to the Texture drop-down menu and choose Load Texture (**Figure 7.49**).
- 4. Navigate to the Textures folder—Program Files > Adobe > Photoshop Elements 4.0 > Presets > Adobe Photoshop Elements and double-click to open the folder. Photoshop Elements includes a premade set of textures that you'll see in the Load Texture window.
- **5.** Select a texture, and then click Open to apply the texture and add it to the Texture drop-down menu list (**Figure 7.50**).

✓ Tip

■ If you have a scanner or digital camera, you can use it to create your own textures. Try scanning or photographing any object that has an unusual or patterned surface, such as a piece of cloth or gift wrap. Import the texture into your computer; then load the texture into the Presets > Textures folder in the Photoshop Elements folder on your computer's hard drive. Be sure to save your texture in the Photoshop (PSD) file format.

Creating Your Own Filters

If all the existing filters aren't enough, you can create your own filters through a rather arcane feature called the Custom dialog box. (Warning! You're now entering territory that's a bit on the advanced side, even for seasoned Photoshop users.)

The Custom dialog box allows you to control the brightness value of each pixel, influencing the neighboring pixels through a process called convolution (a mathematical operation). The first time you try this, it very likely will seem convoluted, but hang in there. With patience and creativity, you can craft filters that would be impossible to create using any other approach.

To create your own filter:

- **1.** From the Filter menu, choose Other > Custom, or double-click Custom in the Filters palette list.
 - The Custom dialog box appears. You can change the brightness of each pixel in the image. As you make changes, each pixel is given a new value based on surrounding pixels (**Figure 7.51**).
- 2. Select the center text box, which controls the initial brightness value for the filter. Enter a value from -999 to +999 (Figure 7.52).
 - The higher the number, the brighter the filter result becomes.
- **3.** Select a text box next to the first pixel box to change the value of the adjacent pixels.

You don't need to enter values in all of the boxes. Just let the visible results be your guide (**Figure 7.53**).

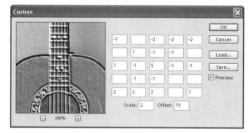

Figure 7.51 The Custom dialog box lets you change the brightness of each pixel.

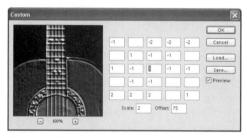

Figure 7.52 The center text box controls the brightness of the selected pixels. The higher the number you enter, the brighter the pixels become.

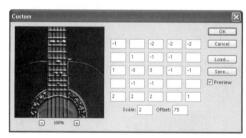

Figure 7.53 Text boxes next to the center box control the brightness of the surrounding pixels.

Working with Color

Most images imported from a digital camera or scanner will open in RGB mode. RGB is shorthand for red, green, and blue, the only three colors that your computer monitor actually displays. RGB combines the three colors in different proportions and intensities to create the thousands or milions of colors you see onscreen. RGB is Photoshop Elements' default color mode, and is the best mode to work in when making color and tonal corrections.

Color cast refers to a shift of color to one extreme or another, and is sometimes introduced into digital photos or scanned images. The image at the top left has an unfortunate pinkish cast, which I removed by applying the Auto Color Correction command (below right).

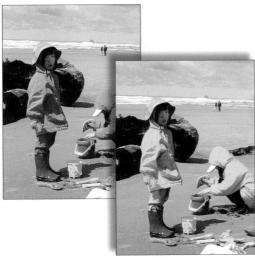

Use the Replace Color command to select a specific color, even if it appears in different areas of the same image, and then replace that color universally. Here, I changed the girls' coats from pink to a sunny yellow.

When you convert an image to grayscale, the three RGB color channels are reduced to just one one grayscale channel. Although the color is removed, a grayscale image still retains all the subtle gradients and tonal value in the original color version.

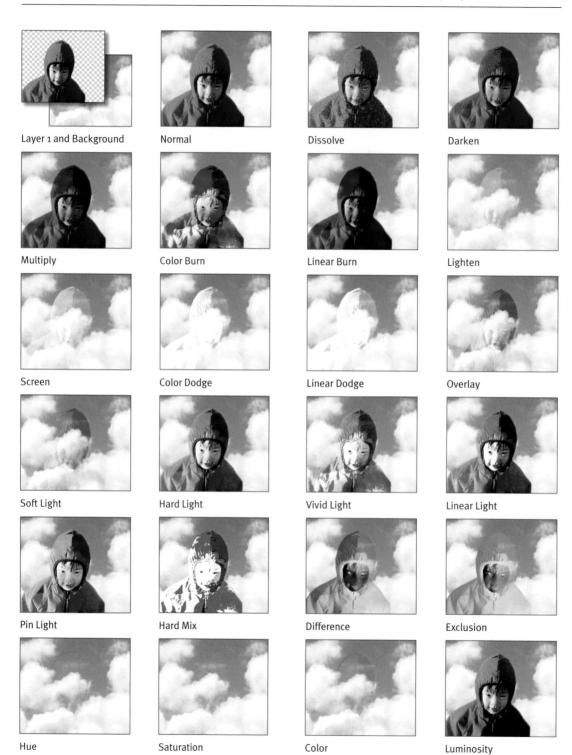

Layer 1 and Background

Normal

Simple Inner Bevel style

Hard Edge Drop Shadow style

Soft Edge Drop Shadow style

Small Border Inner Glow style

Low Inner Shadow style

Noisy Stripes Inner Shadow style

Color Target Complex style

White Grid on Orange Complex style

Rose Impressions Complex style

Orange Glass Glass Button style

Tile Mosaic Image Effects style

Satin Sheets Patterns style

Waves Patterns style

Bumpy Patterns style

Shiny Edge Wow Chrome style

Textured Wow Chrome style

Yellow On Wow Neon style

Aqua Blue Plastic Wow Plastic style

Artistic > Cutout No. of Levels: 8 Edge Simplicity: 2 Edge Fidelity: 2

Brush Strokes > Spatter Spray Radius: 12 Smoothness: 5

Stylize > **Wind** Method: Blast Direction: From the Right

Distort > **Zig Zag** Amount: 35% Ridges: 11 Style: Pond Ripple

Artistic > Dry Brush Brush Size: 4 Brush Detail: 10 Texture: 2

Pixelate > Crystallize Cell Size: 12

Combine both layers using the Soft Light blending mode.

Artistic > Cutout (layer 1) No. of Levels: 3 Edge Simplicity & Fidelity: 4 Smoothness: 5

Sketch > Stamp (layer 2) Light/Dark Balance: 25

Stylize > Emboss Angle: 135° Height: 8 pixels Amount: 110%

Render > Lens Flare Brightness: 135 Lens Type: 105mm Prime

Creative Techniques

Create a panorama with Photomerge

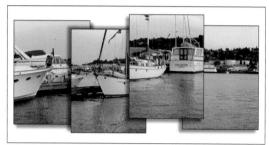

Step 1 Collect all the photos together that you want to assemble into your panorama.

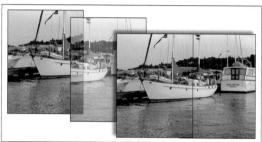

Step 2 Photomerge does its best to assemble your photos together, but you can always adjust their arrangement or position by hand.

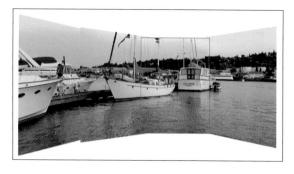

Step 3 Once all the images have been merged, you can apply special lighting and perspective effects, and can change the location of the panorama's vanishing point, if you like. When you're finished making your adjustments, Photoshop Elements saves your panorama as a separate file, where you can then crop it and make any final color and tonal adjustments.

Web Photo Gallery

You can create an interactive gallery of your photos with the Web Photo Gallery feature. Using the Web Photo Gallery dialog box, you can organize your images and choose from a variety of Web page backgrounds and interfaces. When you're ready, Photoshop Elements automatically formats and copies your selected images to a single folder, and even generates the required HTML code for you.

Creative Techniques

Creating Animated GIFs

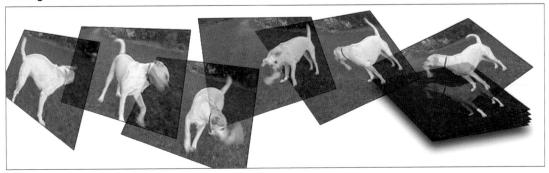

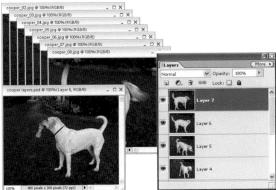

Step 1 Open all the images that you want to use as frames within your animation, then decide on the order that you want them to appear. If you download frames from a video camera, Photoshop Elements gives you several options for naming them in sequence, which can make this task a lot easier.

Step 2 Open a new file, sizing it to the dimensions you want your final animation to be, then drag the individual frames, in order, into the new file. A new layer is created with each image you add to the file. The first frame of your animation will become Layer 1, the second frame will become Layer 2, and so on.

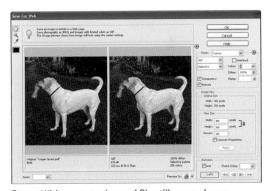

Step 3 With your new layered file still open, choose File > Save for Web to open the Save For Web dialog box. The dialog box opens, with a preview of a sample frame of your animation, and displays according to the optimization settings you choose in the dialog box. Select a GIF setting, then click to select the Animate check box. Photoshop Elements automatically optimizes all the frames of your animation. You can then click the controls at the bottom of the window to preview and set timing and looping options before you click OK to complete your animation.

You can also create animation from a still image by duplicating the image and placing the copies onto a series of layers. By slightly shifting the position of each layer either horizontally or vertically, the saved animation will create the illusion of a camera panning through your photograph.

Creative Techniques

Compositing Images

Step 1 Open all the images that you want to include in your new composite image.

Step 3 Begin your composite by copying and pasting the first file into the background file.

When you combine multiple images together to create a totally new image, that's called compositing. With the help of Photoshop Elements' flexible selection tools and powerful Layers palette, you can combine almost any number of images together to create fun effects.

Step 2 Use the selection and eraser tools to clean up and remove portions of your images that you don't need.

Step 4 Continue to add other image elements until you're satisfied with your composition. Add Layer styles to enhance the image, if appropriate. In this example, I applied the Low Drop Shadow to the boy so that his hands and arm cast a subtle shadow on the planet he's holding.

Figure 7.54 You can name and save your own custom filters and then apply them to other images.

- **4.** Change the Scale value to adjust the intensity of the effect.
 - The filter takes the total of the values you've entered and divides them by the value you've entered here. If the overall effect is too strong, try increasing the Scale value to tone down the intensity of the filter.
- 5. Change the Offset value.

 If you like the look of the filter so far, but think it's too dark, try entering a positive value. If it's too light, enter a negative value.
- **6.** Click OK to apply the custom filter. The Load and Save buttons allow you to save and reapply custom filters (**Figure 7.54**).

A Custom Filter Example

If you can't create a suitable filter through your own experimentation with the Custom filter settings, give this a try. Open an image and then open the Custom dialog box. Enter the settings shown in **Figure 7.55** and click Apply. The results should resemble something like a subtle crayon drawing (**Figure 7.56**). If you like the results, be sure to save your filter so you can use it again. Then try applying the filter a second time to create an even more pronounced effect (**Figure 7.57**). Incidentally, when you load this filter, you'll notice that any box you entered a 0 in is now empty. That's normal, and is just the way the filter is displayed.

Figure 7.55 Try entering the options shown here to produce an artistic crayonlike filter.

Figure 7.56 When you apply this custom filter the first time, the results can be subtle, depending on the size and resolution of your image.

Figure 7.57 Apply the filter a second time for an even more dramatic effect.

PAINTING AND DRAWING

8

A lifetime ago (in computer years, anyway) a little company just south of San Francisco introduced a small beige box with a tiny 9-inch keyhole of a monitor and a mouse resembling a new bar of soap. It could display and print only in black and white, was incapable of reproducing even remotely convincing photographic images, and was strictly limited to a resolution of 72 pixels per inch. And yet, graphic artists smiled a collective smile, because bundled in its modest software suite, alongside its stunted little word processor, Apple's early Macintosh gave the world MacPaint.

Painting and drawing programs have jumped by leaps and bounds since taking those first, early baby steps, but one feature remains the same: they're still so much fun to use!

In this chapter, you'll learn how to use Photoshop Elements' built-in drawing and painting tools to create original artwork or to enhance your digital photos—whether you're filling parts of your image with color, creating a blended gradient, adding a decorative stroked border to a logo or design element, or "painting" a photo with Impressionist-style brushstrokes.

About Bitmap Images and Vector Graphics

Photoshop Elements' painting and drawing tools render artwork in two fundamentally different ways.

The painting tools, including all the varied fills, gradients, brushes, and erasers, work by making changes to pixels—adding them, removing them, or changing their color. A bitmap image is composed entirely of tiny pixels; and digital photos, the mainstay of Photoshop Elements, are bitmap images. Although you can apply paintbrushes, color fills, special effects, and filters to bitmaps, they simply don't resize well. If you try to enlarge a digital photo, for example, you'll see that its image quality suffers as the pixels get bigger, resulting in a blurry mess.

The drawing tools (shape creation tools, really) form images not by manipulating pixels but by constructing geometric paths based on precise mathematical coordinates, or vectors. Images created with these drawing tools, known as vector graphics, hold one decided advantage over their bitmap cousins: they can be scaled up or down, virtually infinitely, with no loss of detail or resolution (Figure 8.1). Photoshop Elements' scalable fonts, for example, are based on vector shapes, so they can be stretched, warped, and resized to your heart's content. Vector graphics also tend to be smaller than comparable bitmap images, since a path shape requires less information for your computer to process and render than a similar shape constructed of pixels.

Although they're designed to work with different kinds of graphics, Photoshop Elements' painting and drawing tools are equally easy to use, and work well together if you want to combine vector and bitmap graphics—such as adding type or custom shapes to a favorite photo.

Figure 8.1 A photographic bitmap image (top) is constructed of pixels. Any attempt to zoom in on or enlarge a portion of the image can make the pixels more pronounced and the image more pixelated. A vector image (bottom) is drawn with a series of geometric paths rather than pixels. Vector graphics can be enlarged or reduced with no loss of detail or resolution.

Figure 8.2 Clicking the foreground or background color swatch in the toolbox opens the Color Picker.

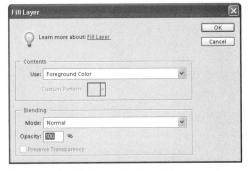

Figure 8.3 The Fill Layer dialog box offers several options for filling a layer or selection with color.

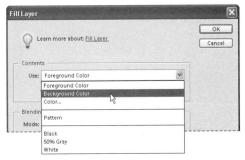

Figure 8.4 The Use drop-down menu contains various sources from which to choose a fill color. Choose the Foreground Color option to apply a specific color chosen from the Color Picker or Swatches palette.

Filling Areas with Color

You have two primary ways of filling areas with a solid color. With the Fill dialog box, you can quickly blanket an entire layer or a selected area of a layer with color. The Paint Bucket tool operates in a more controlled manner, filling only portions of areas based on properties that you set on the options bar. Either method works especially well for those times when you want to cover large, expansive areas with a single color.

To fill a selection or layer with color:

- Using any of the selection or marquee tools, select the area of your image you want to fill with color.
 If you want to fill an entire layer, it's not necessary to make a selection.
- **2.** To select a fill color, *do one of the following*:
 - ▲ Click either the current foreground or background color swatch at the bottom of the toolbox (**Figure 8.2**) to open the Color Picker; then select a color.
 - ▲ From the Swatches palette, click any color to select it.
- **3.** From the Edit menu, choose either Fill Selection or Fill Layer to open the Fill Layer dialog box (**Figure 8.3**).
- 4. From the Use drop-down menu, choose a source for your fill color (**Figure 8.4**). In addition to the foreground and background colors, you can use the Fill command to fill a selection or area with a pattern or with black, white, or 50 percent gray. Or you can choose Color to open the Color Picker and select a different color altogether.

- **5.** From the Blending area of the dialog box, select a blending mode and opacity for your fill. (For more information on blending modes, see "About Opacity and Blending Modes" in Chapter 5.)
- **6.** Click the Preserve Transparency check box if you want to preserve a layer's transparency when you apply the fill.
- Click OK to close the dialog box.
 The selection or layer is filled with the color and properties you specified (Figure 8.5).

✓ Tips

- To save time, you can use simple keyboard shortcuts to fill a selection or layer with either the current foreground or background color. Alt+Backspace will fill a selection or layer with the current foreground color, and Ctrl+Backspace applies the current background color.
- To swap the foreground and background color swatches in the toolbox, press X.
- To convert the foreground and background color to black and white, press D.

Figure 8.5 In this example, an area of the Background layer is selected (left), then filled with a color using the Fill dialog box (right).

About Preserving Transparency

The Preserve Transparency check box works just like the Lock Transparent Pixels button on the Layers palette. If the check box is highlighted and you fill a layer that has both opaque and transparent pixels, the transparent areas will be locked (or protected), and only the

opaque areas of the layer will be filled (Figure 8.6). If you check Preserve Transparency and then try to fill an empty layer (one containing only transparent pixels), the layer will remain unfilled. That's because the whole layer, being transparent, is locked. If you fill a flattened layer, like Photoshop Elements' default background layer, the check box is dimmed and the option isn't available because a background layer contains no transparency.

Figure 8.6 When a layer (left) is filled using the Preserve Transparency option, the transparent areas of the layer will remain protected and untouched, and only the layer object will accept the fill color (right).

Figure 8.7 The Paint Bucket tool.

Figure 8.8 To fill an area with a color, Foreground must be selected on the options bar's Fill drop-down menu.

Figure 8.9 The Paint Bucket tool takes advantage of all of Photoshop Elements' blending modes and opacity options.

Figure 8.10 The options bar contains several settings you can use to fine-tune the Paint Bucket's fill properties.

Figure 8.11 The Paint Bucket tool fills areas based on their tonal values. Here it automatically selects and fills just the light-colored background area.

To apply fill color with the Paint Bucket tool:

- **1.** Select the Paint Bucket tool from the toolbox (K) (**Figure 8.7**).
- **2.** Select a foreground color from either the Color Picker or the Swatches palette.
- 3. On the options bar, check that Foreground is selected in the Fill dropdown menu (**Figure 8.8**).

 The Paint Bucket tool can also be used to fill an area with a pattern.
- **4.** Again on the options bar, select a blending mode and opacity setting, if desired (**Figure 8.9**).
- 5. Still on the options bar, set a Tolerance value; then specify whether you want the colored fill to be anti-aliased, to fill only contiguous pixels, or to affect all layers (Figure 8.10).
 - For more information on these options, see the sidebar "How Does That Paint Bucket Tool Work, Anyway?"
- 6. Click the area of your image where you want to apply the colored fill.
 The selected color is painted into your image (Figure 8.11).

How Does That Paint Bucket Tool Work, Anyway?

If you're familiar with other painting and drawing programs, Photoshop Elements' Paint Bucket tool may leave you scratching your head. In many paint programs, the Paint Bucket tool does little more than indiscriminately dump color across large areas of an image. But Photoshop Elements' Paint Bucket tool is much more intelligent and selective about where it applies color. Depending on the parameters you set in the options bar, it fills areas based on the tonal values of their pixels.

The **Tolerance** slider determines the range of pixels the Paint Bucket fills. The greater the value, the larger the range of pixels is filled.

Click Anti-aliased to add a smooth, soft transition to the edges of your color fill.

Click **Contiguous** to limit the fill to pixels similar in color or tonal value that touch, or are *contiguous* with one another. If you're using the Paint Bucket tool to switch your car's color from green to blue, this ensures that only the *car's* green pixels are turned blue—not all the green pixels within the entire image.

If you select the **Use All Layers** check box, Photoshop Elements recognizes and considers pixel colors and values across all layers, but the fill is applied only to the active layer. This means that if you click the Paint Bucket tool in an area of any *inactive* layer, the fill will be applied to the current *active* layer (**Figure 8.12**).

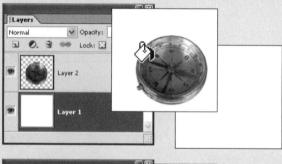

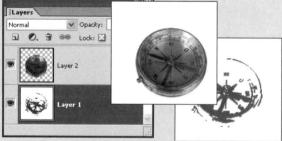

Figure 8.12 If the All Layers check box is selected and you click the Paint Bucket tool in an inactive layer (top), the fill for that specific area is applied to the active layer (bottom).

Figure 8.13
The Gradient tool.

Figure 8.14 Open the gradient picker to select from sets of gradient thumbnails.

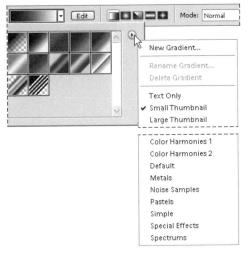

Figure 8.15 The gradient picker's menu offers several picker display options plus access to a variety of gradient sets.

Filling Areas with a Gradient

The Gradient tool fills any layer or selection with smooth transitions of color, one blending gradually into the next. They can be rendered as opaque fills or seamlessly incorporated into a layered project using any of Photoshop Elements' blending modes and opacity settings. You can use a gradient to create an effective background image for a photo; to screen back just a portion of an image; to create an area on which to place type; or you can apply it to any shape or object to simulate the surface texture of metal or glass.

To apply a gradient fill:

- Using any of the selection or marquee tools, select the area of your image where you want to apply the gradient.
 If you want to fill an entire layer, you don't need to make a selection.
- Select the Gradient tool from the toolbox (G) (Figure 8.13).
- **3.** On the options bar, click to open the gradient picker (**Figure 8.14**).
- 4. Click to choose from the list of default gradients, or if you want to view additional gradient sets, click the More button (the triangle to the right of the thumbnail images) to open the Gradient palette menu (**Figure 8.15**).

 Gradient sets are located in the bottommost section of the menu. When you

select a new gradient set, it replaces the

set displayed in the gradient picker.

- On the options bar, click to choose a gradient type (Figure 8.16).
 You can choose from among five gradient types: Linear, Radial, Angle, Reflected, and Diamond.
- 6. In the image window, click and drag in the area where you want to apply the gradient (Figure 8.17).
 The selection or layer is filled with the

The selection or layer is filled with the gradient.

✓ Tip

 Hold down the Shift key to constrain a gradient horizontally, vertically, or at a 45-degree angle.

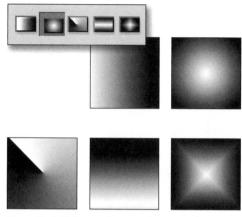

Figure 8.16 Click a gradient type button on the options bar to draw one of five gradient types.

Figure 8.17 Drag from the center to the edge to create a halo effect with the Radial gradient.

Gradient Types

You can create two gradient types from the Gradient Editor: Solid and Noise.

Solid is the default gradient type. When creating or editing a gradient in Solid mode, you can add color and opacity stops and adjust the smoothness of the transition between colors with a percentage slider. You can also change the location of the Color and Opacity stops and their midpoints.

Noise is, well, largely useless. Noise creates random bands of color based on either the RGB or HSB color model, and although there must be some good application for it somewhere, I have yet to stumble on what it might be. Feel free to experiment with this gradient, but you probably won't end up using it much.

Figure 8.18 The Edit button on the options bar opens the Gradient Editor.

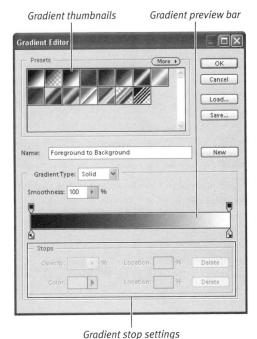

Figure 8.19 The Gradient Editor dialog box.

Creating and Saving Custom Gradients

Although Photoshop Elements ships with a wide variety of gradients and gradient sets, at some point, you may want to create your own customized gradient effects. All of the tools you'll need are provided in one powerful package. With the Gradient Editor, you can not only create new gradients, but you can also create and save new gradient sets, which you can then access and load from the gradient picker. In addition, you can use Photoshop Elements' Preset Manager to organize and edit your new gradient sets.

To create a new gradient:

- 1. Select the Gradient tool from the toolbox.
- 2. On the options bar, click the Edit button to the right of the gradient picker (Figure 8.18).
 - The Gradient Editor dialog box opens (**Figure 8.19**).
- **3.** From among the gradient thumbnails in the Presets area, click to select a gradient similar to the one you want to create. Keep in mind that any new gradient you create is always based on an existing gradient, so you can save yourself a little time by starting with a gradient that has properties (numbers of bands of color, opacity settings, and so on) similar to the new gradient that you have in mind. You create and modify gradients primarily by editing the gradient preview in the lower portion of the dialog box. Color stops on the bottom side of the gradient preview define which colors a gradient contains, whereas opacity stops along the top allow you to add levels of transparency to different sections of the gradient.

- 4. Click a color stop to select it (Figure 8.20).
- **5.** To assign a new color to the color stop, *do one of the following*:
 - Click directly in the Color box to open the Color Picker, and select a new color from there.
 - ▲ Click the arrow next to the Color box to open the Color drop-down menu. From the drop-down menu, choose either the current foreground or background color (**Figure 8.21**).

Be aware that the latter option doesn't assign a specific color to the color stop, but creates a kind of link to the foreground and background color swatches in the toolbox. This means that if you change the foreground or background color, the color stop (and the section of gradient it defines) will change color too. If you want to permanently assign a current foreground or background color to a color stop, first select either option from the drop-down menu, then choose User Color from the same menu. Selecting User Color will break the link to the toolbox swatches and lock that color into the color stop (Figure 8.22).

The gradient preview changes to reflect the color change.

Assign colors to the remaining color stops in the same fashion.

6. To add a new color stop, move the pointer to any spot directly below the gradient preview; then click once (Figure 8.23).
A new color stop appears, which in turn adds a new color to the gradient in the gradient preview.

Figure 8.20 You can position the Gradient Editor's color stops anywhere on the gradient preview bar.

Figure 8.21 Assign a foreground or background color to a color stop from the Color drop-down menu.

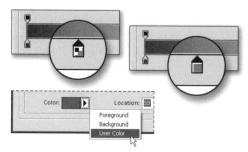

Figure 8.22 Select User Color from the Color drop-down menu to change a linked foreground or background color stop (left) to an unlinked, self-contained color stop (right).

Figure 8.23 You can add and modify any number of new color stops.

Figure 8.24 Move a color stop to change a color's location in the gradient.

Figure 8.25 A gradient midpoint at its default location halfway between two color stops.

Figure 8.26 As you move a gradient midpoint, you change the position of the transition area where two colors in the gradient mix together.

Figure 8.27 With the Smoothness slider set at 100 percent, the transitions between colors are subtle and gradual (top). As the slider moves closer to 0, the transitions become a bit more harsh (bottom).

The color of the new color stop is determined by the current color displayed in the Color box. If the Color box is grayed out and inactive, the last color that appeared in the Color box will be applied to the new color stop.

- **7.** To move a color stop, *do one of the following*:
 - ▲ Click and drag the stop to a new location below the gradient preview (Figure 8.24).
 - ▲ Click to select a stop, then enter a percentage value in its Location text box below the gradient preview.

As the color stop moves, the color associated with it in the gradient preview will shift accordingly.

Between each set of color stops is a gradient midpoint—the point where two gradient colors meet and mix. The default midpoint location is 50 percent, or exactly halfway between color stops (**Figure 8.25**).

- **8.** To move a gradient midpoint, *do one of the following:*
 - ▲ Click and drag the midpoint to anywhere between its two color stops.
 - ▲ Click to select a midpoint, then enter a percentage value in its Location text box below the gradient preview (Figure 8.26).

As the midpoint moves, the area where the two colors mix in the gradient preview will shift accordingly.

9. Drag the Smoothness slider above the gradient preview to decrease or increase the smoothness of the transitions between the new gradient color and those surrounding it (**Figure 8.27**).

10. To remove a color stop, drag the stop straight down, away from the gradient preview.

The color stop disappears, as does its associated color in the gradient preview.

11. To change a gradient's opacity, click to select an opacity stop, located above the gradient preview; then move the Opacity slider in the lower portion of the dialog box (**Figure 8.28**).

Additional opacity stops can be added just like color stops, by clicking directly *above* the gradient preview.

12. Name your gradient, if you like; then click the New button.

Your new gradient appears with the other thumbnail views in the Presets portion of the dialog box (**Figure 8.29**).

Your new gradient is displayed in the gradient picker preview on the options bar.

When you create a new gradient, it's saved (at least temporarily) in Photoshop Elements' preset file. But once you reset the gradients in the gradient picker or select a different gradient set, any new gradients you've created will be lost.

Fortunately, you can use the Gradient Editor and gradient picker to save your own gradient sets.

✓ Tip

If you open the Swatches palette prior to opening the Gradient Editor, you can assign colors to color stops by clicking on the swatches in the palette. Remember, you'll need to have the palette open on your desktop, *outside* of the palette well, to access it once the Gradient Editor is open.

Figure 8.28 Opacity stops, in tandem with the Opacity slider, allow you to change the opacity of areas within a gradient.

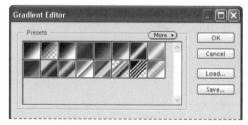

Figure 8.29 When you create a new gradient, it's automatically displayed with the other gradients in the Presets thumbnail window.

Figure 8.30 Click the Gradient Editor's Save button to open the Save dialog box.

Figure 8.31 Enter a name for your new gradient set in the File name text box.

Figure 8.32 The next time you start Photoshop Elements, your new gradient set appears with the others on the gradient picker menu.

To create a new gradient set:

- Create as many new custom gradients as you like, as described in the previous procedure.
- 2. In the Gradient Editor dialog box, click the Save button (Figure 8.30). The Save dialog box opens with the Gradients presets folder automatically selected as the destination to which your new gradient set will be saved (Figure 8.31).
- **3.** Enter a new name for your gradient set; then click Save.

Your new gradient set will be saved with the others (**Figure 8.32**), but it won't appear on either the More menu in the Gradient Editor or the drop-down menu in the gradient picker until after you quit and then restart Photoshop Elements. Once you've created a new gradient set, particularly if you've based it on an existing set, you may want to do a little house-keeping by saving some gradients and throwing others away. You can use the Photoshop Elements Preset Manager to clean up your new gradient sets.

To edit a gradient set:

- From the Edit menu, choose Preset Manager to open the Preset Manager dialog box.
- 2. From the Preset Type drop-down menu, choose Gradients (**Figure 8.33**), or press Ctrl+3.
- **3.** From the Preset Manager's More menu, choose the gradient set that you want to edit.
 - Remember that if you've created a new gradient set, you'll need to quit and then restart Photoshop Elements before your new set will appear in any of the dropdown menus.
- 4. In the thumbnail area, Ctrl+click to select only the gradients that you want to keep in your gradient set (Figure 8.34).
 If you select a gradient by mistake, deselect it by holding down Ctrl and clicking it a second time.
- **5.** Click the Save Set button to open the Save dialog box.
- 6. Check that the name in the File name text box is the same as the one that you've been editing; then click Save.

 Your gradient set will be resaved, this time containing only those gradients that you selected in step 4.

 Alternatively, you can enter a different

Alternatively, you can enter a different name in the File name text box to create a brand-new gradient set.

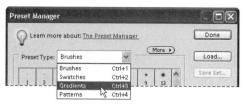

Figure 8.33 The Preset Manager is actually four different preset managers in one.

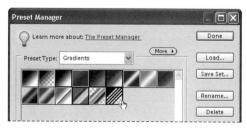

Figure 8.34 Every gradient thumbnail you select will be included in your new gradient set when you click Save Set.

Figure 8.35 The Stroke dialog box.

Figure 8.36 Once an object is selected (top row), you can stroke it either inside, centered on, or outside of the selection (bottom row).

Adding a Stroke to a Selection or Layer

Photoshop Elements' Stroke command adds a colored rule or border around any selected object or layer. With the Stroke command, you can easily trace around almost anything, from simple rectangle or ellipse selections to complex typographic characters. Because you can control both the stroke's thickness and where the stroke is drawn in relation to a selection (inside, outside, or centered), you can create everything from delicate, single-ruled outlines to decorative, multiple-stroked borders and frames.

To apply a stroke:

- Using any of the selection or marquee tools, select the area of your image to which you want to add a stroke.
 If you're adding a stroke to an object on its own transparent layer, there's no need to make a selection. Instead, just check that the layer is active on the Layers palette.
- 2. From the Edit menu, choose Stroke (Outline) Selection to open the Stroke dialog box (**Figure 8.35**).
- In the Width text box, enter the stroke width, in pixels.
 There's no need to enter the pixel abbreviation (px) following the number value.
- **4.** Change the stroke color by clicking the Color box and opening the Color Picker.
- **5.** Select the location of the stroke. The location determines where the stroke is drawn: inside, outside, or centered directly on the selection (**Figure 8.36**).

- **6.** Ignore the Blending portion of the dialog box for now.
- Click OK to apply the stroke to your selection or layer (Figure 8.37).

✓ Tip

■ Photoshop Elements uses the foreground color for the stroke color unless you change it in the Stroke dialog box. So if you want to pick a stroke color from the Swatches palette, click the Swatches palette to assign the foreground color before anything else; then choose Stroke from the Edit menu. The color you chose from the Swatches palette will appear as the stroke color in the dialog box.

Figure 8.37 Select an object (left), then choose the Stroke command to apply a stroke (right).

Creating a Stroke Layer

It's a good habit to create a new layer before applying strokes to your image. That way, you can control attributes such as opacity and blending modes right on the Layers palette. You can even turn strokes off and on by clicking the stroke layer's visibility icon. If you're adding a stroke to a selection, simply create a new layer and then follow the steps in the task "To apply a stroke." If you're stroking an object on a transparent layer and want its stroke on a separate layer, you need to perform a couple of additional steps:

- Identify the object to which you want to add a stroke; then press Ctrl and click once on the layer on the Layers palette.
 - The object is automatically selected in the image window (**Figure 8.38**).
- **2.** Create a new layer by clicking the New Layer button at the top of the Layers palette.
- **3.** With the new layer selected on the Layers palette, choose Stroke (Outline) Selection from the Edit menu; then follow steps 3 through 7 of "To apply a stroke."

A stroke will be created for the object, but placed on its own layer.

Figure 8.38 Ctrl+click the Layers palette to create a selection around a layer object.

Figure 8.39 The first step in creating a multiruled border is to create a thick stroke. Here, I used a stroke of 60 pixels.

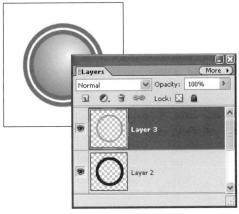

Figure 8.40 Placing a narrow stroke of a different color over the broad first stroke creates an attractive three-ruled border.

To create a decorative border:

- 1. Make a selection, either by using one of the selection or marquee tools, or by selecting an object on a transparent layer as described in the "Creating a Stroke Layer" sidebar.
- Create a new layer; then apply a wide stroke to the selection (Figure 8.39).
 In this example, I used a stroke of 60 pixels.
- **3.** With the selection still active, create a new layer above the first.
- **4.** Apply a stroke narrower than the first and in a contrasting color or value (**Figure 8.40**).
- **5.** Continue to add stroke layers until you achieve the desired result.

✓ Tip

■ You can create different effects by adding inside and outside strokes.

Using the Brush Tool

The Brush tool is a near limitless reservoir of hundreds of different and unique brushes. You can apply painted brushstrokes directly to the surface of any photograph, or open a new file to serve as a blank canvas upon which you can create an original work of fine art. The dozen preset brush libraries offer selections as varied as Calligraphic, Wet Media, and Special Effects, and any brush can be resized from 1 pixel to a staggering 2500 pixels in diameter. You can paint using any of Photoshop Elements' blending modes and opacity settings, and you can turn any brush into an airbrush with a single click of a button. So whether you're a budding Van Gogh, would like to add a color-tint effect to an antique black-and-white photograph, or just enjoy doodling while talking on the phone, Photoshop Elements' brushes can help to bring out your inner artist.

To paint with the Brush tool:

- **1.** To select a paint color, *do one of the following:*
 - Click the current foreground color swatch at the bottom of the toolbox to open the Color Picker.
 - ▲ Choose a color from the Swatches palette.
- **2.** Select the Brush tool in the toolbox (B) (**Figure 8.41**).
- **3.** On the options bar, click to open the Brush Presets palette (**Figure 8.42**).
- **4.** Click to choose from the list of default brushes, or select a different brush set from the Brushes drop-down menu (**Figure 8.43**).

Figure 8.41 The Brush tool.

Figure 8.42 Open the Brush Presets palette to select from sets of different brushes.

Figure 8.43 The Brushes drop-down menu gives you access to a variety of brush sets.

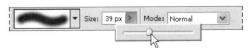

Figure 8.44 Use the brush Size slider to resize your brush.

Figure 8.45 Create realistic brush effects simply by dragging through the image window.

Figure 8.46 Click the Airbrush button on the options bar to give a brush the characteristics of an airbrush.

Once you've selected a brush, you can use it at its predefined size, or you can resize it using the brush Size slider on the options bar (**Figure 8.44**).

- **5.** Again on the options bar, select a blend mode and opacity setting.
- **6.** In the image window, drag to paint a brushstroke (**Figure 8.45**).

✓ Tips

- You can easily resize brushes on the fly using simple keyboard shortcuts. Once a brush of any size is selected, press the] or [key to increase or decrease the current brush size to the nearest unit of 10 pixels. Thus, if you're painting with a brush size of 23 pixels and press the] key, the brush size increases to 30 pixels and then grows in increments of 10 each subsequent time you press]. Conversely, a brush size of 56 pixels is reduced to 50 pixels when you press the [key, and the brush continues to shrink by 10 pixels each time thereafter that you press [.
- When any tool that uses a brush-type pointer is selected (the Eraser, Blur, Sharpen, and Clone tools, for instance), the same keyboard shortcuts as described in the preceding tip apply.
- Almost any brush can be made to behave like an airbrush by clicking the Airbrush button on the options bar (Figure 8.46). With the Airbrush selection activated, paint flows more slowly from the brush and gradually builds denser tones of color. The Airbrush option is most effective when applied to soft, round brushes or to brushes with scatter and spacing properties. (For more information on scatter and spacing properties, see the sidebar "Understanding the Brush Dynamics Palette" later in this chapter.)

Creating and Saving Custom Brushes

With so many different brushes and brush sets at your disposal, you may be surprised to discover that you can change not only the size of brushes, but other characteristics such as flow, shape, and color. Photoshop Elements provides you with all of the tools you need to modify existing brushes and to create your own from photographs or scanned objects, such as leaves or flower petals. Once you've created a new brush, you can store it temporarily in an existing brush set or save and organize it into a new brush set of your own. Any new brush sets you create can then be accessed and loaded from the Brushes drop-down menu on the Brush Presets palette.

To create a custom brush:

- 1. Select the Brush tool from the toolbox (B).
- **2.** From the list of preset brushes on the options bar, click to select a brush you want to customize (**Figure 8.47**).
- **3.** On the options bar, click the More Options button to open the Brush Dynamics palette (**Figure 8.48**).
- 4. Use the sliders on the palette to modify the Spacing, Fade, Hue Jitter, Hardness, and Scatter properties of the brush. For more information on these slider controls, see the "Understanding the Brush Dynamics Palette" sidebar later in this chapter.
- **5.** You can also adjust the angle and roundness of the brush (**Figure 8.49**).

Figure 8.47 To create a new brush, select an existing brush and then customize its properties.

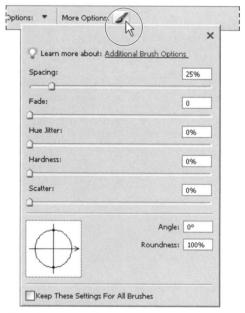

Figure 8.48 The Brush Dynamics palette contains slider controls to modify a brush shape.

Figure 8.49 The lower portion of the Brush Dynamics palette offers controls for angle and roundness.

Figure 8.50 The Brush Presets preview area displaying an original brush (top) and the same brush customized on the Brush Dynamics palette (bottom).

Figure 8.51 Tablet options give you control over how pen pressure affects certain brush settings.

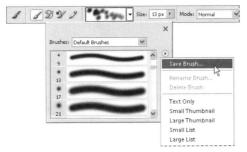

Figure 8.52 Save your customized brushes on the Brush Presets palette menu.

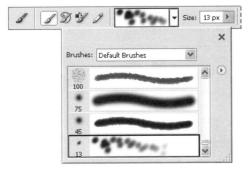

Figure 8.53 A new brush is always displayed at the bottom of the palette list.

As you move the sliders, or enter angle and roundness values, you can refer to the brush presets preview on the options bar to see the effects of your changes. All but the Hue Jitter property will be reflected in the preview on the options bar (**Figure 8.50**).

If you have a pressure-sensitive digital tablet connected to your computer, you can control how the pen's pressure will affect your brush settings.

- **6.** On the options bar, click the Tablet Options button, then check the boxes for the brush settings that you want the pen pressure to control (**Figure 8.51**).
- **7.** When you're satisfied with your changes, click anywhere on the options bar to close the palette.
- **8.** On the options bar, use the brush Size slider to size your brush.
- **9.** Still on the options bar, open the Brush Presets palette; then select Save Brush from the palette options menu (**Figure 8.52**).

The Brush Name dialog box opens.

10. Type a name for your new brush and click OK.

Your new brush appears at the bottom of the current brush presets list on the Brush Presets palette (**Figure 8.53**).

Understanding the Brush Dynamics Palette

With a little bit of exploration, you'll find Photoshop Elements' Brush Dynamics palette to be a useful tool for creating new brushes and modifying the attributes of existing ones.

The **Spacing** slider controls the spacing of the brush shape and is based on a percentage of the brush's current size (**Figure 8.54**). The default for most round brushes is 25 percent; 5 percent seems to be the optimum for most of the fine-art brushes such as the Chalks, Pastels, and Loaded Watercolor brushes.

The **Fade** slider sets the number of steps a brush takes to fade to transparent and can simulate the effect of a brush running out of paint as it draws across a surface. One step is equal to a brush width, so the fade effect is somewhat dependent on the Spacing attribute (**Figure 8.55**).

The **Hue Jitter** slider determines how randomly the brush renders color, based on the foreground and background colors. The lower the jitter percentage, the more the foreground color is favored. If the percentage is set to the maximum of 100 percent, the foreground and background colors (and mixtures of the two colors combined) are represented in equal measure throughout the brushstroke.

The **Hardness** slider controls the hardness or softness of a brushstroke's edges. A Hardness value of 100 percent creates a solid brushstroke with no soft edges (**Figure 8.56**).

The **Scatter** slider determines how much a brush shape is spread around with each stroke. The higher the percentage value, the more brush shapes are scattered and spread across an area. Lower percentage values create almost no scatter at all (**Figure 8.57**).

The **Angle** value allows you to rotate a brush shape to any angle, and the **Roundness** value can be used to flatten out or squish a brush shape.

Figure 8.54 A brush spacing value of 25 percent (left) and 75 percent (right).

Figure 8.55 A brush fade value of o (left) and 15 (right).

Figure 8.56 A brush hardness value of o percent (left) and 100 percent (right).

Figure 8.57 A brush scatter value of o percent (left) and 30 percent (right).

Figure 8.58 A custom brush can be made out of virtually any selected object. In this example, I've selected a large daisy.

Figure 8.59 The selection appears in the brush preview of the Brush Name dialog box.

Figure 8.60 Once saved, your new brush appears in the brush presets list.

To create a brush from a photographic object:

- Open an image that contains an object or area from which you want to create a new brush.
- **2.** To select an object from the image, *do one of the following*:
 - ▲ Using one of the selection tools, select the object or portion of a photograph you want to make into a brush. The Selection Brush and Magnetic Lasso tools both work well for this kind of selection (**Figure 8.58**).
 - ▲ If you already have an object on its own transparent layer, hold down Ctrl and click on the layer thumbnail in the Layers palette.
- From the Edit menu, choose Define Brush from Selection.
 The Brush Name dialog box opens with a representation of your new brush in its preview box (Figure 8.59).
- **4.** Enter a name for the brush and click OK to close the dialog box.
- **5.** Select the Brush tool from the toolbox; then from the options bar, open the Brush Presets palette.
 - Your new brush appears at the bottom of the current brush presets list (**Figure 8.60**).
- **6.** Click to select the new brush; then on the options bar, click the More Options button to open the Brush Dynamics palette.
- 7. Use the sliders on the palette to modify the brush attributes; then click anywhere on the options bar to close the palette.

✓ Tips

- You can use these kinds of brushes to great effect as background textures, type borders, or homemade "rubber stamps" for greeting cards and invitations.
- Images with high contrast generally work best as brush shapes. Remember that you're not saving any color information—just the object's shape and its tonal values—so you'll want to use shapes with as much defined detail as possible.
- Don't be discouraged if you can't seem to duplicate the color and scatter effects of preset brushes such as Maple Leaves. A good number of the built-in brushes weren't created in Photoshop Elements at all, but in Adobe Photoshop. Photoshop offers a host of additional controls, including jitter properties for scatter, angle, hue, and size. For now, while you're working in Photoshop Elements, any blowing leaves or dune grass you create will all have to face the same direction.

Figure 8.61 You can open the Preset Manager directly from the Brush Presets palette.

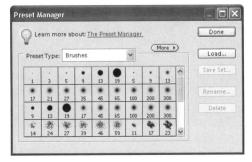

Figure 8.62 The Brushes Preset Manager.

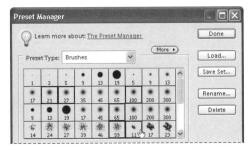

Figure 8.63 Select brushes you want included in your new brush set.

Figure 8.64 Name your new brush set in the Save dialog box.

Managing brush sets

Managing Photoshop Elements' brushes is no different than managing its other presets (such as gradients and patterns). When you create a new brush, it's saved in the presets file. But once you reset the brushes on the Brush Presets palette or select a different brush set, any new brushes you've created will be lost. You can use the Preset Manager to create and save your new brush sets.

To create a new brush set:

- Create as many new brushes as you like, as described in the previous procedures.
- From the Brush Presets palette menu, choose Preset Manager (Figure 8.61).
 The Preset Manager dialog box opens to the current brush set displayed on the Brush Presets palette (Figure 8.62).
- **3.** Scroll through the thumbnail views until you find the brushes you want to include in your new set.
- **4.** In the thumbnail area, Ctrl+click to select all of the brushes that you want to include (**Figure 8.63**).

If you select a brush by mistake, you can deselect it by holding down Ctrl and clicking the thumbnail a second time.

- **5.** Click the Save Set button to open the Save dialog box.
- **6.** In the File name text box, enter a new name to describe your brush set and click Save (**Figure 8.64**).

Your brush set will be saved with the brushes you selected in step 4.

Your new brush set will be saved with the others, but it won't appear on either the More menu in the Preset Manager or the Brushes drop-down menu on the Brush Presets palette until after you quit and

then restart Photoshop Elements.

Creating Special Painting Effects

The Impressionist Brush tool adds a painterly look to any photographic image. Although similar in effect to some of the Artistic and Brush Stroke filters, the Impressionist Brush tool allows you to be much more selective about which areas of an image it's applied to. That's because it uses the same scaleable, editable brushes as the Brush tool. You can use the Impressionist Brush tool to create compelling works of art from even the most mundane of photographs.

To paint with the Impressionist Brush tool:

- **1.** Open the image to which you want to apply the Impressionist Brush effect.
- 2. Select the Impressionist Brush tool from beneath the Brush tool in the toolbox (Figure 8.65).
 - Alternatively, you can press B to select the Brush tool and then press B again to toggle to the Impressionist Brush tool.
- 3. On the options bar, select a brush from the Brush Presets palette. You can, of course, use any brush with the Impressionist Brush tool, but the round, soft-sided brush that Photoshop Elements picks as the default works especially well.
- 4. Again on the options bar, select a size with the brush Size slider (Figure 8.66). You can also select a mode and an opacity option, although in most cases the defaults of Normal and 100 percent are fine.
- **5.** Still on the options bar, click the More Options button to open the Impressionist Brush Options palette (**Figure 8.67**).

Figure 8.65 The Impressionist Brush tool.

Figure 8.66 The brush size can have quite an impact on the way the Impressionist Brush tool affects your photograph. In the photo on the left, I painted with a brushstroke of 10 pixels. In the photo on the right, I changed the brushstroke to 20 pixels.

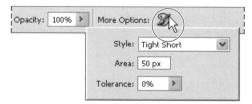

Figure 8.67 The Impressionist Brush Options palette has controls for different brush styles and the amount of image area they affect with each brushstroke.

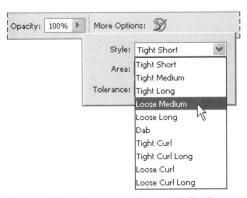

Figure 8.68 Brush styles vary from subtle (Dab) to extravagant (Loose Curl Long).

Figure 8.69 Simply drag the brush through your photo to create a work of art.

- **6.** From the Style drop-down menu, select a brush style (**Figure 8.68**).
 - I tend not to stray much beyond the top three Styles (Tight Short, Medium, and Long), although the Dab style also creates some pretty effects.
- 7. In the Area text box, enter a value, in pixels, for the amount of area you want to affect with each stroke of the brush.

 For example, let's say you start with a brush that makes a single brush mark 10 pixels wide, and then select an Area value of 80 pixels. As you move the brush through the image—and depending on the brush style you chose—it will swoosh around an area of 80 x 80 pixels, distributing the paint in 10-pixel dollops.
- **8.** If desired, select a Tolerance setting to determine the range of pixels affected. You may want to keep the Tolerance slider set at 0 percent and leave it alone. In use with the Impressionist brush, this setting seems wildly erratic and not worth the trouble.
- 9. In the image window, drag the brush through your image.
 The image takes on a painterly look wherever the Impressionist Brush tool is drawn through it (Figure 8.69).

✓ Tips

- Images with resolutions of 150 pixels per inch and higher make the best candidates for the Impressionist Brush tool, because the higher resolution helps to preserve detail when the effect is applied.
- Stick to using smaller brush sizes, particularly on low-resolution images. Although any rules of thumb vary from image to image, a good starting place is a brush size between 6 and 10 pixels and an Area setting of between 30 and 50.

Erasing with Customizable Brush Shapes

The images or brushstrokes you choose to remove from a photograph are often as important as those you decide to add or leave behind. The basic Eraser feature is a powerful tool for cleaning up and fine-tuning your images, taking full advantage of every brush style and size that Photoshop Elements has to offer. Not only can you perform routine erasing tasks such as rubbing away stray pixels, you can also customize an eraser's brush and opacity settings to create unique texture, color, and pattern effects. Three modes allow you to customize your erasers even further, so that you can erase with soft-edged brush shapes, hard-edged pencil shapes, or a simple hard-edged square block.

To use the Eraser tool:

- **1.** Select the Eraser tool from the toolbox (E) (**Figure 8.70**).
- **2.** On the options bar, select a brush from the Brush Presets palette (**Figure 8.71**).
- **3.** Again on the options bar, select a size using the brush Size slider.
- 4. From the Mode drop-down menu, select one of the three eraser modes.
 If you select a soft, anti-aliased brush and then choose Pencil from the mode menu, the eraser will become coarse and aliased (Figure 8.72).
- **5.** Still on the options bar, select an opacity using the Opacity slider.
- **6.** In the image window, drag the eraser through your image.

 The image is erased according to the attributes you've applied to the eraser.

Figure 8.70 The Eraser tool.

Figure 8.71 The same brush presets are available for the Eraser tool as for the Brush tool.

Figure 8.72 An eraser in Brush mode (left) and in Pencil mode (right).

Erasing on Flattened vs. Layered Images

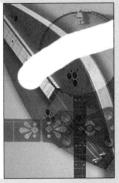

Figure 8.73 On a flattened image layer, the Eraser tool paints with the current background color wherever the eraser is dragged.

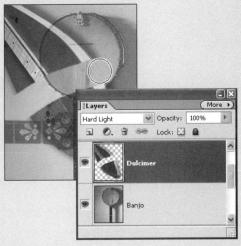

Figure 8.74 When erasing on a layer with transparency, the Eraser tool actually removes image pixels (here, the center of the dulcimer layer) and exposes the image on the layer below (the paint cup).

The Eraser tool functions in a fundamentally different way, depending on whether it's erasing on a flattened image, such as Photoshop Elements' default background, or on a layer of a multilayered file. When erasing on a flattened image, the Eraser tool doesn't really erase at all. Instead, it replaces the image with the current background color displayed in the toolbox. In other words, it simply paints over the image with the background color (**Figure 8.73**).

On the other hand, when erasing a portion of an image from a layer, the Eraser tool actually removes the pixels from the layer, creating a transparent hole and exposing the image on the layer directly below it (**Figure 8.74**).

✓ Tip

■ You're not limited to round or square brush shapes for your erasers. Any brush, even pictorial ones (for instance, Maple Leaves and Dune Grass) or photographic ones (like Scattered Leaves) can be used as erasers. Try experimenting with different brush shapes and opacity settings to create unusual textures and patterns in your photographs.

Erasing Backgrounds and Other Large Areas

The Background Eraser tool is an intelligent (and really quite amazing) little feature. Not only does it remove the background from around very complex shapes, but it does so in a way that leaves a natural, softened, antialiased edge around the foreground object left behind. This technique would be impossible to pull off with the regular Eraser tool, because it indiscriminately removes whatever pixels it touches. Because the Background Eraser tool erases pixels based on colors and tonal values that you control and modify, there is rarely much additional cleanup required once the background has been removed. Additionally, because the Background Eraser tool always erases to transparency, if you use it to remove the background from even a flattened layer, it automatically converts that layer to a floating, transparent one. This allows you to easily place a new background behind a foreground image, or to move it into a different photo composition altogether.

To use the Background Eraser tool:

- **1.** Select the Background Eraser tool from beneath the Eraser tool in the toolbox (**Figure 8.75**).
 - Alternatively, you can press E to select the Eraser tool and then press E again to toggle to the Background Eraser tool.
- **2.** On the options bar, select a size using the brush Size slider.

Figure 8.75 The Background Eraser tool.

Figure 8.76 The Limits drop-down menu controls which pixels beneath the brush are sampled and erased.

Figure 8.77 You use the Tolerance slider to increase or decrease the number of pixels sampled based on their similarity to one another.

Figure 8.78 Begin by placing the crosshairs of the brush in the background portion of the image (left), then drag the brush along the outside edge of the foreground object to erase the background (right). Continue around the edge of the foreground object until it's completely separated from the background.

- From the Limits drop-down menu, select one of the two limit modes (Figure 8.76).
 Contiguous mode erases any pixels within the brush area that are the same as those currently beneath the crosshairs, as long as they're touching one another.
 Discontiguous mode erases all pixels
 - within the brush area that are the same as those beneath the crosshairs, even if they're not touching one another.
- 4. Select a Tolerance value, using the Tolerance slider (**Figure 8.77**). The Tolerance value controls which pixels are erased according to how similar they are to the pixels beneath the eraser crosshairs. Higher Tolerance values increase the range of colors that are erased, and lower values limit the range of colors erased.
- 5. In the image window, position the eraser pointer on the edge where the background and foreground images meet, and then drag along the edge.

 The background portion of the image is erased, leaving behind the foreground image on a transparent background (Figure 8.78). The brush erases only pixels similar to the ones directly below the crosshairs, so the entire background can be completely erased while leaving the foreground image intact.

✓ Tips

- It's okay if the circle (indicating the brush size) overlaps onto the foreground image, but be sure to keep the crosshairs over just the background area. The Background Eraser tool, of course, doesn't really know the difference between background and foreground images, and is simply erasing based on the colors selected, or *sampled*, beneath the crosshairs. If the crosshairs stray into the foreground image, that part of the image will be erased, too.
- There's a third eraser tool—the Magic Eraser tool—that I've chosen not to cover here because, frankly, it doesn't work very well. It operates on the same principle as the Magic Wand tool (and, to some extent, the crosshairs on the Background Eraser tool) by deleting like pixels based on color or tonal value. That's all well and good, but you're not given any feedback or any opportunity at all to modify your selection. You just click, and poof—a large area of color is gone. Since the erasure typically is either not quite enough or a little too much, you undo, reset the tolerance, try again, undo—well, you get the idea. The other two erasers work fabulously well, so I suggest just keeping the Magic Eraser tool in the toolbox.

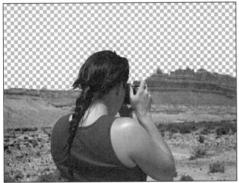

Figure 8.79 Use the Magic Extractor dialog box to identify the foreground and background areas of an image, and then delete an unwanted background.

Removing a Foreground Image from Its Background

The Magic Extractor works much the same way as the Background Eraser tool: both provide a way to remove an unwanted background image while preserving a foreground image floating on a transparent layer. The Magic Extractor distinguishes itself with speed and added control. Rather than using the Background Eraser tool's method, which requires you to painstakingly trace around a foreground image, the Magic Extractor works by using brushes to mark and identify first the foreground image that you want to save, and then the background image that you want to delete (Figure 8.79). A set of additional tools helps you to fine-tune your foreground and background selections, and a number of options are available for preview and for final touch-up.

To use the Magic Extractor tool:

- 1. From the Image menu, choose Magic Extractor to open the Magic Extractor dialog box (**Figure 8.80**).
- 2. From the tool area on the left side of the dialog box, select the Foreground Brush tool (**Figure 8.81**).
- **3.** Use the brush Size slider, if necessary, to adjust the size of your brush, and then use the brush to mark the foreground area of the image—the area of the image that you want to preserve.

 You can mark the foreground with a
 - You can mark the foreground with a series of either dots or scribbles, or a combination of the two. The idea is to use the brush to get a good cross sampling of all the different pixel colors and tones in the foreground (**Figure 8.82**).
- **4.** Select the Background Brush tool, and in the same manner, mark the background area of the image—the area of the image that you want to remove.
- 5. Click the Preview button to see the results of your work (**Figure 8.83**).

 Use the Zoom and Hand tools to move through the preview window and to get a closer look at the transitions between the foreground image and the transparent background.
- **6.** If necessary, use one of the touch-up tools to modify or clean up the transitions between the foreground image and background:
 - ▲ The Point Eraser tool removes portions of marks you've made with either the Foreground or Background Brush tools. When you remove a portion of a mark from the background area, for instance, you're telling the Magic Extractor that you don't want to erase pixels of a particular tonal or color range.

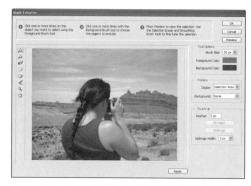

Figure 8.8o Open the Magic Extractor dialog box from the Image menu.

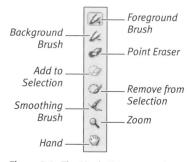

Figure 8.81 The Magic Extractor tool set.

Figure 8.82 Identify the foreground area with a series of dots and scribbles.

Figure 8.83 Click Preview to see the changes you've made to your image in the preview window.

Figure 8.84 Touch Up options give you the ability to soften the edge of your foreground image by feathering; fill in holes that may have been created when using the Foreground and Background brushes; and remove a halo of background color along the edge of a foreground image by applying Defringe.

The Add to Selection tool allows you to paint back in areas of the foreground image that may have been mistakenly removed along with the background.

- ▲ The Remove from Selection tool works like an eraser to remove areas of the foreground image.
- ▲ The Smoothing Brush softens the transition between the foreground image and transparent background by adding a halo of deleted background color to the edge of the foreground image.
- **7.** If necessary, use the options in the Touch Up area of the dialog box to further refine the foreground image (**Figure 8.84**).
- **8.** Click OK to apply your changes and close the Magic Extractor dialog box.

✓ Tip

Within the Magic Extractor dialog box, you can only Undo (Ctrl+Z) the action of two tools: the Remove from Selection tool and the Smoothing Brush tool. But if you're not happy with the results you're getting, you can start over from scratch by either clicking the Reset or Cancel buttons. Clicking the Reset button will undo every action in the Preview window, but will leave the dialog box open, whereas clicking Cancel will exit the dialog box altogether without applying any changes to your image.

Understanding Shapes

In Photoshop Elements, you create shapes not by rendering them with pixels, but by constructing them from vector paths. In Photoshop Elements, those vector paths are actually vector *masks*. We'll use some simple circle and square shapes to illustrate what that means.

Each time you draw a shape with one of the shape tools, Photoshop Elements is performing a little behind-the-scenes sleight of hand. Although it may appear that you're drawing a solid, filled circle, for instance, what you're really creating is a new layer containing both a colored fill and a mask with a circle-shaped cutout (**Figure 8.85**). When you move, reshape, or resize a shape, you're actually just moving or reshaping the cutout and revealing a different area of the colored fill below it (**Figure 8.86**). When you add to or subtract from a shape by drawing additional shapes, you're simply revealing or hiding more of the same colored layer (**Figure 8.87**).

Every time you create a new shape, a new shape *layer* is added to the Layers palette. A shape layer is represented in the palette thumbnails by a gray background (the mask) and a white shape (the mask cutout, or path). Since a shape's outline isn't always visible in the image window—if you deselect it, for instance—the Layers palette provides a handy, visual reference for every shape in your project (**Figure 8.88**). And as with any other layered image, you can use the Layers palette to hide a shape's visibility and even change its opacity and its blending mode.

Figure 8.85 When you draw a shape, you're actually drawing a shape mask.

Figure 8.86 Moving a circle shape really means moving the circle cutout portion of the mask.

Figure 8.87 Adding a shape to a layer masks off another portion of the colored fill below it, in this case giving the illusion that the circle has a square hole in its center.

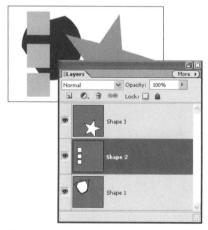

Figure 8.88 Every shape or combination of shapes appears on its own layer on the Layers palette.

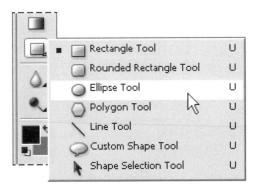

Figure 8.89 The Ellipse shape tool.

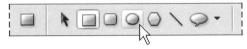

Figure 8.90 All of the shape tools are accessible from both the toolbox and the options bar.

Figure 8.91 Some shape tools, such as the Polygon tool, have properties you can set on the options bar.

Drawing Basic Shapes

In Photoshop Elements, you can draw five basic geometric shapes (a shape selection tool and a tool for creating custom shapes are discussed in detail later in this chapter). Shapes can be drawn freely by clicking and dragging, or they can be constrained according to your specification of size, proportion, and special characteristics. You can use the shape tools to create logos or geometric designs, or, because a new layer is created with every shape you draw, you can draw shapes directly over any photograph or scanned image without fear of damaging the image.

To draw a shape:

1. Select a shape tool from the toolbox (U) (**Figure 8.89**).

To cycle through the shape tools, press U again until you arrive at the shape you want.

Alternatively, once you've selected a shape tool in the toolbox, you can select a different shape from the options bar (**Figure 8.90**).

- **2.** To select a shape color, *do one of the following:*
 - ▲ Click the current foreground color swatch at the bottom of the toolbox, or click the color box on the options bar to open the Color Picker.
 - ▲ Choose a color from the Swatches palette.
- **3.** If they're available for the tool you've selected, you can set special properties for your shape before you draw. On the options bar, enter values specific to the shape you've chosen (**Figure 8.91**).

For the Rounded Rectangle tool, you can enter a corner radius. For the Polygon tool, you can enter the number of sides. For the Line tool, you can enter a pixel weight.

the shape buttons to open the Geometry Options palette (**Figure 8.92**). In the Geometry Options palette, select from the available options for that particular shape or leave the options set to the default of Unconstrained

4. On the options bar, click the arrow next to

- 5. In the image window click and drag to draw the shape (Figure 8.93).
 If you like, you can add a style to your shape from the Custom Shape tool's builtin style picker.
- **6.** On the options bar, click the icon or arrow to open the style picker (**Figure 8.94**).
- 7. Choose from the list of available styles or click the arrow button to the right of the thumbnail images to open the Style palette menu (Figure 8.95).
 The style picker displays the new style set.

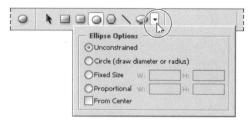

Figure 8.92 Every shape tool has its own particular set of geometry options.

Figure 8.93 Drawing a shape is as simple as clicking and dragging.

Figure 8.94 Whenever any of the custom shape tools are selected, the shape tool style picker appears on the options bar.

Figure 8.95 The style picker's palette menu contains a variety of fun and interesting style sets.

Figure 8.96 A simple circle drawn with the ellipse shape tool (left) is transformed into a shiny, chrome button (right) using just one of the many styles from the style picker.

- **8.** Click a style in the style picker to apply it to your shape (**Figure 8.96**).
- **9.** To deselect the shape and hide the path outline, press Enter.

✓ Tip

■ If you decide to remove a style from a shape, you have two options. With the shape layer selected in the Layers palette, either open the Style palette menu in the style picker and then choose Remove Style; or right-click the Layer Style icon on the desired layer in the Layers palette, and choose Clear Layer Style.

About the Shape Geometry Options Palettes

Polygon Options Radius:	Arrowheads —
Smooth Corners	
Star	Width: 500%
Indent Sides By:	Length: 10009
Smooth Indents	Concavity: 0%

Figure 8.97 The Polygon tool's geometry options and the Line tool's arrowhead options.

Figure 8.98 Using the Polygon tool's Star option, a six-sided polygon (left) can be changed into a six-point star (right).

Each shape tool (with the exception of the Shape Selection tool) has its own unique Geometry Options palette. The two rectangle tools and the Ellipse and Custom Shape tools all offer similar options for defining size, proportions, and constraint properties; and the Polygon and Line tools each have their own unique sets of options (Figure 8.97). The Polygon tool's most distinctive option is the Star check box. When Star is selected, you're presented with a couple of indent properties that fold the polygon in on itself, so that the points of its angles become the tips of a star shape (Figure 8.98). When the Line tool is selected, you can choose from a small set of Arrowhead options based on the pixel weight of the line.

✓ Tip

■ To constrain the proportions of any shape (to make a rectangle a perfect square or an ellipse a perfect circle, for example) without the aid of the Geometry Options palette, hold down the Shift key as you drag.

Transforming Shapes

You're not limited to just creating shapes in Photoshop Elements. You can also scale (resize), rotate, and distort them to your liking. Shapes can be altered either numerically, by entering specific values on the options bar, or manually, by dragging their control handles in the image window. Constrain options, such as proportional scaling, are available for most transformations, and a set of keyboard shortcuts helps to simplify the process of adding distortion and perspective.

To scale a shape:

- **1.** Select the Shape Selection tool by *doing* any of the following:
 - ▲ Choose the Shape Selection tool from beneath the current shape tool in the toolbox (**Figure 8.99**).
 - ▲ Press U to select any shape tool and then press U again until you toggle to the Shape Selection tool.
 - Select any shape tool in the toolbox, then choose the Shape Selection tool from the options bar (it looks like an arrow).
- **2.** In the image window, select the shape with the Shape Selection tool.
- **3.** From the Image menu, choose Transform Shape > Free Transform Shape, or press Ctrl+T.

The options bar changes to show the scale and rotation text boxes, and the reference point locator (**Figure 8.100**).

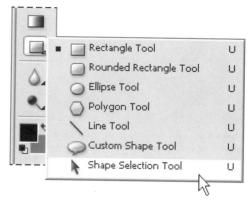

Figure 8.99 The Shape Selection tool.

Figure 8.100 Precise scale and rotation values can be entered for any shape.

Figure 8.101 These rectangles are both being reduced in size by about half. The one on the left is scaled toward its upper-left corner, and the one on the right is scaled toward its center.

Figure 8.102 The Commit Transform button scales the shape to the size you define.

- **4.** On the options bar, click to set a reference point location.
 - The reference point determines what point your shape will be scaled to: toward the center, toward a corner, and so on (**Figure 8.101**).
- **5.** If you want to scale your shape proportionately, click the lock icon between the width and height text boxes.
- **6.** Enter a value in either the height or width text box.
 - The shape is scaled accordingly.
- **7.** On the options bar, click the Commit Transform button (**Figure 8.102**), or press Enter.
- **8.** Click the Commit Transform button a second time (or press Enter) to deselect the shape and hide the path outline.

✓ Tips

- You can scale a shape manually by selecting it with the Shape Selection tool and then dragging any one of the eight handles on the selection border. Constrain the scaling by holding down the Shift key while dragging one of the four corner handles.
- If you want to simply reposition a shape in the image window, click anywhere inside the shape with the Shape Selection tool and then drag the shape to its new position.

To rotate a shape:

- **1.** Select the Shape Selection tool from the toolbox or options bar.
- **2.** In the image window, select the shape with the Shape Selection tool.
- 3. From the Image menu, choose Rotate > Free Rotate Layer (Figure 8.103).
 The options bar changes to show the scale and rotation text boxes, and the reference point locator.
- 4. On the options bar, click to set a reference point location.
 The reference point determines the point that your shape will be rotated around (Figure 8.104).
- **5.** Enter a value in the rotate text box. The shape will rotate accordingly.
- **6.** On the options bar, click the Commit Transform button, or press Enter/Return.
- 7. Click the Commit Transform button a second time (or press Enter/Return) to deselect the shape and hide the path outline.

✓ Tips

- To rotate your shape in 90- or 180-degree increments or to flip it horizontally or vertically, choose Image > Rotate; then choose from the list of five menu commands below the Free Rotate Layer command.
- You can rotate a shape manually by selecting it with the Shape Selection tool and then moving the pointer outside of the selection border until it becomes a rotation cursor (**Figure 8.105**). Drag around the outside of the selection border to rotate the shape. In addition, you can constrain the rotation to 15-degree increments by holding down the Shift key while dragging the rotation cursor.

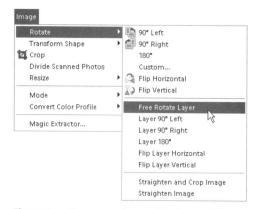

Figure 8.103 You can apply any of the layer rotation menu commands to your shapes.

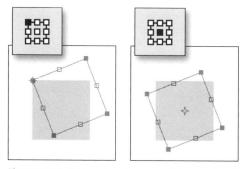

Figure 8.104 These rectangles are both being rotated about 20 degrees. The one on the left is rotated around its upper-left corner, and the one on the right is rotated around its center.

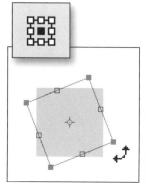

Figure 8.105
Rotate any shape
manually by
dragging it around its
reference point with
the rotation pointer.

Figure 8.106 Choose one of the three specific transformation commands.

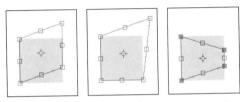

Figure 8.107 The same square shape transformed using Skew (left), Distort (center), and Perspective (right).

To distort a shape:

- **1.** Select the Shape Selection from the toolbox or options bar.
- **2.** In the image window, select the shape with the Shape Selection tool.
- **3.** From the Image menu, choose Transform Shape; then choose Skew, Distort, or Perspective (**Figure 8.106**).
- **4.** On the options bar, check that the reference point location is set to the center. The reference point can, of course, be set to any location, but the center seems to work best when applying any of the three distortions.
- 5. Drag any of the shape's control handles to distort the shape. Dragging the control handles will yield different results depending on the distort option you choose (Figure 8.107).
- **6.** On the options bar, click the Commit Transform button, or press Enter/Return.
- 7. Click the Commit Transform button a second time (or press Enter/Return) to deselect the shape and hide the path outline.

Distortion Shortcuts

With a few keyboard shortcuts, you can avoid having to return to the Image menu each time you want to apply a different distortion.

From the Image menu, choose Transform Shape > Free Transform Shape; then use the following shortcuts while dragging the shape handles in the image window:

To Distort: Ctrl
To Skew: Ctrl+Alt

To create Perspective: Ctrl+Alt+Shift

Creating Custom Shapes

Once you've gained a basic understanding of working with Photoshop Elements' geometric shapes, you can begin adding those shapes together to create even more interesting and intricate shapes. Shape option buttons allow you to perform a little vector path magic by creating brand-new shapes out of the intersections and overlapping portions of the simple rectangle, ellipse, and polygon shapes.

The Custom Shape tool is in a world unto itself, working from a library of nearly 400 complex vector graphics grouped into categories as diverse as ornaments, music, fruit, symbols, and nature—far beyond the relatively simple icons and graphics you can build with the basic geometric shape tools.

To add a shape to an existing shape:

- Follow steps 1 through 5 in the task "To draw a shape" earlier in this chapter.
 Make sure that this first shape's path remains selected (Figure 8.108).
- 2. From either the toolbox or the options bar, select the shape tool for the next shape you want to add. You can use the same shape more than once, if you wish.
- **3.** On the options bar, set color, value, and geometry options as desired.
- **4.** Still on the options bar, click to select one of the shape area options (**Figure 8.109**).
- **5.** In the image window, click and drag to draw the new shape (**Figure 8.110**).
- **6.** To deselect the shapes and hide their path outlines, press Enter/Return.

Figure 8.108 When a shape is selected, its path outline is visible (left). The path disappears when the shape is deselected (right).

Figure 8.109 The shape area options define how one shape reacts with another.

Figure 8.110 As the new shape is drawn, only its outline is visible (left). When the new shape is completed, it's filled according to the preset shape area option (right). In this case, the option was set to Intersect Shape.

✓ Tip

■ The Layers palette can be a useful tool when working with the shape tools. Its layer thumbnails provide good visual feedback, particularly when you're building complex shapes and want to verify that the new shapes you create are being placed on the correct layers.

About the Shape Area Options Buttons

Photoshop Elements gives you five options to choose from when creating a new shape or modifying an existing one (**Figure 8.111**).

Figure 8.111 On the options bar, click to select one of five shape area options.

Create New Shape Layer does just that, draws a new shape on its own, separate layer.

Add to Shape Area draws a new shape on the same layer as the existing shape.

Subtract from Shape Area adds a shape to the same layer as the existing shape, creating a cutout or hole.

Intersect Shape Areas adds a shape to the same layer as the existing shape and causes only those areas where the two shapes overlap to be visible.

Exclude Overlapping Shape Areas does just the opposite of Intersect Shape Areas, creating a cutout or hole where the two shapes overlap.

To combine multiple shapes:

- 1. Select the Shape Selection tool from the toolbox or from the options bar.
- 2. In the image window, click to select the first shape; then Shift+click to select the additional shapes you want to group (Figure 8.112).
- **3.** On the options bar, click the Combine button (**Figure 8.113**).

 The shapes are now combined into a single, complex shape.

✓ Tips

- You can only combine shapes that appear on the same layer on the Layers palette; like the ones we created in the previous procedure. However, if you've created shapes on separate layers, and then decide that you want to combine them, all is not lost. With the shape selection tool, select one of the shapes. Then from the Edit menu, choose Cut (Ctrl+X). In the Layers palette, click to select the shape layer that you want to combine the "cut" shape with, and then from the Edit menu, choose Paste (Ctrl+V). The shape will be pasted into the selected layer along with the other shape. From there, just follow the steps to combine multiple layers.
- When selecting multiple shapes, work from the inside out. In other words, if you have a large shape with a smaller cutout or intersecting shape inside of it, select the smaller, inside shape first. Photoshop Elements doesn't assign any stacking order per se to multiple shapes on a layer, but if a larger, outside shape is selected first, the selection sort of covers up any smaller shapes inside, making them next to impossible to select.

Figure 8.112 Shift+click to select the shapes you want to combine.

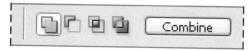

Figure 8.113 The Combine button groups multiple shapes together.

■ Up until the moment that multiple shapes are grouped together with the Combine button, they can be selected individually and then scaled, rotated, and distorted and even duplicated with the Copy and Paste commands.

Figure 8.114 The Custom Shape tool.

Figure 8.115 The Custom Shape tool has geometry options similar to those for the Ellipse and Rectangle tools.

Figure 8.116 Open the custom shape picker to select from sets of complex shape thumbnails.

To draw a custom shape:

- **1.** Select the Custom Shape tool by *doing* one of the following:
 - ▲ Select the Custom Shape tool from beneath the current shape tool in the toolbox (**Figure 8.114**).
 - ▲ Press U to select any shape tool; then press U again to toggle to the Custom Shape tool.
 - ▲ Select any shape tool in the toolbox; then select the Custom Shape tool from the options bar.
- **2.** To select a shape color, *do one of the following*:
 - ▲ Click the current foreground color swatch at the bottom of the toolbox, or click the color box on the options bar to open the Color Picker.
 - ▲ Choose a color from the Swatches palette.
- **3.** On the options bar, click the arrow next to the Custom Shape button to open the Custom Shape Options palette (**Figure 8.115**).

Select from the available options or leave the options set to Unconstrained.

4. Still on the options bar, click to open the custom shape picker (**Figure 8.116**).

continues on next page

- **5.** Click to choose from the list of default shapes, or select a different shape set from the Custom Shapes drop-down menu (**Figure 8.117**).
- **6.** In the image window, click and drag to draw the selected shape (**Figure 8.118**).
- To deselect the shape and hide the path outline, press Enter.

✓ Tip

Custom shapes can be used in combination with other shapes and with the shape area options just like any of the basic geometric shapes.

If you ever want to paint on a shape or apply any filter effects to it, you'll first need to convert the shape from a vector path to a bitmap.

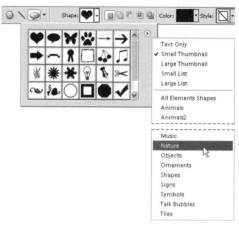

Figure 8.117 The custom shape picker's palette menu offers access to a variety of custom shape sets.

Figure 8.118 You draw a custom shape just as you would any other shape: simply by clicking and dragging. Here, I clicked to apply the butterfly shape (left) and then dragged with the mouse to enlarge it (right).

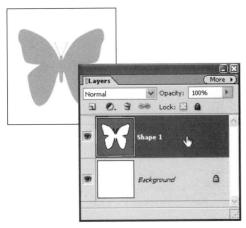

Figure 8.119 Use the Layers palette to select a custom shape's layer.

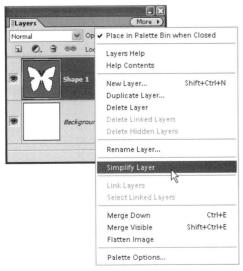

Figure 8.120 The Simplify Layer command converts a custom shape's vector path to a bitmap graphic.

Figure 8.121 The vector path layer thumbnail (left) and the converted bitmap thumbnail (right).

To convert a vector shape to a bitmap:

- **1.** To open the Layers palette, *do one of the following*:
 - ▲ From the Window menu, choose Layers.
 - ▲ Click the arrow on the Layers palette tab in the palette well.
- 2. On the Layers palette, click to select the layer containing the shape (or shapes) you want to convert to bitmaps (Figure 8.119).
- 3. From the More menu on the Layers palette, select Simplify Layer (Figure 8.120).

 The vector shape is converted to a bitmap, and instead of showing the shape's path, the layer thumbnail displays the shape's image on a transparent background (Figure 8.121).

Using the Cookie Cutter Tool

Photoshop Elements' Cookie Cutter tool isn't exactly a painting or drawing tool, although right up to the moment that you press the Commit Transform button, it behaves in exactly the same way as the Custom Shape tool. The Cookie Cutter tool uses the Custom Shape tool's libraries of shapes to create distinctive masked versions of image layers. The difference between the two (and it's a biggie) is that whereas the Custom Shape tool creates vector shapes, the Cookie Cutter tool creates a raster image. So, although you can initially scale, rotate, and otherwise distort a Cookie Cutter shape just like a vector graphic, once you commit the shape to your image, the final result is still a raster (or bitmap) image layer. Once you understand the Cookie Cutter's limitations, it can still be a fun and useful tool.

To mask an image with the Cookie Cutter tool:

- From the toolbox, click to select the Cookie Cutter tool, or press Q (Figure 8.122).
- On the options bar, click the Shape
 Options button to open the Cookie
 Cutter Options palette.
 Select from the available options or leave
 the options set to Unconstrained.
- **3.** Still on the options bar, click to open the Cookie Cutter shape picker (**Figure 8.123**).
- **4.** Click to choose from the list of default shapes, or select a different shape set from the Custom Shapes drop-down menu.

Figure 8.122 The Cookie Cutter tool.

Figure 8.123 The Cookie Cutter tool uses the same shape libraries as the Custom Shape tool.

Figure 8.124 When you draw a shape with the Cookie Cutter tool, any underlying images are visible only within the shape.

Figure 8.125 You can position, scale, rotate, and otherwise transform a Cookie Cutter shape right up to the moment you commit the shape to the image layer.

Figure 8.126 Once you commit the shape, its bounding box disappears.

- 5. In the image window, click and drag over an image layer to draw the selected shape. The image now appears only within the Cookie Cutter shape, leaving the rest of the layer transparent (Figure 8.124). If you apply the Cookie Cutter tool to a flattened, background layer, it automatically converts the layer to a working layer with transparency.
- dow, place the cursor anywhere inside the shape bounding box, and then click and drag.

 Notice that as you drag the shape, different areas of the original image are revealed, as if you were moving a window around on a solid wall (Figure 8.125).

6. To reposition the shape in the image win-

- 7. To scale, rotate, or otherwise transform the shape, refer to the section "Transforming Shapes," earlier in this chapter.
- **8.** When you're satisfied with the size and position of your masked shape, click the Commit Transform button, or press Enter (**Figure 8.126**).

Once you commit the shape to the image layer, you can apply blending modes, opacity changes, and filters just as you would on any other raster image layer.

✓ Tip

■ For a similar effect that affords you more flexibility (namely, the ability to transform your layer mask indefinitely), create a shape with the Custom Shape tool, and then follow the steps in the section "Creating Masking Effects with Layer Groups," in Chapter 5.

9

WORKING WITH TYPE

When you think about all of the sophisticated photo retouching, painting, and drawing you can do in Photoshop Elements, manipulating type may not be a priority on your to-do list. However, you can create some amazing projects with the type tools, including greeting cards, posters, announcements, and invitations—and you don't even have to fire up another software application.

This chapter covers the text formatting options and special type effects you can create with Photoshop Elements. If you've had any experience with word processing programs, the basic text formatting options will be familiar to you. Unlike a word processor, however, Photoshop Elements lets you create myriad special effects, using the type warping and masking tools and layer styles.

Creating and Editing Text

When you use the type tools, your text is automatically placed on a new, unique layer. Since the text exists on its own layer, you can do all of the modifications to your text that layers allow, including moving, applying blending modes, and changing the opacity. Also, having text on its own layer allows you to go back and edit the text whenever you want, with a minimum of fuss.

Editing text is very simple and is pretty much the same as in any word processor. One difference is the way you make a final confirmation of the changes you have entered. This is done with the Commit any current edits icon and with its partner, the Cancel any current edits icon, which together allow you to change your mind as often as you want.

It's likely that you'll want to adjust the position of your text, and this is done just as easily as moving an object on any other layer. If you want to paint on your text or apply filters or effects to it, you'll need to simplify the layer by converting it to a standard bitmap. But remember: after a type layer has been simplified, it becomes part of the image, which means that you can no longer edit the text. Fortunately, as long as you don't close the file, the Undo History palette will let you go back to the state your type was in before it was simplified. And you can always save a separate version of your file prior to simplifying the type layer.

To add text to an image:

 With an image open, click to select the Horizontal Type or Vertical Type tool on the toolbar (Figure 9.1).
 Your pointer changes to an I-beam, as in many other text editing programs (Figure 9.2).

Figure 9.1 Click the type tool icon to choose from four different type tools.

Figure 9.2 When using one of the type tools, your pointer changes appearance to look like an I-beam. The text entry point is indicated by a vertical line whose height is based on the type size.

Figure 9.3 After you click once to establish the insertion point of your type, just start entering text. You'll need to press the Enter key to move to a new line.

Figure 9.4 To confirm the text you've just entered or any changes you've made, click the Commit any current edits check mark on the options bar.

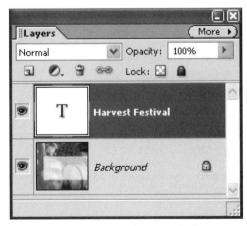

Figure 9.5 Using the type tools automatically creates a new layer on the Layers palette. The layer name is the text you entered.

- 2. In the image window, move the pointer to the area where you want to insert your text, and then *do one of the following:*Click to create a text insertion point.

 This method is perfect if you're setting just a single line of text, or a simple two-or three-line title or heading.

 Click and drag to create a paragraph text box.
 - Use this method if you want to set a long text paragraph.
- 3. Type your text on the image (Figure 9.3). If you want to start a new line, press Enter.

 If you've created a paragraph text box, the text will automatically flow to a new line when it bumps up against the border of
- **4.** To confirm the text you've entered, *do one of the following*:

the text box.

- ▲ Click the Commit icon on the options bar (**Figure 9.4**).
- ▲ Press the Enter key on the numeric keypad.
- ▲ Click anywhere in your image, click a palette, or click a tool on the toolbar.

A new type layer is automatically created and is visible on the Layers palette. The layer name is the text you entered (**Figure 9.5**).

✓ Tips

- If you want to add more text to a different part of your image, simply repeat steps 1 through 4. The new text will be added to its own separate type layer.
- Your image must be in grayscale or RGB mode if you want to add type to it. Photoshop Elements' two other image modes, bitmap and index, don't support type layers.

To edit text:

(Figure 9.8).

- **1.** Click a type layer on the Layers palette to make it active (**Figure 9.6**).
- 2. In the image window, click in the text and edit as you would in any basic word processor, pressing the Backspace key to delete individual characters (**Figure 9.7**), or double-clicking directly on the text to select all of the text at once.
- Confirm your edits by clicking anywhere in your image.If you change your mind, you can click Cancel to return to your last edit

Figure 9.6 To make changes to existing text, click the appropriate layer on the Layers palette.

Figure 9.7 You can delete or make other changes to your text by pressing the Backspace key and entering new text.

Figure 9.8 If you decide you want to abandon any edits and return to the original text, just click the Cancel any current edits icon on the options bar.

Point and Click vs. Paragraph Type

Photoshop Elements allows you to enter text using both the *point and click* and the *paragraph* type methods. When you enter text with the *point and click* method, you simply click a point in the image window and then begin to type. The line of text you enter will continue until you press Enter to create a new line. When you enter *paragraph* type, you drag to create a text area (or text box), and the type you enter will automatically wrap to a new line when you reach the edge of the type's bounding box.

Figure 9.9 Because your text exists on its own separate layer, you can move your text to different areas in your image by using the Move tool.

Figure 9.10 To merge your type layer with the rest of your image, choose Layer > Simplify Layer. Once you do this, the type becomes part of the image and can't be edited with the type tools.

To move text:

- **1.** On the Layers palette, click the type layer that you want to move.
- 2. Click the Move tool on the toolbar.

 When you click the Move tool, your type is surrounded by a selection bounding box, allowing you to move the type as a single object anywhere on your image.
- **3.** In the image window, drag your text to a new location (**Figure 9.9**).

To simplify a type layer:

- **1.** Choose a type layer on the Layers palette by clicking on it.
- 2. From the Layer menu or from the Layers palette menu, choose Simplify Layer (Figure 9.10).

The layer representation changes from the T icon to a thumbnail of the simplified text (**Figure 9.11**).

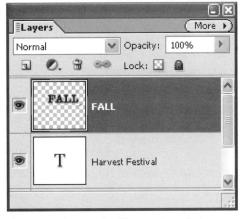

Figure 9.11 After you simplify a type layer, its layer thumbnail changes to show the rasterized type.

Changing the Look of Your Type

You should be comfortable using the type formatting tools—font family, font style, and font size— in Photoshop Elements because they're very similar to those found in most any word processing program. You'll probably want to change the font size first. Photoshop Elements' type tool is automatically set to 12 points, which in many cases will be too small. Making the type bigger makes it *much* easier for you to see how the type looks in your image. You can also change the text alignment and text color. All of these options are available on the text options bar (**Figure 9.12**).

To change any of these attributes, you first need to select the text characters you want to change. Most of the time, you'll want to select and apply changes to an entire line of text, but you can also select individual words or even individual characters.

To select text:

- 1. Click on the type layer you want to edit on the Layers palette, or click on the type itself with the Move tool.
- 2. Select a type tool.
- 3. To select the text, drag across the characters to highlight them (Figure 9.13), or do one of the following:
 - ▲ Double-click within a word to select it (**Figure 9.14**).
 - ▲ Triple-click to select an entire line of text (**Figure 9.15**).
 - Quadruple-click to select an entire paragraph of text (Figure 9.16).

Tip

You can select all of the text on a layer without even touching the text with your pointer. Just select the type layer on the Layers palette and double-click the T icon.

Figure 9.12 The type formatting tools are all available on the text options bar.

Figure 9.13 To select your text, drag across it with the text pointer.

Figure 9.14 Double-click within a word to select it.

Figure 9.15 Triple-click anywhere in a line of type to select the entire line.

Figure 9.16 Quadruple-click anywhere in a paragraph to select the entire paragraph.

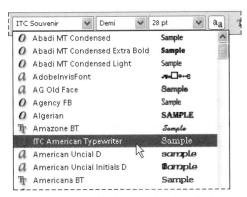

Figure 9.17 All available fonts are listed on the font family menu.

Figure 9.18 Many fonts allow you to select a style from the font style menu.

Figure 9.19 If a font doesn't include style options, you can apply a bold or italic format with the icons on the options bar.

Figure 9.20 Options in the Type Preferences dialog box let you control the display of font previews in the font family menu.

To choose the font family and style:

- 1. Select the text you want to change.
- 2. From the options bar, choose a font from the font family menu (Figure 9.17).
- 3. Still on the options bar, choose a style from the font style menu (Figure 9.18). If the font family you selected doesn't include a particular style, you can click the Faux Bold or Faux Italic button to change the look of your text (Figure 9.19).

✓ Tip

■ If you haven't memorized the look of each and every font on your computer (and who has?), Photoshop Elements' font family menu now displays an example of each font next to its font name. You can change the size of font samples or turn the display of the samples off by choosing Edit > Preferences > Type and then using the drop-down menu in the Type Options section of the Type Preferences dialog box (**Figure 9.20**).

To change the font size:

- 1. Select the text you want to change.
- **2.** Choose a size from the type size menu on the options bar (**Figure 9.21**).

To change to a type size not listed on the menu, just enter a new value in the type size text box. The default type measurement is set to points, but you can also use other units of measure (pixels or millimeters) by selecting them in the Units and Rulers Preferences dialog box.

✓ Tips

- You can quickly adjust the type size up and down using keyboard shortcuts. Just select your text and then press Ctrl+Shift+. (period) to increase the size in 2-point increments. To reduce the size of the text, press Ctrl+ Shift+, (comma).
- You can also adjust the type size up and down in 1- or 10-point increments. Select your text and then select the type size in the type size menu on the options bar. Next, use the up and down keys on your keypad to size the type up and down in 1-point increments. If you hold down the Shift key while pressing the up and down keys, the type will adjust in 10-point increments (**Figure 9.22**).
- To change the default unit of measurement for type, select Edit > Preferences > Units and Rulers. Here you can select among pixels, points, and millimeters (mm) (Figure 9.23).

Figure 9.21

Use the type size menu to adjust the size of your type. To use a size not listed, just enter it in the text box.

Figure 9.22 Hold down the Shift key to quickly increase your type size in 10-point increments.

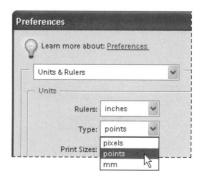

Figure 9.23 You can set type unit preferences to pixels, points, or millimeters.

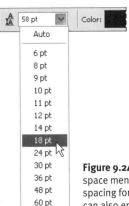

72 pt

Figure 9.24 Use the line space menu to select line spacing for your type. You can also enter a line spacing value in the menu text box.

Autumn in New England is a magical time of year for a walk in the woods.

Autumn in New England is a magical time of year for a walk in the woods.

Figure 9.25 Photoshop Elements default line spacing (top), and the same type but with smaller line spacing (bottom).

Figure 9.26 You can apply the underline and strikethrough styles from the options bar.

To change the line spacing:

- **1.** Select the lines of text that you want to change.
- Choose a value from the line space menu on the options bar (Figure 9.24).
 To change to a line spacing value not listed on the menu, enter a new value in the leading text box.

✓ Tip

The default line spacing value for any type size (Auto) serves as a good starting point, but it's surprising that something as simple as increasing or decreasing line spacing can have a dramatic visual impact (**Figure 9.25**).

To apply underline or strikethrough:

- 1. Select the text you want to change.
- Click either the Underline or Strikethrough icon on the options bar to apply that style to your text (Figure 9.26).
 If your type layer is set to a vertical orientation, the underline will appear on the left side of the type (Figure 9.27).

Figure 9.27 When you apply an underline to vertical text, it appears on the left side of the text.

To change the alignment:

- 1. Select the text you want to change.
- **2.** From the options bar, choose an alignment option (**Figure 9.28**).

The type will shift in relation to the origin of the line of text, or in the case of paragraph text, in relation to one side of the text box or the other. For *point and click type*, the origin is the place in your image where you first clicked before entering the type.

- ▲ **Left Align** positions the left edge of each line of type at the origin, or on the left edge of the paragraph text box.
- ▲ **Center Align** positions the center of each line of type at the origin, or in the center of the paragraph text box.
- ▲ **Right Align** positions the right edge of each line of type at the origin, or on the right edge of the paragraph text box.

To change the text color:

- 1. Select the text you want to change.
- Click the color selection box on the options bar (Figure 9.29).
 The Color Picker appears. Choose a

new type color from the Color Picker (**Figure 9.30**), then click OK to apply the new color to your text.

✓ Tip

■ You can also change the color of all the text on a text layer without selecting the text in the image window. With the Text tool selected in the toolbox, click to select a text layer in the Layers palette to make it the active layer, then follow the procedure to change the text color.

Figure 9.28 When you realign type, it shifts the origin, or the first point you clicked when entering the type.

Figure 9.29 You can change the text color by clicking the color selection box.

Figure 9.30 Use the Color Picker to select a new text color.

Figure 9.31 The Vertical Type tool is located directly under the Horizontal Type tool.

Figure 9.32 When you use the Vertical Type tool, your text appears in descending order (from the top down) on your image.

Figure 9.33 When you press Enter, another line of vertical type is entered to the left of the first.

Working with Vertical Text

Most of the time, you'll use the standard Horizontal Type tool. But you can also change your type to a vertical orientation whenever you want. One of the reasons that Photoshop Elements includes both horizontal and vertical type is to accommodate the needs of the Asian-language versions of the product, such as Korean, Japanese, and Chinese.

To create vertical text:

- With the image window open, click the Vertical Type tool on the toolbar (Figure 9.31).
 - The pointer changes to an I-beam.
- Move the pointer to the area where you want to insert your text, and then do one of the following:
 Click to create a text insertion point.
 Click and drag to create a paragraph text box.
- **3.** Type your text on the image (**Figure 9.32**). The characters appear in descending order on your image.
- **4.** To start a new line that will appear to the left of the first line, press Enter (**Figure 9.33**).

If you've created a paragraph text box, the text will automatically flow to a new line when it bumps up against the bottom of the text box.

To create and control the position of another line of vertical text, reselect the Vertical Type tool and create a separate, independent vertical type layer.

To change the orientation of the text:

- **1.** Select a type layer on the Layers palette.
- 2. Select the Type tool on the toolbar and then click the Change the text orientation icon on the options bar (Figure 9.34). The text changes to the opposite orientation: If your text is horizontal, it flips to vertical orientation—and vice versa.

✓ Tip

■ If you have Asian language fonts installed in your computer and you want to use the Asian type formatting options, choose Edit > Preferences > Type and select Show Asian Text Options (Figure 9.35).

Figure 9.34 You can switch between horizontal and vertical type by clicking the Change the text orientation icon on the options bar.

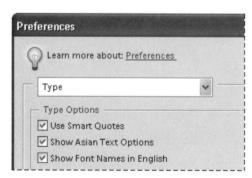

Figure 9.35 If your system supports Asian text options, you can work with them by selecting this feature in the Preferences > Type dialog box.

Paint

Paint

Figure 9.36 You'll usually want to antialias your type, especially when using larger type sizes. This example shows 60-point type viewed at 200 percent.

Time: 2:00pm Location: Main Gallery

Figure 9.37 When using type sizes of about 14 points or less, you may want to turn off anti-aliasing so that your text doesn't become blurry. This example shows 10-point type viewed at 200 percent.

Figure 9.38
You can turn anti-aliasing off and on with this icon on the options bar.

Figure 9.39 Anti-aliasing can also be controlled from the main menu by choosing Layer > Type > Anti-Alias Off or On.

Anti-aliasing Type

You can choose to smooth the edges of, or *anti-alias*, your type, just as you can with image selections as discussed in Chapter 4, "Making Selections." In most cases, you'll be using Photoshop Elements to create fairly large, display-size text. For this reason, you'll normally want to anti-alias your text so that it doesn't appear to be jagged (**Figure 9.36**).

The exception is in cases where you are using smaller font sizes, such as 14 points or less, and are planning to use the image for onscreen viewing on the Web. At smaller sizes, anti-aliasing actually makes your text less readable, and the smoothing effect looks more like blurring (**Figure 9.37**). Also, in the process of anti-aliasing, many more colors are generated, and not all Web browsers support all of these colors, so some unwanted color artifacts may appear around the edges of your type. By default, anti-aliasing is turned on.

To turn anti-aliasing off and on:

- 1. Select a type layer on the Layers palette.
- **2.** Do one of the following:
 - ▲ Click the Anti-aliasing icon on the options bar. To reselect anti-aliasing, click the icon again (**Figure 9.38**).
 - ▲ From the main menu, choose Layer > Type > Anti-Alias Off or Layer > Type > Anti-Alias On (**Figure 9.39**).

Warping Text

Photoshop Elements lets you distort text easily using the Warp tool. You can choose from 15 different warping options in the Warp Text dialog box. In this dialog box, you can adjust the amount of the bend in the type, as well as the horizontal and vertical distortion.

Even after you've warped your text, it's still completely editable, and you can make additional formatting changes to it at any time. But because the warp effect is applied to the entire type layer, you can't warp individual characters—it's all or nothing. The Warp Text Style Gallery includes a few examples of the results you can get with this addictive tool.

To warp text:

- **1.** Select a type layer on the Layers palette.
- **2.** From the toolbar, select a type tool (so that the type options appear on the options bar) and click the Create Warped Text icon (Figure 9.40). The Warp Text dialog box appears.
- **3.** Choose a warp style from the drop-down menu (Figure 9.41).
- **4.** Choose either Horizontal or Vertical orientation for the effect (**Figure 9.42**).

Figure 9.40

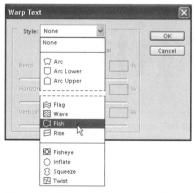

Figure 9.41 You can select from 15 different text warp options and make additional adjustments for each.

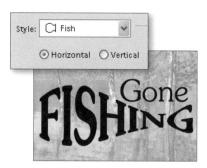

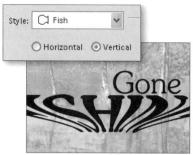

Figure 9.42 The Horizontal and Vertical orientation options create radically different results.

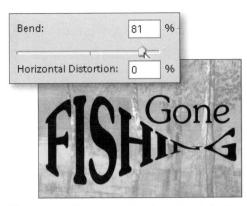

Figure 9.43 In this example, the Bend slider helps to dramatically exaggerate the fish shape.

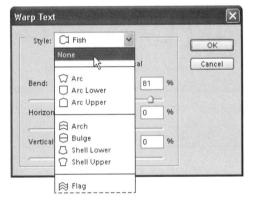

Figure 9.44 To remove text warp, select None from the Style drop-down menu.

- **5.** You can also modify the amount of Bend and Horizontal or Vertical distortion using the sliders (**Figure 9.43**).
- **6.** Click OK to apply the effect.

To remove text warp:

- **1.** On the Layers palette, select a type layer that's been warped.
- **2.** Select a type tool and click the Warp icon on the options bar.
- **3.** Choose None from the Style drop-down menu (**Figure 9.44**).
- **4.** Click OK to remove the effect.

✓ Tip

As you experiment with the various warping options, your text can undergo some pretty dramatic changes. For this reason, you might want to move your text around to see how it looks in different parts of your image. Luckily, you can do this without closing the Warp Text dialog box. If you move your pointer into the image area, you'll see that it automatically changes to the Move tool so you can move your text around while adjusting the warping effect.

Warping Text Style Gallery

Original text

Arc

Arc Lower

Arc Upper

Arch

Bulge

Shell Lower

Shell Upper

Flag

Wave

Fish

Rise

Fisheve

Inflate

Squeeze

Twist

Figure 9.45 To create a type mask, first select the layer you want it to appear on.

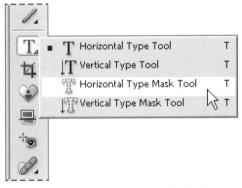

Figure 9.46 You can choose either the Horizontal or Vertical Type Mask tool.

Figure 9.47 Your type appears reversed out of the colored mask.

Creating Text Effects Using Type Masks

Sometimes the text effects you want to create are better done with a type selection, not the actual, editable type. The Horizontal and Vertical Type Mask tools let you enter text, which is automatically converted to a selection in the shape of type. Since it's a selection, you can do everything you can do to any other selection—you can paint or fill the type or transform its geometry by skewing it or applying perspective. Unlike the previous type tools discussed, the type mask tools do not create a unique layer. The type selection appears on whichever layer you have active at the time you use this tool. The bottom line: a type selection is just like any other selection, but in the shape of text.

To create a selection with the type mask tools:

- **1.** Make sure that your active layer is the one where you want the text selection to appear (**Figure 9.45**).
- **2.** Select either the Horizontal or Vertical Type Mask tool (**Figure 9.46**).
- **3.** Set the type options (such as font, style, or size) on the options bar.
- 4. Enter text on the image by either clicking or clicking and dragging.
 The text will appear reversed out of the colored mask overlay (Figure 9.47).

continues on next page

5. Confirm your text selection by clicking the Commit any current edits check mark on the options bar. Your text area is selected (Figure 9.48). You can now apply additional changes to the selection.

✓ Tips

- Up until the moment you click the Commit icon, you can edit your type masks (change their font, size, line spacing, and alignment) just as you would any other line or paragraph of type.
- You can move a text selection around in the image window as if it was any other selection. Once you click the Commit icon, select any of the marquee selection tools from the toolbox. Move the cursor over your text selection until it becomes the Move Selection icon. Then you can click and drag to reposition your text selection.

To fill a text selection with an image:

- Create a text selection following the steps in the preceding task.
 Be sure to position the selection over the image that you want to show through the text.
- **2.** Copy the selection to the clipboard (**Figure 9.49**).
- From the File menu, choose New > Image from Clipboard (Figure 9.50).
 Your text selection appears in its own file, with the image peeking through (Figure 9.51).

Figure 9.48 After you confirm the type, it appears as a selection with the typical selection border.

Figure 9.49 To fill a selection with an image, first copy the selection to the clipboard.

Figure 9.50 When you select File > New > Image from Clipboard, a new file is created that contains your text selection.

Figure 9.51 You can create all sorts of interesting text effects by filling type with images.

Figure 9.52 To fill text with a gradient, start by making a type selection.

Figure 9.53 Click the Gradient tool on the toolbar and then choose a gradient.

Figure 9.54 Drag in the direction you want the gradient to appear inside your type.

Figure 9.55 This example uses the Linear gradient.

To apply a gradient to a text selection:

- **1.** Create a text selection following the steps in the task "To create a selection with the type mask tools" (**Figure 9.52**).
- Click the Gradient tool on the toolbar and choose any gradient style on the options bar (Figure 9.53).
- **3.** Drag across your text selection to establish the direction of the gradient (**Figure 9.54**).
- **4.** Deselect the text selection. Your text now appears with the gradient fill (**Figure 9.55**).

Applying Layer Styles to Type

Since the Horizontal and Vertical Type tools create a unique text layer, you can use layer styles to make all sorts of unusual and interesting changes to your type. The significant advantage of using layer styles with your text (as opposed to using type masks) is that your text remains editable.

When choosing a font, it's a good idea to go with bolder sans-serif typefaces. This way, your type is more likely to remain readable after you've applied the style. Take a look at the Text Layer Style Gallery to see just a few examples of the different styles available.

To apply a layer style to type:

- Enter text in your image using either the Horizontal or Vertical Type tool (Figure 9.56).
- 2. Make sure that the appropriate type layer is selected on the Layers palette, and choose a style from the Layer Styles palette list (**Figure 9.57**).

The style is automatically applied to your type (**Figure 9.58**).

✓ Tip

■ If you're not quite getting the look you want, remember that you can set lighting angle, shadow distance, and other options by selecting Layer Style > Style Settings from the Layer menu, or by double-clicking the Layer Style icon to the right of the layer name in the Layers palette.

Figure 9.56 To use layer styles with your type, first enter text with one of the type tools.

Figure 9.57 You can use any of Photoshop Elements' dozens of layer styles on your type. This example uses a drop-shadow layer style.

Figure 9.58 The drop-shadow layer style adds depth and substance to the type selection, making it appear to pop out of the screen.

Text Layer Style Gallery

Styles

Styles

Styles

Original text

Bevels > Simple Sharp Outer

Drop Shadows > Soft

Inner Glows > Simple

Styles

Styles

Styles

Inner Shadows > Low

Outer Glows > Fire

Visibility > Ghosted

Complex > Cactus

Complex > Rivet

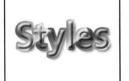

Complex > Toy

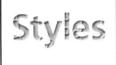

Image Effects > Puzzle

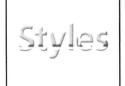

Image Effects > Tile Mosaic

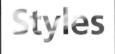

Patterns > Satin Sheets

Patterns > Ancient Stone

Wow Chrome > Shiny Edge

Wow Plastic > White

PREPARING IMAGES FOR THE WEB

PREPARING IMAGES FOR THE WEB

The odds are pretty good that at some point you're going to want to post your images on a Web page, or email a few photos to friends and family. And whether you decide to post a snapshot of an old push mower to an Internet auction site or just want to send vacation photos to your Aunt Ruth, the considerations are pretty much the same.

Size and speed influence most decisions regarding image preparation for the Web, and they are the central themes of this chapter. The goal of virtually every step of every procedure that follows is to make your images as small and compact as possible. That's not to say that we're abandoning aesthetics altogether—after all, there's little purpose in emailing a photograph that's too fuzzy or distorted to be seen clearly. So although this chapter focuses on creating small, easy-to-download images, it's also about creating compact files that look good.

Understanding Image Requirements for the Web

Preparing images for publication on the Web or for distribution via email presents its own unique set of challenges. Because the majority of Internet users still depend on dial-up connections (as opposed to high-speed DSL or cable connections), an image's file size is of primary concern. Your image needs to be small enough to download quickly while retaining enough information to display the colors and details of your original image.

Photoshop Elements helps you accomplish this digital sleight-of-hand through a process called *optimization*. Optimization pares down and streamlines an image's display information based on variables that you select and control. By limiting the number of colors in an image, or by selectively discarding pixels that are less critical than others, Photoshop Elements simplifies an image and reduces its file size. Once an image has been simplified in this way, it is said to be *optimized* (**Figure 10.1**).

Photoshop Elements offers four file format options for optimizing an image: JPEG, GIF, PNG-8, and PNG-24. Generally speaking, JPEG and PNG-24 are most appropriate for images that contain subtle transitions of tone and color (like photographs), whereas GIF and PNG-8 are best for graphics or illustrations containing a lot of flat color or typography (**Figure 10.2**).

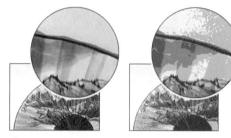

Figure 10.1 The original illustration of the Chinese fan (left) contains a great deal of detail and subtle gradations of tone and color. The optimized version (right) is greatly simplified and contains far less color and image information.

Figure 10.2 The photograph on the left, with its subtle and varied tones and color, is a good candidate for JPEG optimization, whereas the flat, bold colors and use of typography in the illustration on the right make it more appropriate for GIF optimization.

About the Save for Web Dialog Box

The Save for Web dialog box might be more appropriately called the "Prepare Web Images" or "Optimization" dialog box. Within it, you'll find all the tools, drop-down menus, and text fields necessary to transform any digital photograph, painting, or illustration into a graphic suitable for distribution on the Web.

The original and optimized image previews, the heart of this dialog box, provide instant visual feedback whenever even the smallest setting adjustment is made. Information fields below the image previews constantly update to reflect the current optimization format, file size, and download times. And at any time in the optimization process, you can preview and verify exactly how your image will appear in any Web browser loaded on your computer.

Choosing File Formats

JPEG is the most common file format for images on the Web. Because it supports 24-bit color (which translates to over 16 million colors), it's the ideal format for optimizing photos without sacrificing too much image quality. However, because it *does* discard a small portion of image information as it optimizes, it's not the best choice for images where detail and sharpness is critical, such as scanned line art, vector graphics, or images containing a lot of type.

If you want to keep the detail in your images as sharp as possible, try using the **GIF** format. The GIF format sacrifices subtle gradations of tone and color, but retains the sharpness and image detail that can be lost with the JPEG format, making it a good choice for animations, images with transparency, vector graphics, and images with type.

In the pages that follow, I don't go into a lot of detail with regard to the two **PNG** formats. It's not that I have any qualms with the format or its capacity for optimizing different types of images—which, by the way, can be impressive, indeed. It's just that the PNG format does have a couple of limitations significant enough that I recommend against using it.

Foremost among those limitations is its relative newness. PNG hasn't been around as long as GIF and JPEG, and the majority of browsers still don't support the PNG format; so GIF and JPEG are simply more reliable formats for viewing in a wide range of browsers.

And although in some cases PNG-8 images can be slightly smaller than comparable GIF images, PNG formats (particularly PNG-24) tend to produce images markedly larger than their GIF and JPEG counterparts. Keeping with the goal of controlling file size, stick with GIF and JPEG formats for optimizing your images.

Optimizing an Image for the Web

With the Save for Web command, Photoshop Elements provides a simple, automated method that not only saves an optimized copy of your original image, but also preserves the original high-resolution image, untouched and intact. Simply choose from a list of 12 predefined settings, and your image is instantly optimized for the Web. You may want to experiment with the custom optimization settings, but the 12 predefined settings should satisfy the requirements of most of your optimization tasks.

To save an image for the Web:

- 1. Open the image you want to optimize.
- 2. From the File menu, choose Save for Web (Figure 10.3), or press Alt+Shift+Ctrl+S. The Save for Web dialog box opens on top of the active image window, displaying the image in side-by-side original and optimized previews (Figure 10.4).

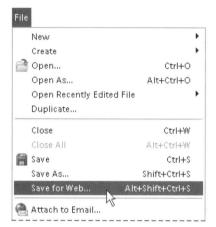

Figure 10.3 Open the Save for Web dialog box from the File menu.

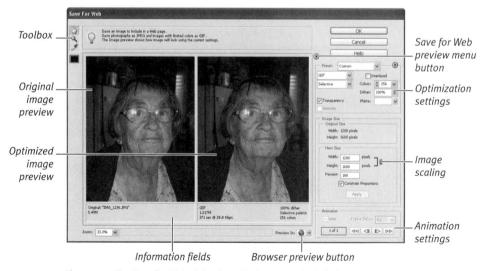

Figure 10.4 The Save for Web dialog box. The image on the left shows the original image. The image on the right shows a preview of what the same image will look like after it's been optimized.

Figure 10.5 Choose from the list of predefined settings for JPEG and GIF or PNG optimization formats.

Figure 10.6 Once you've chosen a predefined optimization setting, the rest of the options change accordingly. Here, the options have automatically changed to reflect the Medium JPEG optimization format.

Figure 10.7 Click OK in the Save for Web dialog box to save your optimized image.

Figure 10.8 Enter a name and destination for your optimized file in the Save Optimized As dialog box.

- 3. From the Preset drop-down menu in the Save for Web dialog box, choose a predefined optimization setting (Figure 10.5). The various drop-down menus within the Preset portion of the dialog box change to reflect the setting you've selected (Figure 10.6), as does the optimized preview in the center of the dialog box.
- **4.** Click the OK button in the Save for Web dialog box (**Figure 10.7**).
- 5. In the Save Optimized As dialog box, type a new name for your file and verify that the file type matches the optimization format you chose in the Save for Web dialog box (**Figure 10.8**).
- **6.** Choose a location for your file and click Save.

The Save Optimized As and Save for Web dialog boxes will automatically close, and your optimized image will be saved to the location you specified.

The Save for Web Preview Menu

The Preview menu (**Figure 10.9**), which you can find by clicking the triangle button to the right of the optimized image in the Save for Web dialog box, is one of those easy-to-overlook tools in a space already packed with check boxes, palettes, and drop-down menus.

As its name implies, the Preview menu works with the image preview (the optimized side of the image preview, to be exact) and establishes parameters for the way that the image preview is displayed. Depending on the color space you select in the top portion of the Preview menu, you can view your image as it would appear in a browser on your own monitor or on a standard Macintosh or PC monitor, or you can see a preview of how it would appear if it were saved with its color profile.

The bottom portion of the menu offers a variety of standard dial-up and high-speed Internet connection settings. Whichever connection speed you choose here determines the estimated connection speed value displayed in the information box below the optimized preview image (Figure 10.10). So, by doing nothing more than selecting from a handful of menu options, you can get a good idea of how much time it will take anyone, with any number of connection speeds, to download and display your image.

None of the settings you choose from the Preview menu affect the actual image file in any way. They're for the purpose of previewing only and are completely independent of the attributes you actually apply to an image in the Settings portion of the dialog box. There's no way to include a setting for connection speed with an image, since connection speed is completely dependent on an individual's modem and the service offered by that person's Internet provider.

Figure 10.9 It's a little hard to find, but you can use the Preview menu to control the appearance of the optimization preview and the information displayed below it.

Figure 10.10 After you've chosen a connection speed from the preview menu, the Save for Web dialog box uses that input, along with the optimization format you've selected, to estimate the size the file will be when optimized and the time it will take to download. That information is displayed below the optimized preview.

About Color Models and Color Lookup Tables

Although you certainly don't have to be proficient in Web color theory to successfully save images for the Web, a little background information on the different color models will help you to make more informed decisions as you make color choices for your Web images. When you optimize an image using the GIF format, Photoshop Elements asks you to pick a *color model* from the Color Reduction Algorithm drop-down menu. Since GIF images are limited to just 256 colors, color models help to define which colors—from the vast spectrum of *millions* of colors—will be used in any individual optimized image. Sets of colors are given priority over others depending on the color model chosen, as follows:

Perceptual color leans toward colors to which the human eye is most sensitive.

Selective color draws from the largest possible range of colors, incorporating colors from the Web-safe palette as much as possible. Selective is the default option.

Adaptive color favors those colors that appear most often in a particular image. For instance, a seascape may contain colors primarily from the blue spectrum.

Restrictive (Web) is limited to the standard 216 Web colors and typically produces color the least true to the original image. Most browsers and personal computer monitors are capable of displaying in thousands and millions of colors, so you'll probably have very little occasion to use this option.

After you've selected a color model and chosen a maximum number of colors from the Colors drop-down menu, Photoshop Elements builds a *color lookup table* specific to the image you're optimizing.

A color lookup table can be thought of as a palette of color swatches. If an original image contains more colors than you specify for its GIF version's color lookup table, any missing colors will be re-created as best they can, using the existing number of colors in the color palette. If the original image contains *fewer* colors than you've specified, the color lookup table will shrink and will contain only the colors in the image.

Either way, no unnecessary color information is included in the color lookup table, meaning that your image's file size is kept to a minimum.

Adjusting Optimization Settings

You're not limited to using predefined settings to optimize your images. You can fine-tune these settings further by using the collection of drop-down menus, check boxes, and sliders available in the Settings portion of the Save for Web dialog box. For example, if you want your JPEGs to retain a little more image quality as they're compressed for the Web, you can change the default quality setting for a Medium JPEG image from 30 to 45, improving its sharpness and detail without increasing its download time. As you make adjustments, refer to the optimized image preview to the left of the Settings column. There, you can see how your changes affect the image, as well as its file size and download time.

To apply custom JPEG optimization settings to an image:

- Open the image you want to optimize, then choose File > Save for Web to open the Save for Web dialog box.
- From the Preset drop-down menu, choose one of the predefined JPEG settings (Figure 10.11).
 - You don't have to choose one of the predefined JPEG settings, but they can serve as a good jumping-off point for building your own settings. For instance, if you decide that small file size and quick download time are priorities, you might want to start with the predefined JPEG Low setting and then customize the settings from there.
- 3. Verify that JPEG is selected from the Optimized file format drop-down menu, or if you've decided to skip step 1, choose JPEG from the Optimized drop-down menu (Figure 10.12).

Figure 10.11 If you like, you can choose one of the predefined JPEG settings to use as a baseline for your own custom settings.

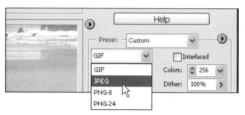

Figure 10.12 Optimization formats can be changed at any time from the drop-down menu.

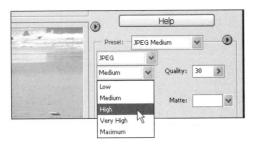

Figure 10.13 You can choose from five basic quality options for JPEG images: Low, Medium, High, Very High, and Maximum.

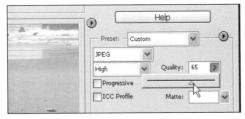

Figure 10.14 Once a quality option has been selected, use the slider control to fine-tune it.

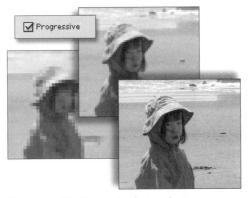

Figure 10.15 The Progressive feature draws your image incrementally on a Web page as it downloads, eventually displaying the image in its final state.

- **4.** To set the image quality, *do one of the following*:
 - ▲ From the compression quality dropdown menu, choose a quality option (**Figure 10.13**).
 - ▲ Drag the Quality slider while referring to the optimized preview (Figure 10.14).

The Quality slider has a direct impact on the Quality drop-down menu, and vice versa. When the slider is set between 0 and 29, the level in the Quality drop-down menu will be Low. A setting of 30 through 59 registers as Medium, 60 through 79 as High, and 80 through 100 as Maximum. Just remember that a quality setting in the Maximum range will usually create a file six to eight times larger than one saved in the Low range.

5. Select the Progressive check box if you want your image to build from a low-resolution version to its final saved version as it downloads in a Web browser (Figure 10.15).

This option is more critical for large, highquality images with download times in the tens of seconds. Rather than leaving a blank space, the low-resolution image appears almost immediately, giving your Web page visitors *something* to look at until the complete file is downloaded.

6. Select the ICC Profile check box if you've previously saved a color profile with your image and want that information preserved in your optimized image.
Unless your photo or art contains some critical color (a logo with a very specific corporate color, for instance), you should leave this box unchecked. Not all Web browsers support color profiles, and the inclusion of the profile information can increase a file's size significantly.

continues on next page

- 7. If your original image contains transparency, see "Making a Web Image Transparent" later in this chapter.
- **8.** Click the OK button in the Save for Web dialog box to rename and save your optimized image.

To apply custom GIF optimization settings to an image:

- Open the image you want to optimize, then choose File > Save for Web to open the Save for Web dialog box.
- 2. From the Preset drop-down menu, choose one of the predefined GIF settings, or choose GIF from the Optimized file format drop-down menu (Figure 10.16).
- 3. From the Color Reduction Algorithm drop-down menu, choose the color lookup table that you want applied to your image (Figure 10.17). (For more information, see the sidebar "About Color Models and Color Lookup Tables" earlier in this chapter.)
- 4. From the Colors drop-down menu, choose the maximum number of colors that will be displayed in your image by specifying the number of colors that the image's palette will contain (Figure 10.18). You can choose from the list of eight standard color palette values, use the arrows to the left of the text box to change the values in increments of one, or simply enter a value in the text box and press Enter/Return.

When formatting GIF images, the number of colors you specify will have a larger impact on final file size and download time than any other attribute you set. Naturally, the fewer colors you select, the smaller the image file size will be, so experiment with different values, gradually reducing the number of colors, until

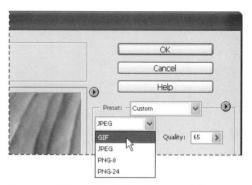

Figure 10.16 Choose the GIF setting to optimize illustrations, vector art, or type.

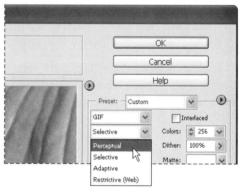

Figure 10.17 The GIF format offers several schemes for interpreting and displaying the color in your image.

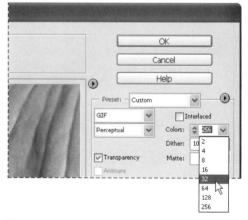

Figure 10.18 A GIF image can contain from 2 to 256 colors.

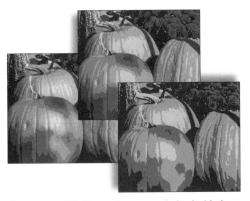

Figure 10.19 This illustration was optimized with three GIF color palettes containing progressively fewer colors. From left to right, the illustrations were saved with palettes of 16, 8, and 4 colors, creating file sizes of roughly 32K, 19K, and 12K, respectively.

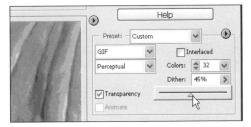

Figure 10.20 Since diffusion is the default dither option for any GIF image you create in the Save for Web dialog box, you can control the amount of dithering that occurs: from 0 to 100 percent.

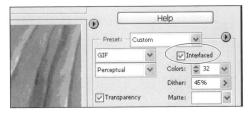

Figure 10.21 The Interlaced feature works like JPEG's Progressive option to draw your image incrementally on a Web page as it downloads.

- you arrive at a setting you find acceptable (**Figure 10.19**).
- 5. Use the Dither slider to specify a percentage for the dither (Figure 10.20).

 Higher percentages create finer dither patterns, which tend to preserve more detail in images where limited color palettes have been specified.

 Although not accessible from the Save For Web dialog box, Photoshop Elements gives you the option to save a GIF image with one of three different Dither options. (For more information, see the sidebar "Choosing Dithering Options.")
- 6. If you want your image to build from a low-resolution version to its final saved version as it downloads in a browser, select the Interlaced check box (Figure 10.21). Interlacing a GIF image works in much the same way as applying the Progressive option to a JPEG image. If you choose not to select the interlace option, your image won't display on a Web page until it's completely downloaded.
- 7. If your original image contains transparency, see "Making a Web Image Transparent" later in this chapter.
- **8.** Click the OK button in the Save for Web dialog box to rename and save your optimized image.

Tip

■ If you want to save an image in the PNG-8 format, you'll find that it uses all the same options as for GIF, and the procedures for applying custom PNG-8 settings will be exactly the same as those for GIF. The only options available for PNG-24 are transparency and interlacing.

Choosing Dithering Options

Because a GIF image works with a limited color palette, it's impossible to reproduce most of the millions of colors visible to the human eye, much less subtle gradations of tone and color. GIF optimization employs a little visual trick called *dithering* to fool the eye into perceiving more colors and softer transitions than are actually there. By reorganizing pixels of different hues and values, dithering can do a surprisingly good job of simulating thousands of colors with a palette of a hundred colors or less (**Figure 10.22**). Dithering works, quite simply, by mixing two available colors to create the illusion of a third. Blue and yellow pixels mixed together will blend to create green. Black and white pixels mixed in varying proportions will simulate a graduated fill or soft-edged drop shadow.

Any dithered GIF that you create in the Save for Web dialog box is saved with a *diffusion* dither. But if you save an image from the Save As dialog box (File > Save As) and select CompuServe GIF from the Format drop-down menu, Photoshop Elements offers you a choice of three dithering options.

Diffusion is the default scheme for any of the predefined GIF settings; it creates a random pattern that usually yields the most natural-looking results. Diffusion is the only option that allows you to control the percentage of dither present in your image.

Pattern, as its name implies, lays down pixels in a uniform grid pattern. It can have the effect of a very coarse halftone screen such as you might see in low-resolution newspaper photography.

Noise creates a random pattern similar to Diffusion, but attempts to blend color transitions further by allowing color from one area to spill over slightly into an adjoining one. It occasionally produces an interesting effect, but will rarely be your first choice.

Figure 10.22 The original image (left) relies on thousands of subtle tonal and value changes to define shapes, shadows, and highlights. The GIF-optimized version (right) shows the close-up results of dithering. Since GIF optimization uses a limited palette of colors, it gathers together pixels of whatever colors are available to reproduce an approximation of the original image.

Optimizing Images to Specific File Sizes

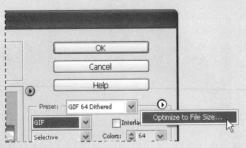

Figure 10.23 Choose Optimize to File Size for additional optimization control.

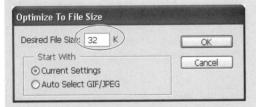

Figure 10.24 In the Optimize to File Size dialog box you can choose to have file size take priority over image quality.

Photoshop Elements has vet one more little optimizing trick. There may be times when image quality isn't as critical as the data size of your files. Perhaps you want to email a weekend's trip worth of photos to some friends, but don't want to clog up their mailboxes with megabytes of image files. You can send a batch of mediocre quality images, and then let them pick out the ones they'd like you to create high-resolution copies or prints of. On the right side of the Save for Web dialog box, just next to the main optimization settings drop-down menu, is the Optimize to File Size arrow button. Click the button, and then select Optimize to File Size (Figure 10.23). In the Optimize to File Size dialog box, type in the size you want your file to be (Figure 10.24). In the Start With area of the dialog box, you can also choose from Current Settings, which tells Elements to do its best with your Save for Web settings; or Auto Select, which allows Elements to choose the format that will work best for your image, given the file size constraints.

Making a Web Image Transparent

In just a few simple steps, you can preserve the transparency of any image using options available in the GIF formatting settings. Once transparency has been set, an image of any shape (even one with a transparent cutout) can be placed on a Web page and made to blend seamlessly with its background (**Figure 10.25**).

To apply transparency to an image:

- 1. Open the image you want to make transparent, then choose File > Save for Web to open the Save for Web dialog box.
- **2.** Select any one of the GIF formats from the Preset drop-down menu.
- If it's not already selected, click to select the Transparency check box (Figure 10.26).
 The image in the optimized preview area will be displayed against a transparency grid pattern (Figure 10.27).

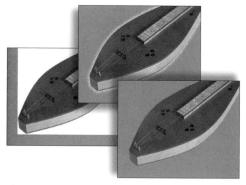

Figure 10.25 The image at left was saved with no transparency and displays with a solid, white background. The center image was saved with transparency, but since its matte color was set to the default of white, it appears to have a ghosted halo around its edge. The image at right was saved both with transparency and with its matte color matching that of the Web page background.

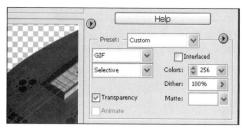

Figure 10.26 GIF optimization offers the added bonus of preserving transparency in your Web-bound images.

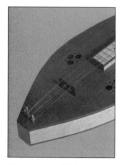

Figure 10.27 If the Transparency box is unchecked, the image is displayed on a solid, colored background (left). If the Transparency box is checked, the image is displayed on a transparent background (right).

Figure 10.28 Choose a matte color from the Color Picker to match your intended Web page background.

Figure 10.29 The Matte drop-down menu offers a limited number of color options.

Figure 10.30 The color you select from the Matte dropdown menu or color box fills in the semitransparent pixels around your image, helping to maintain a smooth edge and creating a seamless transition when the image is placed on a Web page of the same color.

- **4.** To select the color that will be used to blend your image with the Web page background color, *do one of the following*:
 - ▲ Click the Matte color box to open the Color Picker; then select a color from the main color window or enter color values in either the HSB, RGB, or Web color space text boxes (**Figure 10.28**).
 - ▲ From the Matte drop-down menu, choose a color option (**Figure 10.29**).

Only the semitransparent pixels around the edges of the image are filled with the matte color. If the matte color matches the color of the Web page background, the transition between the transparent image and its background will be seamless (**Figure 10.30**).

✓ Tips

- The JPEG format doesn't support true transparency, but as long as your image is placed on a Web page with a solid, colored background, you can simulate transparency by filling the original transparent spaces with a background color. Follow the steps in the earlier task "To apply custom JPEG optimization settings to an image," then click the Matte color box to open the Color Picker. Select a color, then click OK. When you close the Color Picker, any areas that were transparent in the original image will be filled with the matte color.
- Since the Eyedropper tool can sample color only from the two preview boxes in the Save for Web dialog box, the Eyedropper Color option is helpful only if the color of your Web page background also happens to be present in your image. The Other option simply opens the Color Picker. You're better off using the Matte dropdown menu only when selecting the White, Black, and None options.

Identifying Web Page Background Colors

You'll need to do a little homework to identify the color of your Web page background before you can precisely assign a matte color to your transparent GIF images in Photoshop Elements.

The most accurate method of determining the color of the Web page is to identify the color values in the Web page's source code. This isn't nearly as intimidating as it sounds. Open any Web page, then from the browser's main menu, find the command to view the source code. (In

Internet Explorer, you simply choose View > Source.) A window will open, with code describing everything from the location of graphics and text to the background color.

Once you have the source code window open, scan down the entries for the one that begins with <body>. (You'll typically find it within the first dozen entries or so.) On the same line, directly to the right, it will say, bgcolor= followed by either a 6digit Web color code (something like #E2A6A6) or RGB color values (Figure 10.31). The "bg" stands for background, and the color code describes the color for that background. Simply jot down the color values from the Web page source code, then return to Photoshop Elements and enter those same values in the bottom field of the Color Picker to assign the matte color.

Figure 10.31 In this example, I've opened the source code for a page from Peachpit's Web site. On the

dody> line is the color code for the Web page background—bgcolor="#ffffff"—which translates to white. So in this case, the background color code could also have read as either bgcolor=white or bgcolor=255,255,255 (the RGB values for white).

Placing Transparent Images on Patterned Backgrounds

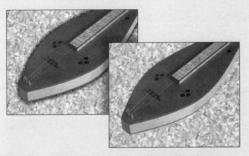

Figure 10.32 When a transparent GIF with a matte color is placed on a patterned background, a colored "halo" may appear around its edges (left). When the matte is set to None, the halo effect disappears and the image appears to blend with the patterned background (right).

Figure 10.33 Select None from the Matte drop-down menu to create a hard-edged transparent image ideal for placing on a patterned background.

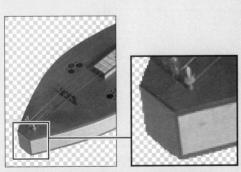

Figure 10.34 When None is selected from the Matte drop-down menu, a hard, aliased edge is created around a transparent image.

You may want to place your transparent GIF image on a patterned background rather than a background with a solid, colored fill. If you try to assign any matte color at all, even one similar to a color in the patterned background, you're likely to be disappointed by a halo that appears around the edges of the image (Figure 10.32). Instead, set the Matte option to None (Figure 10.33). The transparent edges will become hard and jagged, particularly on curved and angled edges (Figure 10.34), but when placed on the patterned background, the edges should be barely noticeable and will blend much more naturally than if you use the haloedged alternative.

Previewing an Image

Before you commit to saving your optimized image, you may want to see exactly how the image will appear in a Web browser window. Although the Save for Web optimized preview gives you a good approximation of how the final image will look, there's no substitute for seeing the image displayed in its natural environment.

Additionally, you can remain within the Save for Web dialog box to preview your image as if it were viewed on an older, lower-end system, limited to just 256 colors. This can be helpful, because it allows you to design primarily for most current computer systems while giving you the opportunity to fine-tune your settings to accommodate the limited display capabilities of older systems. Note that this is only a preview and has no affect on your actual image file and its settings.

To preview an image in a Web browser:

- **1.** Open the image you want to preview, then choose File > Save for Web to open the Save for Web dialog box.
- 2. At the bottom of the Save for Web dialog box, choose a Web browser or click the current browser icon on the Preview In drop-down menu (Figure 10.35).
 The browser opens displaying the optimized image plus its dimensions and the settings you specified (Figure 10.36).
- **3.** Close the browser window to return to the Save for Web dialog box.

Figure 10.35 You can open your optimized image directly in a browser for previewing.

Figure 10.36 When your image opens in a browser, it's accompanied by all of the settings you specified in the Save for Web dialog box.

Figure 10.37 Select Browser Dither from the preview menu if you want to view your image using a limited Web-safe palette.

Figure 10.38 When you select Browser Dither, the optimized preview changes to display your image as it would appear on an older, 256-color monitor.

To preview an image as it would display on older monitors:

- 1. From the preview menu in the Save for Web dialog box, choose Browser Dither (**Figure 10.37**).
 - The image in the optimized preview window appears just as it would on an 8-bit (256-color) monitor, allowing you to anticipate what this image will look like on older computer systems (**Figure 10.38**).
- 2. To turn off the browser dither preview, choose Browser Dither again from the preview menu.

Sending Images by Email

With the Attach to Email feature, Photoshop Elements streamlines the process of sending digital photos to family and friends. If your photo is too large or is in the wrong file format, Photoshop Elements can automatically resize your image and save it as a JPEG file, if you prefer. But it's all up to you—you can send photos and images in any file size or format, as long as you have the bandwidth for it.

To attach a simple photo to email:

- Open the photo or image you want to send.
- From the File menu, choose Attach to Email (Figure 10.39).
 Photoshop Elements automatically
 - Photoshop Elements automatically launches the Elements Organizer, and the E-mail dialog box appears.
- 3. From the E-mail Client drop-down menu, select the email service you want to use, and then click Continue (Figure 10.40). The Attach to E-mail dialog box appears (Figure 10.41).

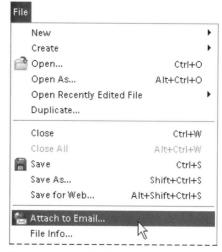

Figure 10.39 From the File menu, choose Attach to Email.

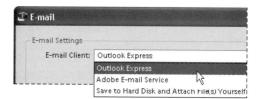

Figure 10.40 Choose the email service you want to use from the E-mail dialog box

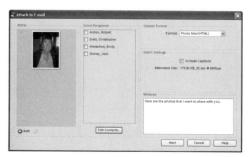

Figure 10.41 The Attach to E-mail dialog box gives you options for attaching and sending your images.

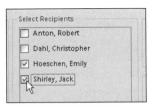

Figure 10.42 You can select a single person, or multiple persons to receive your image.

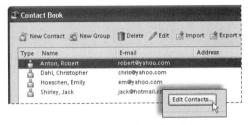

Figure 10.43 You can also add or edit recipient names by clicking the Edit Contacts button.

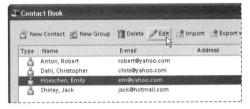

Figure 10.44 Select a contact to edit in the Contact Book dialog box.

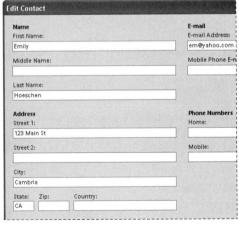

Figure 10.45 Enter detailed contact information for each of your recipients in the Edit Contact window.

- **4.** In the Attach to E-mail dialog box, choose a name (or names) from the Select Recipients window list (**Figure 10.42**).
 - If you're using the Attach to E-mail function for the first time, your Select Recipients window will probably be empty, and you'll want to create a recipient list.
- To create a new contact/recipient, or to edit a recipient's contact information, click the Edit Contacts button in the Attach to E-mail dialog box (Figure 10.43).
- In the Contact Book dialog box, click New Contact, or select an existing contact, and then click the Edit button (Figure 10.44).
- In the Edit Contact window, you can add detailed telephone and mailing address information (Figure 10.45).
- **8.** When you've finished editing your contact information, click OK to close the Edit Contact window. Then click OK again to close the Contact Book dialog box.

continues on next page

- 9. From the Format drop-down menu in the Attach to E-mail dialog box, select Individual Attachments (Figure 10.46).
- 10. Check that the Convert Photos to JPEGs option is selected (Figure 10.47).
 When the Convert Photos to JPEGs option is selected, you can make size and quality adjustments to your email attachment.
- **11.** From the Maximum Photo Size dropdown menu, you can choose to change the size of your attachment or leave it unchanged (**Figure 10.48**).
- **12.** If you choose an option other than Use Original Size, you can use the Quality slider to control the size and download speed of your attachment (**Figure 10.49**).

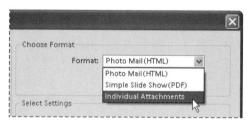

Figure 10.46 To email a single photo, check that Individual Attachments is selected.

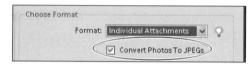

Figure 10.47 The Convert Photos to JPEG option allows you to make changes to your photo attachment before you send it.

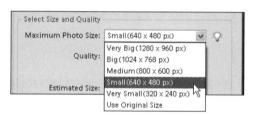

Figure 10.48 You can change the size of your image attachment without affecting the original image file.

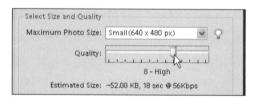

Figure 10.49 A Quality slider allows you to make size and quality adjustments to your image, just as you can in the Save for Web dialog box.

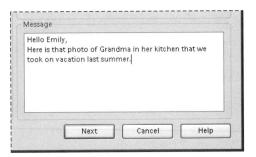

Figure 10.50 You can type an email message directly in the Attach to E-mail dialog box.

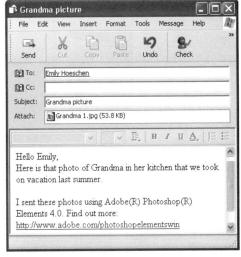

Figure 10.51 An email, with the attachment included, is automatically created for you.

- **13.** If you like, you can enter a message in the Message area in the lower-right corner of the dialog box (**Figure 10.50**).
- 14. Once you're satisfied with your settings, click the Next button.
 Your default email program opens automatically and attaches a copy of your photo to your email (Figure 10.51).

✓ Tip

■ You can import contact information you've created in Outlook Express directly into your Photoshop Elements Contact Book. Click the Import button in the Contact Book dialog box. In the Choose Contact Source dialog box, click to select Outlook Express, and then click OK. Your Photoshop Elements Contact Book will automatically be populated with your Outlook Express contacts.

To attach a photo on custom stationery to email:

- 1. Open the photo or image that you want to send, and then follow the steps in the previous procedure to select a list of recipients.
- 2. From the Format drop-down menu in the Attach to E-mail dialog box, select Photo Mail(HTML) and then click the Next button (Figure 10.52).

Your photo opens in the Stationery & Layouts Wizard (**Figure 10.53**).

- **3.** From the Stationery pane on the left side of the Wizard window, choose a stationery layout on which you'd like to place your photo (**Figure 10.54**). Then click the Next Step button at the bottom of the Wizard.
- **4.** If you like, use the various sliders, buttons and drop-down menus to customize the look of your stationery (**Figure 10.55**).

Figure 10.54 You can choose from an extensive list of predesigned stationery templates.

Figure 10.52 To create a custom email attachment, select Photo Mail(HTML).

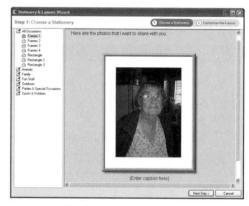

Figure 10.53 The Stationery & Layouts Wizard.

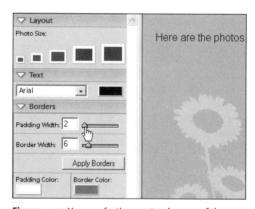

Figure 10.55 You can further customize any of the stationery templates to give them just the look you want.

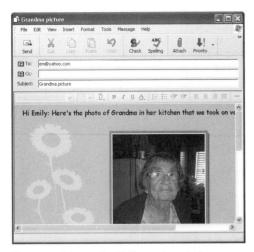

Figure 10.56 An email, with the custom stationery attachment included, is automatically created for you.

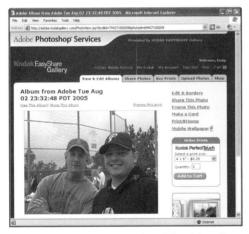

Figure 10.57 In cooperation with Kodak, Adobe offers a fun and simple way to use Web posting service, so that you can share your photos with anyone who has online access.

5. Insert a message and caption into the placeholder text areas, and then click the Next button.

Your default email program opens automatically and places your photo on its special stationery into the body of your email (**Figure 10.56**).

✓ Tip

■ You can also share your photos with friends and family all over the world, with the Adobe Photoshop Services Kodak EasyShare Gallery. From the Photoshop Elements Organizer, click the Share button and select Share Online to launch your Web browser and open the EasyShare Gallery homepage. Once you follow the simple steps for creating an account, you can post photos and send email notices to direct your family and friends to your personal online photo galleries (Figure 10.57).

SAVING AND PRINTING IMAGES

With Photoshop Elements, you can save images in a number of file formats, each with its own set of specialized uses and limitations. In this chapter, we'll begin with a discussion of formatting options and then move on to other considerations for saving your image files and preparing them for printing. We'll look at how to format and save multiple images (known as batch processing) and then look at tools you can use to layout, organize, and catalog your image files. In addition, we'll look closely at the steps necessary to get the best prints from your digital images, whether you're printing them at home or uploading your files to an online photo service.

Understanding File Formats

Photoshop Elements lets you save an image in any of 15 different file formats, from the native, information-rich Photoshop format to optimized formats for the Web, such as GIF and JPEG. Among these is an extremely specialized collection of formats (PCX, PICT Resource, Pixar, PNG, Raw, Scitex CT, and Targa) that you'll rarely ever need to use and won't be discussed here. What follows are descriptions of the most common file formats, presented in the order that they appear in the Format drop-down menu in the Save As dialog box.

Photoshop

Photoshop (PSD) is Photoshop Elements' native file format, meaning that the saved file will include information for any and all of Photoshop Elements' features, including layers styles, effects, typography, and filters. As its name implies, any file saved in the PSD format can be opened not only in Photoshop Elements, but also in Adobe Photoshop. Conversely, any Photoshop file saved in its native format can be opened in Photoshop Elements. However, Photoshop Elements doesn't support all of the features available in Photoshop, so although you can open any file saved in the PSD format, some of Photoshop's more advanced features (such as layer sets) won't be accessible to you within Photoshop Elements.

A good approach is to save every photo you're working on in the native Photoshop format and then, when you've finished, save a copy in whatever format is appropriate for that image's intended use or destination. That way, you always have the original, full-featured image file to return to if you want to make changes or just save in a different format.

Figure 11.1 The choices available in the BMP Options dialog box vary depending on the color or tonal content of the particular image.

BMP

As a Windows user, you may recognize the .bmp file extension, which identifies a bitmap file. BMP has long been Windows' standard graphics format, and it's the one you'll want to use if you're creating images for screen savers or computer wallpaper.

Radio buttons in the BMP Options dialog box (**Figure 11.1**) offer bit-depth options you can use to set the maximum number of colors or values, but Photoshop Elements does a pretty good job of selecting the appropriate settings for any particular image. So, unless you know that you have a special requirement (like keeping file size to a minimum to conserve disk space, for instance) you can leave these options alone.

A *compression* (or optimization) scheme is available when certain combinations of file format and bit depth are selected. However, if you plan to use this format to save an image for wallpaper or a screen saver, *don't* select this compression. If you do, the Windows operating system won't recognize your file.

Photoshop EPS

Photoshop EPS is actually a format you'll probably not want to save to. Although EPS (Encapsulated PostScript) files are compatible with a host of graphics and page layout programs, they're not the best choice for saving raster, bit-mapped images, which are what Photoshop Elements creates. The EPS format adds layers of PostScript code to describe everything from the way an image appears in preview to the way it's color managed, which translates into overhead in the form of bloated file size and slower display time. Any advantage this format holds for displaying and printing vector art and typography is lost on Photoshop Elements' raster art.

Photoshop PDF

Portable Document Format (PDF) is the perfect vehicle for sharing images across platforms or for importing them into a variety of graphics and page layout programs. PDF is also one of only three file formats (native Photoshop and TIFF are the other two) that support an image file's layers, meaning that layer qualities (like transparency) are preserved when you place a PDF into another application like Adobe Illustrator or InDesign. The real beauty of this file format is that any document saved as a PDF file can be opened and viewed by anyone using Adobe's free Acrobat Reader software, which Adobe bundles with its applications and makes available as a free download from its Web site.

PDF offers two compression schemes for controlling file size: ZIP and JPEG (**Figure 11.2**). ZIP removes whatever extraneous file information it can without the loss of any image quality and so is referred to as *lossless* compression. Since some degree of image fidelity is lost in the JPEG compression process, it's known as a *lossy* compression. JPEG compression also offers you five image quality options, from Low to High.

PICT File

The PICT file format can be a valuable, if somewhat limited, format (**Figure 11.3**). Although it doesn't print particularly well from some applications, it does look nice onscreen, and so is a good choice for creating placeholder images when you're working on complex page layouts or on designs that might slow down your computer under the weight of numerous megabyte-sized images. Once the design work is done, you can replace the low-resolution PICT files with high-resolution TIFF or native PSD files of the same images just before you print your work.

Figure 11.2 When you save your work as a PDF file, you can apply JPEG or ZIP compression.

Figure 11.3 PICT-formatted images can be used as low-resolution placeholder art.

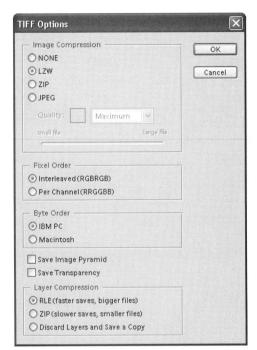

Figure 11.4 Although the TIFF format offers several compression schemes, LZW is usually the most reliable.

TIFF

Tagged Image File Format (TIFF) is the one true workhorse among the file formats. The TIFF format was designed to be platform independent, so TIFF files display and print equally well from both Windows and Macintosh machines. Additionally, any TIFF file created on one platform can be transferred to the other and placed in almost any graphics or page layout program.

You can optimize TIFF files to save room on your hard drive using one of three compression schemes, or you can save them with no compression at all (**Figure 11.4**). Of the three compression options, LZW is the one supported by the largest number of applications and programs.

The Pixel Order option should be left at the default of Interleaved, because that is the option supported by Photoshop Elements' Organizer.

The Byte Order option encodes information in the file to determine whether it will be used on a Windows or Macintosh platform. On rare occasions, TIFF files saved with the Macintosh option don't transfer cleanly to Windows machines. But since the Mac has no problem with files saved with the IBM PC byte order, I recommend you stick with this option.

Checking the Save Image Pyramid check box saves your image in different tiers of resolution, so that you can choose to use the full-resolution image or a lower-resolution version. However, not many applications (Photoshop Elements included) support the Image Pyramid format as yet, so you should leave this box unchecked.

continues on next page

Checking the Save Transparency check box ensures that transparency will be maintained if you place your image into another application like Illustrator or InDesign.

If your image contains layers, you can choose from two Layer Compression schemes, or choose to discard the layers altogether and save a copy of your image file.

JPEG and GIF

The two major Web file formats (JPEG and GIF) are covered in detail in Chapter 10, "Preparing Images for the Web," so we'll look at them just briefly here. Of particular note is the fact that you can indeed use the Save As command to save an image as a GIF or JPEG file, with virtually all of the same file options as in the Save for Web dialog box—so the obvious question is why use one saving method over the other when saving for the Web?

The Save for Web dialog box offers several features that the individual GIF and JPEG Save As command dialog boxes don't. For one, the Save for Web dialog box provides a wonderful before-and-after preview area, displaying side-by-side comparisons of your original and optimized images while an information area displays the optimized version's file size and projected download time.

No less valuable is the flexibility you have to change and view different optimization formats on the fly. An image just doesn't appear the way you expected in GIF? Try JPEG. Additionally, with the click of a button, you can open and preview your optimized image in any browser present on your system.

Choosing Compression Options

As you save images in the various formats available, you're presented with a variety of format-specific dialog boxes, each containing its own set of options. One of those options, present in most of the dialog boxes, is a choice of compression settings. Compression, which is just another term for optimization, makes an image's file size smaller; so the file will download faster when you attach it to an email or post it to a Web page, for example. Following is a brief rundown of the compression schemes you can save to in Photoshop Elements.

JPEG: Yes, JPEG is presented in Photoshop Elements as a formatting option, but at its core, it's just a very powerful, flexible compression scheme. JPEG works best with continuous-tone images like photographs. It compresses by throwing away image information and slightly degrading the image, and is therefore a lossy compression.

LZW: This is the standard compression format for most TIFF images. Although it works best on images with large areas of a single color, it will help reduce file size at least a little for nearly any image it's applied to. Since it works behind the scenes, throwing out code rather than image information (and so doesn't degrade the image), LZW is a lossless compression.

RLE: This is a lossless compression similar to LZW, but it's specific (in Photoshop Elements) to BMP compressed files. It's particularly effective at compressing images containing transparency.

ZIP: This compression scheme is also similar to LZW, but it has the advantage of adding a layer of protection to files that makes them less susceptible to corruption if they're copied between systems or sent via email. Zip files are common on the Windows platform, although Macintosh systems can open Zip compressed files if they have Stuffit Expander installed.

Setting Preferences for Saving Files

The Saving Files portion of the Preferences dialog box provides a number of ways to control how Photoshop Elements manages your saved files, including options for displaying file extensions and thumbnail previews.

To set the Saving Files preferences:

- From the Edit menu, choose Preferences > Saving Files (Windows).
 The Preferences dialog box opens with the Saving Files window active (Figure 11.5).
- 2. From the On First Save drop-down menu, you can choose when you want to be prompted with the Save As dialog box (Figure 11.6).
- **3.** From the Image Previews drop-down menu, choose an option to either save or not save a preview with the file (**Figure 11.7**).

When an application supports them, images saved with a preview will appear with a thumbnail version in that application's Open or Place dialog box.

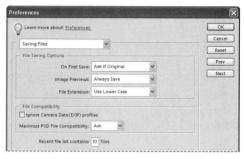

Figure 11.5 The Saving Files window of the Preferences dialog box.

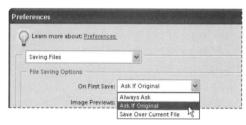

Figure 11.6 The On First Save drop-down menu lets you control when the Save As dialog box appears.

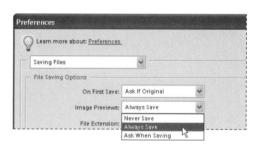

Figure 11.7 You can save a preview of your image that will display a thumbnail of your image in the Open dialog box of some applications.

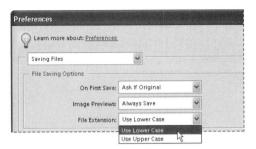

Figure 11.8 Use the File Extension drop-down menu to determine how you want filename extensions displayed.

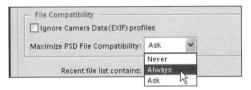

Figure 11.9 The Always option will ensure your saved files are compatible with other applications.

Figure 11.10 Specify the number of filenames that are displayed when you choose Open Recent from the File menu.

- **4.** From the File Extension drop-down menu, choose whether you want your file extensions in uppercase or lowercase characters (**Figure 11.8**).
- 5. In the File Compatibility portion of the dialog box, set the Maximize PSD File Compatibility drop-down menu to Always (**Figure 11.9**). This ensures that the maximum number of compatibility options is always available to you.
- **6.** Digital cameras assign their own color profiles (EXIF profiles) to your digital photos. If you'd prefer to assign your own profiles once you've opened your image in Photoshop Elements, select the Ignore Camera Data (EXIF) profiles check box.
- In the Recent File List Contains text box, enter a number from 1 to 30 (Figure 11.10).

This sets the number of filenames available to you when you select Open Recent from the File menu.

8. Click OK to close the dialog box and apply your preferences settings.

Adding Personalized File Information

With any Photoshop Elements file open. choose File Info from the File menu to open the File Info dialog box (Figure 11.11). Within this simple dialog box, you can add personalized information specific to any file, including title, author, caption, and copyright information. Although most of the information entered here is accessible only by opening the dialog box from within Photoshop Elements, some of it does have practical uses both inside and outside the application. Entries from the Title, Author. Caption, and Copyright Notice text fields can be included when you create a Picture Package (see "Creating a Photographer's Picture Package" later in this chapter). Also, the Caption field can be included with any saved image (see "Setting Additional Printing Options" later in this chapter). And if you select Copyrighted Work from the Copyright Status drop-down menu, a copyright symbol appears in the Image Window title bar, alerting anyone who receives a copy of your file that it's copyright protected (Figure 11.12).

The File Info dialog box is also useful for retrieving information. Many digital cameras include EXIF annotations (such as date and time, resolution, exposure time, and f-stop settings) for each digital photo. To access this information, click the Camera Data 1 or Camera Data 2 heads in the left column of the dialog box. Any EXIF information exported with the photo from your digital camera will be displayed in the File Info dialog box (Figure 11.13). You can use this information to record exposure and f-stop settings from your more successful photos, a handy reference for future photography outings. You can also view EXIF annotations in the Information area of the File Browser.

Figure 11.11 Use the File Info dialog box to add title, copyright, and other information to any specific file.

Figure 11.12 When a file is assigned copyright status in the File Info dialog box, a copyright symbol appears next to the filename at the top of the image window.

Figure 11.13 The File Info dialog box displays EXIF information included with photos exported from digital cameras.

Figure 11.14 You can save groups of files from a number of different sources.

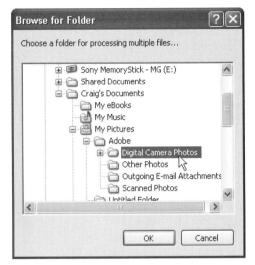

Figure 11.15 Select a folder containing all of the images you want to save at one time.

Formatting and Saving Multiple Images Automatically

You've just finished a prolific day of shooting pictures with your digital camera, and as a first step to sorting through and cleaning up all those images, you'd like to convert them to Photoshop Elements' native Photoshop format and then change their resolution to 150 dpi. You could, of course, download them from your camera, open each one individually, and apply the desired formatting and resizing changes. But Photoshop Elements' Batch Processing command saves you all that tedious, repetitive work by doing it for you. Just enter a few parameters in the Batch dialog box and sit back. Within seconds, your images are converted and saved to a location of your choice.

To batch process multiple files:

- 1. From the File menu, choose Process Multiple Files to open the Process Multiple Files dialog box.
- **2.** From the Process Files From drop-down menu (**Figure 11.14**), *do one of the following:*
 - ▲ To select images within a folder on your hard drive, choose Folder, click the Browse button, and then locate and select the folder containing the images you want to convert (Figure 11.15). If there are folders within the folder you select that *also* contain files you want to convert, click the Include All Subfolders check box in the Process Multiple Files dialog box.

continues on next page

- ▲ To select images stored in a digital camera, scanner, or PDF, choose Import; then select the appropriate source from the From drop-down menu (**Figure 11.16**). The choices in the From pop-up menu will vary depending on the hardware connected to your computer.
- To select files that are currently open within Photoshop Elements, choose Opened Files.
- 3. Click the Destination Browse button; then locate and select a folder to save your converted files to.
 In the Browse for Folder dialog box that appears, you're also offered the option of creating a new folder for your converted files.
- 4. If you want to add a file naming structure to your collection of converted images, select the Rename Files check box; then select naming options from the two dropdown menus (Figure 11.17).
 Refer to the Example text (located below the Rename Files check box) to see how the renaming changes will affect your filenames.
- 5. Select the Compatibility check boxes for whichever platforms you want your filenames to be compatible with. A good approach is to select all three of these, just to be on the safe side. Notice that the Windows platform is preselected for you and dimmed.

Figure 11.16 Batch processing can save you the effort of renaming and formatting images one by one. Import them from your digital camera or scanner, and then apply the changes.

Figure 11.17 You can choose from a number of file naming options to arrange your images in consecutive order.

Figure 11.18 You can resize entire groups of images to the same width or height dimensions.

Figure 11.19 Choose a resolution to apply to all of the files in your selected group.

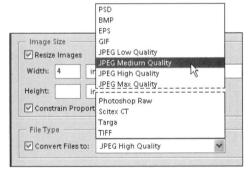

Figure 11.20 Choose a formatting option to apply to all the files in your selected group.

- **6.** If you want to change either the physical dimensions of your image or its resolution, click the Resize Images check box, then *do one or both of the following*:
 - ▲ To convert all of your images to a specific size, first select a unit of measure from the Units drop-down menu, then enter the width *or* height in the appropriate text box, making sure that the Constrain Proportions check box is selected (**Figure 11.18**).
 - ▲ From the Resolution drop-down menu, choose a resolution in dots per inch (dpi) to change the resolution of all your images (**Figure 11.19**).

The resolution setting in this dialog box is in dots per inch (print resolution) rather than pixels per inch (screen resolution), so changing just the resolution here will do nothing to alter your image, or change its file size. It changes only the dimensions of the final printed image, but has no effect on the size it displays onscreen. (For more information on image resizing, see "Changing Image Size and Resolution" in Chapter 2, "Creating and Managing Images.")

- **7.** From the Convert Files To drop-down menu, choose the desired format type (**Figure 11.20**).
- **8.** Click OK to close the dialog box and start the batch process.

The selected files are opened, converted in turn, and then saved to the folder you've chosen.

If you've chosen one of the import options, an additional series of dialog boxes will appear, guiding you through the selection of images you want to import.

continues on next page

For example, if you've chosen PDF, you'll first be asked to select a PDF file from which to import the images, then you'll be presented with a dialog box to choose the images you want to import (**Figure 11.21**). Once you've made your image selections, the files are opened, converted, and saved to the destination folder you assigned in step 3.

✓ Tips

- The import options within the Batch dialog box are also accessible by choosing Import from the File menu. But the Import command offers no options for image sizing, resolution, or file naming (not to mention the ability to save to specified destination folders). So even if you're importing just one image at a time (as would normally be the case when importing from a scanner, for instance) you may find that the Batch dialog box still holds a decided advantage over the File menu's Import command.
- Using a little simple math can help you to convert pixel dimensions to inches. Just multiply the resolution you've selected by the number of inches (of either height or width) that you want your final image to be. For example, if you've selected a resolution of 72 dpi, and you want the width of your images to be 4 inches; simply multiply 72 by 4, then enter the total (288) in the width text box.
- You can enter width and height values for your images *without* constraining to the proportions of the original images, although this approach isn't recommended. Unless you know the exact dimensions of your original images (and unless they all share the same dimensions or proportions), you run the probable risk of distorting your converted images.

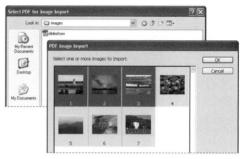

Figure 11.21 When you import a batch of images from a PDF file, you first select the PDF and then select the files you want to import.

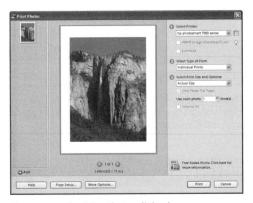

Figure 11.22 The Print Photos dialog box.

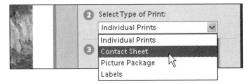

Figure 11.23 Choose Contact Sheet from the list of available print options.

Figure 11.24 As you select different print options, the preview window will change.

Creating a Contact Sheet

You may have lots of photographs downloaded from your digital camera, but because they have unhelpful filenames like 102-0246_ IMG.JPG, organizing and sorting them can be a difficult task. And although Photoshop Elements' Organizer lets you view and sort through your images, sometimes it's nice to have a printed hard copy to study and mark up. In traditional photography, contact sheets are created from film negatives and provide a photographer or designer with a collection of convenient thumbnail images organized neatly on a single sheet of film or paper. Photoshop Elements' Contact Sheet feature works in much the same way. Taking advantage of Photoshop Elements Organizer, allows you to select photos from groups and collections that you define ahead of time.

To make a contact sheet:

 Open one of the photos that you would like to include in your contact sheet, then from the File menu, choose Print Multiple Photos.

Photoshop Elements automatically launches the Elements Organizer, and the Print Photos dialog box appears (**Figure 11.22**).

- 2. From the Select Printer drop-down menu, choose a printer.
- **3.** From the Select Type of Print dropdown menu, choose Contact Sheet (**Figure 11.23**).

The preview window in the center of the dialog box changes to reflect your print type selection (**Figure 11.24**).

Now you can add more photos to your contact sheet.

continues on next page

4. In the lower-right corner of the Print Photos dialog box, click the Add button (**Figure 11.25**).

The Add Photos dialog box opens.

- 5. In the Add Photos From area of the Add Photos dialog box, select from one of five options (Figure 11.26):
 - ▲ Photos Currently in Browser displays all of the photos currently visible in the Organizer's Browser window.
 - ▲ Entire Catalog displays every photo you've imported into the Photoshop Elements Organizer.
 - ▲ Collection displays photos that you've organized into a single collection.
 - ▲ Tag displays photos that you've assigned a specific attribute tag to: like Favorites, or People, or Places.
 - Photo Bin displays just those photos currently open and residing in the Photo Bin.

For more information about the Photoshop Elements Organizer and ways that you can organize and catalog your photos, see Chapter 13, "The Windows Photo Organizer."

6. If you choose the Collection or Tag option, choose a photo group from the Select Items drop-down menu (**Figure 11.27**).

The Add Photos dialog box is populated with all of the photos from the option you selected in the Add Photos From area.

Figure 11.25 The Add button sends you to the Add Photos dialog box, where you select the photos you want included in your contact sheet.

Figure 11.26 You retrieve photos for your contact sheet using one of five source options.

Figure 11.27 You can view photos from groups that you've previously collected together.

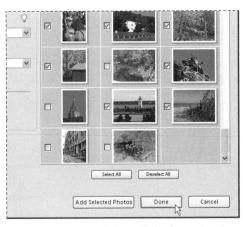

Figure 11.28 In the Add Photos dialog box, select the photos to include in your contact sheet.

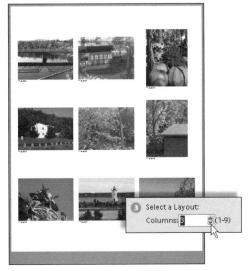

Figure 11.29 You can control the number of thumbnails that appear on each page of your contact sheet.

Figure 11.30 You can include labeling information with each photo on your contact sheet.

- 7. Click to select the photos that you want to include on your contact sheet, and then click Done (Figure 11.28).
 The preview window in the center of the Print Photos dialog box now includes all of the photos you have selected.
- **8.** Click on the arrows to the right of the Columns text box to designate the number of columns per page that your photo thumbnails will occupy (**Figure 11.29**).
- **9.** Click to select the type of text information that you would like to have appear below each photo thumbnail (**Figure 11.30**).
- **10.** Click Print to send your completed contact sheet to your printer.

✓ Tip

The number of columns and rows you choose to display your cataloged images will vary depending on the types of images involved and your reasons for creating the contact sheet in the first place. If all you want are small thumbnail versions of your photos to help with sorting or organizing, you may be able to group a large number of images on one page. On the other hand, if you have a series of similar images you want to study for the purposes of comparing subtle differences in exposure settings or picture composition, you may want to limit the number to just four or six. Then you'll be able to more clearly see the qualities of each individual photo.

Creating a Photographer's Picture Package

Photoshop Elements' Picture Package creates a page with multiple copies of the same image, just like the kind you'd receive from a professional photographer's studio. Photos can be arranged in a number of layouts and sizes, from a sheet made up only of wallet-sized images to a variety pack of different sizes and quantities. Printing images this way is also more economical, because you waste less photo paper.

To make a picture package:

- 1. Open the photo that you would like to include in your picture package, then from the File menu, choose Print Multiple Photos.
 - Photoshop Elements automatically launches the Elements Organizer, and the Print Photos dialog box appears (**Figure 11.31**).
- **2.** From the Select Printer drop-down menu, choose a printer.
- **3.** From the Select Type of Print dropdown menu, choose Picture Package (**Figure 11.32**).

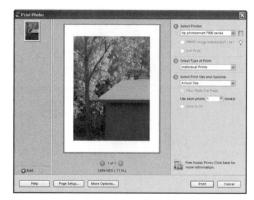

Figure 11.31 The Print Photos dialog box.

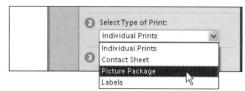

Figure 11.32 Choose Picture Package from the list of available print options.

Figure 11.33 As you select different print options, the preview window will change.

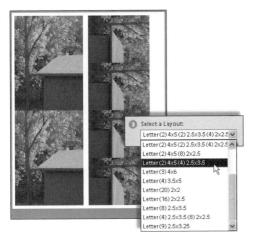

Figure 11.34 Layout templates let you display and print a variety of image sizes and orientations.

The preview window in the center of the dialog box changes to reflect your print type selection (**Figure 11.33**).

If the file that you intend to print is at too low a resolution to yield a good quality image, Photoshop Elements will present you with a Printing Warning dialog box, including information on the final print resolution you should expect to see.

- **4.** From the Select a Layout drop-down menu, choose the layout and dimensions for your picture package (**Figure 11.34**).
- **5.** If you like, select a frame from the bottommost drop-down menu, then click Print to send your completed picture package to the printer.

Setting Up Your Computer for Printing

Setting up your computer to print from Photoshop Elements is a simple process, providing you've installed the proper printer driver that you received with your printer. If you stumble at all through this section, refer to the documentation for your particular printer. It will probably also cover the same material as in this topic, but if not, you can return here once your printer is properly installed.

To select a printer:

- 1. From the File menu, choose Page Setup to open the Page Setup dialog box (**Figure 11.35**).
- **2.** In the Page Setup dialog box, click the Printer button to open a second Page Setup dialog box (**Figure 11.36**).
- **3.** In the Name drop-down menu (in the topmost dialog box), confirm that the printer you want to use is visible. If the printer you want to use *isn't* visible, select it from the list of printers in the Name drop-down menu.
- **4.** Click OK to close the topmost Page Setup dialog box; then click OK again to close the remaining dialog box.
 - Your Windows system is ready for printing.

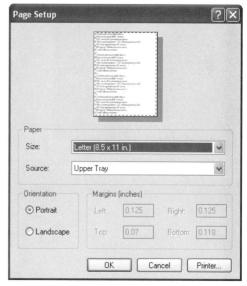

Figure 11.35 The Page Setup dialog box.

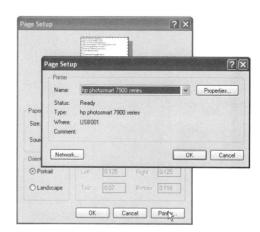

Figure 11.36 Select a printer by clicking the Printer button in the first dialog box.

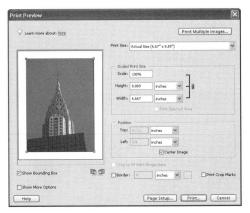

Figure 11.37 The Print Preview dialog box.

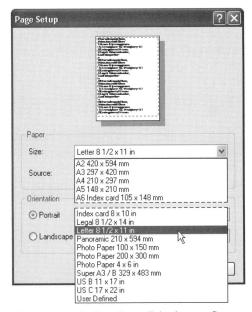

Figure 11.38 In the Page Setup dialog box, confirm that the paper size matches the paper in your printer.

Figure 11.39 Checking the Center Image check box perfectly centers your image on the page.

Preparing an Image for Printing

Photoshop Elements offers a simple, elegant, intuitive tool to help you print your images. From the Print Preview dialog box, you can choose paper sizes, and you can position your image on the page, scale it, and even make some last-minute modifications.

To reposition an image on a page:

- **1.** Select an image you want to print, then open it in Photoshop Elements.
- 2. From the File menu, choose Print to open the Print Preview dialog box (**Figure 11.37**).
- **3.** At the bottom of the dialog box, click the Page Setup button to open the Page Setup dialog box.
- 4. From the Size drop-down menu in the Page Setup dialog box, choose a paper size (Figure 11.38).
 The default paper size is Letter, 8.5 x 11.
- **5.** Close the Page Setup dialog box.

 The page preview on the left side of the dialog box reflects the page size in proportion to the image you want to print.
- **6.** If you want your image printed in the center of the page, confirm that the Center Image check box is selected (**Figure 11.39**).

Center Image is Photoshop Elements' default.

continues on next page

- 7. If you want to move your image to a different area of the page, first uncheck Center Image; then make sure that the Show Bounding Box check box is selected below the print preview image (Figure 11.40). Show Bounding Box is Photoshop Elements' default setting.
- **8.** To move the image to a new area on the page, *do one of the following*:
 - ▲ Move the pointer onto the image until it becomes a crossed-arrow cursor; then drag the image to a new spot on the page (**Figure 11.41**).
 - ▲ Enter new values in the Top and Left text boxes. You can change the measurement system from the default of inches by selecting a different unit from the drop-down menus (**Figure 11.42**).

Note that in either case, the position displayed in the text boxes is measured from the upper-left corner of the page to the upper-left corner of the image. In other words, if you enter 0 in both the Top and Left text boxes, your image will be positioned in the upper-left corner, directly on the top and left margins of the page.

To resize an image by entering size or percentage values:

To resize, do one of the following:

- In the Scale text box, enter a new percentage value. The default is 100 percent.
- Enter either a new Height or Width value in the respective text box. Just as when positioning, you can change the measurement systems for both height and width from the accompanying drop-down menus (Figure 11.43).

Note that the Scale, Height, and Width text boxes are linked together, and that a change to any one of the boxes will be reflected in the other two.

Figure 11.40 The Show Bounding Box check box must be selected before you can reposition your image.

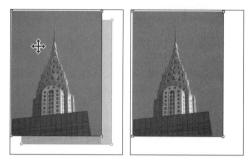

Figure 11.41 Drag to manually move your image to a new location on the page.

Figure 11.42 To reposition your image on the page, choose a measurement value for your document.

Figure 11.43 Choose a measurement system, and then enter either a scale or a height or width value to resize an image numerically.

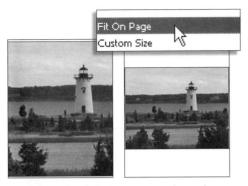

Figure 11.44 The Fit On Page menu option scales an image to precisely fill out the dimensions of a page.

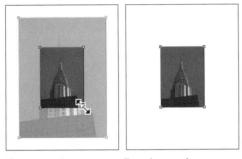

Figure 11.45 Drag to manually resize your image.

To resize an image to fit the dimensions of your page:

• From the Print Size drop-down menu, choose Fit On Page.

The image is sized proportionally to most efficiently fill the page (**Figure 11.44**). The Fit On Page option is best used if the original image is too large to fit on the page and needs to be reduced. Remember that when rescaling an image, it's best to avoid scaling up (upsampling) whenever possible.

To resize an image manually:

 See that the Show Bounding Box check box is selected; then in the image preview, drag any of the four bounding box handles (Figure 11.45).

The image is resized, and its new scale and dimension values are displayed in the Scaled Print Size text boxes.

✓ Tip

■ Remember that the changes you make to an image from within the Print Preview dialog box have no effect on the actual image itself—that is, the image's file size and physical dimensions don't actually change. Any repositioning, scaling, or other modifications you perform in the Print Preview dialog box affect only the way that the image appears on the printed page.

Setting Additional Printing Options

At the bottom of the Print Preview dialog box, you'll find a set of features that you can use to modify the printed output of your image. The Border option can be particularly handy if you want to experiment with adding a colored stroke to your image without the risk of harming the actual image files.

To add a stroked border:

 Click the Border check box to select the Border option. Then, click Show Bounding Box to deselect (turn off) that option (Figure 11.46).

The border can be difficult to see in the page preview if the Bounding Box is also visible.

- Click the small color swatch to open the Color Picker, where you can select a color for your border (Figure 11.47).
- **3.** From the Units drop-down menu, select a measurement unit, and then in the Border text box, enter a border size (**Figure 11.48**).

A stroke is applied to the image in the page preview.

- **4.** To resize the border, enter a new value in the Border text box.
- **5.** To delete the border, click the Border check box to deselect the border option.

Figure 11.46 Turning off the Show Bounding Box option will make it easier to see your stroked border in the preview window.

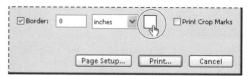

Figure 11.47 Click the color swatch to open the Color Picker, where you can choose the color to apply to your border.

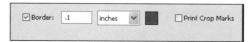

Figure 11.48 Select a measurement unit and size for your stroked border.

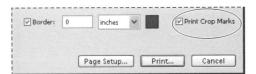

Figure 11.49 Click to add crop marks around your printed image.

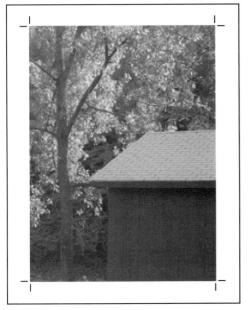

Figure 11.50 Crop marks are automatically positioned around the margins of an image.

To add crop marks:

◆ Select the Print Crop Marks check box (**Figure 11.49**).

Crop marks appear outside the corners of the image in the page preview (**Figure 11.50**).

To add a label:

- 1. Click the Show More Options check box to expand the Print Preview dialog box (**Figure 11.51**).
- 2. Under the Label heading, click to select the File Name and/or the Caption check box.

If a document title or description were entered for the image in the File Info dialog box, they will be represented in the page preview as gray bars. The document title (File Name) will appear at the top, and the description (Caption) will appear at the bottom (**Figure 11.52**). (See the sidebar "Adding Personalized File Information" earlier in this chapter.) When the image is printed, the labels will appear in the locations indicated in the page preview.

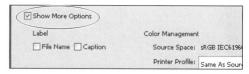

Figure 11.51 Additional print options appear if you click the Show More Options check box.

Figure 11.52 Labeling information will appear as simple gray bars in the preview window.

Figure 11.53 After you've applied print settings to your image, click the Print button in the Print Preview dialog box.

Choosing Paper

You can choose from a wide range of papers for your inkjet printer. For most photos, you'll want to print on either photo paper or glossy photo paper (glossy photo paper is thicker, and a little more durable). Quality matte paper is often preferred for high-resolution photographs, and you can even find archival-quality paper that won't fade for 100 years. If you just want to print a quick proof, your regular inkjet printer paper will do in a pinch.

Before you start buying paper, it's a good idea to review the documentation that came with your printer (or check out your printer manufacturer's Web site) to see a list of recommended paper choices.

Printing an Image

Once all of the desired options (like scaling, borders, labels) have been set in the Print Preview dialog box, printing your image is simply a mouse click away.

To print an image:

- **1.** From the File menu, choose Print to open the Print Preview dialog box.
- **2.** Confirm the image's position, scaling, page size, and other applicable options, as described in the two previous topics.
- **3.** Click the Print button to open the Print dialog box (**Figure 11.53**).
- **4.** In the Print dialog box, set the desired options.
 - Print dialog boxes vary from one printer to another, so you should refer to your printer's documentation if you have any questions regarding options.
- 5. Click OK to close the Print dialog box and send your image file to the printer. Your image will print just as it was displayed in the page preview area of the Print Preview dialog box.

To print a selected area of your image:

- 1. Select the Rectangular Marquee tool from the toolbox; then in the image window on your desktop, select the area of your image that you want to print (**Figure 11.54**).
- **2.** From the File menu, choose Print to open the Print Preview dialog box.
- 3. In the Print Preview dialog box, select the Print Selected Area check box.

 The area you selected in the image window is displayed in the page preview (Figure 11.55).
- **4.** Click the Print button; then follow steps 4 and 5 in the previous procedure.

Figure 11.54 Drag a selection around a specific area of an image you want to print.

Figure 11.55 Select the Print Selected Area check box to print just the portion of the image you selected.

CREATIVE TECHNIQUES

If you've read through earlier chapters of this book, you've learned how to use specific formatting, retouching, and painting tools in Photoshop Elements. In this chapter, you'll explore some specific Photoshop Elements tools and work environments, and develop techniques to help you create a number of different projects from start to finish. We'll first take a look at Photomerge, a feature that automates much of the work required to stitch together multiple images into a single panorama. Then we'll look at two different ways of delivering sets of images: using PDF slide shows and Web photo galleries. Next, we'll explore a couple of techniques for creating animation using the Layers palette and the Save for Web dialog box. Finally, we'll look at a couple of methods for using the power of transparency and layers for creating compelling composite images.

Creating Panoramas

With Photoshop Elements, you can create wide, panoramic images that would be difficult to capture with a single shot from a standard camera. If you've ever taken a series of photographs and tried "stitching" them together with tape or glue to assemble a continuous panoramic photo, you know how frustrating this can be. The Photomerge command does this for you automatically. Photomerge analyzes your individual photos and assembles them into a single image (Figure 12.1). From there, you can manually move and rotate your images, adjust for slight exposure differences, and correct for distorted perspective—all problems particular to merging images together.

Taking pictures for panoramas

If you're getting ready to snap some scenic photos and know you want to assemble them into a panorama later, making a few camera adjustments will make it easier to assemble a seamless panorama.

- Use a consistent zoom level when taking the pictures.
- Use a consistent focus. If your subject matter is far away, set your camera's focus to infinity, if that option is available.
- ◆ Use consistent exposure. A panorama with widely varied lighting will be difficult to merge seamlessly. Set your camera's exposure manually or lock the exposure setting if possible. Photomerge can make slight adjustments for images with different exposures, but it is not as effective when the image exposure varies greatly (Figure 12.2).

Figure 12.1 Photomerge combines several separate photos into a single panoramic picture.

Figure 12.2 Images with different lighting exposures can be more difficult to merge than a series of images with consistent exposures.

Figure 12.3 Photomerge does its best to merge images that are rotated slightly. When shooting panoramic photos, try using a tripod to ensure that all your shots have consistent angles.

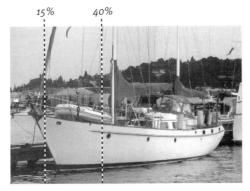

Figure 12.4 The more your images overlap, the better your chances of successfully merging them together. Try for an overlap of between 15 and 40 percent.

- If possible, use a tripod. You can take pictures for a panorama with a handheld camera, but you might find it difficult to keep all of the images perfectly level (Figure 12.3).
- ◆ Overlap sequential images by about 15 to 40 percent (**Figure 12.4**). Photomerge looks for similar detail in the edges of your images to match consecutive pictures. Try to capture as much detail throughout the frame to give Photomerge more reference points to match up. A large area of clear sky will be difficult to merge automatically, whereas an image containing unique, discernable shapes like peaked rooflines, or the boats in my example, make the best candidates.

✓ Tips

- Try taking *two* versions of your panorama images: one with the camera held horizontally and one with the camera held vertically. See which option makes a better panorama.
- You're not limited to creating horizontal panoramas. You can also create vertical panoramas of tall subjects, such as skyscrapers or redwood trees.

Assembling images into a panorama

To create a panoramic image, you select the images you want to merge and then let Photomerge work its magic. You may end up with a perfectly seamless image on the first try, but chances are good that you'll need to make some additional adjustments before you're completely satisfied. (See the color plate section of this book for a full-color example of creating a panorama.)

To create a panorama:

- 1. Open the images you want to merge together to create your panorama.

 The Organizer is handy for selecting multiple images and even rotating them if necessary. If you want to make any adjustments, such as tonal corrections or cropping, make your corrections first, before you begin assembling the images together.
- 2. From the File menu, choose New > Photomerge Panorama.
 The Photomerge dialog box appears (Figure 12.5). Any images that are open in Photoshop Elements will appear in the Source Files list. If you need to delete a file from the list, select it and then click the Remove button.
- **3.** If you want to add more images, click the Browse button to open the Open dialog box; then navigate to the folder containing the images that you want to merge.
- 4. When you have all of the images you want in the Source Files list, click OK.

 Photoshop Elements automatically opens the images in the Source Files list (if they're not already open), and with a little behind-the-scenes trickery, merges them into a single panorama in the Photomerge dialog box (Figure 12.6).

 Don't worry if your panorama isn't perfect.

 Photomerge has tools to adjust your images.

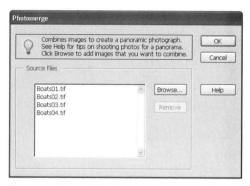

Figure 12.5 Browse for photos to merge in the first Photomerge dialog box.

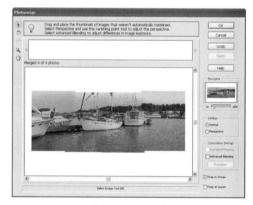

Figure 12.6 The main Photomerge dialog box provides a work area, where you adjust your images, and a Lightbox, where Photoshop Elements stores images that you aren't yet using. You'll also find additional tools and navigational aids on both sides of the dialog box.

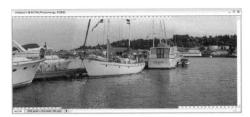

Figure 12.7 When you click OK to save a new Photomerge composition, your merged images open in a new Photoshop Elements file.

- Once you click OK to create your panorama, there's no returning to the Photomerge dialog box to make further adjustments. If you're not happy with the way your panorama rendered, you'll just need to start over from the beginning. Refer to the following topics for further instruction on how to make additional adjustments to your panorama before you click the OK button.
- If seams are still visible in the panorama, try touching up those areas with the Clone tool.

- 5. You may see an alert message telling you that some images can't be assembled. If Photomerge can't find enough common details in your images, it will place some images in the Lightbox section of the dialog box. It may also place images off to the side of the panorama.
 - If your images aren't matching up correctly, or if they appear in the Lightbox rather than the work area section of the dialog box, see "To reposition images in the panorama" later in this chapter.
- **6.** If your images have matched up correctly and you want to explore different perspective or blending options, see "Enhancing perspective in a panorama" later in this chapter.
- 7. When you are satisfied with your merged composition, click OK.
 Photoshop Elements creates a new image file of your panorama, leaving your original files unaffected (Figure 12.7).

✓ Tips

As a general warning, be aware that some panoramas will take longer to process and render than others. In particular, if you're working on a computer with an older, slower processor, or if your original images are particularly large, it's not uncommon for rendering time to take a minute or so. That can seem like an awfully long time when you're staring at a motionless screen, so be patient. The payoff of the rendered panorama is usually worth the wait.

Adjusting images within a panorama

The Photomerge function doesn't always work quite as well as you might hope. You may find the separate images loosely arranged or even scattered in the work area. Some images may have not made it into the work area at all, but may have been placed in the Lightbox instead. Photoshop Elements tries its best to merge the images automatically, but sometimes it needs a little help. Fortunately, the Photomerge dialog box makes it fairly easy to make the necessary adjustments.

To reposition images in the panorama:

- 1. If one of your images is in the Lightbox area, add it to the work area by dragging it from the Lightbox (**Figure 12.8**). If you want to remove an image from the panorama, you can also drag images from the work area back into the Lightbox. Once all the images are in the work area, they still may not be lined up perfectly.
- **2.** Check that the Select Image tool is highlighted in the Photomerge dialog box (**Figure 12.9**).
- **3.** Drag the image over the image it should merge with.

As you drag, the image becomes transparent so that you can more easily line it up with the one below it (**Figure 12.10**).

Figure 12.8 Drag or double-click an image in the Lightbox to move it to the work area.

Figure 12.9
The Select Image tool in the Photomerge dialog box.

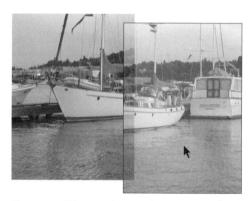

Figure 12.10 When you drag one image over another, the top image becomes semitransparent, allowing you to align the images.

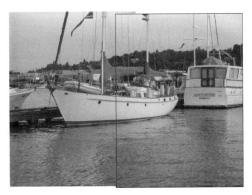

Figure 12.11 Images that share similar detail merge together automatically when the Snap to Image option is selected.

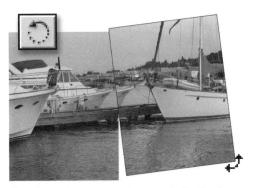

Figure 12.12 You can rotate images to help align them in the work area.

- **4.** When the two images match up, release the mouse button.
 - If Snap to Image is selected in the dialog box, any two overlapping images will automatically try to match up with one another (**Figure 12.11**). If Snap to Image is not selected, Photomerge allows you to match up the overlapping image manually. Turning off Snap to Image allows you to move the images in small increments if they are not matching up exactly. You may also need to rotate an image slightly to make it match up with its neighbor correctly.
- 5. Select the Rotate Image tool in the Photomerge dialog box, then drag to rotate the selected image (Figure 12.12). The Photomerge dialog box offers several options for moving through its work area while working on your panoramas, including its own built-in navigator.

continues on next page

- **6.** To navigate through the work area, *do one of the following:*
 - Select the Move View tool in the dialog box and drag in the work area (Figure 12.13).
 - ▲ In the Navigator, drag the view box. This changes the view in the work area (**Figure 12.14**).
 - ▲ Use the scroll bars at the bottom and left edges of the work area.
- **7.** To change the zoom level in the work area, *do one of the following:*
 - ▲ Select the Zoom tool in the dialog box and click in the work area to zoom in.
 - ▲ Hold down the Alt key while clicking to zoom out.
 - ▲ Move the slider under the thumbnail in the Navigator (**Figure 12.15**).
 - ▲ Click the Zoom icons under the thumbnail in the Navigator section of the dialog box.

Figure 12.13The Move View tool in the Photomerge dialog box.

Figure 12.14 Drag the view box in the Navigator to change the view in the work area.

Figure 12.15 Move the slider under the Navigator window to zoom in and out in the work area.

Figure 12.16 Click the Perspective radio button to add exaggerated perspective to your merged composition.

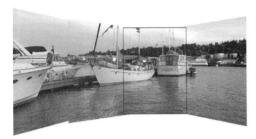

Figure 12.17 When you select the Perspective setting, Photomerge adjusts and distorts the images to create the illusion of a vanishing point. Here, the vanishing point image is identified by the blue outline.

Enhancing perspective in a panorama

You may find that some panoramas you create appear a little flat, or just not quite right, particularly as they progress out toward the edges. That's because even the most sophisticated camera lens has a tendency to flatten what little depth or perspective is present in the landscapes or objects they capture. Photomerge lets you add back that lost perspective to create a more natural-looking panoramic image. In addition, you can adjust the vanishing point (the point where natural perspective recedes into the distance) to help draw attention to a specific area or object in your panorama. Photomerge even provides an option to correct unwanted distortion that may appear as a result of using the Perspective feature, and another that will adjust for minor exposure differences between images that sometimes become more noticeable when you apply perspective.

To add perspective to a panorama:

1. In the Settings section of the dialog box, select the Perspective option (**Figure 12.16**).

The outside edges of the panorama become distorted, creating a more dramatic, and sometimes more realistic, perspective view (**Figure 12.17**).

The middle of the center image is designated as the vanishing point, and the outside images appear to recede into its center. The center (vanishing point) image is identified by a blue outline when it's selected.

continues on next page

- **2.** To make a different image the vanishing point image, first select the Set Vanishing Point tool (**Figure 12.18**).
- **3.** Click a different image in the work area. The panorama changes the perspective to make it look as if the other images now recede into the new Vanishing Point image (**Figure 12.19**).
- **4.** If the perspective option doesn't give you the effect you'd hoped for, select the Normal option in the Settings section of the dialog box to return your panorama to its original state.

You can also remove the perspective from your panorama by dragging the Vanishing Point image to the Lightbox.

Sometimes the perspective effect can be a little severe, creating more distortion in your image than you think is acceptable. Use the Cylindrical Mapping feature (described in the following task) to reduce this distortion.

Figure 12.18
The Set Vanishing Point tool in the Photomerge dialog box.

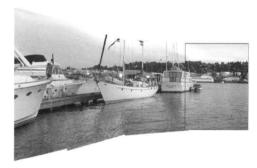

Figure 12.19 When you change the Vanishing Point image, the other images adjust and distort in response to change the perspective.

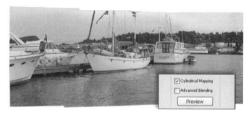

Figure 12.20 The Cylindrical Mapping check box helps even out some of the distortion caused by the Perspective setting.

Figure 12.21 After you have rendered the panorama in the Photomerge dialog box, you can use the Crop tool in Photoshop Elements to trim the image.

■ Before you print your final panorama, take the time to examine its size in the Image Size dialog box (from the File menu, choose Resize > Image Size). Depending on the size and resolution of the images you've used, your panoramas can quickly grow to exceed the standard paper stock sizes for your printer (which are usually no larger than 8.5 x 14 or 11 x 17 inches). Once you've determined the final image dimensions, use either the Image Size dialog box or the controls in the Print Preview dialog box to resize your image so that it will fit on whatever paper stock you have available.

To make further adjustments to your panorama:

- by the Perspective setting, click the Cylindrical Mapping box; then click the Preview button (**Figure 12.20**). The panorama is adjusted again, this time removing the shape distortion created by the Perspective check box. Note that any adjustments you make with the Cylindrical Mapping check box are visible only in Preview mode. Note also that you can't work on the panorama while in Preview mode, and that the cylindrical mapping isn't applied to your panorama until you click OK in the Photomerge dialog box.
- To compensate for slight variations in exposure or lighting in the separate images, click the Advanced Blending box; then click the Preview button. Photoshop Elements attempts to even out the color differences. As with Cylindrical Mapping, this setting is visible only in Preview mode.

✓ Tips

■ Even after you've used the cylindrical mapping feature to correct some of the perspective distortion, you may still find that your image's edges are a little raggedy. Use Photoshop Elements' Crop tool to remove those rough edges and give your panorama a nice, crisp rectangular border (**Figure 12.21**).

Making Your Own Slide Show

With Photoshop Elements, you can create a self-contained, portable slide show—a useful and elegant way to share your photos and images with friends and family.

Although Photoshop Elements can output a slide show as a movie (.wmf) or even burn it. to a DVD. in this exercise we'll focus on creating a slide show as an Adobe Acrobat PDF (Portable Document Format) file. The operative word here is portable. You can view a PDF file on nearly any Windows or Macintosh computer, as long as Adobe's Acrobat Reader is installed. Acrobat Reader, a small program that Adobe offers as a free download, is one of the most widely used helper applications available and can be downloaded from Adobe's Web site at www.adobe.com. Additionally, the Acrobat Reader installer is included on a variety of software installation disks, including Photoshop Elements.

When you open the slide show file in Acrobat Reader, the slide show automatically opens in full-screen mode. Slides can change with a transition you select when creating the PDF (**Figure 12.22**). In an automatic slide show, the slides change at preset intervals you set when you generate the file. Alternatively, if you prefer to advance each slide manually, you can create a slide show that changes slides with keyboard commands.

To create a PDF slide show:

- 1. On the shortcuts bar, click the Create button to launch the Photoshop Elements Organizer (Figure 12.23). The Creation Setup window opens.
- 2. In the Creation Setup window, check that Slide Show is selected in the Select a creation type column, then click OK (Figure 12.24). The Slide Show Preferences dialog box opens.

Figure 12.22 When you create a slide show, you can specify how your slide show transitions from one image to the next. This slide show displays the Wipe Down transition, where a new image rolls down over the previous image's slide.

Figure 12.23 The Create button opens the Creation Setup window.

Figure 12.24 Slide Show is selected as the default in the first screen of the Creation Setup window.

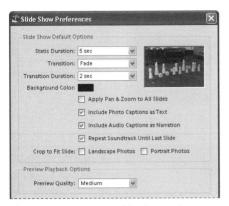

Figure 12.25 You can set slide show preferences before you create your slide show from the Slide Show Preferences dialog box.

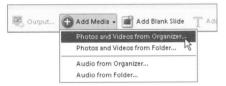

Figure 12.26 You can add photos, video, and even audio to a slide show from either the Organizer or from a folder.

Figure 12.27 The Slide Show Editor window.

Figure 12.28 The Slide Show Editor features a complete set of controls to help you play and navigate through your slide show during its creation.

The Slide Show Preferences dialog box is where you select all of the different options for your slide show. Here you can apply transition effects, change the background color, crop photos to fit a land-scape or format, and set quality options (Figure 12.25).

- **3.** Select the options you would like to apply to your slide show, and then click OK to close the dialog box.
 - The Photoshop Elements Slide Show Editor window opens automatically.
- **4.** To add a photo or series of photos to your slide show, click the Add Media button above the slide show preview window, and then choose a source for you photos from the menu (**Figure 12.26**).

 Note that not only can you add photos to
- **5.** Click to select the photos that you want to include in your slide show, and then click Done (or click Open, if your source was a folder).

a slide show, but you can also add video.

- The Slide Show Bin at the bottom of the Slide Show Editor is populated with all of the photos and video you selected, complete with the transitions you chose from the Slide Show Preferences dialog box. Above in the Slide Show Preview area, the last image in your slide show is displayed (Figure 12.27).
- **6.** To preview your slide show, click first the Rewind and then the Play buttons below the Slide Show preview (**Figure 12.28**).

✓ Tip

■ You can return to the Slide Show Preferences dialog box at any time during the creation of your slide show by choosing Slide Show Preferences from the Slide Show Editor's Edit menu.

To reorder slides:

- 1. In the Slide Show Bin, click to select the slide that you would like to move (Figure 12.29).
- **2.** Hold down the mouse button and drag the slide to a different location in the Slide Show Bin

When you release the mouse button, the slide and its transition snap into place in the new location (**Figure 12.30**).

Alternately, you can click the Quick Reorder button above the Slide Show Bin so that you can see all of the slides in your slide show at once. Click and drag to move slides in the Quick Reorder window just as you do in the Slide Show Bin.

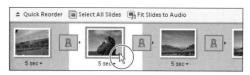

Figure 12.29 You can select slides and transitions in the Slide Show Bin.

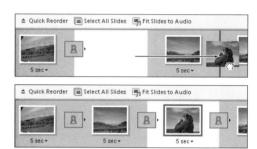

Figure 12.30 Click and drag a slide in the Slide Show Bin to move it to a different spot in your slide show (top). When you release the mouse button, the slide and its transition snap into place.

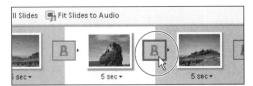

Figure 12.31 Click any transition to edit its properties.

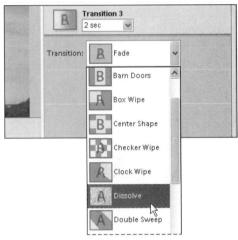

Figure 12.32 The Slide Show Editor offers a myriad of transitions to choose from.

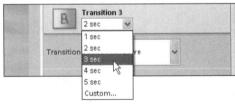

Figure 12.33 Control the transition time from one slide to the next with the Duration drop-down menu.

To edit slide transitions:

- 1. In the Slide Show Bin, click the transition between the two slides that you would like to change (**Figure 12.31**).
- 2. From the Transition drop-down menu, select a new transition (Figure 12.32). If you'd like, you can also change the duration of the transition—the amount of time it takes to transition from one slide to the next.
- **3.** From the Duration drop-down menu, select a time, in seconds (**Figure 12.33**).

✓ Tip

■ You can apply new transition effects to more than one slide at a time by selecting multiple transitions at once. Click to select the first transition that you want to change, and then Ctrl-click to select subsequent transitions. Alternately, if you want to select every transition in your slide show, choose Select All Transitions from the Slide Show Editor Edit menu.

To add a clipart graphic to a slide:

- In the Slide Show Bin, click to select the slide that you want to apply a graphic.
 The slide appears in the Slide Preview.
- 2. Click the Graphics button to the right of the Slide Preview to open the graphics clipart collections; then scroll to find the piece of art that you would like to use in your slide (Figure 12.34).
- **3.** Click and drag a selected graphic directly onto the slide in the Slide Preview (**Figure 12.35**).
- **4.** You can reposition the graphic by clicking anywhere within its bounding box and dragging it to a new location.
- **5.** You can scale the graphic up or down by dragging on any of its bounding box handles (**Figure 12.36**).
- **6.** To delete a graphic from a slide, simply click to select the graphic and then choose Cut from the Edit menu (Ctrl+X), or press delete.

Figure 12.34 The Slide Show Editor comes complete with libraries of clipart that you can add to your slides.

Figure 12.35 To add a clipart graphic to a slide, you simply click and drag.

Figure 12.36 Clipart graphics can be scaled and repositioned once you drag them onto a slide.

Figure 12.37 The Slide Show Editor offers a collection of default type styles to choose from.

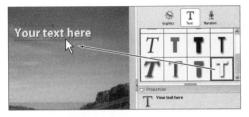

Figure 12.38 Click and drag to add a text placeholder to a slide.

Figure 12.39 When you type in the Edit Text dialog box, the new text appears immediately in the Slide Preview.

To add text to a slide:

- **1.** In the Slide Show Bin, click to select the slide that you want to apply the text to. The slide appears in the Slide Preview.
- 2. Click the Text button to the right of the Slide Preview to open the default text collection; then scroll to find the text style that you would like to use in your slide (Figure 12.37).
- **3.** Click and drag the selected text directly onto the slide in the Slide Preview (**Figure 12.38**).
- **4.** Double-click the default text in the Slide Preview to open the Edit Text box.
- **5.** Type the text that you would like to appear on your slide and then click OK (**Figure 12.39**).
- **6.** Use the controls in the Properties area of the Slide Show Editor to change your type's font, size, color, and orientation (**Figure 12.40**).
- **7.** You can reposition the type by clicking anywhere within its bounding box and dragging it to a new location.

Figure 12.40 You can use the Slide Show Editor's default type styles, or use the type controls to customize your type manually.

To save a slide show:

- **1.** From the File menu, choose Save Slide Show Project, or press Ctrl+S.
- **2.** In the Save dialog box, type a name for your slide show and click Save (**Figure 12.41**).

Your slide show will be automatically saved to the Organizer's Photo Browser, where you can reopen it at any time to make revisions or to output a PDF slide show.

- **3.** To close the Slide Show Editor, do one of the following:
 - ▲ From the File menu, choose Exit Slide Editor, or press Ctrl+Q.
 - Click the close button in the upperright corner of the Slide Show Editor window.
 - If you want to output a slide show right away, leave the Slide Show Editor open and proceed to the next task.

To output a slide show:

- Click the Output button near the top of the Slide Show Editor (Figure 12.42).
 The Slide Show Output window opens.
- 2. To output a simple PDF slide show, first check that Save As a File is selected in the options column on the left side of the window (**Figure 12.43**).
- **3.** Click the PDF File radio button in the center of the window, and then choose the settings that you would like to apply to your slide show (**Figure 12.44**).
- 4. Click OK to close the Slide Show Output window. Then, in the Save As dialog box, navigate to the location where you would like to save your slide show, rename it if you would like, and click Save.
 If you selected View Slide Show after Saving in the Slide Show Output dialog box, Acrobat Reader will launch automatically and play your slide show.

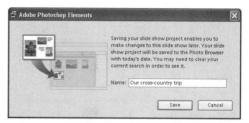

Figure 12.41 The Slide Show Editor has it's own unique Save dialog box.

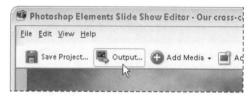

Figure 12.42 The Output button is the first step to creating a PDF from your slide show.

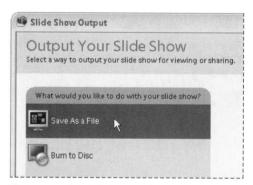

Figure 12.43 The Slide Show Output window offers several different ways to export your slide show.

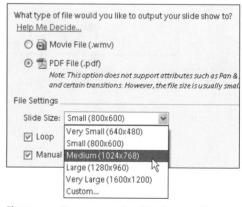

Figure 12.44 You can export a slide show as either a PDF or a movie file.

To view a slide show:

- Make sure that Adobe Acrobat Reader is installed on your computer.
 If it's not installed, install it from the Photoshop Elements installation disc, or download it free from www.adobe.com.
- 2. In Acrobat Reader, open the PDF slide show you created in Photoshop Elements.

 The slide show appears, taking up the full screen. If the slide show is set to run automatically, each image will be displayed for the time you set in the Slide Show dialog box.
- **3.** To navigate through your slide show in Acrobat Reader, use the following keyboard commands:
 - ▲ Move forward one slide by pressing Enter, or press the right arrow key.
 - ▲ Move back one slide by pressing Shift+Enter, or press the left arrow key.
 - ▲ Exit Full Screen view and access Acrobat Reader's interface by pressing Ctrl+L.

✓ Tip

■ The transitions and auto advance features of your PDF slide show will only work in Acrobat Reader 5.0 or later. The slide show will open and display with older versions of Acrobat, but you'll need to navigate through the slides manually using the keyboard commands listed above.

About Web Photo Galleries

Preparing a gallery of photos for use on the Web can be repetitive, tedious work. You have to resize and format each image, one at a time—a lengthy process. Luckily, Photoshop Elements eliminates this drudgework for you with its automated Web Photo Gallery feature (Figure 12.45). When you create a Web photo gallery, Photoshop Elements instantly opens a group of image files, resizes them to identical dimensions, and creates smaller thumbnail versions. Photoshop Elements also creates HTML code for each Web page in the gallery. (HTML stands for Hypertext Markup Language and is the code that describes the size, location, color, and other attributes of any and all objects and text on a Web page.) All of the images and HTML files are stored in a designated folder on your hard drive. Once the photo gallery is completed, you can then view the gallery on your hard drive or on the Web. If you have a digital camera full of images that you can't wait to share over the Web, this feature can help you get them posted online quickly. (See the color plate section of this book for a full-color view of a Web photo gallery.)

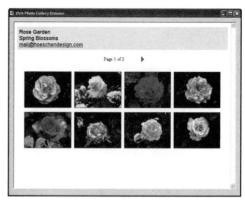

Figure 12.45 Create a Web gallery of your favorite digital photos with Photoshop Elements' automated Web Photo Gallery feature.

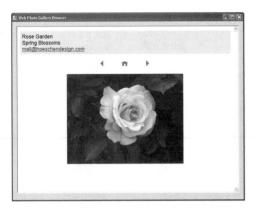

Figure 12.46 In a Web gallery, you can navigate backward or forward through the images or go back to the main page.

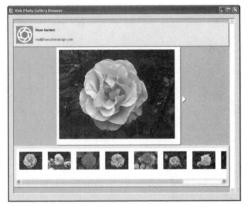

Figure 12.47 In galleries like Horizontal Neutral, thumbnails are in one frame, and full-sized images appear in the other frame.

You can create two main types of Web galleries, each with different ways of navigating through the images. All of the photo gallery styles available in Photoshop Elements fall into one of these two types:

- ◆ One gallery type consists of a main Web page with a *grid* of image thumbnails. To navigate, you click on a thumbnail to display the full-sized image on its own page. Each full-sized image page contains buttons to move to the previous image, the next image, or back to the main gallery page. The Simple gallery style is an example of this type (**Figure 12.46**).
- ◆ The other gallery type consists of a main page divided into two areas, or *frames*. When you click a thumbnail, the full-sized image displays in the other frame. To view different full-sized images, you click the different thumbnails. The Horizontal Neutral style is an example of this type (**Figure 12.47**).

When you save a group of images as a Web photo gallery, Photoshop Elements creates the following items and assembles them into one main folder:

- ◆ A main HTML page (index.htm)
- A folder of full-sized JPEG images
- A folder of thumbnail images
- A folder of linked HTML pages
- Navigation buttons for your HTML pages

To create a Web photo gallery:

- 1. On the shortcuts bar, click the Create button to launch the Photoshop Elements Organizer (Figure 12.48).
- 2. In the Select a creation type column of the Creation Setup window, select HTML Photo Gallery, and then click OK (Figure 12.49).

The Adobe HTML Photo Gallery dialog box opens (**Figure 12.50**).

Figure 12.48 The Create button opens the Creation Setup window.

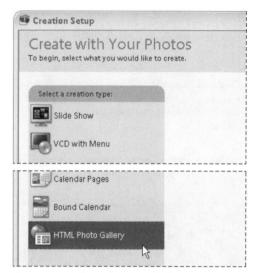

Figure 12.49 Select HTML Photo Gallery from the bottom of the creation type column.

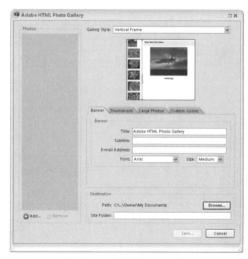

Figure 12.50 The Adobe HTML Photo Gallery dialog box.

Figure 12.51 The Add button opens the Add Photos dialog box.

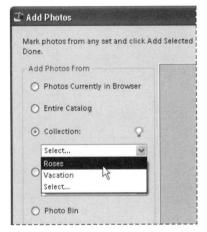

Figure 12.52 The Add Photos dialog box makes it easy to choose which photos to include in your slide show.

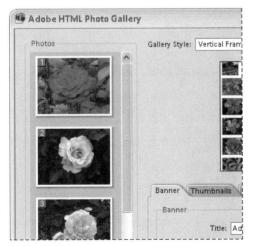

Figure 12.53 The Adobe HTML Photo Gallery dialog box gives you a visual list of all of the photos you selected to include in your gallery.

- **3.** In the lower-left corner of the Adobe Web Photo Gallery dialog box, click the Add button (**Figure 12.51**).

 The Add Photos dialog box opens.
- **4.** In the Add Photos From area of the Add Photos dialog box, select from one of the five source options (**Figure 12.52**). For this example I've chosen some photos of roses that I previously assembled into a collection
 - For more information about the ways that you can organize and catalog your photos, see Chapter 13, "The Photo Organizer."
- 5. Click to select the photos that you want to include in your Web photo gallery, and then click OK.
 Thumbnail views of the photos you selected appear in the Photos area of the Adobe Web Photo dialog box

(Figure 12.53).

continues on next page

- **6.** From the Gallery Style drop-down menu, select a Web gallery template (**Figure 12.54**).
 - When you choose a gallery style, a preview appears just below the Gallery Style drop-down menu.
- 7. In the center of the dialog box, below the Web page preview, click the four tabs to enter information and settings for your Web photo gallery (**Figure 12.55**):
 - ▲ In the Banner section, enter and style text for various items (like Title and E-mail Address information) that will appear on the Web photo gallery pages.
 - ▲ In the Thumbnails section, set the size of the photo thumbnails, as well as style properties for the thumbnail captions.
 - ▲ In the Large Photos section, set size and quality settings for the large photos, as well as style properties for the large photo captions.
 - ▲ In the Custom Colors section, set colors to override the Adobe Web Gallery defaults for the background, banner, text, and links.

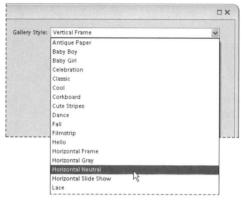

Figure 12.54 You can choose from over 30 different styles of preformatted Web gallery templates.

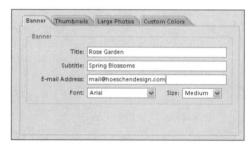

Figure 12.55 You can customize the look of your Web gallery from different sets of options you access by clicking the option tabs.

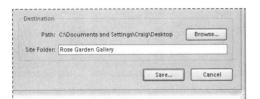

Figure 12.56 Select the location on your computer where you would like Photoshop Elements to place your rendered Web gallery files.

- **8.** In the Destination section at the bottom of the dialog box, click the Browse button to select a location for your final Web gallery files, and then enter a name for the Web gallery folder that Photoshop Elements will automatically create (**Figure 12.56**).
- gallery.

 Depending on the number of images, the Web gallery creation can take as long as a minute or two. Once the process is finished, Photoshop Elements will display

9. Click Save to create your Web photo

the gallery in your Web browser.

✓ Tips

- The small thumbnail views of the different galleries in the Web Photo Gallery dialog box aren't really big enough to give you a good idea of what the final gallery will look like, but you can quickly create a series of galleries with just one or two images and then save them to use as a visual reference when creating your final galleries.
- Once you create and save your Web gallery, all of the images and HTML files are stored in a folder on your hard drive. Since all ISPs (Internet Service Providers) operate in a slightly different fashion, you'll want to contact your ISP directly before you try posting your gallery to the Web. They should be able to provide you with complete instructions and parameters for uploading and displaying your Web gallery files.

Creating Animated GIFs

In Chapter 10, "Preparing Images for the Web," we discussed GIF files, but I decided to wait until this chapter of special techniques to delve into one of the more interesting uses of GIFs-animation. GIF animations are widely used on Web pages as a device to help draw special attention to particular icons, graphics, or logos. But they can also be used as a way to deliver compact little "movies" from a limited number of video images, or from a single still photo. In addition to posting animated GIFs to the Web, you can share them with friends by including them as email attachments. To view your animation, all your recipients need to do is open the GIF file from within their Web browser.

Animated GIFs contain a sequence of images that are displayed sequentially, like a flipbook, creating the illusion of motion (**Figure 12.57**). Like all GIF files, they can be displayed in most Web browsers and have a relatively small file size because of their compression and limited color palette.

Photoshop Elements creates the individual frames of an animated GIF file from the individual layers in an image file, so you'll need to create your animation in a file with multiple layers. The bottom layer on the Layers palette is always the first frame of the animation, so you'll build your animated GIF file from the bottom up (**Figure 12.58**). (See the color plate section of this book for full-color images from this animated GIF tutorial.)

Figure 12.57 Animated GIFs create the illusion of motion by sequentially displaying a series of frames.

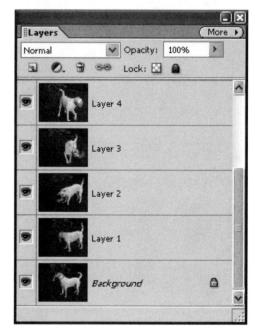

Figure 12.58 The bottom layer of the Photoshop Elements Layers palette becomes the first frame of an animated GIF file.

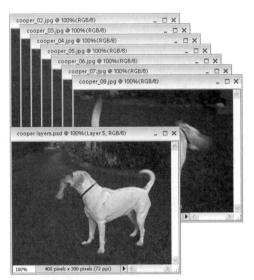

Figure 12.59 Collect all of the files you want to use to build your animation; then choose the image file that you want to use as the first frame.

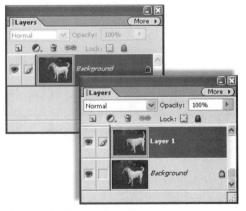

Figure 12.60 When you paste a selection into an image, it creates a new layer on the Layers palette.

To prepare a layered file for animation:

- **1.** Open all of the images you want to use as frames for your animated GIF file.
- 2. Select the image that you want to use as the first frame of the animated GIF file (**Figure 12.59**).
- Choose File > Save As and save the image as a Photoshop Elements file with a new name.
 This will be the layered "source" file for
- creating your animated GIF.

 4. Click to select the image window of the
- 4. Click to select the image window of the image that you want to use as the next frame in your animation; then, from the Select menu, choose All, or press Ctrl+A.
- **5.** From the Edit menu, choose Copy, or press Ctrl+C.
- 6. Select the image with the first frame; then, from the Edit menu, choose Paste, or press Ctrl+V.
 The second image is pasted on top of the first image and is represented by a new layer on the Layers palette (Figure 12.60).
- **7.** Repeat steps 4 through 6 for each additional frame, continuing to add layers to the first image.
- 8. Save your image.

✓ Tip

■ With animated GIFs, less can be more. You may be surprised at how few frames you need to convey motion. Start with a small number of frames (5 or 6 are probably adequate) and then add more only if you think they're needed.

To create an animated GIF:

- Open the layered file you've built as the source for your animation.
 (If you don't have a layered file ready, see the preceding task, "To prepare a layered file for animation.")
- **2.** From the File menu, choose Save for Web, or press Alt+Shift+Ctrl+S to open the Save for Web dialog box (**Figure 12.61**).
- **3.** Choose GIF in the Preset area of the dialog box; then select the Animate check box (**Figure 12.62**).
- 4. Click the Play button to move the animation one frame forward (Figure 12.63). You can use the Play button and the other control buttons to step through the animation, but the animation will not show in real time.
- In the Animation section of the dialog box, set the options for frame delay and looping (Figure 12.64).

Frame delay sets the amount of time that each frame is displayed before the next frame appears. You can set the frame delay for as short as one-tenth of a second and as long as 10 seconds.

When the Loop check box is selected, your animation will play continuously. If Loop is not checked, your animation will play once through all of its frames and then stop.

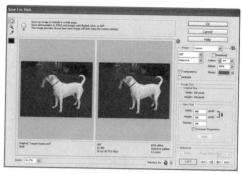

Figure 12.61 Open the Save for Web dialog box to make additional changes to your animated GIF file.

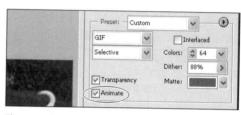

Figure 12.62 Select a GIF setting; then click the Animate check box.

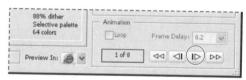

Figure 12.63 Click the Play button to step through the frames of your animation, one frame at a time.

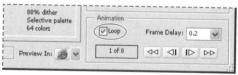

Figure 12.64 You can choose to have your animation loop, so that it will play continuously, over and over again.

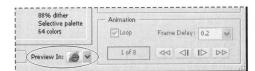

Figure 12.65 When you click the Preview In button, a Web browser opens and plays the animated GIF file.

Animating GIF Images from Video Files

One way to create frames for an animated GIF file is to use frames you've captured from a video file. You can use Photoshop Elements to capture individual frames from video, combine them in a single layered file, and then convert the layers to an animated GIF by following the steps in this section. (For detailed information on capturing frames from video footage, see "Importing Images from Cameras and Scanners" in Chapter 2, "Creating and Managing Images.")

Many digital cameras also have the ability to capture short movies, so even if you don't have a video camera, you may still be able to gather digital video. Check the specifications and documentation that came with your camera.

6. Click the Preview In button to view the animated GIF file in a Web browser (**Figure 12.65**).

You may need to return to Photoshop Elements and adjust your settings and preview again. When you are satisfied, close the browser.

- **7.** Still in the Save For Web dialog box, click the OK button.
 - The Save Optimized As dialog box opens.
- **8.** In the Save Optimized As dialog box, type a new name for your animation and verify that GIF is selected for the optimization format.
- **9.** Choose a location for your file, then click Save.

The Save Optimized As and Save For Web dialog boxes automatically close, and your animated GIF is saved to the location you specified.

Creating motion from a still image

Another method for creating the illusion of motion in Photoshop Elements is to start with a single still image, duplicate the image onto a series of separate layers, and then slightly shift each layer either horizontally or vertically. When saved as an animation, it will appear as if a camera is slowing panning through a scene. You've probably seen this technique used in documentaries, where for lack of film or video footage, the camera pans slowly over an archival photograph.

In this example, we'll shift successive frames horizontally to create the illusion of panning past a ship at rest in a harbor. You can use this same technique with photos of large family groups or any other instance when you want to control exactly where your viewer's attention is drawn. This technique can be particularly effective when used along with the wide panoramic images you create using Photomerge Panorama.

To mimic camera movement in an animated GIF file:

- **1.** Open the image you want to use as the source file for your animation.
- 2. Create a new file with either the width or height dimensions (or both) smaller than those of your source image.

 Since we'll be panning from side to side across our image, we've made the width of our new file about half that of the source image (Figure 12.66).
- Drag the large image into the file you just created (Figure 12.67).
 A new layer is created on the Layers palette.
- **4.** On the Layers palette, drag the background layer to the trash (**Figure 12.68**).

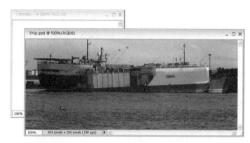

Figure 12.66 Start with a source image that is larger than the final size of the animated GIF image.

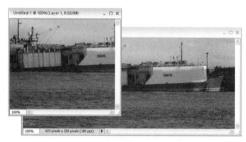

Figure 12.67 Drag the larger source image into the final animated GIF project image window.

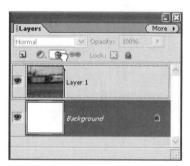

Figure 12.68 Delete the background layer by dragging it to the Delete Layer icon on the Layers palette.

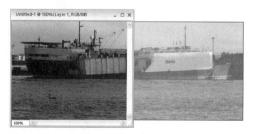

Figure 12.69 Position the first (bottom) image layer for the first frame of your animation.

Figure 12.70 Duplicate the bottom image layer to create an image for the second frame of your animation.

Figure 12.71 Move the new layer in the image window. Since the layer is larger than the final image size, it still contains information beyond its frame.

Figure 12.72 Create as many layers as you need. Each layer will become a frame in the animated GIF file.

The new image layer becomes the only layer in the file.

Remember that the bottom layer always becomes the first frame of an animated GIF file. Since the first layer in any new file is empty, we've deleted it so as not to include a blank frame in our animation.

5. Select the Move tool and drag the image to compose your first frame.

In this example, I dragged the image all the way to its left edge, since I want to create the illusion of panning from left to right (**Figure 12.69**).

Notice that even though you can see only a portion of the original, source image, it's all still there, hidden outside the borders of the image window.

- 6. On the Layers palette, drag the layer to the Create a New Layer icon. A duplicate of the new, first layer is created (Figure 12.70).
- 7. With the Move tool still selected, move the new layer a little to the left in the image window.

A portion of the image that had been hidden beyond the right edge of the image window comes into view, and a portion originally visible disappears beyond the left edge (**Figure 12.71**).

- **8.** On the Layers palette, drag the new top layer onto the Create a New Layer icon; then drag this new layer a little farther to the left in the image window.

 Continue to repeat the process, creating
 - successive layers and gradually moving the image through the image window (**Figure 12.72**).
- **9.** Choose File > Save for Web and follow steps 3 through 9 from the "To create an animated GIF" task earlier in this chapter.

Compositing Images

Combining multiple images together to create a single merged image is called *compositing*, and the possibilities for compositing are endless. You can combine different digital photos or scanned images to create effects that range from subtle to spectacular to silly. For example, you can replace a landscape's clear blue sky with a dramatic sunset, create complex, multilayered photo collages, or replace the face of the Mona Lisa with that of your Uncle Harold. We'll explore just a few of the ways you can composite images with Photoshop Elements.

Photoshop Elements lets you combine pictures in ways that would be difficult or even impossible to accomplish in the darkroom. The selection tools let you isolate the parts of an image you want to use, and the Layers palette provides a powerful and elegant tool for combining and merging different image elements. Although you can do some compositing without the aid of the Layers palette (cloning parts of an image from one file to another, for example), layers give you much more flexibility to move and adjust and modify one area of an image while leaving other areas untouched.

In the following example of an image for a travel agency brochure, we want the composite image to look as if it were an original unretouched photograph.

Figure 12.73 We'll enhance this image by replacing its lackluster background.

Figure 12.74 Use the Background Eraser tool to remove the sky and create a transparent background.

To replace part of an image with another image:

want to replace.
We'll call this the "target" image.
In the example, the sky isn't very interesting, and we want to add a more dramatic background (**Figure 12.73**). Even though the sky and the ship are both blue, the edges are well defined, so the image is a good candidate for the Background

1. Open an image that contains an area you

2. From the toolbox, select the Background Eraser tool; then adjust its brush size and tolerance values.

Eraser tool.

- We set the tolerance value fairly low because the sky and the ship both contain a lot of blue. If we set the tolerance value higher, a broader range of pixels may be selected, and some parts of the ship might be erased. (For more information on using the Background Eraser tool, see "Erasing Backgrounds and Other Large Areas" in Chapter 8, "Painting and Drawing.")
- 3. Position the Background Eraser tool along the outside edge of the foreground shape (the ship). Making sure that the brush crosshairs are over the background (sky), drag along the edge to erase the background. Continue to erase the background until the area is completely transparent (Figure 12.74).

continues on next page

- **4.** Open the image that you want to use to replace the transparent pixels in your original image.
 - We'll call this the "source" image.
- **5.** Select the Move tool and drag the source image into the target image (**Figure 12.75**).

In the example, the sky image is larger than the empty background area, which allows flexibility in positioning the new sky in the composition.

If you like, you can also use the selection tools to select just a portion of the source image, then drag just that selection into the target image.

- **6.** On the Layers palette, drag the source layer below the target layer (**Figure 12.76**).
- 7. In the image window, use the Move tool to adjust the position of the source image until you're satisfied with the composition.

If you want, you can use the image adjustment tools on each layer to create a more natural-looking composition.

✓ Tip

■ It's always good practice to save a copy of your composition retaining the layers in case you want to make further adjustments. Layered files should be saved as Photoshop Elements (PSD) files.

Figure 12.75 Drag the source image (the sky) into the target image (the ship).

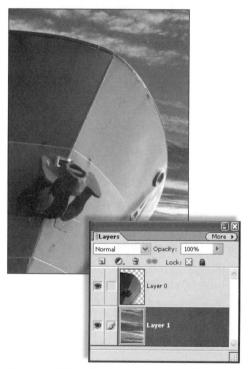

Figure 12.76 Move the sky layer below the ship layer on the Layers palette and adjust the position in the image window.

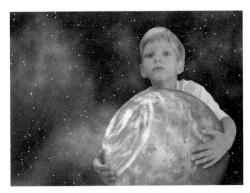

Figure 12.77 This final composite image was created from two separate images.

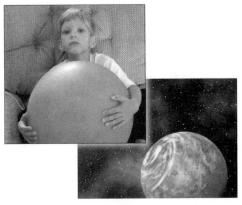

Figure 12.78 Here, I used a picture of a boy and a photograph of space to create an otherworldly image.

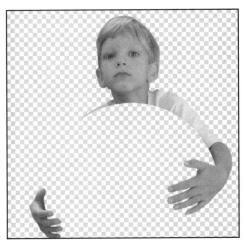

Figure 12.79 Use the Background Eraser tool (or any other selection tool) to isolate your source image.

Creating whimsical composite images

In many cases, as in the previous example, you composite images to improve them in a way that isn't obvious to the viewer. You don't want to draw attention to your work; you just want to improve the image (as in the ship and sky example). But sometimes you want your audience to wonder how you created that cool special effect. This composite for an elementary school astronomy fair poster is an image that looks pretty realistic, if a little fantastical (**Figure 12.77**). (See the color plate section of this book for a full-color view of this task.)

To combine images:

- **1.** Open two images that you want to composite (**Figure 12.78**).
- 2. Use the selection tools and/or eraser tools to isolate part of the source image. In this case, we'll use the Background Eraser tool to erase the background from the boy, leaving the area around him transparent (Figure 12.79). This way, he'll insert nicely into the target image, with no messy halos or edges around his body.
- **3.** Copy the area of the source image that you want to composite.

continues on next page

- **4.** Paste that selection into the target image (**Figure 12.80**).
 - This creates a new layer.
- **5.** Using the Move tool in the image window, position and resize the source image (top layer) to match the target image (bottom layer).
- 6. If you like, you can add layer styles to enhance the image.
 In this example, I chose the Low option in the Drop Shadow section of the Layer Styles palette to create an effective drop shadow on the boy's hand (Figure 12.81).

Figure 12.80 After pasting the source image (the boy) into the target image, the source image is placed on a new layer above the target image. That makes it easy to drag the image of the boy into its proper position.

Figure 12.81 The original composite lacked a little realism (left), so I added a drop shadow layer effect below the boy's hands (right) to complete the effect.

Figure 12.82 This image is a composite of two image layers: a shape layer and a text layer with layer styles applied.

Figure 12.83 Open the images you want to composite.

Figure 12.84 Select a custom shape that you'll use to define the shape of one of your composite layers.

Figure 12.85 Draw the Custom Shape so that it fills a large portion of the image window.

Creating new composite images

In the previous examples, we simply combined different objects we'd photographed in order to enhance those objects. In these types of compositions, the source images (the ship and little boy) were still recognizable; they were just composited into new backgrounds or environments.

A second compositing technique combines digital photos or scanned objects to create something entirely new, and in the process the individual replacement images used become barely recognizable. (A classic example of the old adage, "the whole is better than the sum of its parts.") In the next example, we'll combine multiple layers to create a collage for a quilting Web site (**Figure 12.82**). We'll use the Custom Shape tool to create a layer group, and then we'll apply layer styles to a text layer.

To create a layered photo collage:

- Open the two images you want to combine (Figure 12.83).
 We're going to combine scans of two contrasting fabrics to create the look of a quilt.
- 2. Select the Custom Shape tool and choose a shape from the menu on the options bar. I chose the Tile 4 option, since it looks like a diamond quilt pattern (Figure 12.84).
- In the background image file, drag the Custom Shape tool to create the shape pattern. Hold down the Ctrl key and drag inside the shape to reposition it if necessary.

A new layer with the shape is created (**Figure 12.85**).

Now we'll use the shape to create a mask for the other fabric layer.

continues on next page

- 4. Copy and paste the foreground image into the Background image file. The foreground image creates a new layer in the Background image file, immediately above the shape layer we just created (Figure 12.86).
- **5.** Make sure that the foreground image is selected; then, from the Layer menu, choose Group with Previous, or press Ctrl+G.

A layer group is created. The foreground image now shows only within the area of the custom shape below it. The fabrics look as if they have been quilted together in a pattern (**Figure 12.87**).

6. Select the Text tool, then click in the image and enter your text.
Select the Move tool and position the text if necessary.
For this example, I used a bold type-face and set the text color to white (Figure 12.88).

Figure 12.86 Paste the layer you want to composite above the custom shape layer.

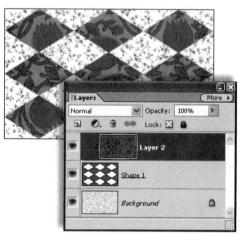

Figure 12.87 When you create a layer group, the bottom layer acts as a mask, allowing the layer above to show through only those areas in the bottom layer that are opaque.

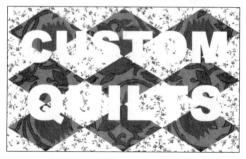

Figure 12.88 Create a new text layer on top of the other layers.

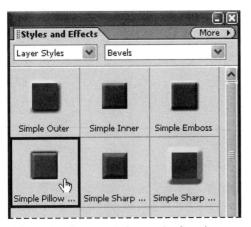

Figure 12.89 Choose an Emboss option from the Bevels styles in the Styles and Effects palette.

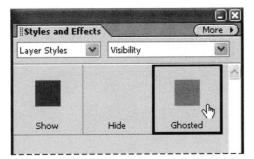

Figure 12.90 Choose an option from the Visibility styles in the Styles and Effects palette.

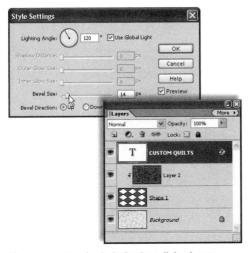

Figure 12.91 Use the Style Settings dialog box to adjust your layer styles.

- 7. With the text layer selected on the Layers palette, choose a layer style from the Styles and Effects palette.

 I chose Simple Pillow Emboss from the Bevels styles (**Figure 12.89**).
- **8.** From the Library drop-down menu on the Styles and Effects palette, choose Visibility.
- Select the Ghosted option (Figure 12.90).
 The text looks like it has been quilted into the fabric.
- **10.** To make further adjustments to the embossing effect, click the Layer Style icon on the text layer on the Layers palette.

The Style Settings dialog box appears, where you can make adjustments to the Layer style you have applied (**Figure 12.91**).

THE PHOTO ORGANIZER

13

Digital photography can be a bit of a double-edged sword. Ironically, its greatest advantage to the amateur photographer—the ability to quickly and easily capture a large number of images, and then instantly download them to a computer—can also be its greatest source of frustration. Once hundreds of images have been downloaded, photographers find themselves faced with the daunting task of sorting through myriad files, with incomprehensible filenames, to find those dozen or so "keepers" to assemble into an album or post to the Web for friends.

Photoshop Elements' Organizer workspace comes to the rescue with a relatively simple and wonderfully visual set of tools and functions to help you locate, identify, and organize your photos. And since the Organizer is designed to work hand in hand with the Creations workspace, categories and collections of images that you assemble in the Organizer can be imported directly into Creations projects like slide shows, calendars, and Web photo galleries.

Understanding the Photo Organizer Work Area

The Organizer work area is divided into two main components: the Photo Browser and Organizer Bin. The Photo Browser, along with its timeline, is used to find and view thumbnail representations of your photos. The Organizer Bin contains the Tags and Collection Panes that you'll use to group and organize your image files (**Figure 13.1**).

The Photo Browser and timeline

At the core of the Photoshop Elements
Organizer is the Photo Browser. Every digital
photo or scan downloaded into Photoshop
Elements is automatically added to the
Photo Browser. Clear, resizable thumbnails
in the Photo Browser window make it easy
to scan through even a large number of
images. (For information on importing
images, see "Importing Images from
Cameras and Scanners," in Chapter 2,
"Creating and Managing Images.")

The timeline located just above the Photo Browser provides a way to quickly navigate from one set of images to another. For instance, when a Date viewing option is selected in the Browser window, the timeline uses date and time information embedded in each image to construct bars (month markers) to represent sets of photos taken within specific months and years. When a month marker is selected in the timeline, that month's photos are displayed at the top of the Photo Browser (**Figure 13.2**).

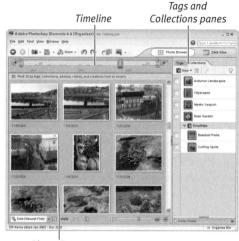

Photo Browser

Figure 13.1 The Photoshop Elements Organizer workspace.

Figure 13.2 Click on a month marker in the Organizer timeline to view that month's photos on the Photo Browser.

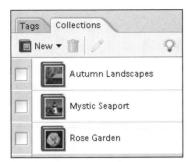

Figure 13.3 The Organizer Bin contains the Tags and Collections panes.

The shortcuts bar, menus, and panes

The other components in the Organizer look and operate in a similar fashion to their counterparts in the Photoshop Elements Edit workspace.

- A menu bar across the top of the window provides a source for commands and functions, whereas the shortcuts bar contains buttons for importing and printing, as well as for changing views within the Organizer, and for opening the Creations and main Edit workspaces.
- ◆ The Organizer Bin on the right side of the window holds the Tags and Collections panes. Working with the thumbnail images in the Photo Browser, you'll use these to identify, sort, and organize your photos (**Figure 13.3**).

Working in the Photo Browser

The centerpiece of the Photoshop Elements Organizer is the Photo Browser, a flexible workspace that provides a number of options for customizing the way you manage and view your image files. Throughout this chapter we'll cover a variety of ways to work in the Photo Browser to label, identify, and organize your photos. But first it's important to know how best to select, sort, and display the image thumbnails within the main Photo Browser window.

To select photo thumbnails:

Do one of the following:

- Click to select a thumbnail in the Photo Browser.
 - A heavy blue line appears, indicating that the thumbnail is selected (**Figure 13.4**).
- Ctrl+click to randomly select several thumbnails at once (Figure 13.5).
- Shift+click to select a group of thumbnails in sequence (Figure 13.6).
- From the Edit menu, choose Select All, or press Ctrl+A to select every thumbnail in the Photo Browser.

✓ Tip

■ If you're working on a computer with a slower processor, you may experience some delay in the time it takes thumbnails to appear as you scroll through the Photo Browser. If so, choose Preferences > Files from the Edit menu, and select the option to *Use lower quality thumbnails from files in the grid to improve scrolling performance.* You should notice a marked difference in the way your thumbnails display as you scroll.

Figure 13.4 A selected thumbnail is bordered with a heavy blue line.

Figure 13.5 Ctrl+click to select nonconsecutive thumbnails.

Figure 13.6 Shift+click to select consecutive thumbnails.

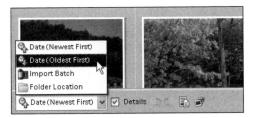

Figure 13.7 You can select from one of four options to sort thumbnails in the Photo Browser.

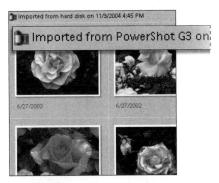

Figure 13.8 When you select the Import Batch option, thumbnails in the Photo Browser are displayed in grouped, batch sets.

To deselect photo thumbnails:

Do one of the following:

- Ctrl+click to deselect a single thumbnail.
- From the Edit menu, choose Deselect, or press Ctrl+Shift+A to deselect every thumbnail in the Photo Browser.

To sort photo thumbnails:

- From the Arrangement drop-down menu in the lower-left corner of the Photo Browser, choose from one of four sorting options (Figure 13.7).
 - ▲ **Date (Newest First)** displays the photos that you have taken or imported into Photoshop Elements most recently first.
 - ▲ Date (Oldest First) displays photos in order from the first one taken to the last.
 - ▲ Import Batch displays photos grouped together into the batches they were imported in. Included with each batch is information on when the batch was imported and from what source (Figure 13.8).
 - ▲ **Folder Location** displays photos grouped together into the folders in which they're stored, and provides detailed file-path information to make it easy to locate the folder and original files on your hard drive.

To resize photo thumbnails:

- In the lower-right corner of the Photo Browser, drag the thumbnail slider to the right to increase the size of the thumbnails, or to the left to make them smaller (Figure 13.9).
- Click the Small Thumbnail button to the left of the slider to display the thumbnails at their smallest possible size (Figure 13.10).
- Click the Single Photo View button to the left of the slider to display just one large photo thumbnail at a time.

✓ Tip

■ You can quickly toggle between your current multiple thumbnail view settings and Single Photo View. Simply double-click on any thumbnail in the Photo Browser to automatically change to Single Photo View. Then, double-click the large Single Photo View image to return to your most recent multiple thumbnail view settings.

Figure 13.9 When you drag the thumbnail slider to the right, the thumbnails grow larger (top). When you drag the slider to the left, they become smaller (bottom).

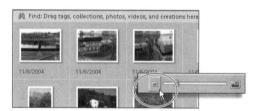

Figure 13.10 The Small Thumbnail button displays the thumbnails at their smallest size.

Instant Slide Shows with Full Screen View

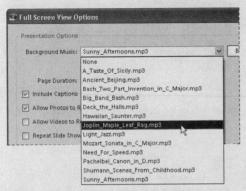

Figure 13.11 Photoshop Elements ships with a collection of looping music clips that you can use as background tracks for your Photo Review slide shows.

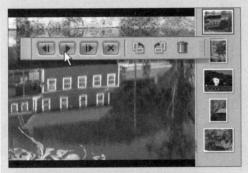

Figure 13.12 Use the control bar in Photo Review to play and pause your slide show, and rotate and apply Ouick Fix effects to your images while you review them.

Photoshop Elements Organizer provides an efficient and entertaining way to view a series of images. **Full Screen View** builds an instant slide show, complete with transitions and a background music track, from thumbnails that you select in the Photo Browser. And Full Screen View not only displays large format views of your images, but also allows you to rotate and apply automatic color and tonal corrections on the fly as the slide show plays.

To use the Full Screen View feature, first choose which images you want to view by selecting them in the Browser window. (If you don't make any selections, every image in your Photo Browser will be displayed.) From the View menu, choose View Photos in Full Screen to shift to Full Screen View and to open the Full Screen View Options dialog box. In the dialog box, you can set options for slide duration, captions, and image size, and then choose from one of the supplied background music tracks (Figure 13.11). (If you like, you can browse for and select any MP3 file on your computer to use as background music.) When you're satisfied with your settings, click OK. Your screen displays your images in Full Screen mode, where you can use a control bar to play the slide show and make minor image corrections (Figure 13.12). To return to the Organizer, press Esc.

Displaying and Changing Information for Your Photos

Images that you import from a digital camera or scanner carry embedded file information; everything from the date and time a photo was shot or scanned, to whether or not the camera's flash fired. The Organizer uses that date and time information to determine the order that the photo thumbnails display in the Photo Browser.

Although you can't change the embedded file information, you can control the order that images are sorted and displayed. The Adjust Date and Time dialog box lets you substitute a new date and time for any image file. Photoshop Elements then ignores the embedded information in favor of the new information that you've supplied. Simply change the date and time information of a photo (or group of photos), and their sorting order will automatically change in both the Photo Browser and the timeline.

To adjust the date and time:

- At the bottom of the Photo Browser, check that the Details option is selected (Figure 13.13).
 - Date and filename information will not display below the image thumbnails unless the Details option is selected.
- 2. In the Photo Browser, click to select the thumbnails whose date and time you would like to change.
- **3.** From the Edit menu, choose Adjust Date and Time (or Adjust Date and Time of Selected Items if more than one thumbnail is selected in the Photo Browser), or press Ctrl+J (**Figure 13.14**).

Figure 13.13 The Details option allows you to view title and date information in the Photo Browser.

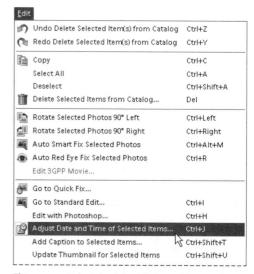

Figure 13.14 Select the Adjust Date and Time option to open its dialog box.

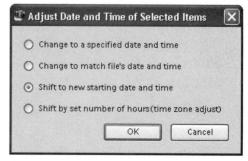

Figure 13.15 The Adjust Date and Time dialog box offers different options for changing an image's date and time information.

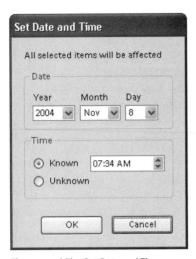

Figure 13.16 The Set Date and Time dialog box.

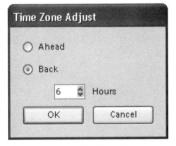

Figure 13.17 Use the Time Zone Adjust dialog box to set the time of your images backward or forward in one-hour intervals.

■ You can view file names in addition to dates in the Photo Browser with yet another Preferences option. In the General Preferences dialog box, select the Show File Names in Details option.

- **4.** In the Adjust Date and Time of Selected Items dialog box, choose one of the four options and click OK (**Figure 13.15**).
 - ▲ Change to a specified date and time opens the Set Date and Time dialog box where you can set a specific year, month, day, and time Figure 13.16.
 - ▲ Change to match file's date and time reverts the date and time information back to what is embedded in the original image file.

 Remember that date and time changes you enter here are only for sorting and organizing your images within the Photo Organizer. Date and time information that is embedded in an image file at the time that it's scanned or captured with a digital camera is always preserved.
 - ▲ Shift to new starting date and time allows you to set a new date and time for the earliest (oldest) photo in a selected group, and then changes the date and time of the other photos in the group in relation to that earliest photo. In other words, if the date of the earliest photo is set back one month from its original date, all of the photos in the selected group will be shifted back one month from their original dates.
 - ▲ Shift by set number of hours (time zone adjust) adjusts the time of selected images forward or back by the number of hours that you specify (Figure 13.17).

✓ Tips

■ You can set a preference so that you can open the Adjust Date and Time dialog box by simply clicking on the date in the Photo Browser. From the Edit menu, choose Preferences > General, then select the Adjust Date and Time by Clicking on Thumbnail Dates option.

To add a caption to a photo:

- **1.** In the Photo Browser, click to select an image thumbnail.
- **2.** From the Edit menu, choose Add Caption, or press Ctrl+Shift+T.
- In the Add Caption dialog box, enter a caption for your image, then click OK (Figure 13.18).

Although captions don't display with images in the Photo Browser window, they will appear along with your photos when you create projects like Web Photo Galleries, Picture Packages, and Photo Album Pages, to name just a few.

✓ Tips

- Captions do appear along with images in Single Photo View, and it's there that you can also add and edit captions. In Single Photo View, click the *Click here to add caption* text. The text changes to a text box where you can type a new caption. If you've previously entered a caption, click on the caption text to edit or delete it.
- You can add the same caption to multiple images at the same time. Select a group of images in the Photo Browser, and then from the Edit menu choose Add Caption to Selected Items. The caption you enter in the Add Caption to Selected Items dialog box will be applied to all of the selected images.

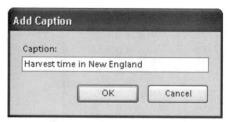

Figure 13.18 The Add Caption dialog box.

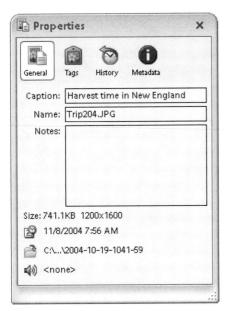

Figure 13.19 Each image thumbnail has its own Properties pane where you can enter caption and titling information. In addition, you can view properties relating to its associated tags and collections, and track its printing history.

Figure 13.20 When you change an image name in the Properties pane, that change is reflected in the Photo Browser.

To rename a photo:

- **1.** In the Photo Browser, click to select an image thumbnail.
- 2. From the Window menu, choose Properties, or press Alt+Enter to open the Properties pane (Figure 13.19).

 You can also open the Properties pane by right-clicking on an image thumbnail and choosing Show Properties from the thumbnail menu.
- **3.** In the Name text box (below the Caption text box) in the Properties pane, enter a new name for your image file.
- **4.** Click the Properties pane close button to return to the Photo Browser (**Figure 13.20**).

To add a note to a photo:

- 1. Select an image thumbnail; then from the Window menu, choose Properties, or press Alt+Enter to open the Properties pane.
- In the Notes text box, enter the text you want to include with your photo (Figure 13.21).

Notes can only be viewed from the Properties pane in the Photoshop Elements Organizer.

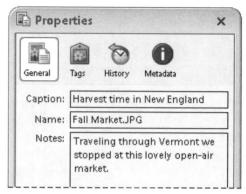

Figure 13.21 Notes entered for images in the Properties pane are accessible only from the Properties pane.

About the Properties Pane

The Properties pane may not look like much at first glance, but it contains a storehouse of information about each and every image in the Photoshop Elements Organizer. In the preceding procedures you learned how it can be used to enter and record image data like captions, names, and notes—but what are those other icons for?

The icons across the top of the pane actually serve as buttons that allow you to view different property types.

The **General** area displays (and allows you to enter) caption, name, and note information. In addition, three buttons along the lower-left edge give you access to the Adjust Date and Time dialog box; provide a jump, via Windows Explorer, directly to the folder containing your images; and (if you have a computer setup with a microphone) allow you to record audio captions.

The **Tags** area displays any tags associated with an image and any collections that it's a part of. We'll begin discussing Tags and Collections in the next section.

The **History** area displays date and time information for an image, as well as a general history of where the file has been and what it's done. For instance, you can see when the image was printed and if it's been used in Creations like Web photo galleries or PDF slide shows.

The **Metadata** area displays all of the detailed camera data (Exif information) embedded in a digital photo file. This is the same data that you can view in the File Information pane of the File Browser.

Figure 13.22 Click the Organize Bin button to show and hide the Tags and Collections panes.

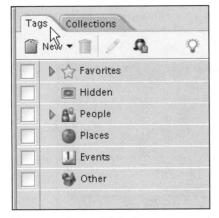

Figure 13.23 Tags and Collections are grouped in tabbed palettes called panes.

Creating Tags

The humble little tag serves as the foundation for the Organizer's sorting and filing system. You can create a tag from scratch or create one based on a set of photos grouped within a folder. In either case, give special attention to the way that you name your tags. Tend toward names that are descriptive, but that aren't so specific that you can only apply them to a limited number of photos.

To show or hide the tags pane:

- **1.** If the Tags tab isn't visible, click the Organize Bin button in the lower-right corner of the Photo Browser (**Figure 13.22**).
- **2.** If necessary, click the Tags tab to bring the Tags pane to the front of the Organize Bin (**Figure 13.23**).

✓ Tip

■ The Tags pane features a helpful tip window containing short, one-line primers on creating and using tags. To open the window, just click on the lightbulb tip icon on the right side of the Tags tab.

To create a new tag:

- **1.** Click the New button at the top of the Tags pane.
- 2. From the New drop-down menu, choose New Tag to open the Create Tag dialog box (Figure 13.24).

You can also press Ctrl+N to open the New Tag dialog box.

- **3.** From the Category menu in the Create Tag dialog box, choose the category or subcategory in which you want to place your new tag (**Figure 13.25**).
- **4.** In the Name text box, enter a name for your tag.
- 5. In the Note text box, enter information relevant to the photos that you may want to apply the tag to (Figure 13.26).

 The first photo to which you attach a new tag automatically becomes the icon for that tag. This is an easy and convenient way to assign tag icons, so we'll ignore the Edit Icon button for now
- **6.** Click OK to close the Create Tag dialog box. Your new tag appears in the Tags pane within the category you chose (**Figure 13.27**).

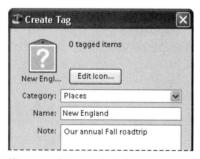

Figure 13.26 Tags can include notes to help you recall details about the photos that they're applied to.

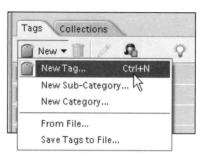

Figure 13.24 Click the New button at the top of the Tags pane to create a new tag.

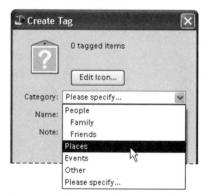

Figure 13.25 All tags reside in categories. You define a category for your new tag in the Create Tag dialog box.

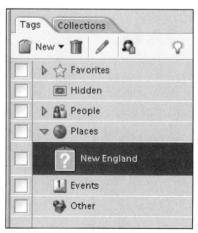

Figure 13.27 Tags appear nested below their categories in the Tags pane.

Figure 13.28 The Folder Location option displays photos grouped in folders.

Figure 13.29 Every folder group in the Photo Browser has its own Instant Tag button.

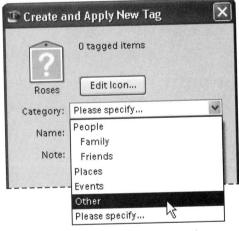

Figure 13.30 When you click the Instant Tag button, the Create and Apply New Tag dialog box appears.

To create a tag from a folder:

- 1. From the Arrangement drop-down menu in the lower-left corner of the Photo Browser, choose Folder Location (Figure 13.28).
 - In the Photo Brower, your photos will be displayed in folder groups.
- 2. Identify the folder group that you want to tag, and then near the right edge of the Photo Browser, click the Instant Tag button (**Figure 13.29**).
- **3.** From the Category menu in the Create and Apply New Tag dialog box, choose the category or subcategory in which you want to place your new tag (**Figure 13.30**).

continues on next page

- **4.** The Name text box is automatically filled with the name of the folder you selected. You can use the folder name for your tag, or enter a new name (**Figure 13.31**).
- **5.** In the Note text box, enter information relevant to the photos that you're creating the tag for.
- **6.** Click OK to close the Create and Apply New Tag dialog box.

The new tag appears in the Tags pane within the category you chose, and all of the photos within the folder are automatically selected and tagged (**Figure 13.32**). The tag's icon is selected from the first photo in the folder.

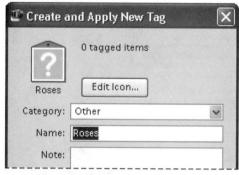

Figure 13.31 Photoshop Elements automatically gives your tag the same name as the folder you select. You can use the folder name or enter a different name altogether.

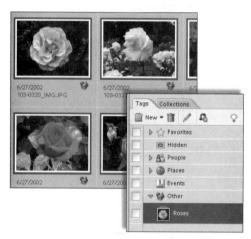

Figure 13.32 When a new tag is created from a source folder, all of the photos within that folder are automatically tagged.

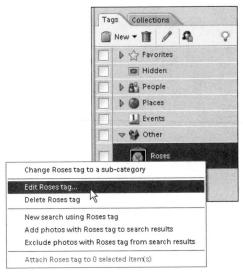

Figure 13.33 Open the Edit Tag dialog box from the tag drop-down menu.

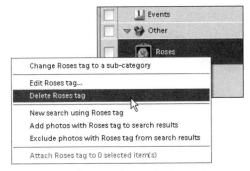

Figure 13.34 Delete a tag in one simple step from the tag drop-down menu.

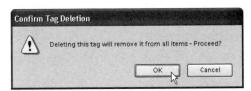

Figure 13.35 The Confirm Tag Deletion warning box reminds you that when a tag is deleted from the Tags pane, the tags are also removed from the thumbnails in the Photo Browser.

To change a tag's properties:

- 1. In the Tags pane, right-click on the tag whose properties you would like to change.
- **2.** From the tag drop-down menu, choose Edit (*name of tag*) tag (**Figure 13.33**).
- **3.** In the Edit Tag dialog box, make the desired changes and click OK.

To delete a tag:

- **1.** In the Tags pane, right-click on the tag you would like to delete.
- **2.** From the tag drop-down menu, choose Delete (*name of tag*) tag (**Figure 13.34**).
- **3.** In the Confirm Tag Deletion warning box, click OK (**Figure 13.35**).

The tag is removed from the Tags pane and from any photos tagged in the Photo Browser.

Using Tags to Sort and Identify Photos

Tags are little markers that you attach to groups of photos that share a common feature or theme. Tags operate independent of where photos are located on your computer, so you can attach a tag to different photos in different folders—even on different hard drives—and then use that tag to quickly find and view those photos all at once. And since you can attach more than one tag to a photo, they serve as a great cross-referencing tool. For instance, if your daughter plays softball for the college she attends, a photo of her pitching on her home field might have a tag called "Emily"; but could also have additional tags like "Softball" and "UCSD."

To attach a tag to a single photo:

◆ Drag a tag from the Tags pane onto any photo in the Photo Browser, and then release the mouse button (**Figure 13.36**). A category icon appears below the photo in the Browser window to indicate that it has been tagged; in the Tags pane, the tag assumes that photo for its tag icon (**Figure 13.37**).

To attach a tag to multiple photos:

- 1. In the Photo Browser, Ctrl+click to select any number of photos, and then release the mouse button.
- 2. From the Tags pane, drag a tag onto any one of the selected photos (Figure 13.38). A category icon appears below all of the selected photos in the Browser window to indicate that they have been tagged.

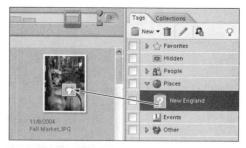

Figure 13.36 To attach a tag to a photo, simply drag it from the Tags pane to a thumbnail image in the Photo Browser.

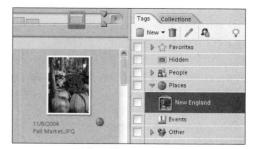

Figure 13.37 When you use a tag for the first time, the photo you attach it to serves as the source for the tag icon.

Figure 13.38 You can select multiple photos, and then tag them all at once by dragging a tag icon over just one.

Figure 13.39 You can easily select large sets of photos when you display them by their import batch or folder location.

Figure 13.40 When you click on an import batch or folder icon, all of the photos in that batch or folder are selected at once.

Figure 13.41 When you tag just one photo in a selected batch or folder, every photo in that batch or folder is tagged at the same time.

To attach a tag to an import batch or folder:

- From the Arrangement drop-down menu in the lower-left corner of the Photo Browser, choose either Import Batch or Folder Location (Figure 13.39).
 In the Photo Brower, your photos will be displayed in either batch or folder groups.
- 2. Identify the import batch or folder group that you want to tag, and then click on either the import batch or folder icon for that group (Figure 13.40).
 All of the photos in the group are automatically selected.
- 3. From the Tags pane, drag a tag onto any one of the selected photos (Figure 13.41). A category icon appears below all of the selected photos in the Browser window to indicate that they have been tagged. If the tag you are applying does not already have an icon, the tag's icon will be selected from the first photo in the import batch or folder (Figure 13.42).

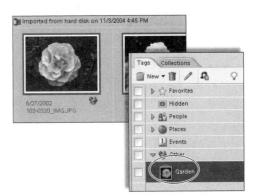

Figure 13.42 If you're using a tag for the first time, its tag icon will be based on the first photo in the batch or folder that you tag.

To view a set of tagged photos:

In the Tags pane, do one of the following:

- Double-click on a tag.
- ◆ Click the blank box to the left of a tag.

 A small binoculars icon will appear in the box, and the Photo Browser will change to display just the photo or photos that carry the attached tag (Figure 13.43).

 To return to the main Photo Browser window, click the Back to All Photos button, or click the binoculars icon in the Tags pane.

To remove a tag from a photo:

Select a photo thumbnail in the Photo Browser, and then *do one of the following*:

- Right-click inside a photo thumbnail; then from the thumbnail pop-up menu choose Remove Tag > (name of tag) (Figure 13.44).
- Right-click on the category icon below the photo thumbnail and select Remove (name of tag) tag from the small pop-up menu (Figure 13.45).

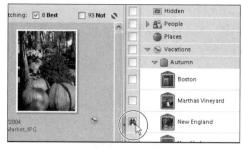

Figure 13.43 When the binoculars icon is visible next to a tag in the Tags pane, only that tag's photos will appear in the Photo Browser.

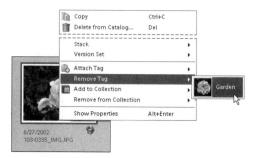

Figure 13.44 Thumbnail menus give you quick access to tasks such as attaching and removing tags.

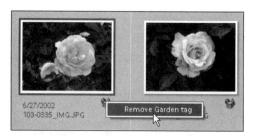

Figure 13.45 Remove a tag from a photo with a single click on the category icon below the thumbnail in the Photo Browser.

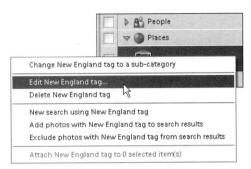

Figure 13.46 Open the Edit Tag dialog box from a tag drop-down menu in the Tags pane.

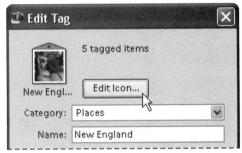

Figure 13.47 Click the Edit Icon button to open the Edit Tag Icon dialog box.

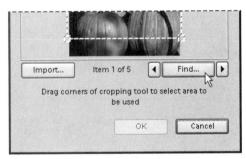

Figure 13.48 Use the Find button in the Edit Tag Icon dialog box to browse for a new photo to use as the source for your tag icon.

To change a tag's icon:

- 1. In the Tags pane, right-click on the tag whose icon you would like to change.
- **2.** From the tag drop-down menu, choose Edit (*name of tag*) tag (**Figure 13.46**).
- 3. In the Edit Tag dialog box, click the Edit Icon button (Figure 13.47).

 To assign a new icon image in the Edit Tag Icon dialog box, you can select from any of the photos that the tag has been applied to, or you can import a completely new photo.
- 4. To select a different tagged photo, click the Find button in the Edit Tag Icon dialog box (Figure 13.48).

continues on next page

- 5. In the Select Icon for (name of tag) Tag window, click to select a photo thumbnail and click OK (Figure 13.49).
 The new image appears in the preview window of the Edit Tag Icon dialog box.
- **6.** To crop the area of the photo that will appear on the tag icon, click and drag any of the four cropping handles in the image preview (**Figure 13.50**).
- 7. To select a different cropped area of the photo to appear on the tag icon, click inside the crop box and drag it in the preview window (Figure 13.51).
 Any changes you make in the preview window are reflected in the tag icon preview at the top of the dialog box (Figure 13.52).
- 8. When you're satisfied with the look of your icon, click OK to close the Edit Tag Icon dialog box, then click OK again to close the Edit Tag dialog box.

 The new icon will appear on the tag in the Tags pane.

✓ Tip

■ If you'd like to use an image for your icon different than any of the photos that you've tagged, click the Import button in the Edit Tag Icon dialog box. In the Import Image for Tag Icon window, you can browse through your computer to select an image. Once you've selected an image, click Open to return to the Edit Tag Icon dialog box. From there just follow the steps for cropping and adjusting the icon image.

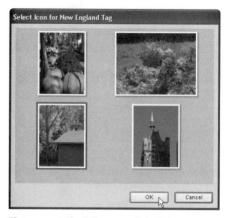

Figure 13.49 The Select Icon dialog box.

Figure 13.50 Resize the selection rectangle in the Edit Tag Icon dialog box to crop a tag icon.

Figure 13.51 Move the selection rectangle to choose a different area of a photo to use for your tag icon.

Figure 13.52 The tag icon preview shows you how your final tag icon will appear.

Hidden Tags

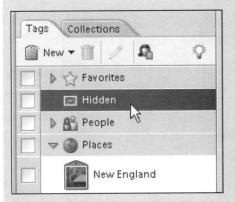

Figure 13.53 You can use the Hidden tag to make photo thumbnails "disappear" from the Photo Browser until you're ready to use them.

Figure 13.54 Photos with the Hidden tag attached are only visible when the binoculars icon is turned on.

In addition to the tags that you create, Photoshop Elements provides you a single tag with a very specific function (**Figure 13.53**). As its name implies, you use the Hidden tag (located near the top of the Tags pane) to make photo thumbnails in the Photo Browser invisible. If you have a set of photos that you're not yet ready to part with, but that you feel are cluttering up the Photo Browser, you can use the Hidden tag to keep them out of sight until you need them.

You assign the Hidden tag to a photo just as you would any other tag. In the Photo Browser, either drag it onto a single photo thumbnail, or onto a series of selected thumbnails. A closed eve icon will appear on the face of the photo thumbnail as well as below it, but won't be hidden just yet. In the Tags pane, click the blank box to the left of the Hidden tag. A small binoculars icon will appear in the box and the Photo Browser will change to display just the photo or photos that carry the Hidden tag (Figure 13.54). To return to the main Photo Browser window, click the Back to All Photos button, or click the binoculars icon in the Tags pane. The hidden photo will not appear in the Photo Browser with the other thumbnails until you remove the Hidden tag.

Using Face Recognition to Apply Tags to Photos

The Find Faces for Tagging feature provides a quick and easy way to sort, identify, and tag photos based on the people pictured in the photos. Simply click the Find Faces for Tagging button at the top of the Tags pane to open the Face Tagging window, whose unique browser fills with faces cropped from your Organizer photos (Figure 13.55). The Face Tagging window has its own Tags pane from which you can create tags for all of the people represented in its browser. As you assign tags to faces, they vanish from the Face Tagging browser, so you can't mistakenly tag the same face twice. Once you've finished with your tagging, click the Done button to return to the main Photo Browser. There you'll find that all of the photos containing the tagged faces have been tagged, and the new tags you created appear in their proper place in the Organizer Tags pane (Figure 13.56).

Figure 13.55 The Find Faces for Tagging button opens the Face Tagging window.

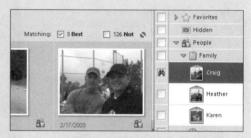

Figure 13.56 Any tags that you assign in the Face Tagging window are automatically assigned to the proper photos in the Organizer's main Photo Browser.

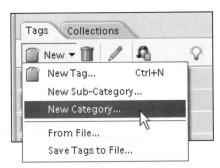

Figure 13.57 Use the New menu in the Tags pane to open the Create Category dialog box.

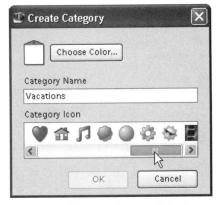

Figure 13.58 The Create Category dialog box features a variety of icons you can use to represent your new category.

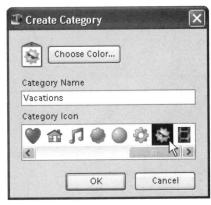

Figure 13.59 When you select an icon, it appears in the preview area at the top of the dialog box.

Using Categories to Organize Tagged Photos

Just as tags in the Tags pane each represent a group or set of photos, categories and subcategories can be thought of as the file drawers and folders that hold those sets of photos. With the exception of the Hidden tag, all tags must reside in either a category or subcategory. The Organizer starts you off with five ready-made categories, but you can create as many new categories and subcategories as your photo library and personal organizational style require. Tags can easily be moved from one category to another, and if the volume of photos becomes too unwieldy for one tag to manage, it can be converted to a subcategory that contains its own set of tags.

To create a new category:

- **1.** Click the New button at the top of the Tags pane.
- 2. From the New drop-down menu, choose New Category to open the Create Category dialog box (**Figure 13.57**).
- **3.** In the Create Category dialog box, enter a name in the Category Name text box.
- **4.** In the Category Icon area of the dialog box, use the scroll bar or arrows to search for an icon you would like use to identify your new category (**Figure 13.58**).
- Click to select a category icon. The icon will appear in the category preview at the top of the dialog box (Figure 13.59).
- **6.** At the top of the Create Category dialog box, click the Choose Color button to open the Color Picker.

continues on next page

- In the Color Picker, select the color that you would like to appear on all the subcategory and tag icons within your new main category (Figure 13.60).
- **8.** Click OK to close the Color Picker. Then, if you're satisfied with your other category settings, click OK again to close the Create Category dialog box.
- **9.** Your new category appears at the bottom of the list in the Tags pane (**Figure 13.61**).

✓ Tip

■ Although new categories are always placed at the bottom of the list in the Tags pane, you don't have to leave them there. To move a category, first click to select it, and then hold down the mouse button and drag it to a different position in the Tags pane (a dark line will indicate the category's new position). Release the mouse button and the category will snap into its new position (Figure 13.62).

Figure 13.60 You can select a color from either the basic color swatches or by clicking in the color window on the right side of the Color Picker dialog box.

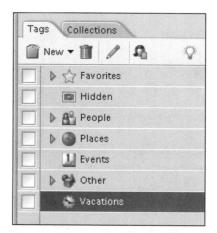

Figure 13.61 New categories are added to the bottom of the list in the Tags pane.

Figure 13.62 You can reorder categories in the Tags pane by simply clicking and dragging them to different locations in the stacking order.

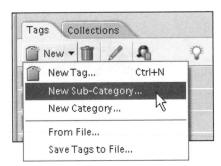

Figure 13.63 Use the New menu in the Tags pane to open the Create Sub-Category dialog box.

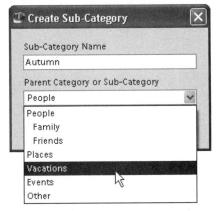

Figure 13.64 Subcategories can be nested within categories or other subcategories.

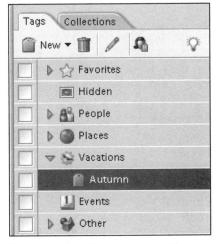

Figure 13.65 Subcategories appear within a category in the Tags pane.

To create a new subcategory:

- **1.** Click the New button at the top of the Tags pane.
- 2. From the New drop-down menu, choose New Sub-Category to open the Create Sub-Category dialog box (**Figure 13.63**).
- 3. In the Create Sub-Category dialog box, enter a name in the Sub-Category Name text box.
- **4.** From the Parent Category or Sub-Category drop-down menu, choose a location in which to place your new subcategory (**Figure 13.64**).
- **5.** Click OK to close the Create Sub-Category dialog box.
- **6.** Your new subcategory appears in the Tags pane, within the category or subcategory you selected (**Figure 13.65**).

To convert a tag to a subcategory:

- 1. In the Tags pane, right-click on the tag that you want to convert.
- **2.** From the tag pop-up menu, choose Change (*name of tag*) tag to a sub-category (**Figure 13.66**).

In the Tags pane, the tag icon will change to a subcategory icon.

✓ Tip

■ If at some point you decide that you'd like to convert a subcategory (that was formerly a tag) back to a tag, just choose the Change sub-category to a tag option on the Sub-Category drop-down menu. After you make the conversion, you'll find that all of the tag's properties, including its icon, have been retained.

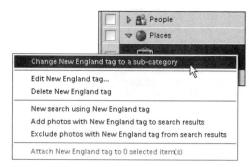

Figure 13.66 Convert a tag to a subcategory from the tag pop-up menu in the Tags pane.

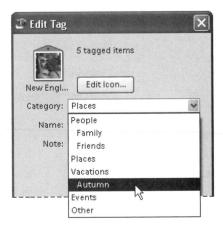

Figure 13.67 You can easily move a tag from one category to another from the Edit Tag dialog box.

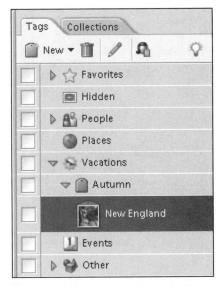

Figure 13.68 Changes you make to a tag's placement in the Edit Tag dialog box appear instantly in the Tags pane.

To assign a tag to a new category or subcategory:

- **1.** In the Tags pane, right-click on the tag you want to place.
- **2.** From the tag pop-up menu, choose Edit (*name of tag*) tag.
- **3.** From the Category menu in the Edit Tag dialog box, choose the category or subcategory in which you want to place the tag (**Figure 13.67**).
- 4. Click OK to close the Edit Tag dialog box. In the Tags pane, the tag will appear within the category and subcategory you defined (Figure 13.68).
 If you've already applied the tag to a photo or photos in the Photo Browser, the category icons below the photo thumbnails will automatically update to display the icon of the new category.

✓ Tip

■ You can also move tags into new categories or subcategories right in the Tags pane. With both the tag and the category or subcategory visible, simply click to select a tag and then drag it onto a category or subcategory icon. The tag will nest beneath the category or subcategory you choose. The disadvantage of this method (as compared to the one outlined in the procedure) is that you have to be able to see the tag and category or subcategory in the Tags pane. Since the Tags pane can get filled with categories pretty quickly, it may require that you do quite a bit of scrolling and searching, whereas the Category menu in the Edit Tag dialog box gives you a list of every category and subcategory in one convenient place.

To view a category or subcategory:

In the Tags pane, do one of the following:

- Double-click on a category or subcategory.
- Click the blank box to the left of a category or subcategory.

A small binoculars icon will appear in the box, and the Photo Browser will change to display just the photos in that category or subcategory set.

To return to the main Photo Browser window, click the Back to All Photos button, or click the binoculars icon in the Tags pane.

To delete a category or subcategory:

In the Tags pane, click to select a category or subcategory, and then *do one of the following*:

- Right-click to display the category popup menu, and then select Delete (category name) category (Figure 13.69).
- ◆ Click the Delete icon at the top of the Tags pane (**Figure 13.70**).

✓ Tip

■ Before you delete a category or subcategory, bear in mind that you will also delete all related subcategories and tags and will remove those tags from all tagged photos. In some circumstances, a better alternative may be to change a category or subcategory's properties to better match the content or theme of related tagged photos rather than delete a category altogether.

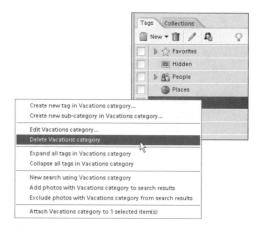

Figure 13.69 Delete a category in one simple step from the category pop-up menu.

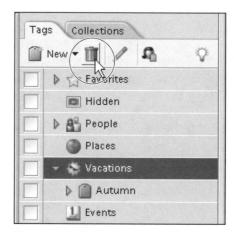

Figure 13.70 Delete a category or tag from the Tags pane by clicking the Delete button.

Figure 13.71 The Collections pane shares the Organize Bin with the Tags pane.

Using Collections to Arrange and Group Photos

At first glance, the concept of collections might seem a little redundant: aren't they just another container for tagged image files, sort of like categories or subcategories? But collections act in a uniquely different way from either categories or tags. For one thing, collections aren't limited to a single tag or category. That is, a collection can be composed of photos from a number of different tags or categories. And, unlike categories that are dependent on one of the four arrangement options to sort and display their photos, the photos within collections can be sorted and reordered, independent of their date or folder structure. The sorting feature of collections is particularly useful when you're creating a project like a PDF slide show or Web photo gallery. Not only can you select the photos that you want to include, you can also arrange them to display in whatever order you want.

To show or hide the collections pane:

- 1. If the Collections tab isn't visible, click the Organize Bin button in the lowerright corner of the Photo Browser.
- **2.** Click the Collections tab to bring the Collections pane to the front of the Organize Bin (**Figure 13.71**).

✓ Tip

■ The Collections pane features a helpful tip window containing short, one-line primers on creating and using collections. To open the window, just click on the lightbulb tip icon on the right side of the Tags tab.

To create a new collection:

- 1. Click the New button at the top of the Collections pane.
- From the New drop-down menu, choose New Collection to open the Create Collection dialog box (Figure 13.72).
- Leave the Group menu set to None (Top Level).
 You'll learn more about collection groups later in this section.
- **4.** In the Name text box, enter a name for your collection.
- 5. In the Note text box, enter information relevant to the photos that you may want to include in the collection (Figure 13.73). The first photo you add to a collection automatically becomes the icon for that collection. Since this is an easy and convenient way to assign collection icons, we'll ignore the Edit Icon button for now.
- dialog box.
 Your new collection appears in the
 Collections pane (**Figure 13.74**).
 By default collections are sorted in alpha-

betical order in the Collections pane.

6. Click OK to close the Create Collection

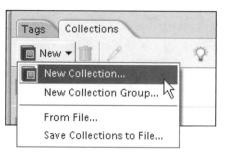

Figure 13.72 Use the New menu in the Collections pane to open the Create Collection dialog box.

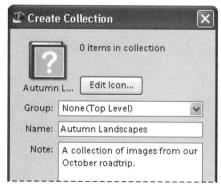

Figure 13.73 The Create Collection dialog box is similar to the Create Tag dialog box with areas to enter name and note information.

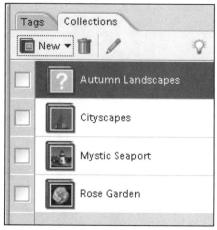

Figure 13.74 New collections appear in alphabetical order in the Collections pane.

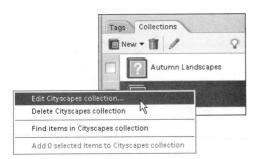

Figure 13.75 Use a collection's pop-up menu to open its Edit Collection dialog box.

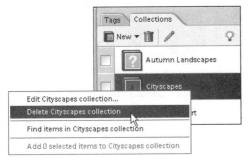

Figure 13.76 Delete a collection in one simple step from the collection pop-up menu.

Figure 13.77 The Confirm Collection Deletion warning box gives you an opportunity to change your mind before you delete a collection.

To change a collection's properties:

- **1.** In the Collections pane, right-click on the collection whose properties you would like to change.
- **2.** From the collection pop-up menu, choose Edit (*name of collection*) collection (**Figure 13.75**).
- **3.** In the Edit Collection dialog box, make the desired changes and click OK.

To delete a collection:

- **1.** In the Collections pane, right-click on the collection you would like to delete.
- **2.** From the collection pop-up menu, choose Delete (*name of collection*) collection (**Figure 13.76**).
- In the Confirm Collection Deletion warning box, click OK (Figure 13.77).
 The collection is removed from the Collections pane, and the link to any images in the Photo Browser is broken.

To add photos to a collection:

Do one of the following:

- From the Photo Browser, drag a photo onto the appropriate collection in the Collections pane.
- From the Collections pane, drag a collection onto a photo thumbnail in the Photo Browser.

A collection icon appears below the photo in the Browser window to indicate that it is part of a collection, and in the Collections pane, the collection assumes that photo for its collection icon (**Figure 13.78**).

To view a photo collection:

In the Collections pane, do one of the following:

- ◆ Double-click on a collection.
- Click the blank box to the left of a collection.

A small binoculars icon will appear in the box, and the Photo Browser will change to display just the photos in that collection (**Figure 13.79**).

To return to the main Photo Browser window, click the Back to All Photos button, or click the binoculars icon in the Collections pane.

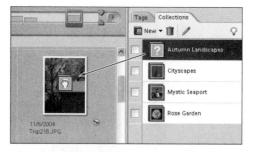

Figure 13.78 The first photo that you add to a collection will serve as that collection's icon in the Collections pane, and a collection icon will appear below every photo thumbnail in the Photo Browser added to a collection.

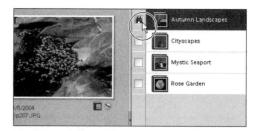

Figure 13.79 When the binoculars icon is visible next to a collection in the Collections pane, only that collection's photos will appear in the Photo Browser.

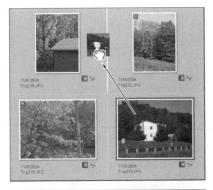

Figure 13.80 To reorder photos within a collection, drag a thumbnail to a new location in the Photo Browser (top). When you release the mouse button, the thumbnail will snap into place in its new location (bottom).

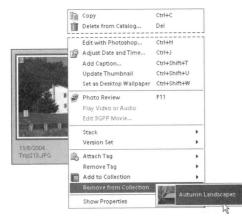

Figure 13.81 Thumbnail menus give you quick access to tasks such as adding and removing a tagged photo from a collection.

To arrange photos within a collection:

- **1.** In the Collections pane, double-click on a collection to view it in the Photo Browser.
- 2. In the Photo Browser, click to select a photo, and then drag it to a new location (**Figure 13.80**).

When you release the mouse button, the photo will snap into place in the new location, and the photo thumbnails will automatically renumber.

To remove photos from a collection:

With a collection displayed in the Photo Browser, select a photo thumbnail and then do one of the following:

- Right-click inside a photo thumbnail, then from the thumbnail pop-up menu choose Remove from Collection > (name of tag) (Figure 13.81).
- Right-click on the collection icon below the photo thumbnail and select Remove from (name of collection) collection from the small pop-up menu (Figure 13.82).

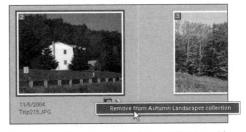

Figure 13.82 Remove a photo from a collection with a single click on the collection icon below the thumbnail in the Photo Browser.

To create a collection group:

- **1.** Click the New button at the top of the Collections pane.
- From the New drop-down menu, choose New Collection Group to open the Create Collection Group dialog box (Figure 13.83).
- **3.** In the Collection Group Name text box, enter a name for your collection Group (**Figure 13.84**).
- **4.** Leave the Parent Collection Group option set to None (Top Level).
 - You can group one collection group within another. If you'd already created a collection group, its name would be displayed in the Parent Collection Group menu, and you then would have the option of nesting your new collection group within the existing one.
- Click OK to close the Create Collection Group dialog box.Your new collection group appears in the

Collections pane (**Figure 13.85**). Your new collection group appears at the bottom of the list in the Collections pane.

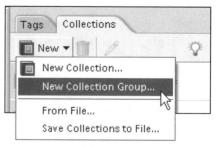

Figure 13.83 Use the New menu in the Collections pane to open the Create Collection Group dialog box.

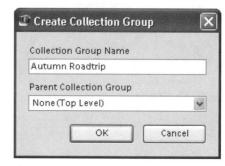

Figure 13.84 The Create Collection Group dialog box.

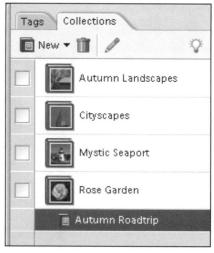

Figure 13.85 New collection groups appear at the bottom of the stacking order in the Collections pane.

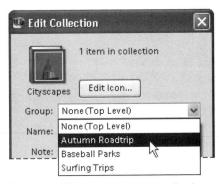

Figure 13.86 Once you've created a collection group, you can add collections to it from the Edit Collection dialog box.

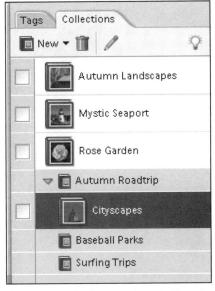

Figure 13.87 Collections appear nested in their collection groups in the Collections pane.

To add a collection to a collection group:

- **1.** In the Collections pane, right-click on the collection you want to include in the collection group.
- **2.** From the collection pop-up menu, choose Edit (*name of collection*) collection.
- **3.** From the Group menu in the Edit Collection dialog box, choose the group in which you want to place the collection (**Figure 13.86**).
- **4.** Click OK to close the Edit Collection dialog box.
 - In the Collections pane, the collection will appear within the collection group you defined (**Figure 13.87**).

✓ Tip

■ You can also move collections into collection groups right in the Collections pane. With both the collection and the collection group visible, simply click to select the collection and then drag it onto a collection group icon. The collection will nest beneath the collection group you choose.

Using Stacks to Organize Similar Photos

You've spent a day on the valley floor of Yosemite shooting picture after picture, and when you return home in the evening and download all of those photos to your Photo Browser, you realize that you have about a dozen shots of the same waterfall: some lit a little differently than others; some with different zoom settings; but all very similar just the same. Stacks serve as a convenient way to group those related photos together. They not only save valuable space in the Photo Browser, they also make assigning tags much faster, because tagging a stack automatically tags every photo in the stack. When you're ready to take a careful look at all of those waterfalls and weed out the greats from the not so greats, you simply expand the stack to view all of the stacked photos at once.

To create a stack:

- In the Photo Browser, Ctrl+click to select the photos that you want to include in a stack.
- 2. Right-click inside any of the selected photo thumbnails; then from the thumbnail pop-up menu choose Stack > Stack Selected Photos, or press Ctrl+Alt+S (Figure 13.88).

The photos are stacked together, indicated by a Stack icon in the upper-right corner of the top photo in the stack (**Figure 13.89**).

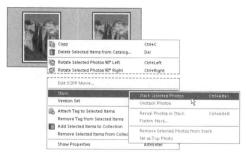

Figure 13.88 Stacks are easily created from photo thumbnail pop-up menus

Figure 13.89 Photo stacks are identified by their own unique icon.

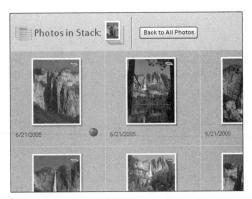

Figure 13.90 You can view all of the photos in a stack with the Reyeal Photos in Stack command.

Figure 13.91 Exit the Photos in Stack window with the Back to All Photos button.

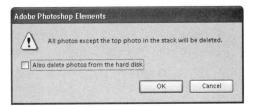

Figure 13.92 A warning box reminds you that you are about to delete all but the top photo in your stack.

To view all photos in a stack:

- 1. In the Photo Browser, right-click on a stack thumbnail; then from the thumbnail pop-up menu choose Stack > Reveal Photos in Stack, or press Ctrl+Alt+R.

 The photos appear in their own Photos in Stack browser window (Figure 13.90).
- **2.** To return to the main Photo Browser window, click the Back to All Photos button (**Figure 13.91**).

✓ Tip

■ While you're in the Photos in Stack browser window you can unstuck the photos, remove specific photos from a stack, or designate a new photo to be the top photo (the photo that appears at the top of the stack in the Photo Browser). Just right-click on any photo in the Photos in Stack browser and then from the thumbnail pop-up menu, select an option from the Stack submenu.

To flatten a stack:

- 1. In the Photo Browser, right-click on a stack thumbnail; then from the thumbnail pop-up menu choose Stack > Flatten Stack.
- 2. In the warning dialog box that appears, click OK to delete all of the photos except for the top photo in the stack (**Figure 13.92**).

You can also choose to delete the same photos from your hard drive.

To unstack photos in a stack:

 In the Photo Browser, right-click on a stack thumbnail; then from the thumbnail pop-up menu choose Stack > Unstack Photos.

The stacked photos return to their original locations in the Photo Browser window.

Using Catalogs to Store Your Photos

Catalogs are the behind-the-scenes backbone of the Organizer workspace. Catalogs are actually where all the information for tags and categories and collections are stored. When you install Photoshop Elements, a default catalog (called "My Catalog") is automatically set up for you on your computer, and may very well be all that you'll ever need. There are two circumstances where additional catalogs might be helpful. If your business requires you to maintain a large library of digital images, you may want to have a catalog to keep those business images separate from your personal photos. Or, if more than one person is sharing and downloading images to the same computer, it may be nice to have discrete catalogs for each person's photos: "Bob's Catalog," "Sara's Catalog," and so on.

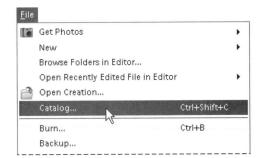

Figure 13.93 Choose Catalog from the File menu to open the Catalog dialog box.

Figure 13.94 Make sure to give your new catalog a name that's different from any existing catalogs.

To create a new catalog:

- 1. From the File menu choose Catalog, or press Ctrl+Shift+C (Figure 13.93). In the lower-left corner of the Catalog dialog box is the Import free music into all catalogs check box. Leave this option selected so that the music files you received with Photoshop Elements (to use as background tracks for PDF slide shows and other creations) will be available in the new catalog.
- 2. In the Catalog dialog box, click New.
- 3. In the New Catalog window, choose a location for your new catalog.

 The default location that appears in the New Catalog window is the Photoshop Elements Catalogs folder, a good location to store any new catalogs.
- 4. In the File Name text box, enter a name for your new catalog (Figure 13.94).
 Be sure not to use My Catalog as the name, because that is the name already assigned to your original catalog.
- 5. Click Save to create your new catalog.

Finding Photos

In addition to locating photos using the Tags and Collections panes, the Organizer offers a host of other options for searching, finding, and viewing photos in your catalog. We'll touch on just a couple of the more popular methods here for locating photos by their embedded date information. The timeline allows you very quick and easy access to photos via its month markers. Just click on a marker and your Photo Browser is instantly populated with the photos acquired in that particular month. Additionally, the Date View windows offer you a highly visual and interactive way to search and locate photos from yearly and monthly calendars. For instance, in the Month calendar view, sets of photos shot in a given day are represented by a thumbnail image of the first photo shot that day. And by simply clicking on that day's photo thumbnail, you can scroll through and view all of the photos from that day. A singleday view window provides yet another way to view a day's worth of photos, with the advantage of displaying a large preview of each photo rather than just a small representative thumbnail.

To set a range of dates for finding photos:

- **1.** If necessary, from the View menu choose Timeline, or press Ctrl+L to view the timeline (**Figure 13.95**).
- **2.** From the Find menu, choose Set Date Range, or press Ctrl+Alt+F.
- **3.** In the Set Date Range dialog box, use the text boxes and drop-down menus to enter a start and end date (**Figure 13.96**).
- 4. The timeline will change to highlight just the range of dates that you selected (Figure 13.97).

Figure 13.95 If the timeline isn't visible, choose Timeline from the View menu.

Figure 13.96 Enter start and end dates in the Set Date Range dialog box.

Figure 13.97 Before you set a date range (top), the contents of the entire timeline will be visible in the Photo Browser. After you set a date range (bottom), only those photos that fall within the specified range will be visible in the Photo Browser.

Figure 13.98 Choose a sort option from the Arrangement drop-down menu in the Photo Browser.

Figure 13.99 Bars (month markers) in the timeline represent sets of images shot or acquired in specific months. Click on a timeline marker to view its set of photos.

To find photos using the timeline:

- 1. From the Arrangement drop-down menu in the lower-left corner of the Photo Browser, choose a sorting option (**Figure 13.98**).
- 2. In the timeline, click on a bar corresponding to a specific month and year (**Figure 13.99**).

The Photo Browser will automatically scroll to display the photos for the month you selected.

✓ Tip

■ From the Find menu, you can search for photos to view in the Photo Browser by a number of different criteria. Some that you'll probably use most often are by caption or note; by filename; by history (imported on date, and printed on date, among others); and by media type (photos, video, audio, and creations). Just choose an option and then fill in its dialog box (when applicable) to refine your search.

To find photos in the date view:

- **1.** In the shortcuts bar, click the Date View button (**Figure 13.100**).
- 2. At the bottom of the Date View window, click to select a view option (Figure 13.101).
- 3. Use the navigation buttons in calendar view to move from one year, month, or day to another (Figure 13.102). In Year view, dates shaded in blue indicate the days that those photos were taken. A preview window to the right contains a thumbnail of the first photo in the set, plus navigation buttons to view the remaining photos in the set (Figure 13.103).

Figure 13.100 Click the Date View button on the shortcuts bar to change to the Organizer Date View window.

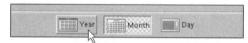

Figure 13.101 At the bottom of the Date View window, you can select from one of three calendar view options.

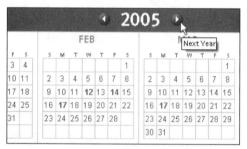

Figure 13.102 Buttons in the different calendar views allow you to quickly jump to the next (or previous) year, month, or day.

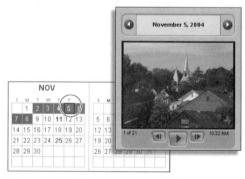

Figure 13.103 Click on a shaded date in Year view to see the photos associated with that day.

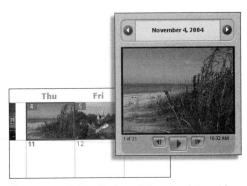

Figure 13.104 In Month view, click on the dates with photo thumbnails to see the photos associated with that day.

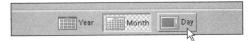

Figure 13.105 Choose the Day option to see larger views of the photos for a single day.

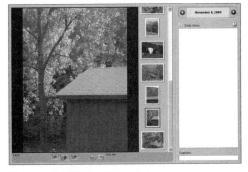

Figure 13.106 The Day View window.

In Month view, dates with photo thumbnails indicate the days that photos were taken (**Figure 13.104**).

- **4.** To view the complete set of photos for any given day, *do one of the following:*
 - ▲ Double-click on either a shaded day in Year view or on a day thumbnail in Month view.
 - ▲ Click to select a day in either Year or Month view, and then click the Day button at the bottom of the Date View window (**Figure 13.105**).

In the Day view window you can see large, single-image views of your photos. You can also add notes for a complete day's set of photos and enter a caption for individual photos (**Figure 13.106**).

EDITOR KEYBOARD SHORTCUTS

To choose a tool	
Tools	
Move	V
Zoom	Z
Hand	Н
Eyedropper	I
Marquee	M
Lasso	L
Magic Wand	W
Magic Selection Brush	F
Selection Brush	A
Type & Type Mask	T
Crop	C
Cookie Cutter	Q
Straighten	P
Red Eye Removal	Υ
Healing Brush	J
Clone Stamp	S
Eraser	E
Brush	В
Pencil	N
Paint Bucket	K
Gradient	G
Rectangle	U
Blur	R
Sponge	0

To cycle through tools

MARQUEE TOOL	
Marquee tools	
Lasso tools	L
Type & Type Mask tools	Т
Healing Brush tools	J
Clone Stamp tools	S
Eraser tools	E
Brush tools	В
Shape tools	
Blur & Sharpen tools	R
Dodge & Burn tools	0

Working with tools

MARQUEE TOOL

Draw marquee from center Constrain to square or circle

Draw from center and constrain to

MOVE TOOL

Constrain move to 45° Copy selection or layer Nudge selection or layer 1 pixel Nudge selection or layer 10 pixels

LASSO TOOL

Add to selection
Delete from selection
Intersect with selection
Change to Polygonal Lasso

POLYGONAL LASSO TOOL

Add to selection
Delete from selection
Intersect with selection
Draw using Lasso
Constrain to 45° while drawing

MAGNETIC LASSO TOOL

Add to selection

Close path

Delete from selection Intersect with selection Add point Remove last point (Alt)+drag

Shift)+drag

Shift + Alt + drag square or circle

Shift +drag
Alt +drag

Arrow key

Shift]+arrow

Shift)+click, then draw

Alt +click, then draw

(Alt)+(Shift)+click, then draw

Click, then (Alt)+drag

Shift +click, then draw

(Alt)+click, then draw

(Alt)+(Shift)+click, then draw

Alt +drag

Shift +drag

Shift +click, then draw

Alt +click, then draw

(Alt)+(Shift)+click, then draw

Single click

Backspace or Delete

Double-click or Enter

Working with tools

MAGNETIC LASSO TOOL

Close path over start point

Close path using straight line segment

Switch to Lasso

Switch to Polygonal Lasso

CROP TOOL

Rotate crop marquee Move crop marquee Resize crop marquee

Resize crop box while maintaining

its aspect ratio

SHAPE TOOLS

Constrain to square or circle Constrain Line tool to 45°

Transform shape

Distort Skew

Create Perspective

TYPE TOOL

Select a word Select a line

Select a paragraph Select all characters

Left align text Center text

Right align text Increase by 2 points

Decrease by 2 points Scroll through fonts

PAINT BUCKET TOOL Change color of area

BRUSH AND PENCIL TOOL

Decrease or increase size by 10 pixels

Smudge using Foreground color

SMUDGE TOOL EYEDROPPER TOOL

Choose Background color

Click on start point

Alt +double-click

Alt +drag

Alt +click

Drag outside crop marquee

Drag inside crop marquee

Drag crop handles

Shift)+drag corner handles

Shift]+drag

Shift +drag

Ctrl +T

Ctrl +drag

Ctrl +(Alt)+drag

Ctrl + Alt + Shift + drag

Double-click in text Triple-click in text

Ouad-click in text

Ctrl +A

Ctrl + Shift +L

Ctrl + Shift +C

Ctrl + Shift + R

Ctrl + Shift + . (period)

Ctrl + Shift + , (comma)

Select font in menu+up/down arrow

Shift +click outside canvas around canvas

[(key) or] (key)\ (or by 1 pixel when size is less than 10 pixels)

Alt +drag

Alt +click

Display Shortcuts

CHANGE VIEW

Zoom In Zoom out

Zoom to 100%

Zoom to fit window

Fit on screen Actual pixels

Show/hide edges of selection

Show/hide ruler

HAND TOOL

Toggle to zoom in Toggle to zoom out

Fit image on screen

Zoom Tool Zoom out

Actual size

MOVE IMAGE IN WINDOW

Scroll up one screen
Scroll down one screen
Scroll left one screen
Scroll right one screen
Scroll up 10 pixels
Scroll down 10 pixels
Scroll left 10 pixels

Scroll right 10 pixels Move view to upper left

Move view to lower right

 $\fbox{Ctrl} + Spacebar + click/drag \ or \ \fbox{Ctrl} + + (plus)$

Alt +Spacebar+click/drag or Ctrl +-(minus)
Double-click Zoom tool

Double-click Hand tool

Ctrl +o

Ctrl + Alt +o

Ctrl +H

Ctrl +R

Ctrl Alt

Double-click tool

Alt +click

Double-click tool

Page Up Page Down (Ctrl)+page up

Ctrl +page down
Shift +page up
Shift +page down

Ctrl +Shift +pageup

Ctrl +Shift +page down

Home key End key

Menu Shortcuts

FILE MENU Ctrl +N New Ctrl +0 Open Alt +Ctrl +0 Open As Close Ctrl +W Close All Alt + Ctrl +W Save Ctrl +S Save As Ctrl + Shift +S Ctrl +(Alt)+(Shift)+S Save for Web Ctrl + Shift + P Page Setup Print Ctrl +P Print Multiple Photos Alt + Ctrl +P Ctrl +Q Exit EDIT MENU Undo Ctrl +Z Ctrl +Y Redo Cut Ctrl +X Copy Ctrl +C Ctrl + Shift +C Copy Merged Paste Ctrl +V Paste Into Selection Ctrl + Shift + V Color Settings Ctrl + Shift + K Ctrl +K Preferences > General IMAGE MENU Free Transform Ctrl +T Image Size (Alt)+(Ctrl)+I ENHANCE MENU Alt + Ctrl +M Auto Smart Fix Auto Levels Ctrl + Shift +L Ctrl +(Alt)+(Shift)+L Auto Contrast Auto Color Correction Ctrl +(Shift)+B Auto Red Eye Fix Ctrl +R Ctrl + Shift + M Adjust Smart Fix Adjust Lighting > Adjust Levels Ctrl +L

Adjust Color > Adjust Hue/Saturation

Adjust Color > Remove Color

Ctrl +U

Ctrl + Shift + U

Menu Shortcuts	
LAYER MENU	
New > Layer	Ctrl +Shift +N
New > Layer via Copy	Ctrl +J
New > Layer via Cut	Ctrl +Shift +G
Group with Previous	Ctrl +G
Ungroup	Ctrl +Shift +G
Arrange > Bring to Front	Ctrl +Shift +] #+Shift +]
Arrange > Bring Forward	Ctrl +]
Arrange > Send Backward	Ctrl +[
Arrange > Send to Back	Ctrl + Shift +]
Merge Layers	Ctrl +E
Merge Visible	Ctrl +Shift +E
SELECT MENU	
All	Ctrl +A
Deselect	Ctrl +D
Reselect	Ctrl +Shift +D
Inverse	Ctrl +Shift +I
Feather	Ctrl +Alt +D
Nudge selection marquee 1 pixel	Arrow key
Nudge selection marquee 10 pixels	Shift +Arrow key
FILTER MENU	
Last Filter	Ctrl +F
Adjustments > Invert	Ctrl +l
LIQUIFY FILTER	
Warp tool	W
Turbulence tool	A
Twirl Clockwise tool	R
Twirl Counterclockwise tool	L
Pucker tool	Р
Bloat tool	В
Shift Pixels tool	S
Reflection tool	M
Reconstruct tool	E
Zoom tool	Z
Hand tool	H
Reverse direction for Shift Pixels	Alt +tool and Reflect tools

Up and down arrow keys

Up and down arrow keys

Increase/decrease brush pressure by 1

Increase/decrease brush size by 1

ORGANIZER KEYBOARD SHORTCUTS

ORGANIZER KEYBOARD SHORTCUTS

Menu Shortcuts	
FILE MENU	
Get Photos > From Camera or Card Reader	Ctrl +G
Get Photos > From Scanner	Ctrl +U
Get Photos > From Files and Folders	Ctrl + Shift + G
Get Photos > From Mobile Phone	Ctrl + Shift + M
Catalog	Ctrl +Shift +C
Burn	Ctrl +B
Duplicate	Ctrl +Shift +D
Rename	Ctrl +Shift +N
Move	Ctrl +Shift +V
Export > To Computer	Ctrl +E
E-mail	Ctrl +Shift +E
Page Setup	Ctrl +Shift +P
Print	Ctrl +P
Exit	Ctrl +Q
EDIT MENU	
Undo last action	Ctrl +Z
Redo last action	Ctrl +Y
Сору	Ctrl +C
Select All	Ctrl +A
Deselect	Ctrl + Shift +A
Delete from Catalog	Del key
Rotate 90° Left	Ctrl +Left
Rotate 90° Right	Ctrl +Right
Auto Smart Fix	Ctrl +(Alt +M
Auto Red Eye Fix	Ctrl +R
Go to Standard Edit	Ctrl +l
Edit with Photoshop	Ctrl +H
1	

Adjust Date and Time

Update Thumbnail

Add Caption

Ctrl +

Ctrl + Shift +T

Ctrl + Shift + U

Menu Shortcuts

Set as Desktop Wallpaper

Stack > Stack Selected Photos

Stack > Reveal Photos in a Stack

Color Settings

Preferences > General

FIND MENU

Set Date Range

Clear Date Range

By Caption or Note

By Filename

All Version Sets

By Media Type > Photos

By Media Type > Video

By Media Type > Audio

By Media Type > Creations

By Media Type > Items with Audio Captions

By Media Type > PDF

Items with Unknown Date or Time

Untagged Items

VIEW MENU

View Photos in Full Screen

Compare Photos Side by Side

Refresh

Go To > Back

Go To > Forward

Media Types

Details

Timeline

Collapse All Tags

Expand All Tags

Expand All Stacks

WINDOW MENU

Photo Browser

Date View

Tags Collections

Properties

HELP MENU

Photoshop Elements Help

Ctrl + Shift + W

Ctrl + Alt +S

Ctrl + Alt +R

Ctrl + Alt +G

Ctrl +K

Ctrl + Alt +F

Ctrl + Shift + F

Ctrl + Shift + J Ctrl + Shift + K

Ctrl + Alt +V

Alt +1

Alt +2 Alt +3

Alt +4

Alt +5

Alt +6

Ctrl + Shift + X

Ctrl + Shift +Q

F11

F12

F5

Alt +Left

Alt +Right

Ctrl +M

Ctrl +D

Ctrl +L

Ctrl +(Alt)+T

Ctrl + Alt +X

Ctrl + Alt +Y

Ctrl +(Alt)+0

Ctrl +(Alt)+C Ctrl +T

Ctrl +(Alt)+L

(Alt)+(Enter)

F1

Navigating in the Photo Browser

Move Selection up/down/left/right

Up/Down/ Left/Right

Show full-size thumbnail of selected photo

Enter

Viewing Photos in Full Screen mode

Start slide show

Show next slide

Show previous slide

Pause slide show

End slide show

Spacebar Right/Down Left/Up Spacebar

Esc

INDEX

A
Accented Edges filter, 198
actions, Blur filters, 207–211
Actual Pixels command (View menu), 18
adaptive colors, 309
Adaptive option (Indexed Color palette), 63
Add Caption command (Edit menu), 406
Add Caption dialog box, 406
Add Noise filter, 199
Add Photos dialog box, 344, 379
Add to Selection icon, 107
Add to Selection tool, 263
Add to Shape Area option, 273
Adjust Color command (Enhance menu), 80
Adjust Color for Skin Tone command (Enhance
menu), 80
Adjust Color for Skin Tone dialog box, 80
Adjust Date and Time command (Edit menu), 404
Adjust Date and Time dialog box, 404
Adjust Date and Time option, 404
Adjust Hue/Saturation command (Enhance menu),
184
Adjust Hue/Saturation dialog box, 184
Adjust Lighting command (Enhance menu), 74
adjustment layers, 149–151
Adobe Gamma
dialog box, 66
monitor color calibration, 65–67
Adobe HTML Photo Gallery dialog box, 378
Adobe Photo Downloader, 32
Adobe Web Photo Gallery dialog box, 379
Airbrush button, 247
Aligned option, 165
alignment type, 290
All command (Select menu), 135
Always Optimize for Printing option, 64
ambience, light property, 220
Ancient Stone style, 301
Angle value, 250
Angled Strokes filter, 198

animation, GIF files, 382 creating, 384-385 motion, 386-387 preparing layered files, 383 Anti-Alias Off command (Layer menu), 293 Anti-Alias On command (Layer menu), 293 anti-aliasing smoothing selection edges, 110-111 type, 293 Arc Lower style, 296 Arc style, 296 Arc Upper style, 296 Arch style, 296 Arrange command (Layer menu), 123 Artist Surfaces set, 171 Artistic filters, 197 As a Copy option, 9 Asphalt effect, 206 Attach to E-mail command (File menu), 322 Attach to E-mail dialog box, 322 Auto Color Correction command (Enhance menu), 79 Auto Contrast command (Enhance menu), 73 Auto Levels command (Enhance menu), 72

В

Back to All Photos button, 34
Background Brush tool, 262
Background Color option (Background Contents drop-down menu), 30
Background Color tool, 4
Background Eraser tool, 258–260
Background From Layer command (Layer menu), 133
backgrounds
convert layers, 133
erasing, 258–260
layers, 121
lighting improvement, 77
removing foreground, 261–263
Web page color identification, 318

Pag Paliof filton 201	11:
Bas Relief filter, 201 batch processing, 329, 339–342	captions, adding to photos, 406 Cast Shadow effect, 205
Bevel Direction radio buttons, 148	casts, colors, 79–81
Bevel Size slider, 147	Catalog command (File menu), 437
Bevels style, 301	Catalog dialog box, 437
Bicubic interpolation, 39	catalogs, 436–437
Bicubic Sharper interpolation, 39	categories, tags
Bicubic Smoother interpolation, 39	assigning, 425
Bilinear interpolation, 39	creating, 421–422
Bitmap command (Image menu), 60	deleting, 426
Bitmap dialog box, 60	subcategories, 423
bitmap images, 230	viewing, 426
Bitmap mode, 56, 60-61	Chalk & Charcoal filter, 201
Blank File command (File menu), 29	Change View tool, keyboard shortcuts, 446
Blizzard effect, 205	Charcoal filter, 201
Bloat tool, 214	Chrome filter, 201
Blue Omni style, 218	Clear button, 156
Blur command (Filter menu), 207	Clear Emboss effect, 205
Blur filters, 198, 207–211	Clear Layer Style command (Layer menu), 145
Blur More filter, 198, 211	Clear Undo History command (Window menu), 153
Blur tool, 4, 176	clipart, slide shows, 372
blurring images, 176	Clone Stamp tool, 4, 164–165
BMP formats, 331	Close All command (File menu), 7
BMP Options dialog box, 331	Close command (File menu), 7
Bold Outline effect, 205 Royder command (Select many) 112	Clouds filter, 200
Border command (Select menu), 112 borders	Cold Lave effect, 206
creating, 245	collages, composited images, 393–395
printing options, 352	collections Collections pane, 427
reposition with marquee tools, 93	creating new, 428
selection modification, 112–113	deleting, 429
Bricks effect, 206	group creation, 432–433
Bring Forward command (Layer menu), 123	photos
Bring to Front command (Layer menu), 123	adding to, 430
Browse For Folder window, 32	arranging, 431
browsers, previewing images, 320-321	removing, 431
Brush Dynamics palette, 250–251	properties, 429
Brush Name dialog box, 249, 251	viewing, 430
Brush Presets palette, 246, 253	Collections pane, 427
Brush Strokes filters, 198	Color Halftone filter, 200
Brush tool, 4, 246, 445	Color Picker, 58
Brushed Aluminum effect, 204	Color Picker dialog box, 422
Brushed Metal effect, 205	Color Settings command (Edit menu), 69
brushes	Color Settings dialog box, 64, 69
Brush Dynamics palette, 250	Color Variations command (Enhance menu), 81
creating, 248–249	Color Variations dialog box, 81
erasing, 256–257	Colored Pencil filter, 197
object creation, 251–252	colorization, 185–188
sets, 253	colors, 53
Bulge style, 296	adjusting
Burn tool, 181	automatically, 72–73
	manually, 74–75
C	cast corrections, 79–81
Cactus style, 301	histograms, 71
cameras	lighting
compact storage cards, 31	background, 77 foreground, 76
importing images, 32–34	lookun tahles 309

management, 64	Open, 6
imperfect science, 68	Page Setup, 348
monitor calibration, 65–67	Print, 349
settings, 69	Print Multiple Photos, 343
models, 54, 309	Process Multiple Files, 339
modes	Resize, 367
Bitmap, 56	Save, 8
changing, 58–62	Save As, 8
Grayscale, 56	Save for Web, 306
Indexed, 57	Save Slide Show Project, 374
RGB, 54–55	Filter menu
paint fills, 231–234	Blur, 207
profile, 64	Distort, 213
Quick Fix window, 78	Other, 226
removing, 183–184	Render, 216
replacing, 82–84	Sharpen, 174
selections	Help menu, Photoshop Elements Help, 22
expanding area, 100	Image menu
including similar colors, 100	Convert Color Mode, 64
Magic Selection brush, 101	Crop, 159
Magic Wand, 98–99	Magic Extractor, 262
tonal correction, 70	Mode, 59
type change, 290	Resize, 39
Combine button, 274	Rotate, 270
commands	Transform Shape, 268
Edit menu	Layer menu
Add Caption, 406	Arrange, 123
Adjust Date and Time, 404	Bring Forward, 123
Color Settings, 69	Bring to Front, 123
Copy, 135	Delete Layer, 121
Cut, 109	Duplicate Layer, 132
Define Brush from Selection, 251	Group with Previous, 143
Deselect, 401	Layer Style, 145, 300
Fill Layer, 231	Simplify Layer, 285
Fill Selection, 231	Type, 293
Paste, 135	Ungroup, 143
Preferences, 9, 49	More menu, Place in Palette Bin when Closed, 14
Preset Manager, 242	Rotate menu
Stroke (Outline) Selection, 243	Straighten and Crop Image, 160
Undo, 195	Straighten Image, 160
Undo Auto Contrast, 73	Select menu
Undo Auto Levels, 72	All, 135
Undo Grayscale, 59	Deselect, 109
Enhance menu	Grow, 100
Adjust Color, 80	Inverse, 111
Adjust Lighting, 74	Modify, 112
Auto Color Correction, 79	Reselect, 109
Auto Contrast, 73	Similar, 100
Auto Levels, 72	View menu
File menu	Actual Pixels, 18
Attach to Email, 322	Grid. 50
Catalog, 437	New Window, 46
Close, 7	Print Size, 42
Close All, 7	Rulers, 48
Exit Slide Editor, 374	Timeline, 438
File Info, 338	Window menu
Import, 34	Images, 47
New, 29	Info, 13, 43
,	Account of the Control of the Contro

1 / 1)	
commands (continued)	Create Collection Group dialog box, 432
Layers, 117	Create New Shape Layer option, 273
Navigator, 20	Create Sub-Category dialog box, 423
Reset Palette, 117	Create Tag dialog box, 410
Reset Palette Locations, 15	Create Warped Text icon, 294
Styles and Effects, 144, 190	Creation Setup window, 368
Undo History, 152	Crop command (Image menu), 159
Commit Transform button, 136, 269	Crop tool, 4, 156–158, 161, 445
compact storage cards, 31	cropping
CompactFlash card, 31	images, 156–159
Complex style, 301	marks, 353
compositing images, 388	Crosshatch filter, 198
combining images, 391–392	
layered collage, 393–395	Crystallize filter, 200
	Custom command (Filter menu), 226
replace part with another, 389–390	Custom dialog box, 226
compression options, file formats, 335	Custom option (Indexed Color palette), 63
computers, color models, 54	Custom Shape tool, 275–276
Confetti effect, 205	customizing
Constraining Proportions option, 42	filters, 226–228
Contact Book dialog box, 323	gradients, 237–242
contact sheets, 343–345	shapes, 275–276
Conte Crayon filter, 201	Cut command (Edit menu), 109
Contents tab (help system), 23	Cut Out effect, 204
Contiguous mode, 259	Cutout filter, 197
Contract command (Select menu), 112	
Convert Color Mode command (Image menu), 64	D
Cookie Cutter Options palette, 278	ט
Cookie Cutter tool, 4, 278–279	Dark Strokes filter, 198
Copy command (Edit menu), 135	Date View button, 440
corrections, 155	Date View window, 440-441
blurring specific areas, 176	dates
colorization, 185–188	adjusting, 404–405
cropping images, 156–159	finding photos, 438
imperfections, 163	Default Colors tool, 4
Clone Stamp tool, 164–165	defaults, palette locations, 15
Healing Brush tool, 167	Define Brush from Selection command (Edit
Spot Healing Brush tool, 166	menu), 251
patterns	Defringe dialog box, 131
Paint Bucket tool, 168–169	Defringe Layer command (Enhance menu), 131
Pattern Stamp tool, 170–171	Delete Layer command (Layer menu), 121
Red Eye Removal tool, 172	Deselect command
removing color, 183–184	Edit menu, 401
,	Select menu, 109
sharpening	Despeckle filter, 199
image, 173–175	
specific area, 177	Destination Browse button, 340
Smudge tool, 178	dialog boxes
straightening photos	Add Caption, 406
crooked digital photos, 162	Add Photos, 344, 379
scanned automatically, 160–161	Adjust Color for Skin Tone, 80
tonal adjustments, 179	Adjust Date and Time, 404
Burn tool, 181	Adjust Hue/Saturation, 184
Dodge tool, 180	Adobe Gamma, 66
Sponge tool, 182	Adobe HTML Photo Gallery, 378
Craquelure filter, 203	Adobe Web Photo Gallery, 379
Create Adjustment Layer button, 149	Attach to E-mail, 322
Create and Apply New Tag dialog box, 411	Bitmap, 60
Create Category dialog box, 421	BMP Options, 331
Create Collection dialog box, 428	Brush Name, 249, 251

Catalog, 437	Style Settings, 146, 147–148
Color Picker, 422	Time Zone Adjust, 405
Color Settings, 64, 69	Type Preferences, 287
Color Variations, 81	Units & Rulers, 49
Contact Book, 323	Unsharp Mask, 174
Create and Apply New Tag, 411	Warp Text, 294–295
Create Category, 421	Difference Clouds filter, 200
Create Collection, 428	Diffuse filter, 202
Create Collection Group, 432	Diffuse Glow filter, 199
Create Sub-Category, 423	Diffusion Dither option, 61
Create Tag, 410	diffusion dithering options, 314
Custom, 226	digital cameras
Defringe, 131	compact storage cards, 31
Duplicate Layer, 132	importing images, 32–34
E-mail, 322	Directional lights, 219
Edit Collection, 429	Discontiguous mode, 259
Edit Tag, 413, 425	Distort command
Edit Text, 373	Filter menu, 213
File Info, 338	Image menu, 138, 271
Fill Layer, 231	Distort filters, 199, 212-215
Filter Options, 193	distorting shapes, 271
Frame From Video, 35	dithering options, 314
Gradient Editor, 237	docking palettes, 15
Grid Preferences, 51	Document Dimensions option, 45
Hue/Saturation, 83	Document Profile option, 45
Image Size, 38–39	Document Sizes option, 45
Indexed Color, 62	Dodge tool, 180
Lens Flare, 220	dots per inch (dpi), 28
Levels, 74	downsampling, 41
Lighting Effects, 216	dpi (dots per inch), 28
Liquefy, 213	drawing, 229
Magic Extractor, 262	background removal, 258–260
Motion Blur, 208	Brush tool, 246
New file, 29	brushes
New Image, 29-30	Brush Dynamics palette, 250
New Layer, 119	creating, 248–249
Open, 6, 9	erasing, 256–257
Optimize to File Size, 315	object creation, 251–252
Page Setup, 348	sets, 253
Photomerge, 360	color fills
Preferences, 336	Paint Bucket tool, 233–234
Preset Manager, 242, 253	selections, 231–232
Print, 355	gradient
Print Photos, 343	customizing, 237–242
Print Preview, 349	fills, 235–236
Process Multiple Files, 339	removing foreground from background, 261–263
Quick Fix, 2, 78	shapes, 264, 265–267
Radial Blur, 209	adding to existing, 272
Replace Color, 82, 84	combining multiple, 274
Save As, 8	Cookie Cutter tool, 278–279
Save for Web, 305, 306	custom, 275–276
Save Optimized As, 307	distorting, 271
Saving Files, 9	rotating, 270
Select Icon, 418	scaling, 268–269
Set Date Range, 438	vector conversion to bitmap, 277
Shadows/Highlights, 76	stroke application, 243–245
Slide Show Preferences, 369	vector graphics, 230
Stroke, 243	Drop Shadow effect, 204

D 01 1 1 1 1 1 1 1 1 1 1 1 1 1 1 1 1 1 1	
Drop Shadows style, 301	Enhance menu commands
Dry Brush filter, 197	Adjust Color, 80
Duplicate Layer command (Layer menu), 132	Adjust Lighting, 74
Duplicate Layer dialog box, 132	Auto Color Correction, 79
Dust & Scratches filter, 199	Auto Contrast, 73
	Auto Levels, 72
-	keyboard shortcuts, 447
E	
e-mail	EPS (Encapsulated PostScript) format, 331
photo on custom stationary attachment, 326–327	Eraser tool, 4, 256–257
simple photo attachment, 322–325	Exact option (Indexed Color palette), 63
	Exclude Overlapping Shape Areas option, 273
E-mail dialog box, 322	Exit Slide Editor command (File menu), 374
Edit Collection dialog box, 429	Expand command (Select menu), 112
Edit Icon button, 417	exposure, light property, 220
Edit menu commands	Extrude filter, 202
Add Caption, 406	Eyedropper tool, 4, 445
Adjust Date and Time, 404	
Color Settings, 69	F
Copy, 135	Г
Cut, 109	face recognition, applying tags to photos, 420
Define Brush from Selection, 251	Facet filter, 200
Deselect, 401	Fade slider, 250
Fill Layer, 231	feathering, selection edges, 111
Fill Selection, 231	50% Threshold option, 61
keyboard shortcuts	File Info command (File menu), 338
Editor, 447	File Info dialog box, 338
Organizer, 449–450	File menu commands
Paste, 135	Attach to Email, 322
Preferences, 9, 49	Catalog, 437
Preset Manager, 242	Close, 7
Stroke (Outline) Selection, 243	Close All, 7
Undo, 195	
	Exit Slide Editor, 374
Undo Auto Contrast, 73	File Info, 338
Undo Auto Levels, 72	Import, 34
Undo Grayscale, 59	keyboard shortcuts
Edit Tag dialog box, 413, 425	Editor, 447
Edit Text dialog box, 373	Organizer, 449
editing type, 284	New, 29
Editor keyboard shortcuts, 443–448	Open, 6
effects	Page Setup, 348
application, 196	Print, 349
gallery, 204–206	Print Multiple Photos, 343
lighting	Process Multiple Files, 339
adding to image, 216–217	Resize, 367
lens flare, 220–221	Save, 8
properties, 219–220	Save As, 8
styles, 218	Save for Web, 306
types, 219	Save Slide Show Project, 374
painting, 254–255	files
plug-ins, 191	closing, 7
Styles and Effects palette, 190–192	formats, 305
textures, 222–225	BMP, 331
Effects palette, 196	compression options, 335
Ellipse tool, 265, 267	contact sheets, 343–345
Elliptical Marquee tool, 91–92	EPS (Encapsulated PostScript), 331
elliptical selections, marquee tools, 91–92	GIF, 334
Emboss filter, 202	JPEG, 334
Encapsulated PostScript (EPS) format, 331	multiple image formatting, 339–342
Encapadiated robtollibt (EF3110HIML, 331	multiple image formatting, 559-342

PDFs, 332	EPS (Encapsulated PostScript), 331
personalizing information, 338	GIF, 334
Photoshop, 330	JPEG, 334
PICT, 332	multiple image formatting, 339–342
printer packages, 346-347	PDFs, 332
TIFF (Tagged Image File Format), 333–334	personalizing information, 338
opening, 6	Photoshop, 330
saving, 8-9, 336	PICT, 332
Fill Layer command (Edit menu), 231	printer packages, 346–347
Fill Layer dialog box, 231	TIFF (Tagged Image File Format), 333–334
fill layers, 149	saving files as, 8–9
Fill Selection command (Edit menu), 231	Fragment filter, 200
Film Grain filter, 197	Frame From Video command (File menu), 35
Filter menu commands	Frame From Video dialog box, 35
Blur, 207	Frames effects, 204
Distort, 213	Free Rotate command (Image menu), 137
keyboard shortcuts, 448	Free Rotate Layer command (Image menu), 270
Other, 226	Free Transform command (Image menu), 136
Render, 216	Free Transform Shape command (Image menu), 268
Sharpen, 174	Fresco filter, 197
Filter Options dialog box, 193	From Camera or Card Reader option, 32
filters	Full Screen mode, keyboard shortcuts, 450 full tonal ranges, 71
application, 193–195	Fuzziness slider, 83
Blur, 207–211	1 uzzmess shuer, os
creating, 226–228 Distort, 212–215	
gallery, 197–203	G
plug-ins, 191	Gaussian Blur filter, 198, 211
Styles and Effects palette, 190–192	Geometry Options palette, 266-267
Filters palette, 194	Get Photos button, 32
Find Edges filter, 202	Ghosted style, 301
Find menu commands, keyboard shortcuts, 450	GIF formats, 305, 334
Fire style, 301	animation, 382
Fish style, 296	creating, 384–385
Fisheye style, 296	motion, 386–387
fixing photos. See corrections; retouching	preparing layered files, 383
Flag style, 296	dithering options, 314
Flashlighting style, 218	Web optimization settings, 312–313
Flatten Image command (Layers palette), 129	Glass filter, 199
flattened images, Eraser tool, 257	gloss, light property, 219
Floodlight style, 218	Glowing Edges filter, 202
Fluorescent Chalk effect, 205	Gold Sprinkles effect, 206
folders, creating tags, 411–412	Grab Frame button, 36 Gradient Editor dialog box, 237
fonts, type	Gradient palette, 235
selection, 287	Gradient tool, 4, 235
size change, 288	gradients
Forced option, 62	customizing, 237–242
Forced Web option, 62 foreground	fills, 235–236
0	type masks, 299
lighting improvement, 76 removing from background, 261–263	Grain filter, 203
Foreground Color effect, 204	Graphic Pen filter, 201
Foreground Color tool, 4	Grayscale command (Image menu), 59
formats	Grayscale mode, 56, 59
files, 305	Green Slime effect, 206
BMP, 331	Grid command (View menu), 50
compression options, 335	Grid Preferences dialog box, 51
contact sheets, 343–345	grids, settings, 50–51
	The state of the s

Group with Previous command (Layer menu), 143	digital cameras, 32–34
groups	scanned photos, 37
collections, 432–433	video footage, 35–36
layers, 142–143	management, 25
palettes, 14	display, 28
Grow command (Select menu), 100	Info palette, 43–46
	multiple views, 46–47
Н	printing, 28
Halftone Pattern filter, 201	rulers, 48–49
halos, image layers, 131	printing, 355–356
Hand tool, 4, 19, 214, 446	sizes, 26, 38–42. See also resolution
Hardness slider, 250	Images command (Window menu), 47
Healing Brush tool, 4, 167	imperfections, 163 Clone Stamp tool, 164–165
Help menu commands	Healing Brush tool, 167
keyboard shortcuts, 450	Spot Healing Brush tool, 166
Photoshop Elements Help, 22	Import command (File menu), 34
help system, 22–23	importing images, 31
hidden tags, 419	scanned photos, 37
hidden tools, 10–11	video footage, 35–36
histograms, colors, 71	Impressionist Brush tool, 254–255
Horizontal Type Mask tool, 297	Index tab (help system), 23
Horizontal Type tool, 282	Indexed Color command (Image menu), 62
How To palette, 5, 21	Indexed Color dialog box, 62
HSB color model, 58	Indexed Color palette options, 63
Hue Jitter slider, 250	Indexed mode, 57
Hue/Saturation dialog box, 83	Inflate style, 296
Hue slider, 83	Info command (Window menu), 13, 43
hues, 58	Info palette, 43–46
_	Ink Outlines filter, 198
1	Inner Glow Size slider, 147
icons, tag changes, 417–418	Inner Glows style, 301
Image effects, 205	Inner Shadows style, 301
Image Effects style, 301	interpolation, 39
Image from Clipboard command (File menu), 298	Intersect Shape Areas option, 273 Intersect with Selection icon, 108
Image menu commands	
Convert Color Mode, 64	Inverse command (Select menu), 111
Crop, 159	
keyboard shortcuts, 447)
Magic Extractor, 262	JPEG formats, 305, 334
Mode, 59	compression options, 335
Resize, 39	Web optimization settings, 310–311
Rotate, 270	
Transform Shape, 268	K
Image Size command	
File menu, 367	keyboard shortcuts
Image menu, 39	Editor, 443–448
Image Size dialog box, 38–39	Full Screen mode, 450
images. See also photos	Organizer, 449–450
compositing, 388 combining images, 391–392	Photo Browser navigation, 450
layered collage, 393–395	shape distortion, 271 tool selection, 11
replace part with another, 389–390	tool selection, 11
creating, 29–30	
displaying at 100 percent, 18	L
grid settings, 50–51	labels, printing options, 354
importing, 31	Lasso tool, 94
1	